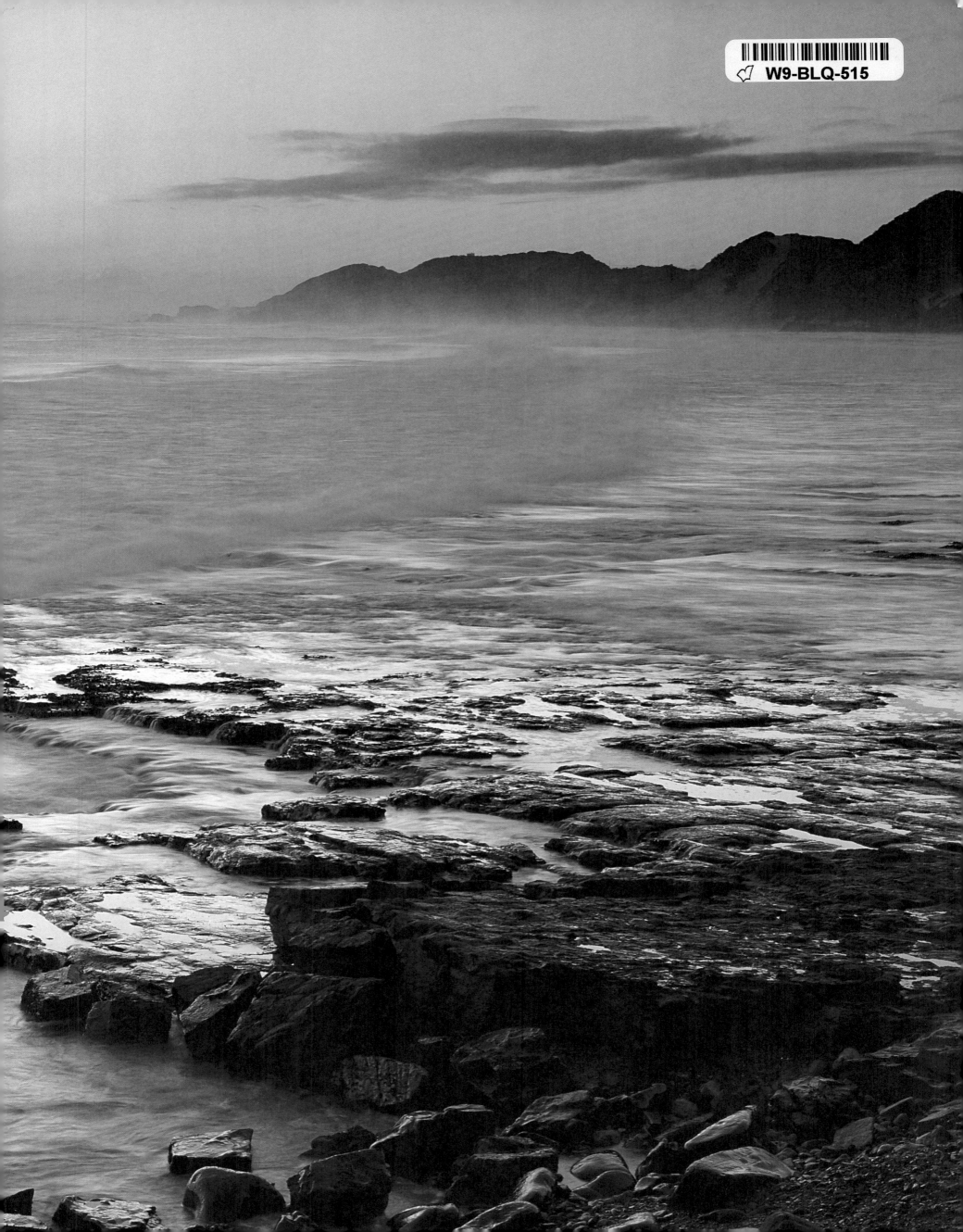

South Africa

A VISUAL CELEBRATION

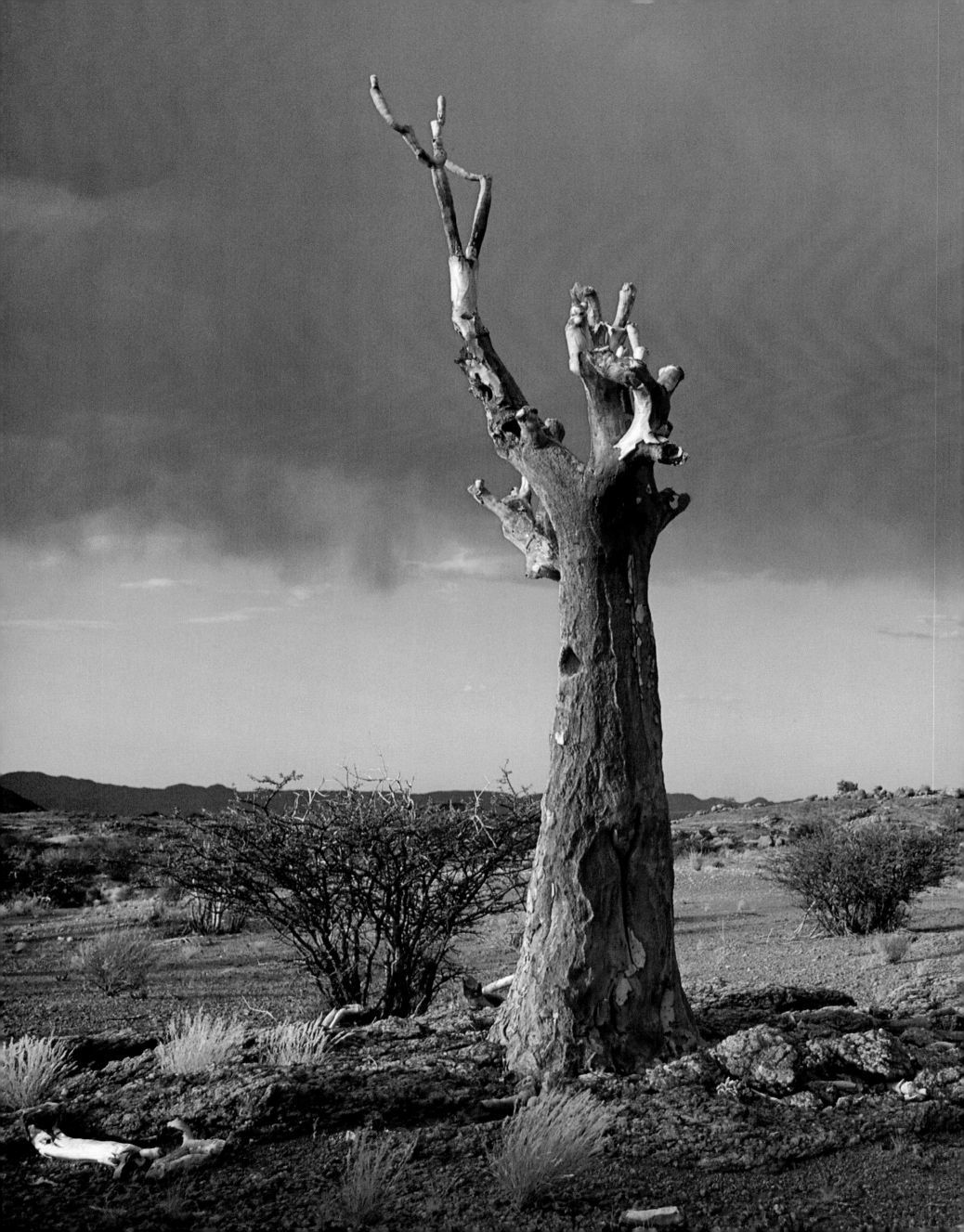

South Africa

A VISUAL CELEBRATION

TEXT BY ELAINE HURFORD

Struik Publishers (Pty) Ltd
(A member of Struik New Holland Publishing (Pty) Ltd)
Cornelis Struik House
80 McKenzie Street
Cape Town
8001

Reg. No.: 54/00965/07

First published in 1996

4 6 8 10 9 7 5

Designer Janice Evans
Design assistant Lellyn Creamer
Typesetter Deirdre Geldenhuys
Cartographer Caroline Bowie
using Mountain High Maps™
copyright © 1993 Digital Wisdom
Reproduction by Hirt & Carter Cape (Pty) Ltd
Printed and bound by Tien Wah Press (Pte) Ltd

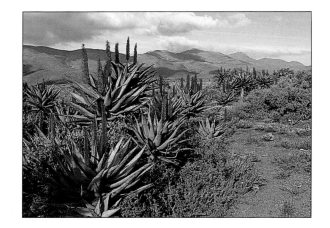

ISBN 1 86825 957 9

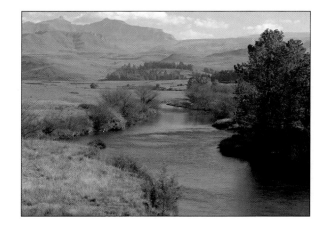

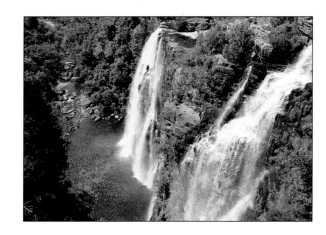

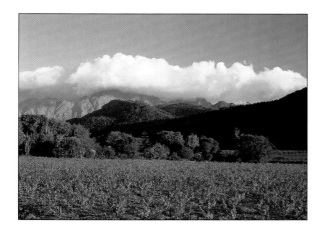

CONTENTS

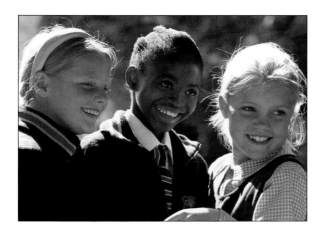

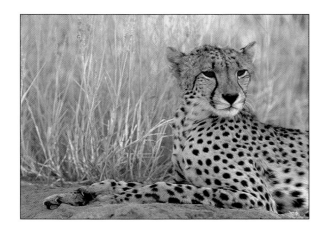

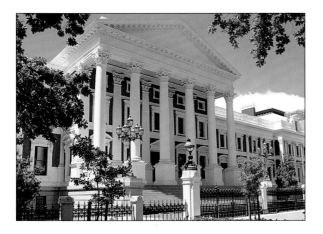

INTRODUCTION

From 'the Fairest Cape in the Whole Circumference of the Earth' to the 'great, grey, greasy Limpopo' and clean across the great sweep of the central plateau – 'a strange, haunted atmosphere ... once perhaps the greatest habitat of dinosaurs and other prehistoric life in the world' – South Africa is a country of breathtaking natural splendour. Extolled by Sir Francis Drake, Rudyard Kipling and Sir Laurens van der Post, among other writers captivated by its charms, South Africa has as frequently been revered in literature as it has been reviled in newsprint for the political imbalances which have only recently begun to be redressed. Its sometimes mean history is offset by the generosity of its landscapes and its bountiful beauty – a wide, glorious land where only nature has remained serene through the tumult of the centuries. Great men bequeathed her assets to successive generations: General Smuts cautioned not to pick but to 'worship and pass on'; President Kruger set aside the first great sanctuary to safeguard the magnificent animals; and Cecil John Rhodes gave the nation vast tracts of his personal property, including whole mountain slopes, for a wildflower garden. South Africa is big and bold – a country of broad brushstrokes, great sweeps of colour, immense unpopulated areas. Massive mountain chains ring the country and it lies between two of the world's greatest oceans. Even its animals are big,

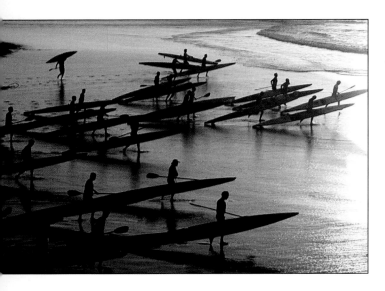

and in spirit, so too are its more than 40 million people. Although South Africa is, broadly speaking, composed of no more than three physical elements – the plateau, the coastal terrace and the mountains that separate them – it is nevertheless a land of tremendous diversity with a disparate topography, which takes in astonishing differences in the full botanical spectrum. Its southwestern shores are wild places of jagged

ABOVE *A benign Indian Ocean and long beaches give the river port of East London the edge for watersports and family holidays.*

RIGHT *The baobab* (Adansonia digitata) *reaches immense age and girth and is imbued with myth by many tribal peoples.*

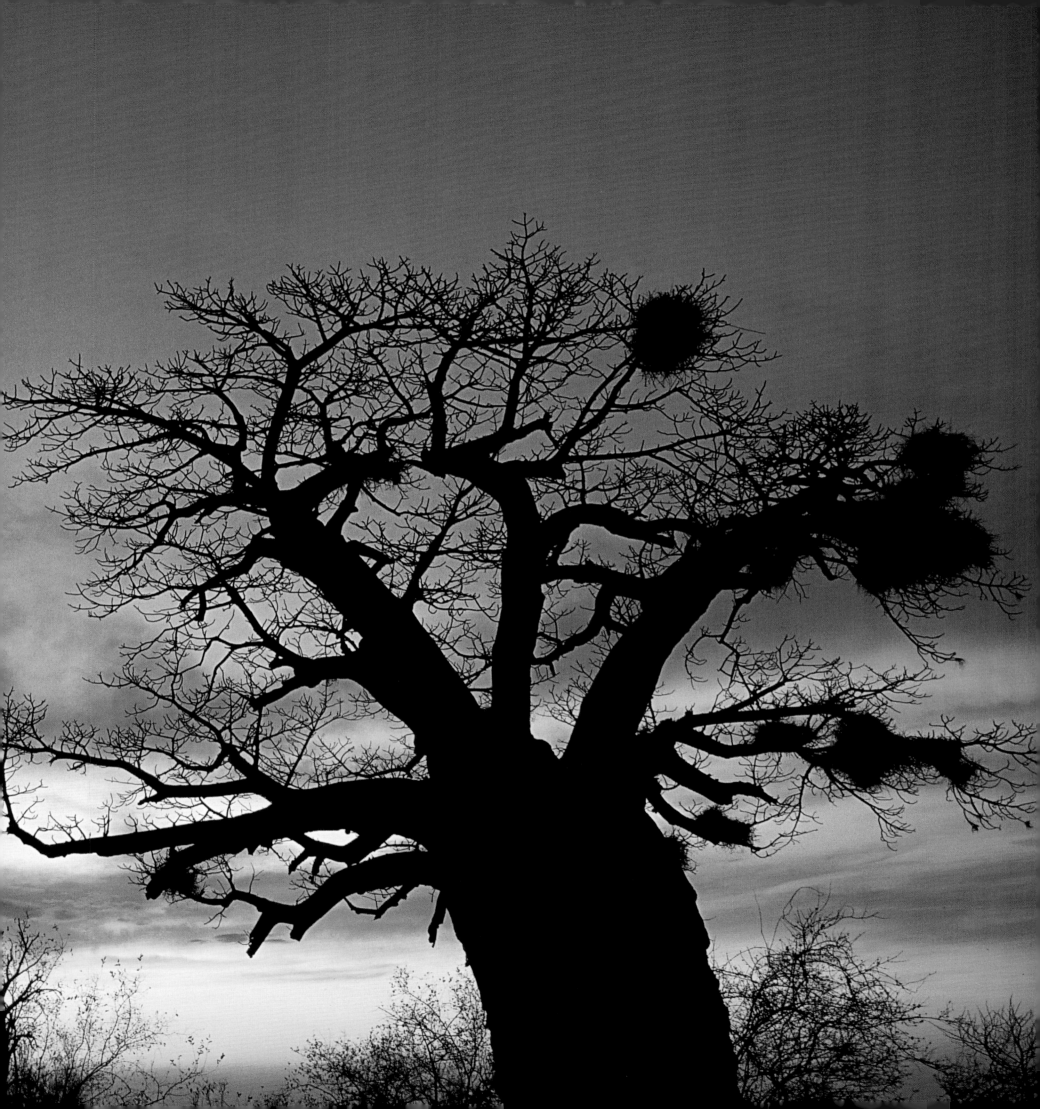

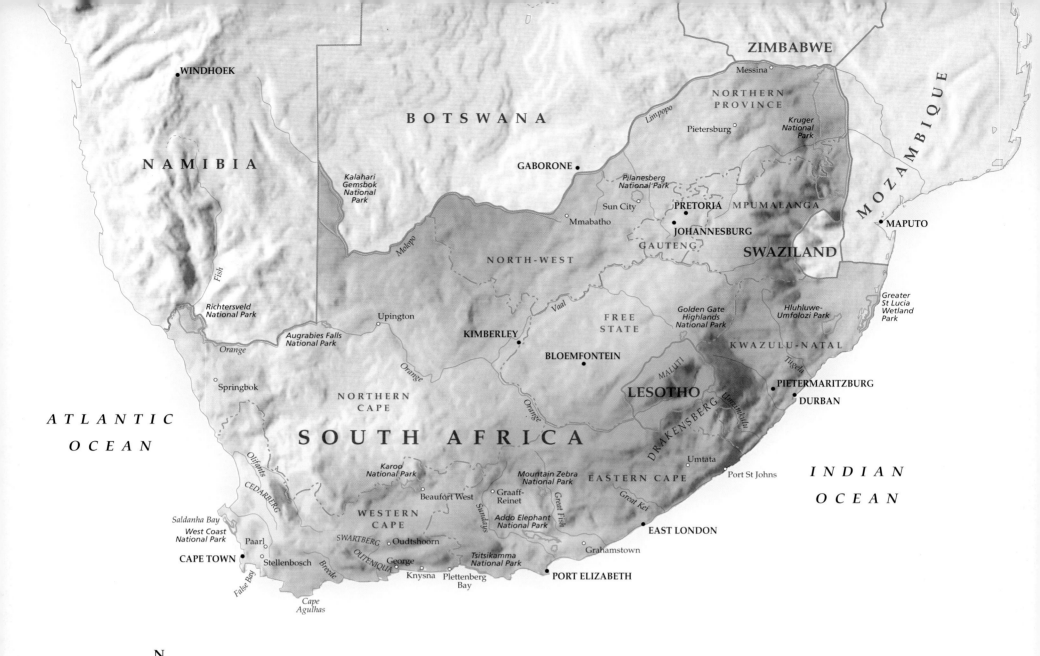

N

0 200 km
0 100 miles

ABOVE *South Africa has three dominant physical characteristics: an immense inland plateau, a slender coastal terrace and a massive mountain wall dividing them.*

OPPOSITE *West Coast wildflowers blaze in homage to spring, laying carpets of colour across the barren landscape during August and September.*

OVERLEAF *The day ebbs in tones of pewter at low tide on Muizenberg beach. Twenty kilometres of white sandy beach lie between the western and eastern shores of False Bay.*

rock and high sea cliffs pounded by the cold Atlantic Ocean. In the east, all is serene – white, sandy beaches, some up to 20 kilometres in extent, are lapped by the Indian Ocean and ribboned with a network of estuaries; rivers, rising in the uplands and mountains, plummet down sheer cliffs or ease their way through shaded gorges to merge with the sea. These estuarine systems are complex ecological compositions, containing a universe of creatures which are nevertheless a mere fraction of the floral and faunal wealth of the country. South Africa has some of the rarest species on earth, chiefly protected within reserve areas regarded internationally as models of eco-tourism.

Not all is idyllic, however. Many sensitive ecological systems are challenged by encroaching urbanisation and industry. But it remains a land where man can fuse his spirit with nature and, briefly, become one with the great energy of the universe. Man cannot live by his senses alone. There's bread and butter to be put on the table. Although South Africa's natural assets are reaping increasing riches from tourism, it is mining and manufacturing, industry and commerce, agriculture, forestry and fishing that bring home the bacon. The informal sector makes a big contribution, fitting into the financial scheme of things somewhere between commerce and agriculture. Mining too has been overthrown by manufacturing, but gold is still the country's biggest export and the foundation of its challenged currency. For visitors, this produces a bonus in the form of highly favourable exchange rates which make South Africa one of the most affordable destinations in the world. For locals, however, it is becoming an increasing luxury to remain at home in the face of escalating property, transport and food prices.

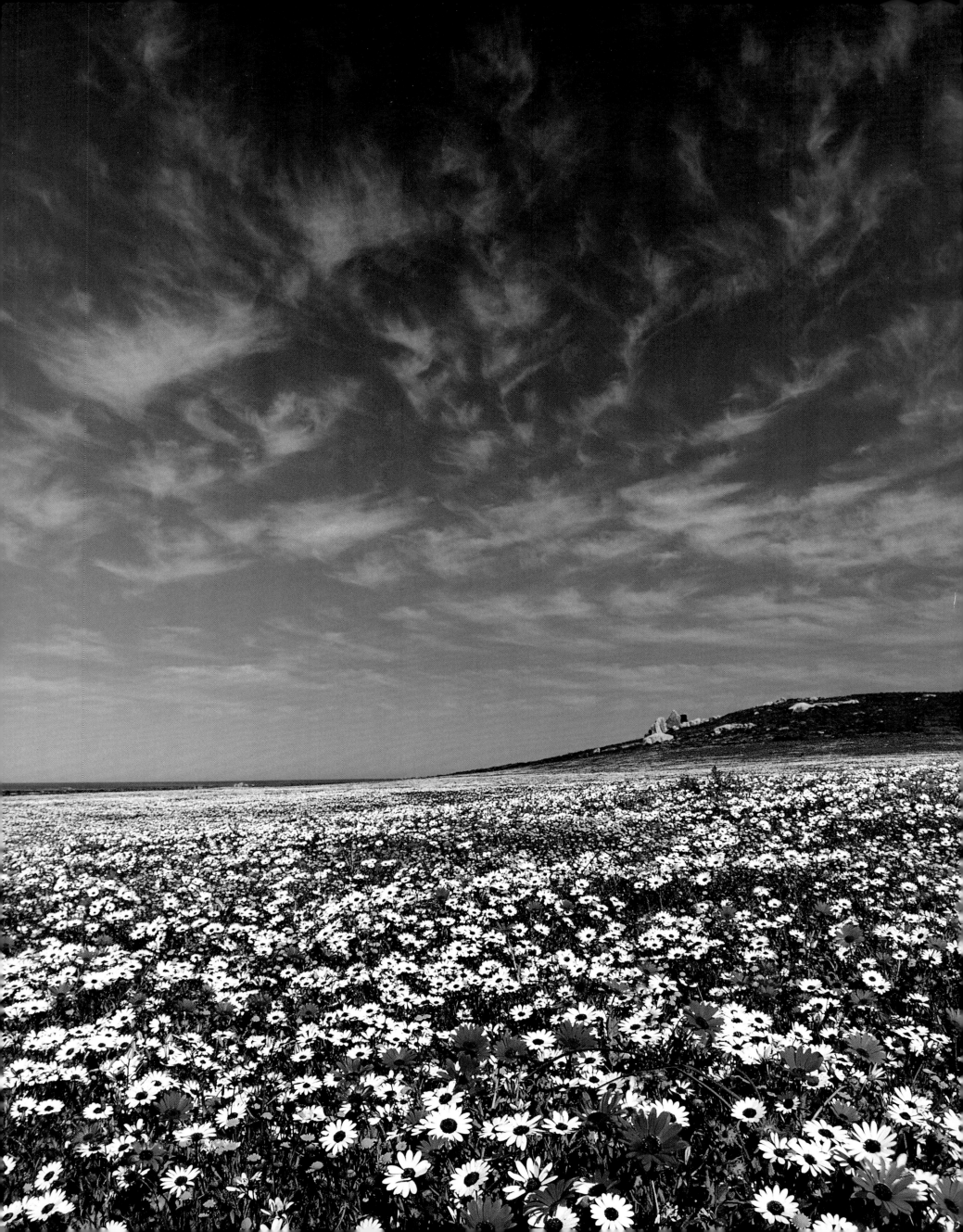

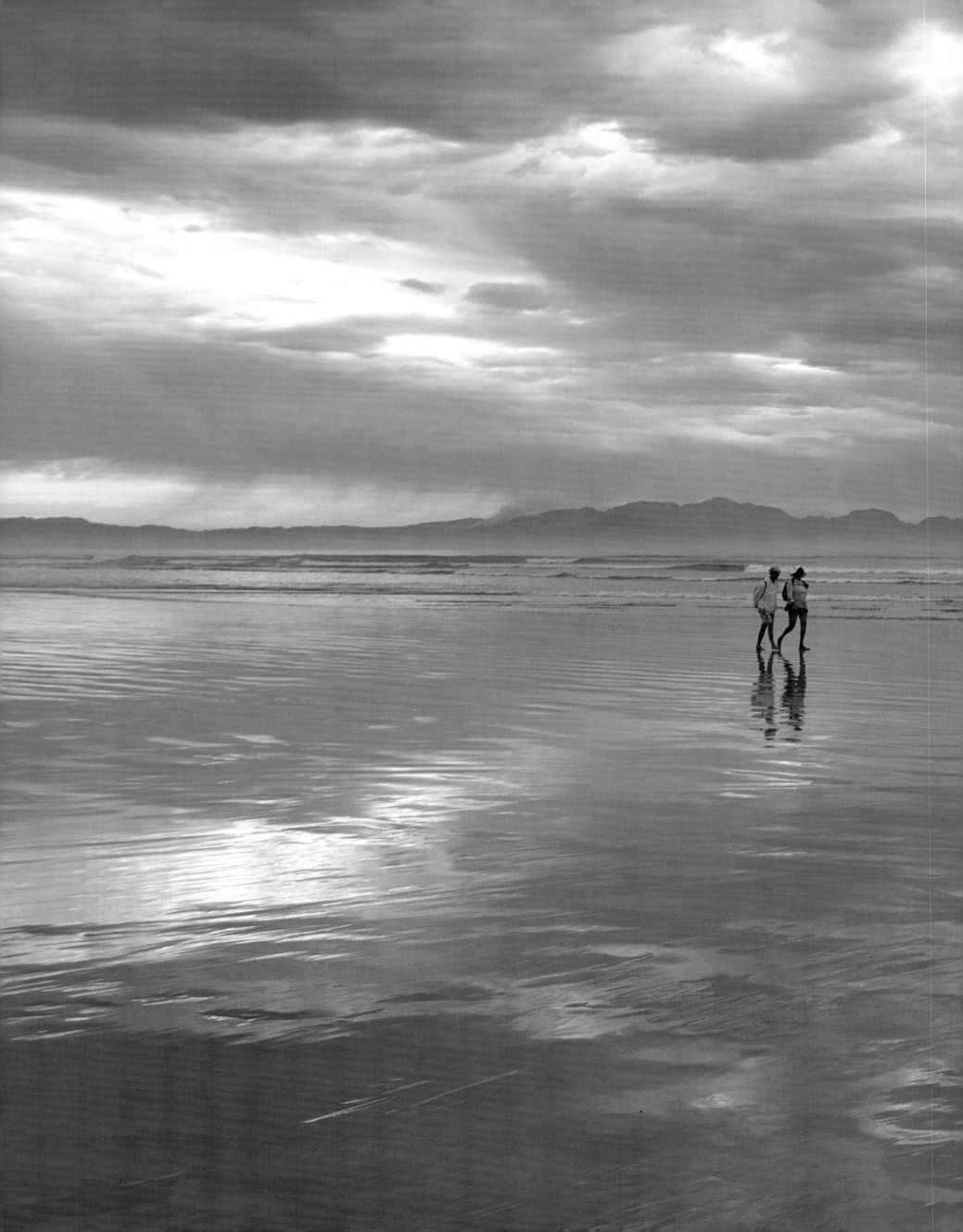

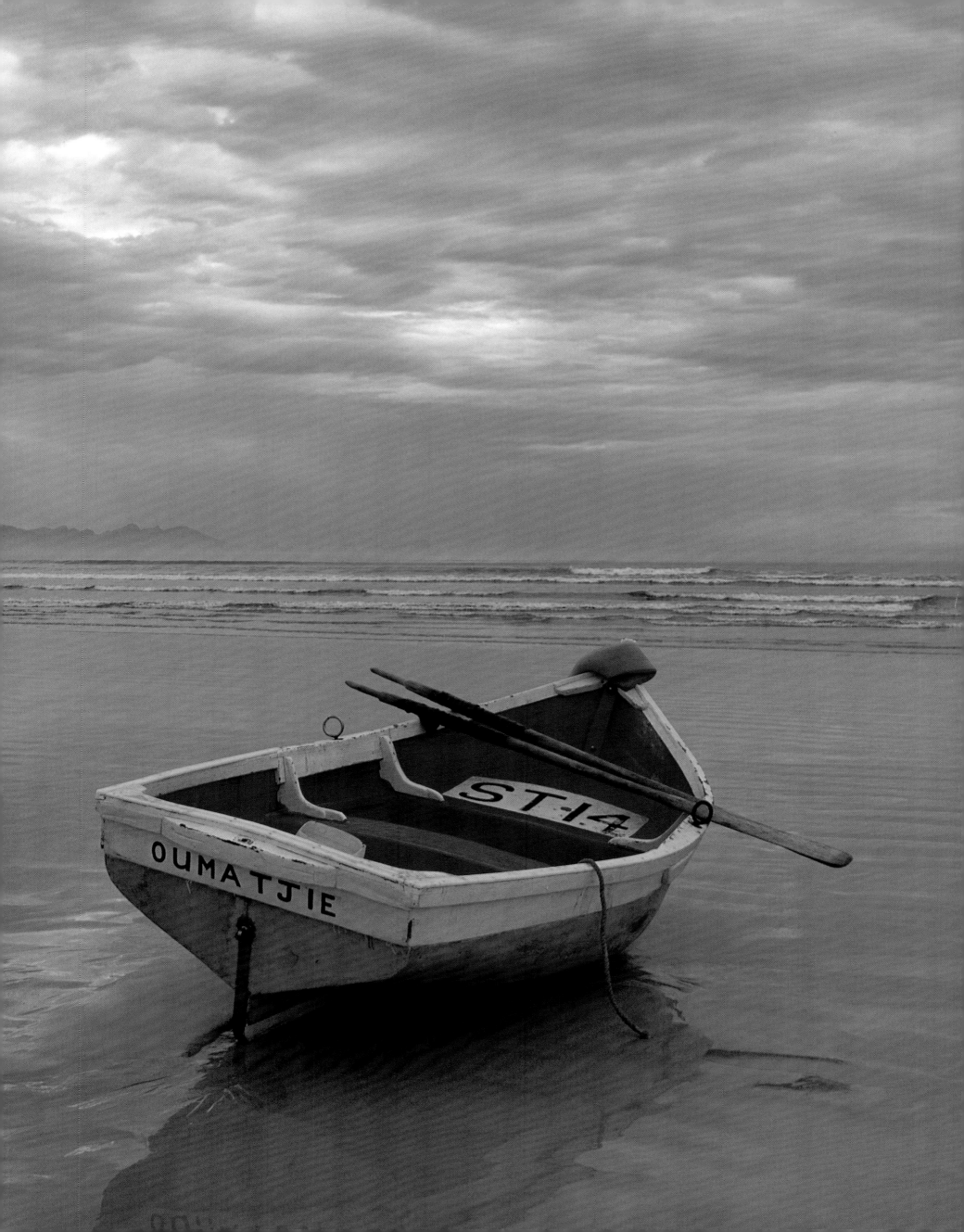

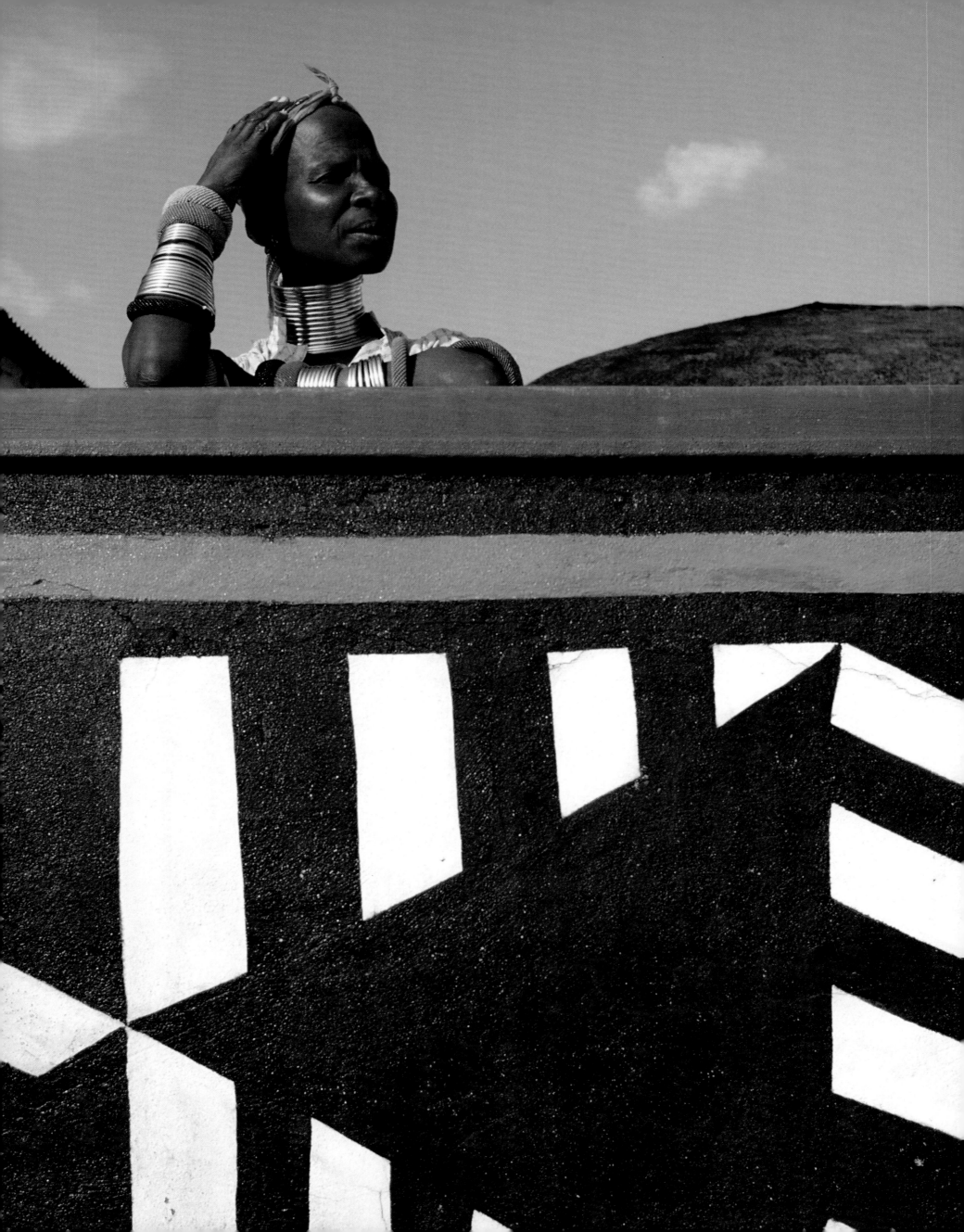

The crucible of financial power is Gauteng, with Johannesburg at its centre, the emerging financial centre of southern Africa and entry-point for many of the country's visitors. Elegant Pretoria is the country's administrative and diplomatic capital, traditionally the retreat of parliamentarians between sessions. The country's prettiest girls are reputed to live in Bloemfontein, 'city of roses' of the landlocked Free State. Although colonial Pietermaritzburg is the capital of KwaZulu-Natal, the major port of Durban is one of the world's fastest-growing cities, with Cape Town, a close second. Cape Town too, has recently become the preferred place for a second home among the who's who of the world's wealthy as well as a somewhat louche community of immigrant aristocrats. Port Elizabeth, said to be the country's friendliest city, is one of South Africa's finest coastal playgrounds and home to several generations of bred-in-captivity dolphins.

This is South Africa, 350 years old and reborn time and again, from a tiny 17th century Dutch settlement seized by the colonial hands of the British and French, divided into fiercely independent Boer Republics and, in 50 years of Afrikaner nationalist rule, into 'homelands' that confined ethnic groups in rural areas, far from jobs and the urban version of civilisation. It is a history that has been wracked with war cries, a land whose people have wept. Reborn once more in 1994 as The New South Africa, it is a country still buffeted by winds of change as it probably will be for a decade or more to come.

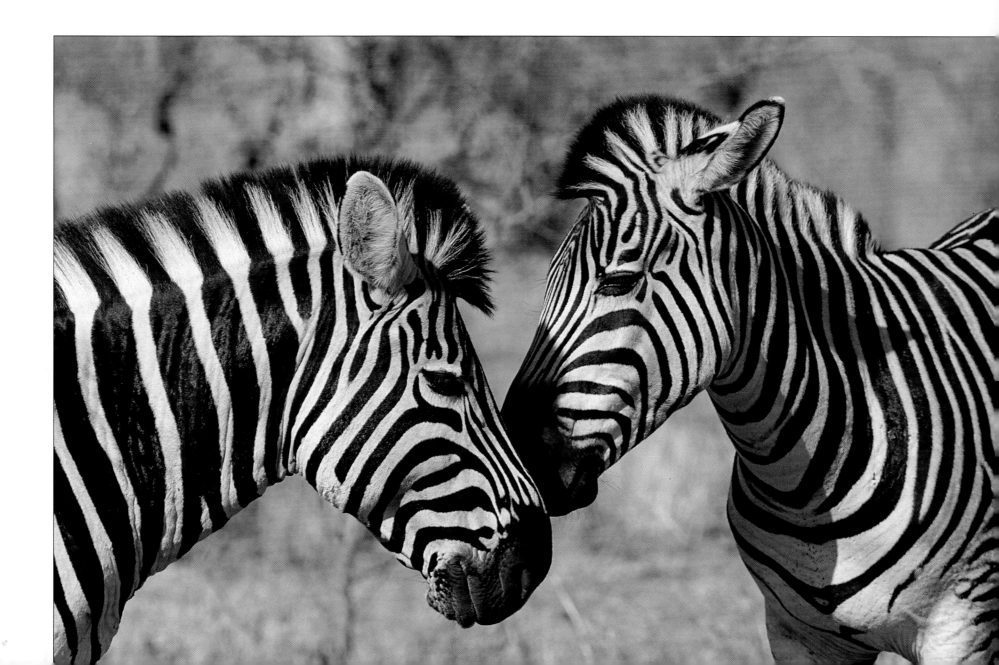

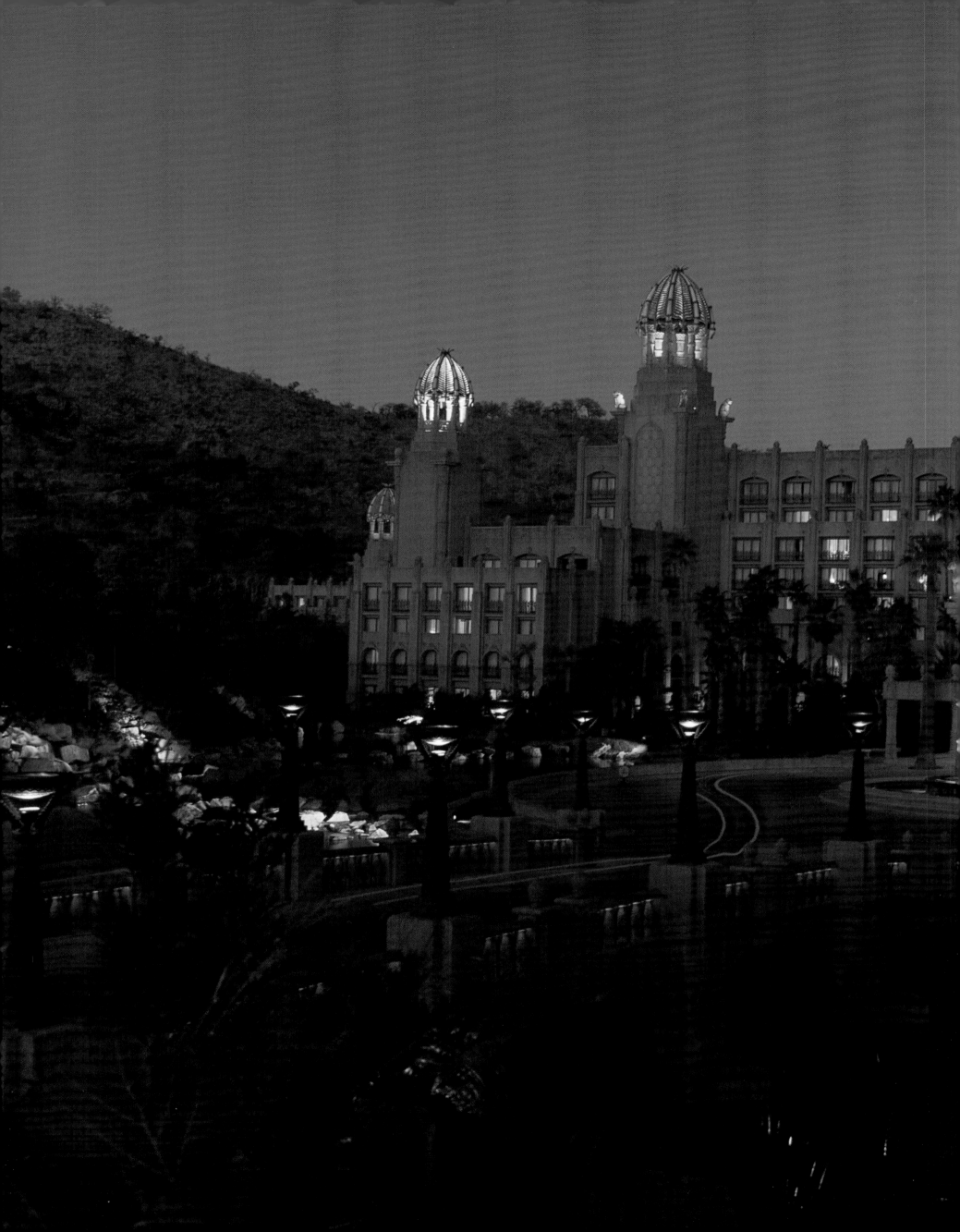

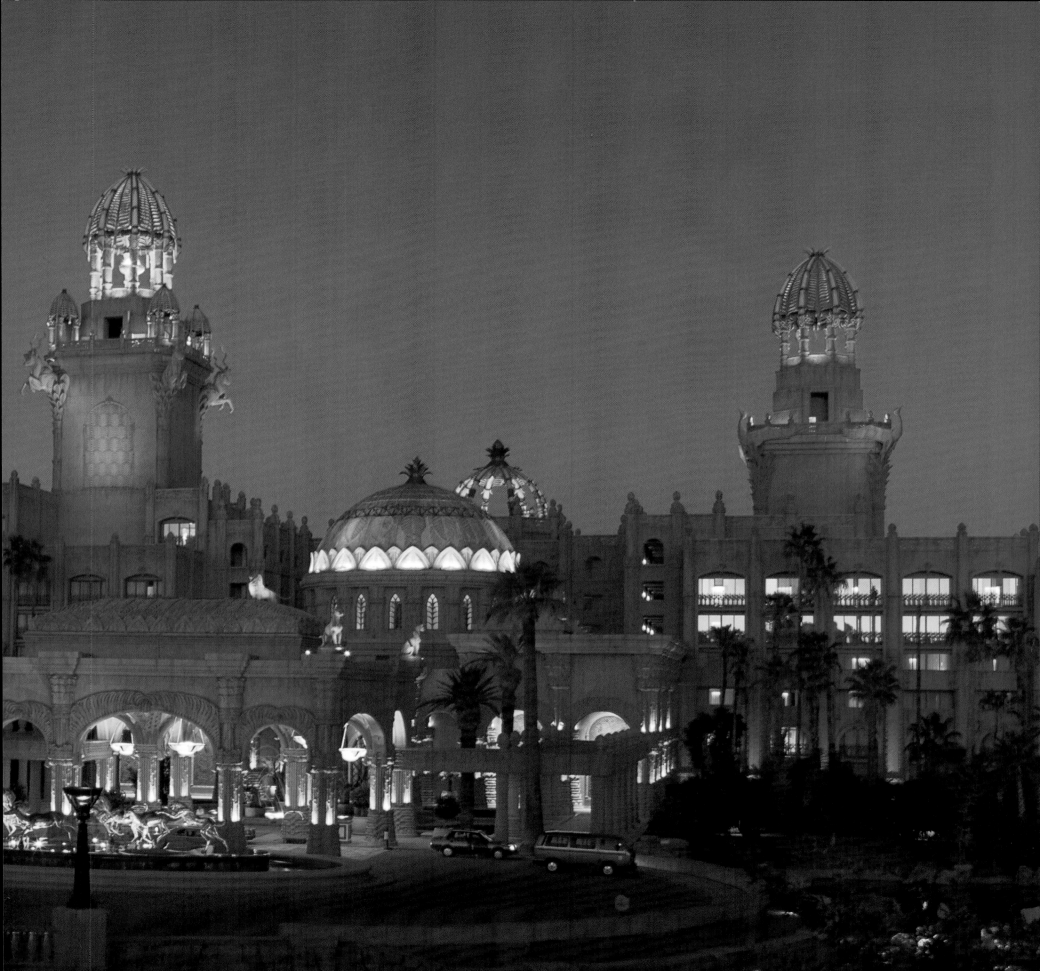

COAST OF MANY COLOURS

I n parts stormy and in others serene, harshly windswept or softly subtropical, South Africa's coastline is lapped, and at times lashed, by the waters of two great oceans – the Indian and the Atlantic – which meet on a windswept beach of the southern Cape coast. It is a coastline, three thousand kilometres in extent, of remarkable contrasts. The impact of the oceans produces a stark, coastal desert in the west and languid, subtropical shores in the east. The result is a multitude of specialised ecosystems which form the links of an almost continuous chain of marine and onshore reserves. Most combine an admirable balance of recreation and conservation and several are listed among the most significant natural sanctuaries in the world. These sanctuaries protect a myriad species from the tiny seahorse *(Hippocampus capensis)* found in Knysna's lagoon and the delectable West Coast lobster *(Jasus lalandii)*, to the marine mammoths – migratory southern right and humpback whales – which mate and calve off the coast each year from May to December. The whales can be seen along a 900-kilometre Whale Route that stretches from Doringbaai in the west to the Tsitsikamma National Park in the southeast. Three centuries of often tragic

history have created evocative titles such as the Skeleton Coast, the Cape of Storms and the Wild Coast, remembering almost 3 000 ships and countless souls lost in the wild waters. But as brutal as it may often be, so the South African coast is also benevolent, and there are as many places that are calm and lovely, where people can rest or play in sweet isolation or in a convivial jostle of fellow-vacationers.

ABOVE *An immense sweep of white sandy beach fronts the small fishing village of Paternoster on the West Coast.*

RIGHT *Knysna's languid lagoon reflects the metamorphoses of the skies and the seasons. The 17-square-kilometre lagoon is at the heart of a national lake area.*

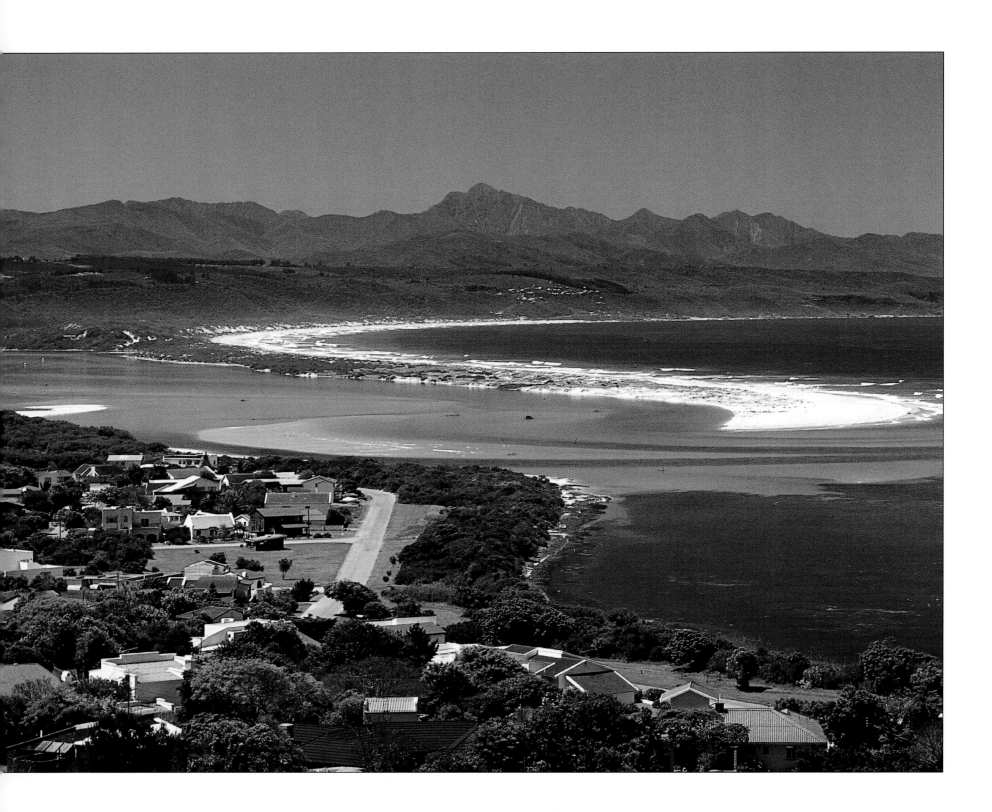

ABOVE *Plettenberg Bay presents a lavish natural composition of ocean, estuary and dune forest against a backdrop of the Tsitsikamma Mountains. Lookout Beach, east of the village, is reputedly the finest beach in South Africa.*

RIGHT *The Swartvlei lake merges with the sea at Sedgefield at the eastern end of a protected wetland system which extends for 35 kilometres along the coast.*

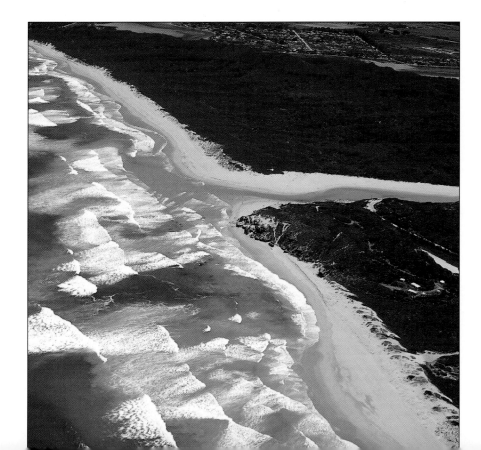

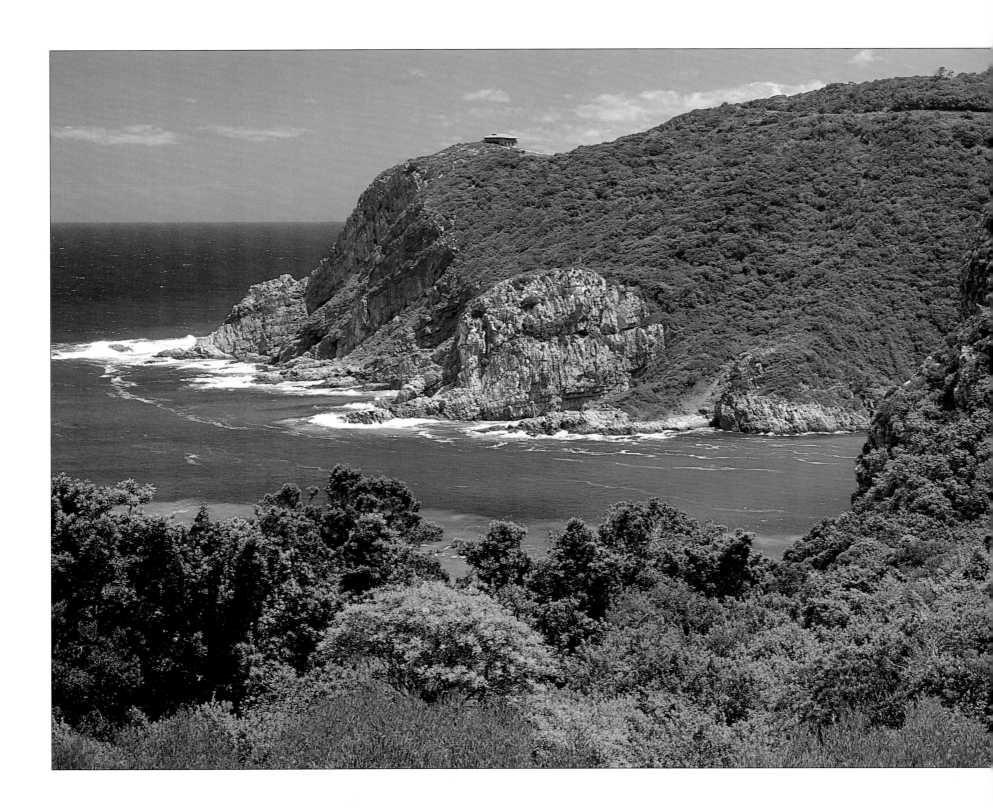

ABOVE *A pair of sandstone buttresses guards the entrance to the Knysna Lagoon. The western head is part of a private nature reserve which has a small population of rare blue duikers.*

LEFT *The Serpentine Channel cuts a swathe through the floodplain between the Touw River and Island Lake at Wilderness. The wetlands of the southern Cape coast encourage habitation by a wonderful variety of waterbirds.*

19

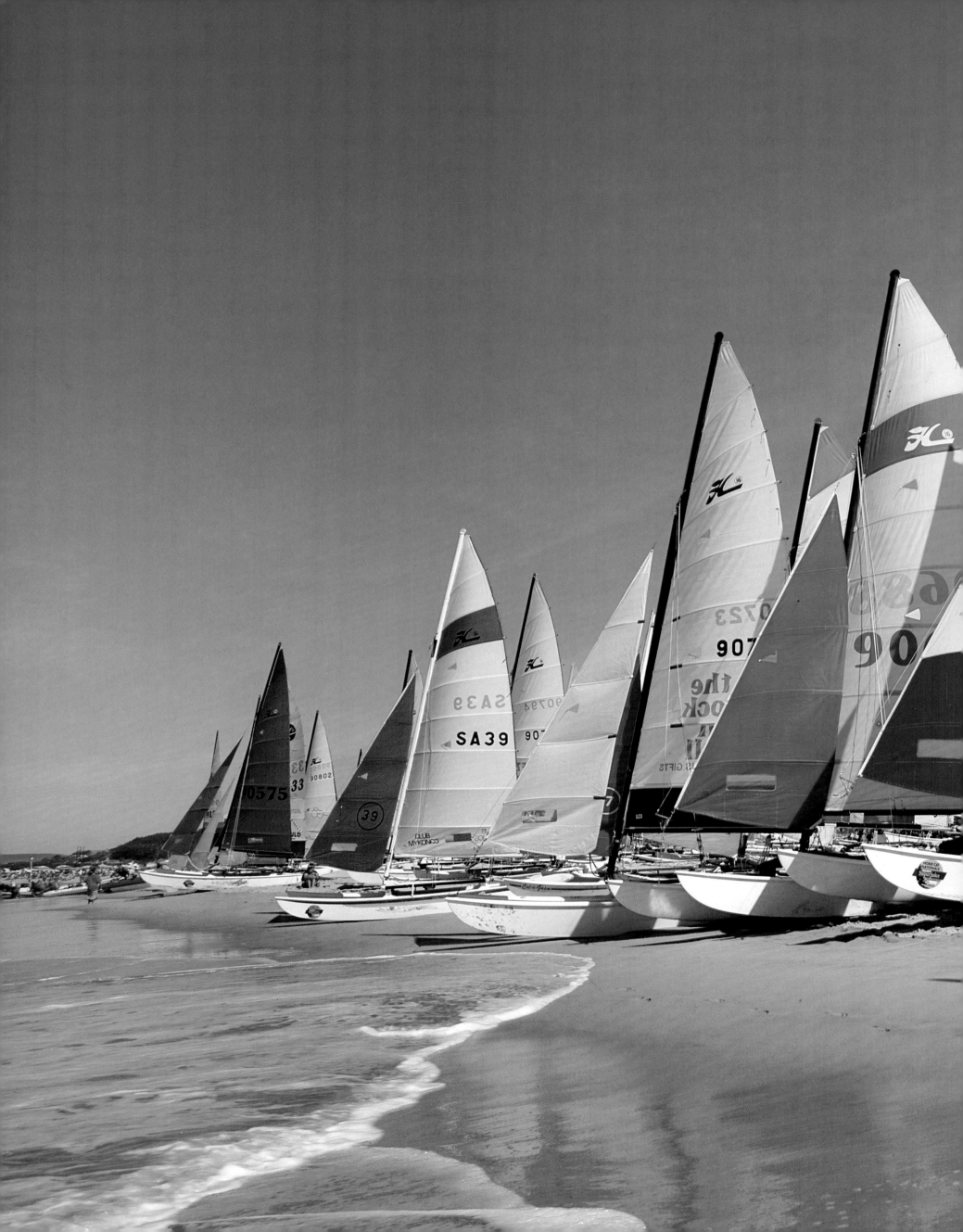

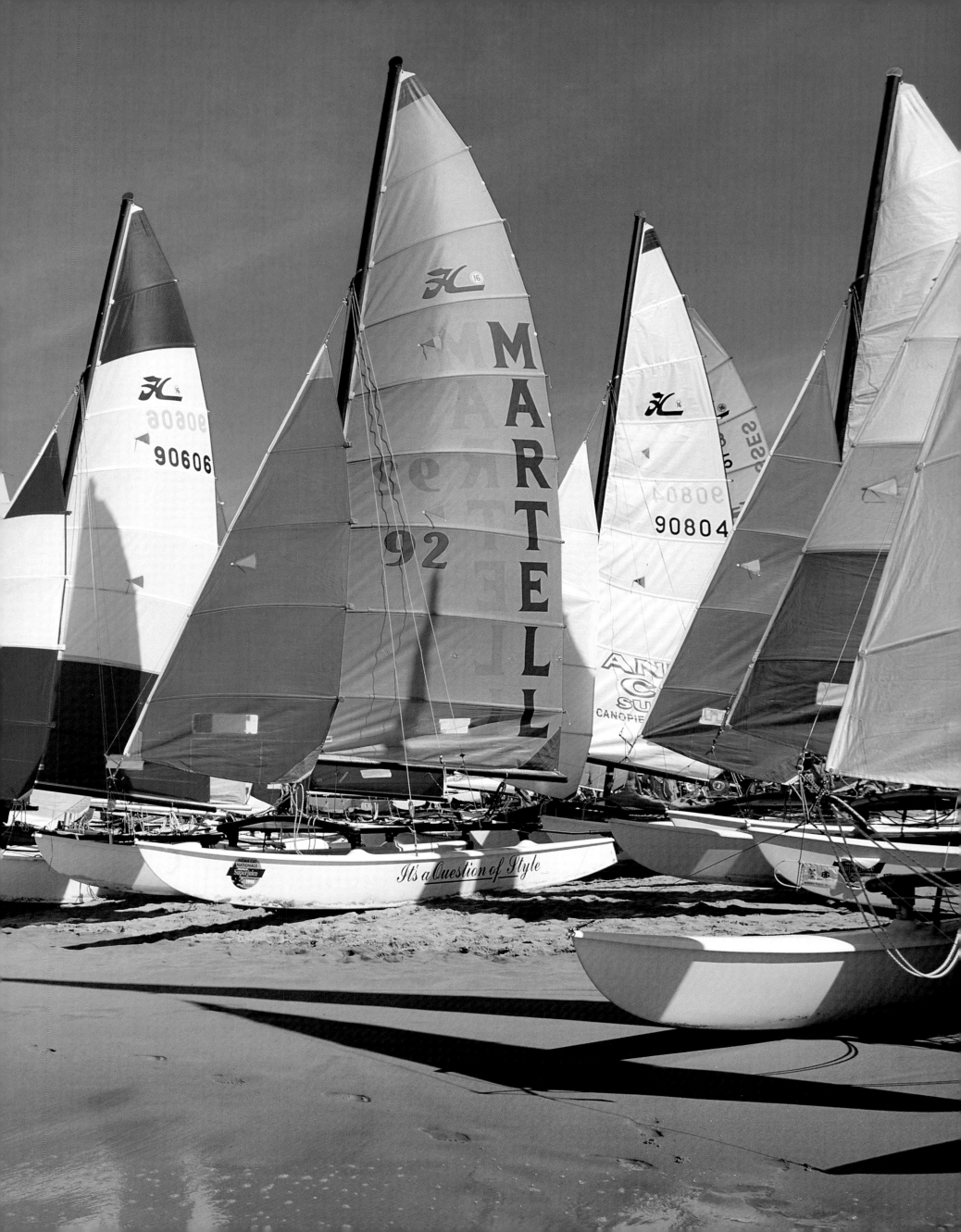

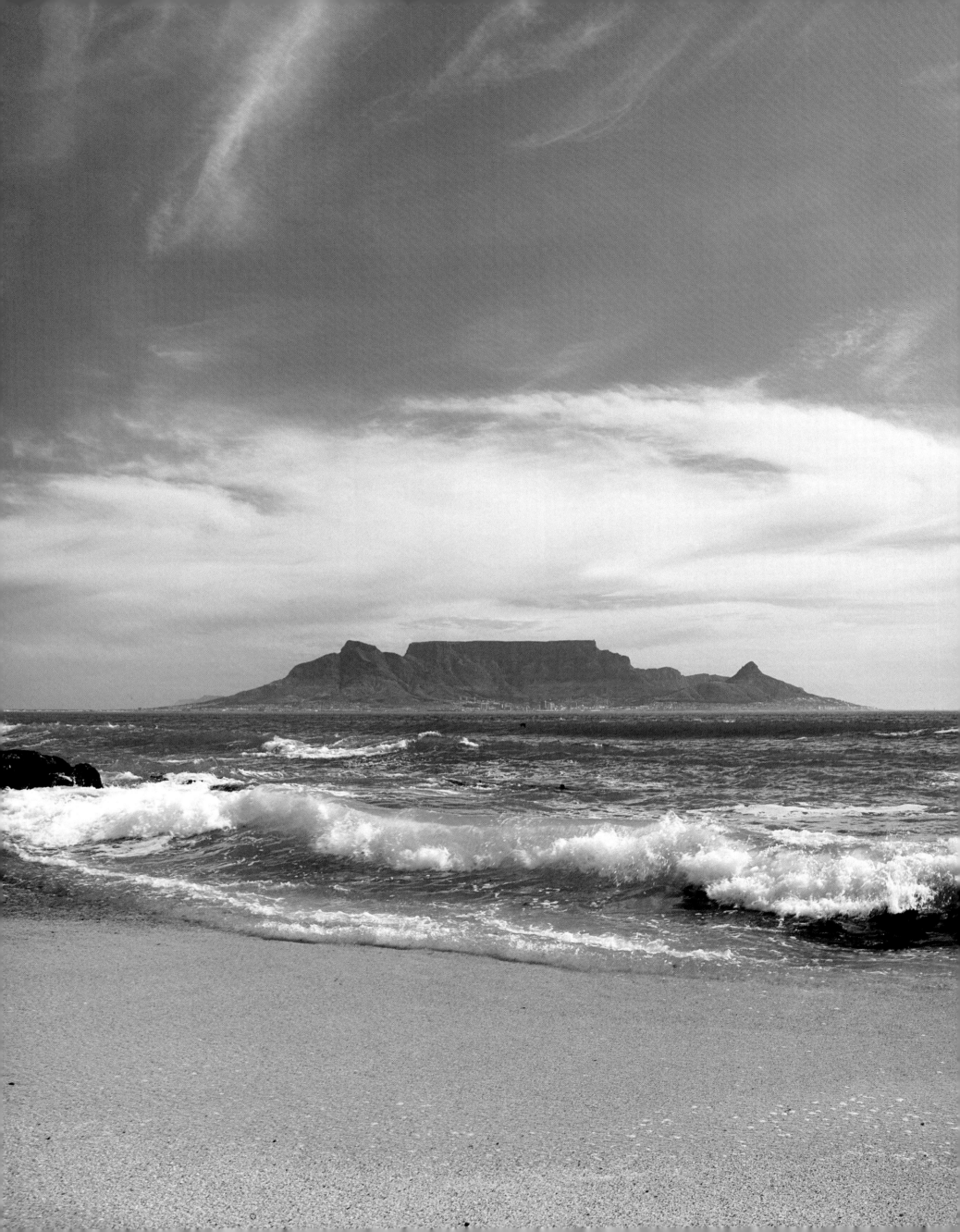

PREVIOUS PAGE *With warm waters and plentiful sunshine, Plettenberg Bay is a favourite destination for watersport enthusiasts. Hobie Cats mass in bright ranks on Hobie Beach, east of Robberg Peninsula, for one of the year's championship events.*

LEFT *Table Mountain has been a natural feature at the southern tip of the African continent for 350 million years. Visible for more than 240 kilometres out to sea, it has, through the ages, meant shelter for early peoples, a sanctuary for animals and plants, a welcome landfall for weary sailors, and an abiding symbol of Cape hospitality.*

BELOW *One of Cape Town's superb Atlantic coast beaches, Camps Bay, lies at the foot of a series of sandstone buttresses, 'The Twelve Apostles'.*

OVERLEAF *The shores of False Bay, including the popular family beach at Fish Hoek, are generally more bather-friendly due to the milder sea temperatures and tempering effect of the onshore winds.*

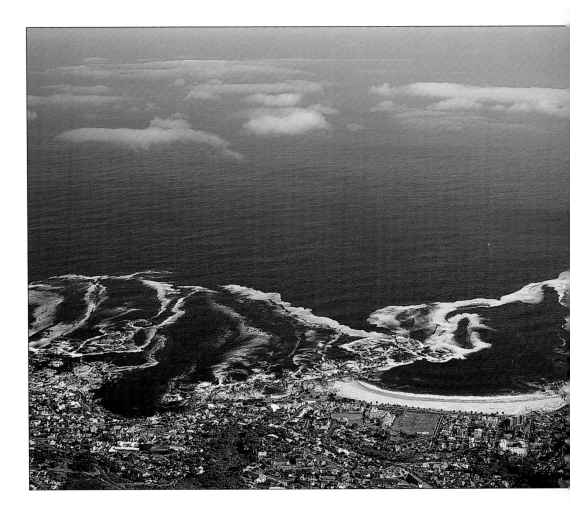

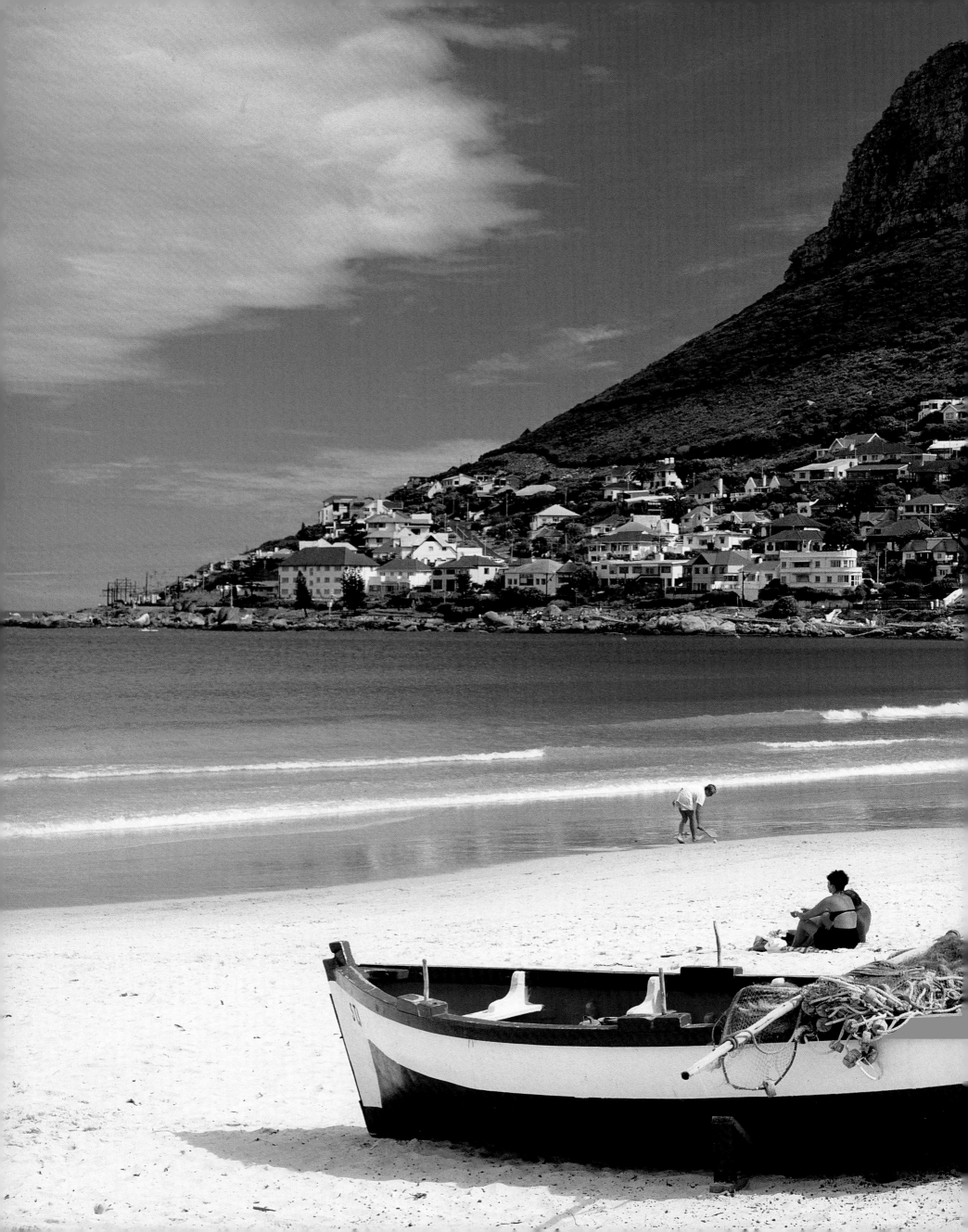

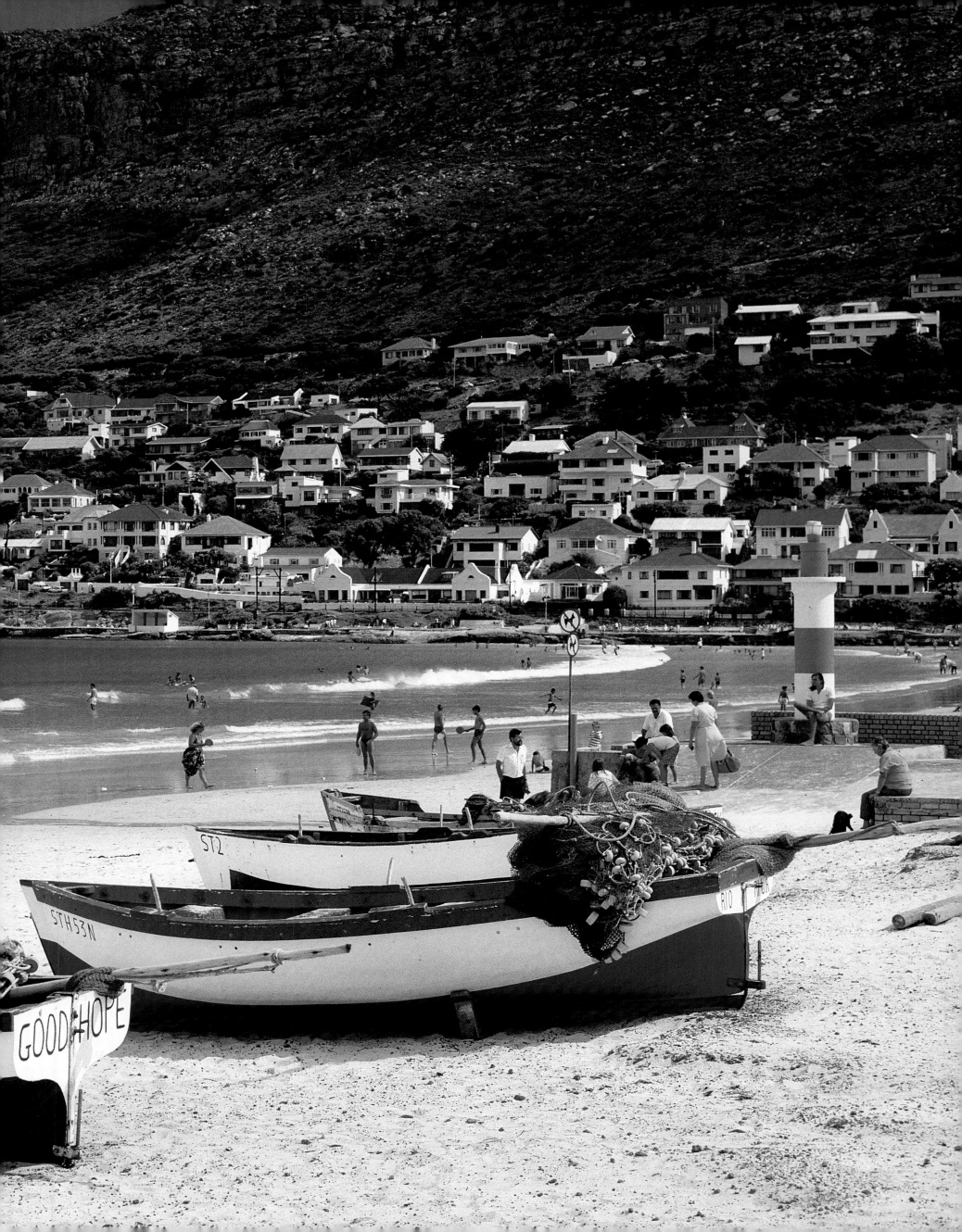

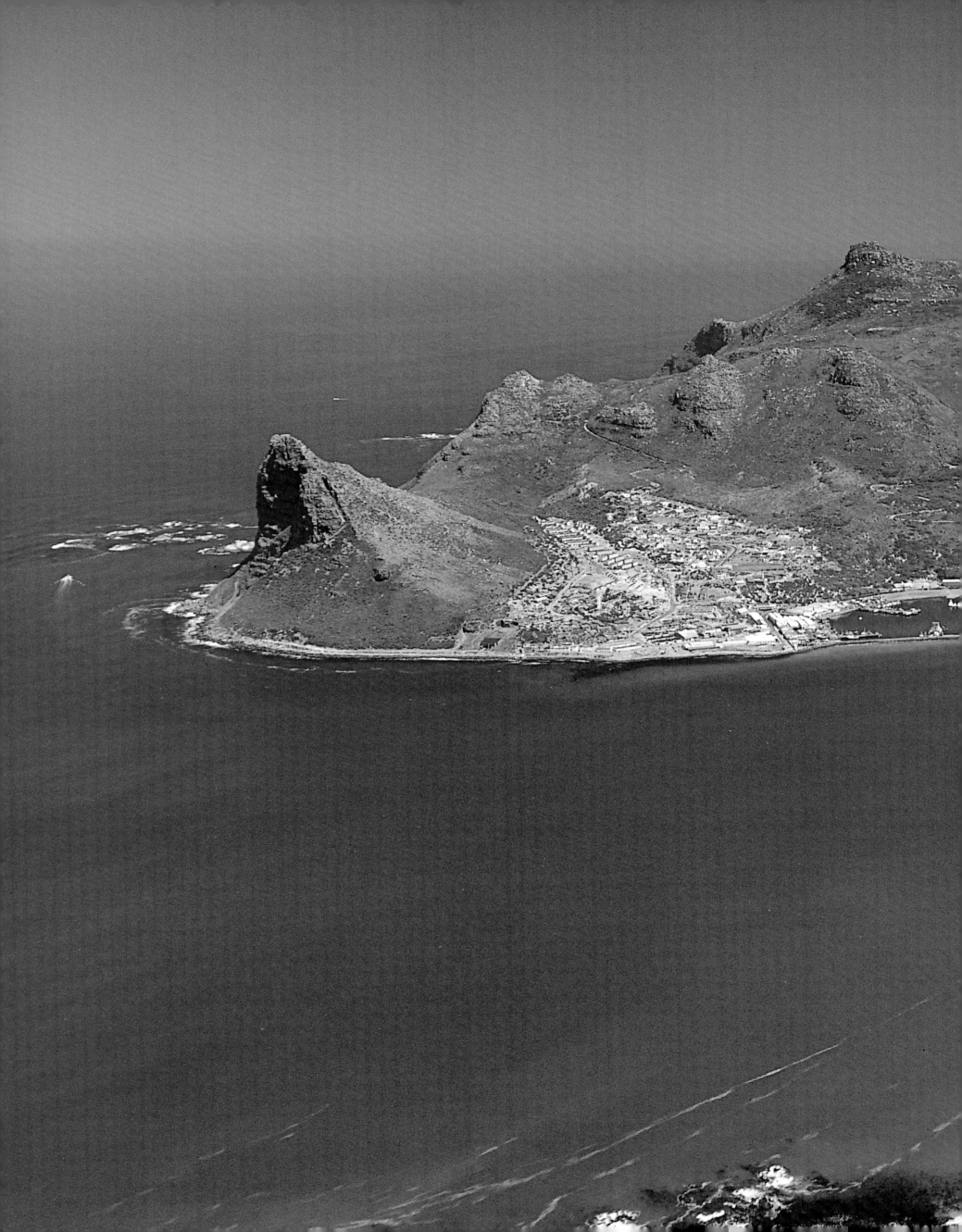

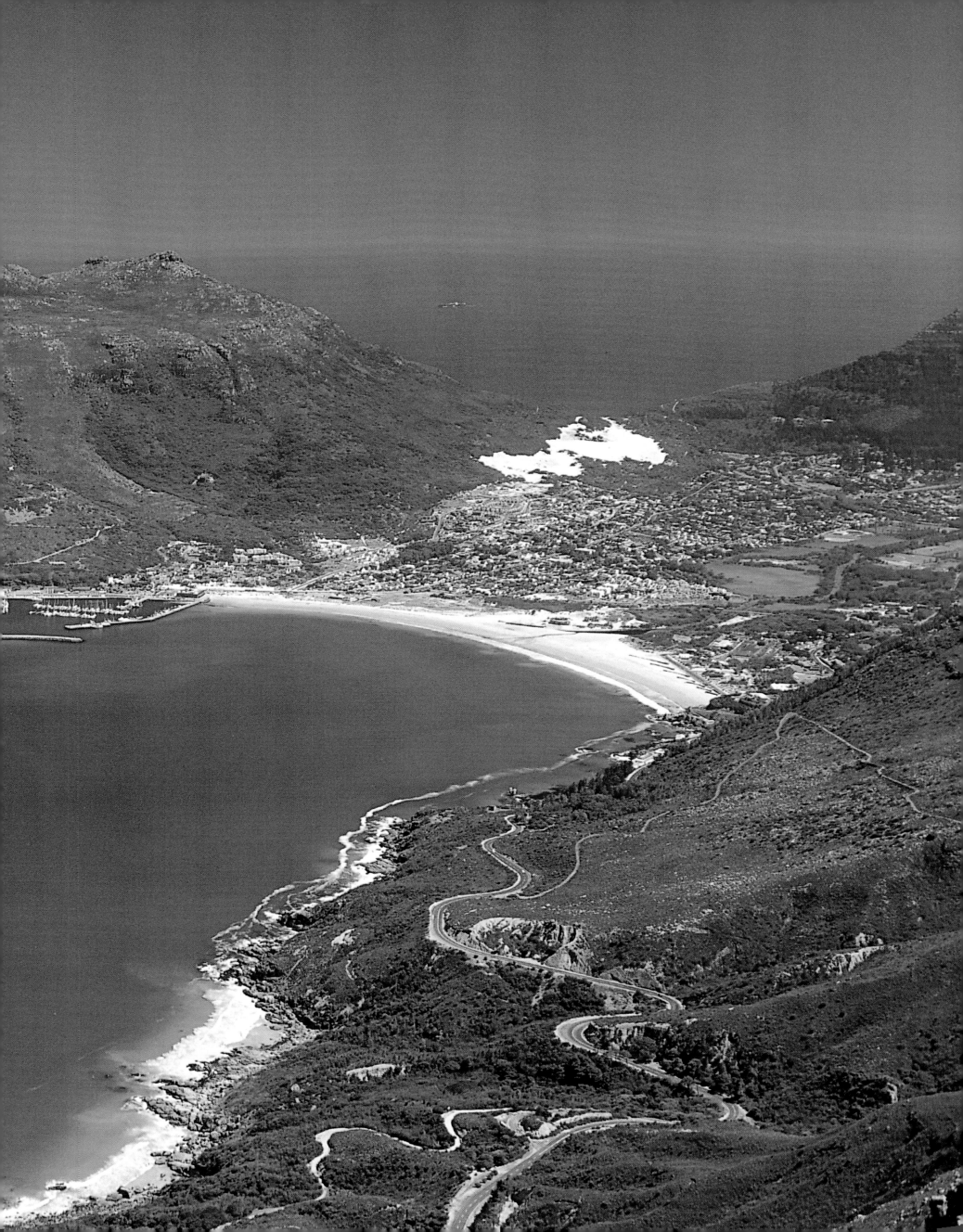

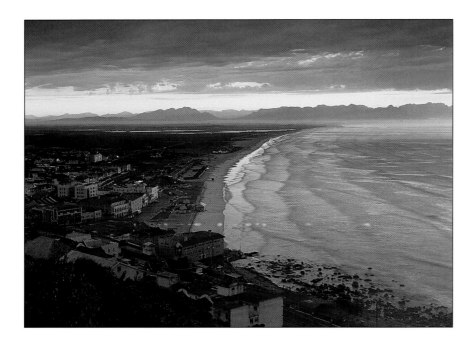

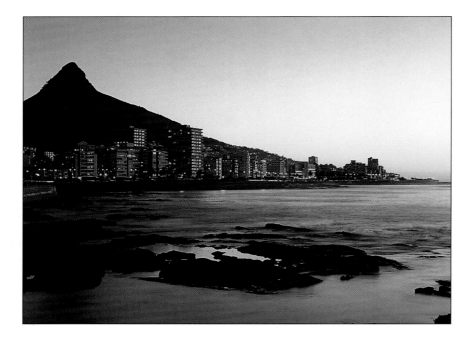

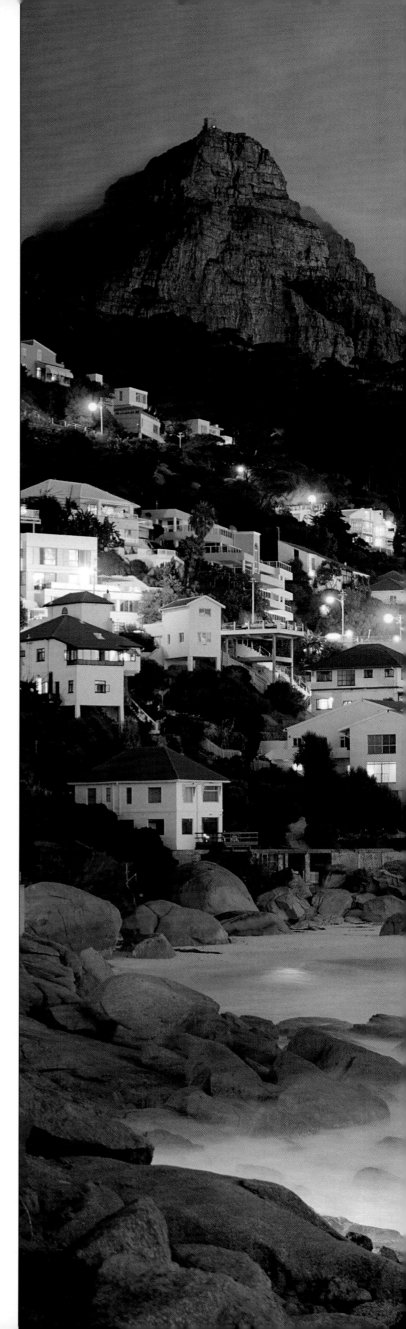

PREVIOUS PAGE *The fishing harbour and village at Hout Bay slumbers in the shadow of the sandstone Sentinel.*

TOP *Twenty kilometres of white, sandy beach stretches from Muizenberg, half an hour's drive south of the city, to the harbour village of Gordon's Bay.*

ABOVE *Cape Town's Sea Point promenade at the foot of Signal Hill is a medley of shops, restaurants and expensive apartment buildings.*

RIGHT *Luxurious condominiums and palatial private homes cascade down the lower slopes of Table Mountain's western face at Clifton.*

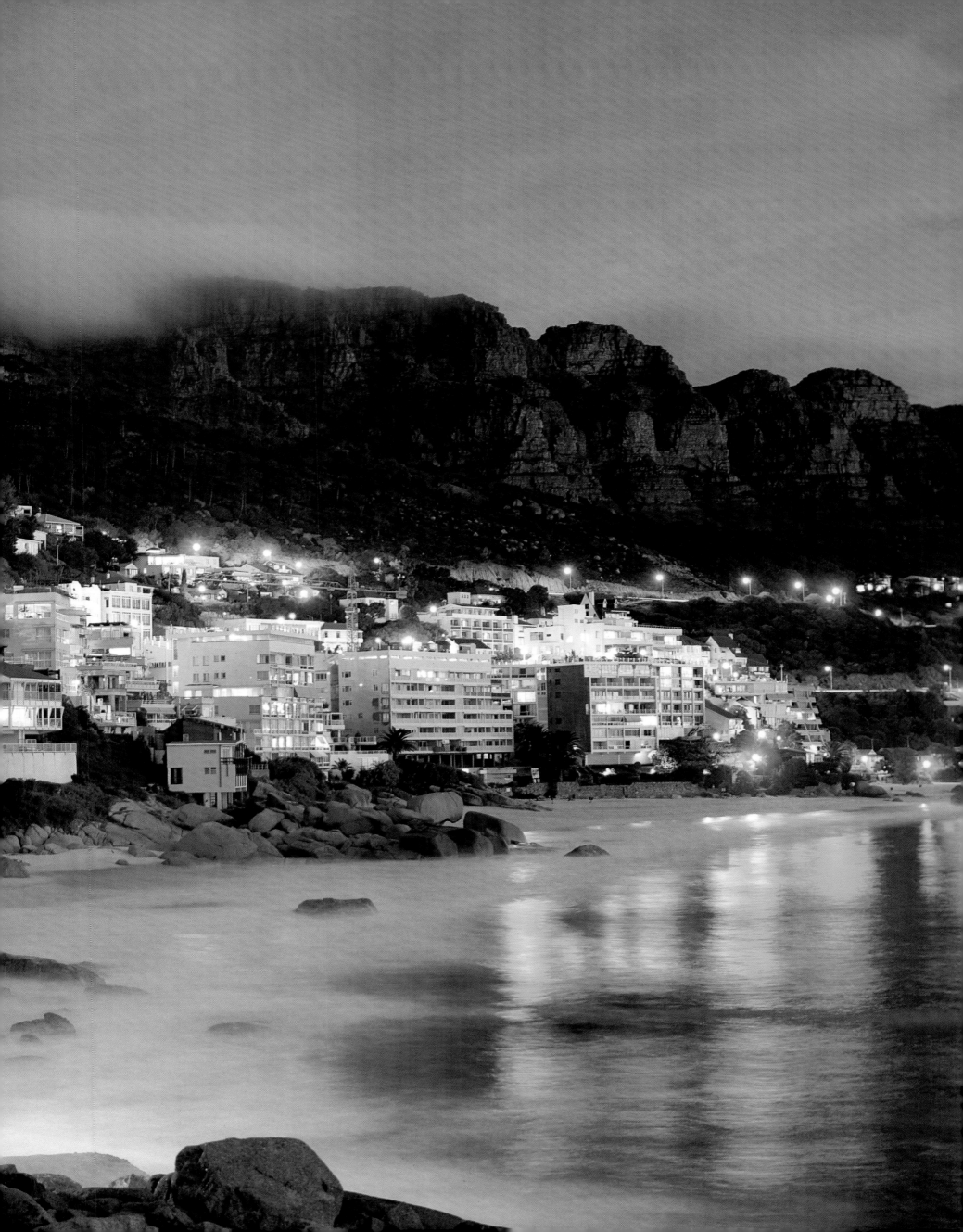

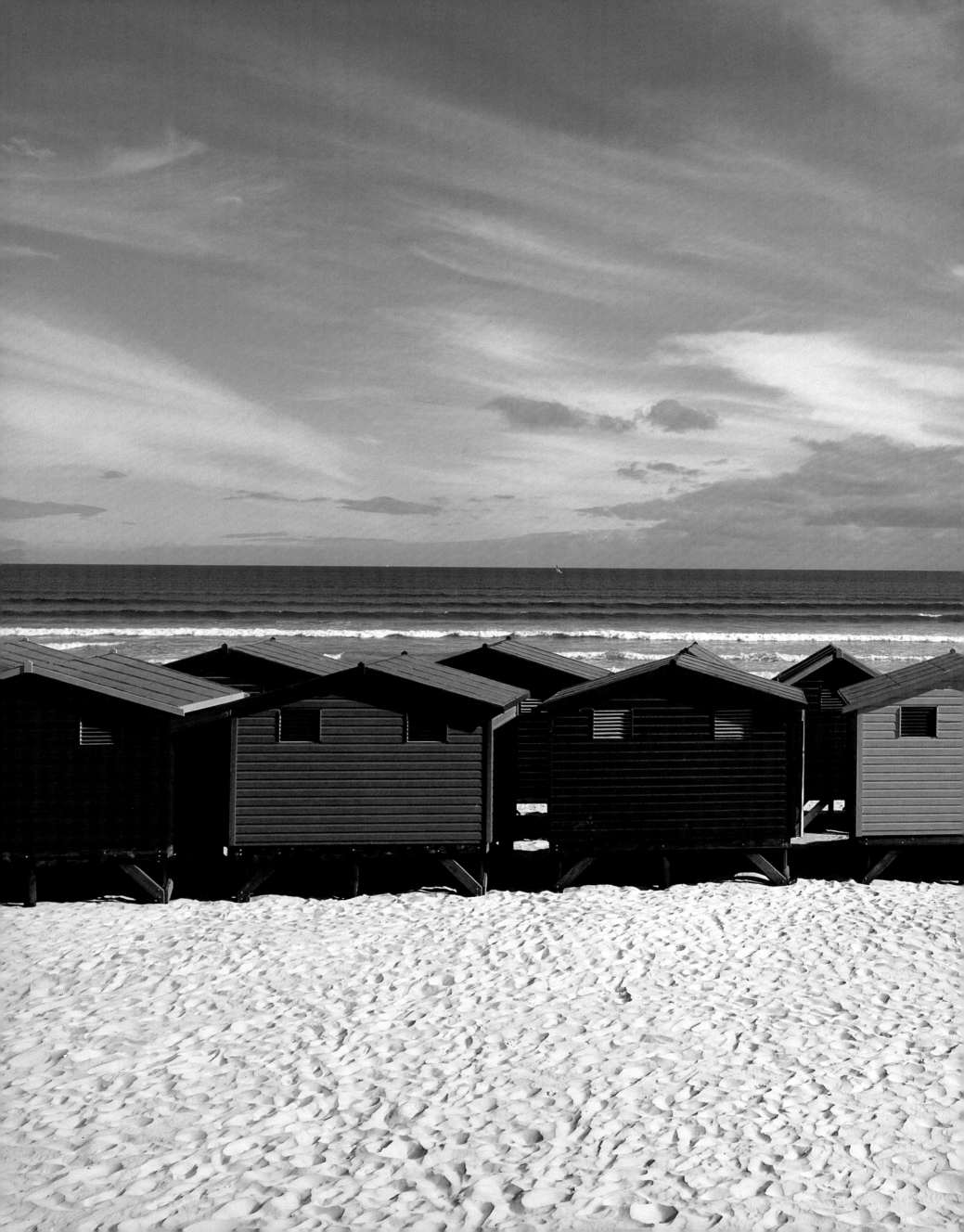

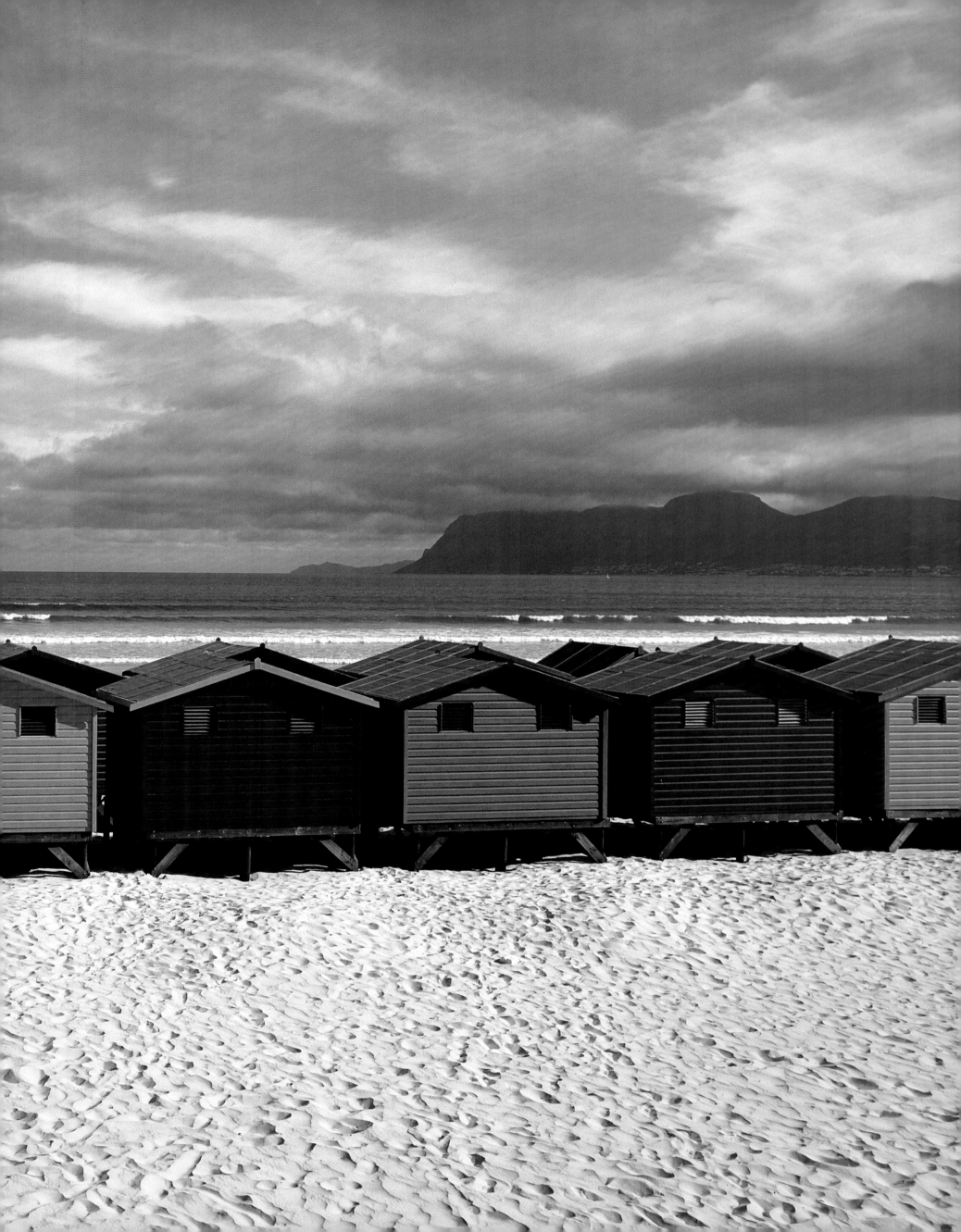

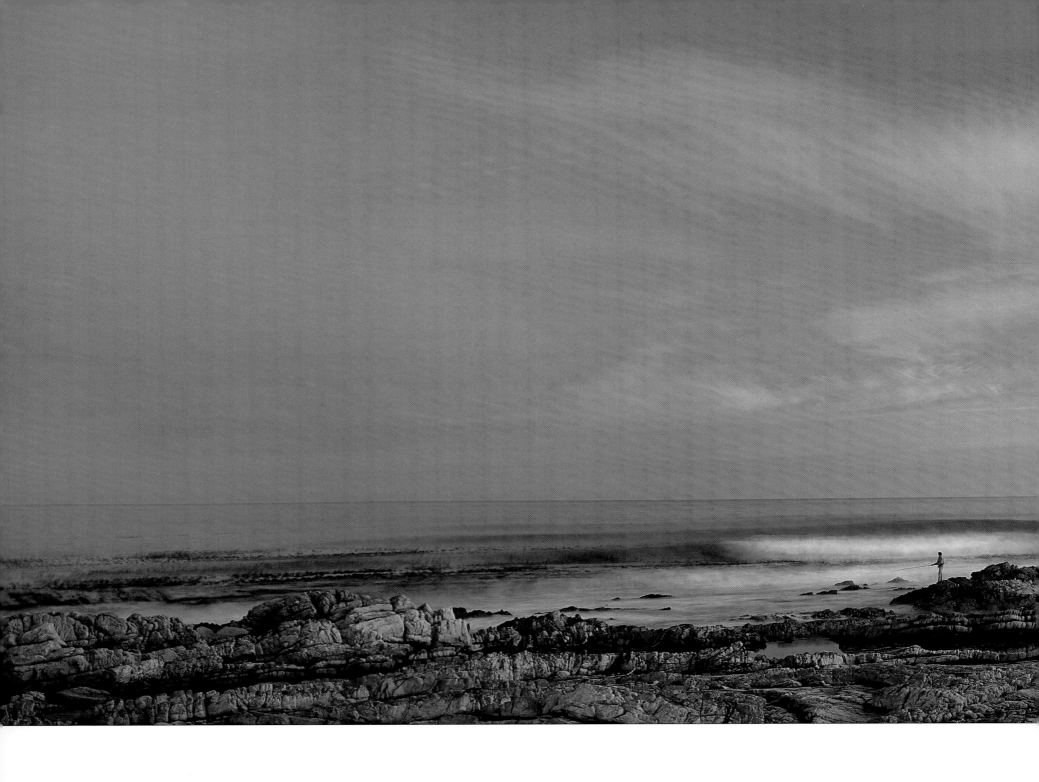

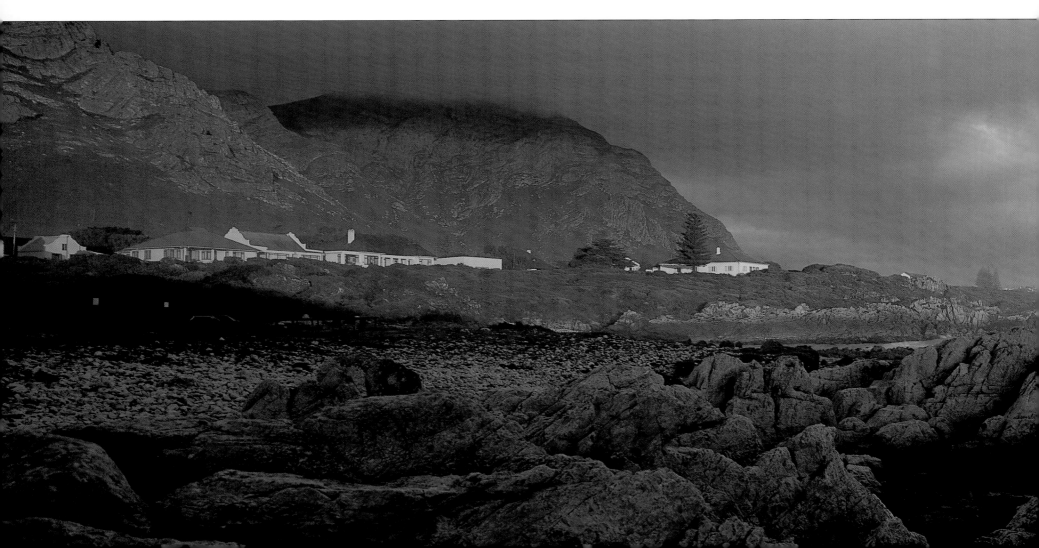

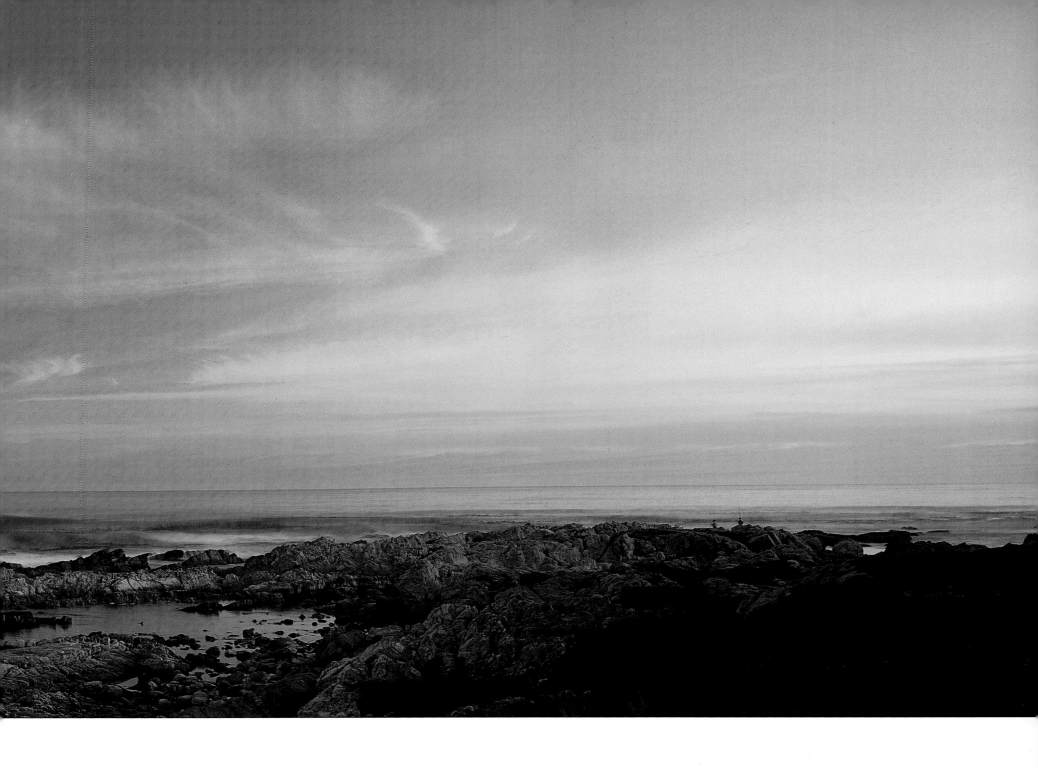

PREVIOUS PAGE *Smartly painted bathing booths at Muizenberg recall the days when bathers were required to withdraw in the name of propriety.*

ABOVE *The tiny settlement at Vermont – hideaway for several of South Africa's best known writers and artists – overlooks tranquil seascapes.*

LEFT *Private homes hug the cliff path at Hermanus. This once-sleepy seaside village has become a bustling resort town famed for its whale-watching opportunities from about June to November each year.*

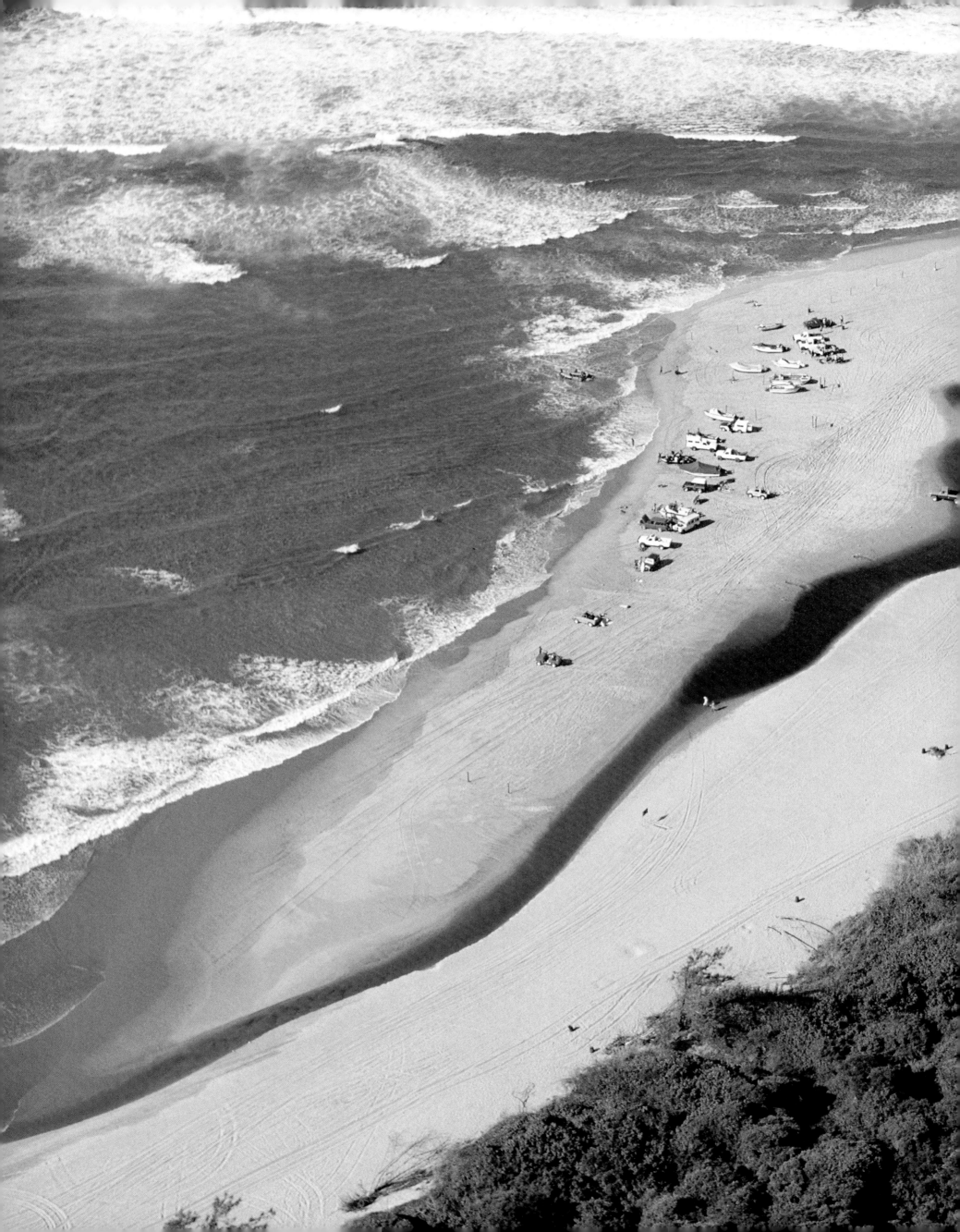

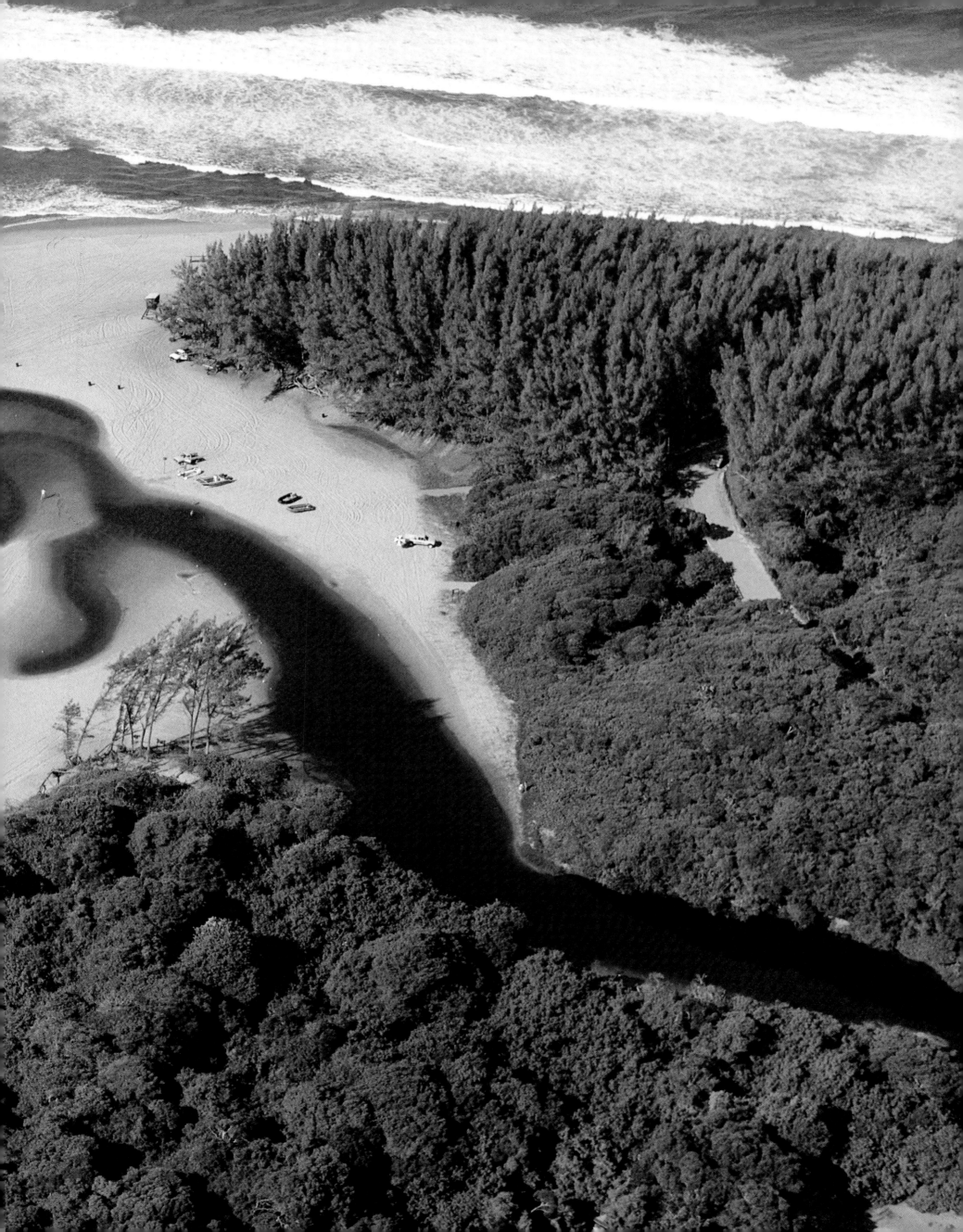

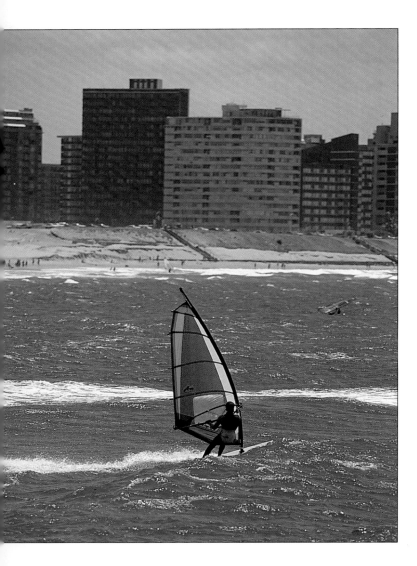

PREVIOUS PAGE *South Africa's far northeastern regions are a stunning composite of high, forested dunes, estuaries, floodplains and wetlands, woodland and savannah, and the world's southernmost coral reefs.*

ABOVE *While the less fortunate man their workstations in Durban's CBD, those who can, surf. Sea temperatures in this subtropical zone are seldom lower than 15 °C.*

RIGHT *A sunbeam escapes from its stormcloud captors to throw surreal rays across Durban's Golden Mile, six kilometres of urban diversions along a beachfront boulevard.*

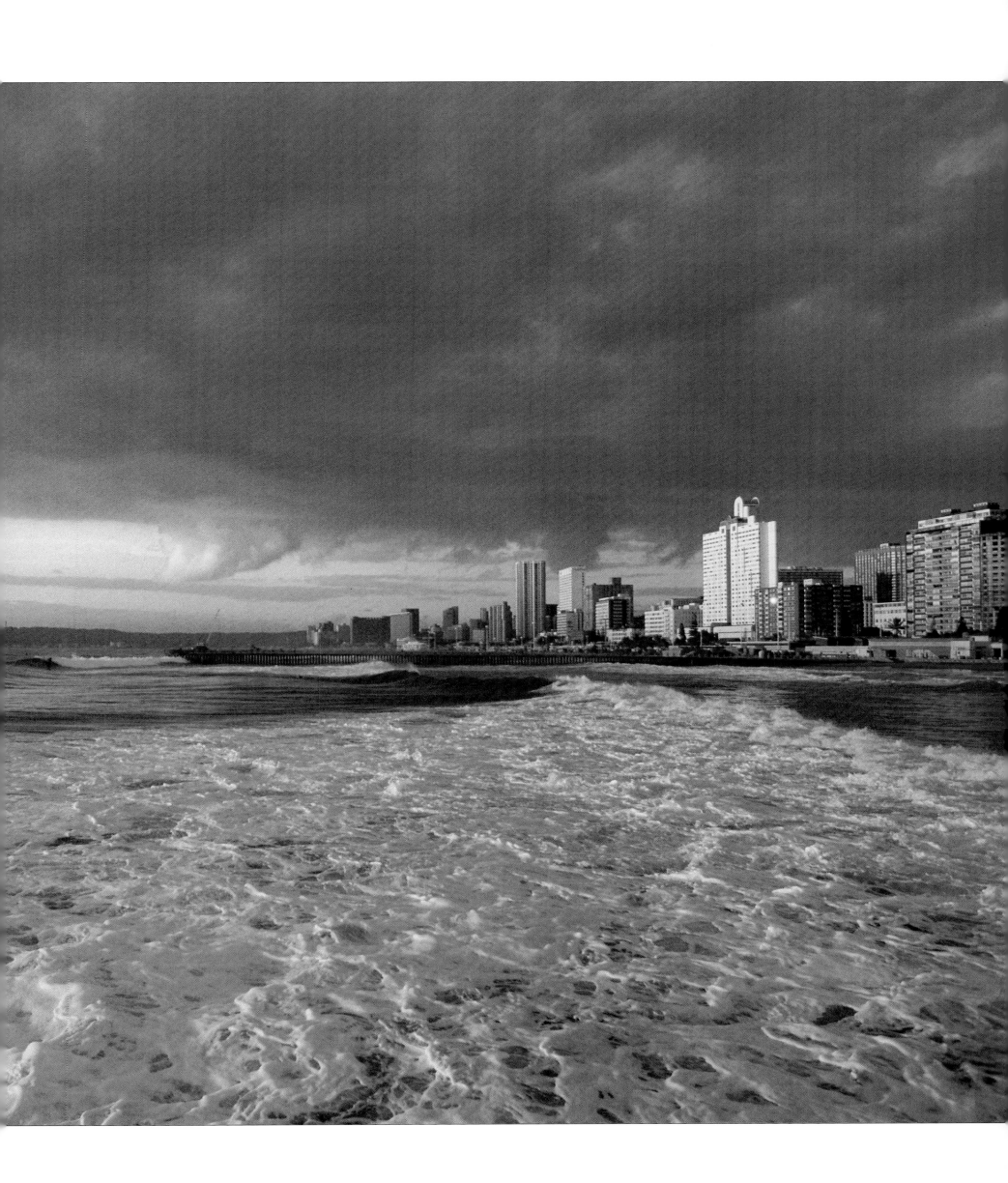

FLORAL ATTRIBUTES

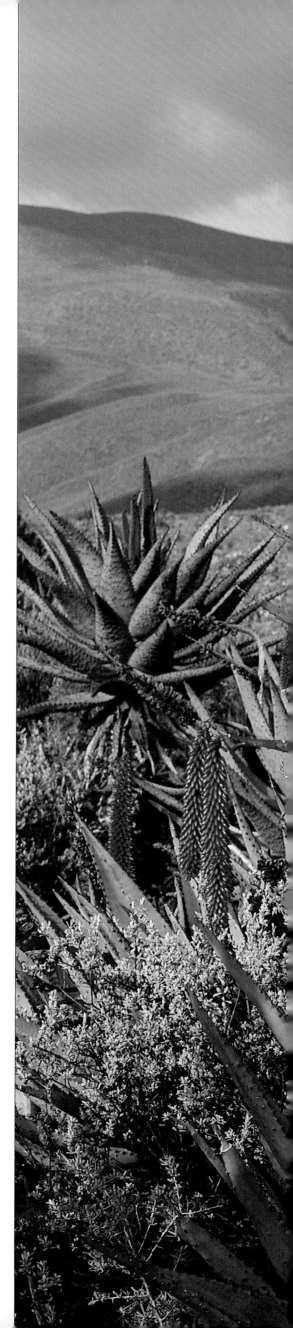

For a land that is predominantly dry, South Africa is blessed with an astonishing variety of flora – one-tenth of all the species on planet Earth. Most of the country's flowering plants have had to adopt clever strategies to outwit the climate: burning sunshine and bitter cold, wind, frost, hail, and sometimes, for years on end, the complete absence of rain. The evergreen fynbos which dominates the Cape floral kingdom is characterised by small tough leaves and woody stems to minimise moisture loss; the succulents of the semi-arid Karoo regions store precious water in their fleshy leaves and stems; the ephemeral varieties of the coastal desert in the west frantically germinate, flower and seed in a few short weeks after rain. Other species store water in bulbs, corms and tubers buried beneath the ground. Probably the most celebrated flowering plant is the protea, symbol of South African flora, strikingly varied in size, colour and shape. The protea is one of a large group of species including erica, restios and heath that make up the characteristic fynbos of the Cape. Table Mountain alone hosts 1 400 of the country's 22 000 flowering species and is the nucleus of the smallest and richest of the world's six floral kingdoms. The most exuberant celebration of South Africa's floral gifts comes with Namaqualand's spring flowers, when the land is transformed to a many-splendoured garden. *Lithops* (stone flowers), *mesembryanthemaceae* and *crassulas* push bold blooms through coats of dreary winter camouflage, and the vivid ephemerals, their lives all the more brilliant for their brevity, complete another urgent life cycle.

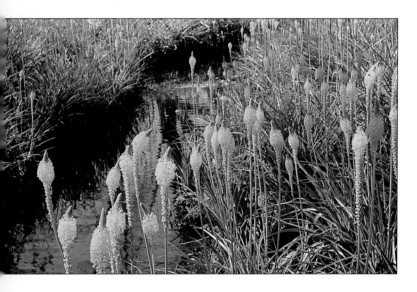

ABOVE *Yellow cats' tails* (Bulbinella latifolia) *bloom fervently in spring. The fleshy, speared leaves contain a clear jelly valued for numerous medicinal applications.*

RIGHT *The plants of the Little Karoo show marked adaptations to their arid environment. Aloes, of which South Africa has 140 endemic species, store moisture in tough, fleshy leaves.*

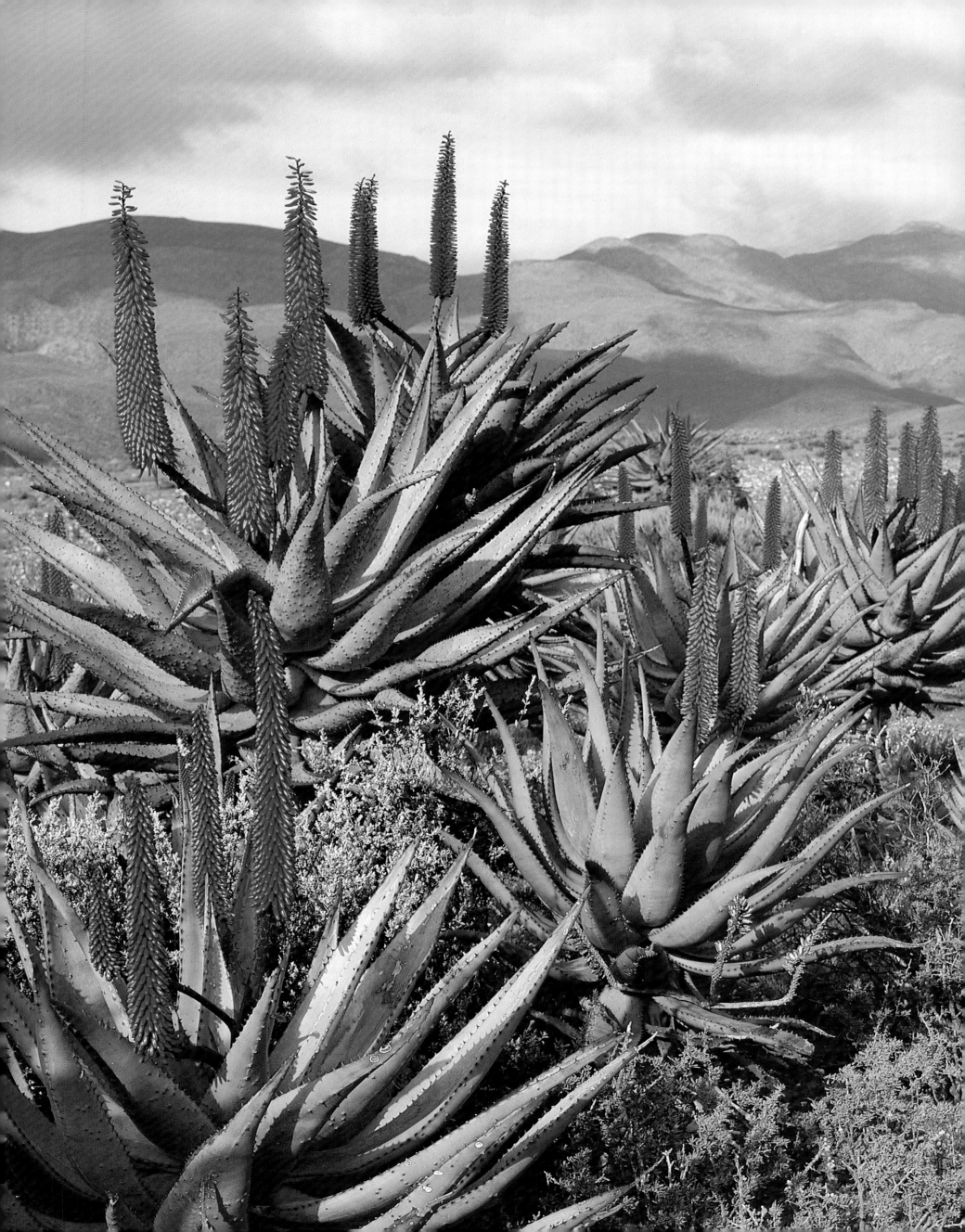

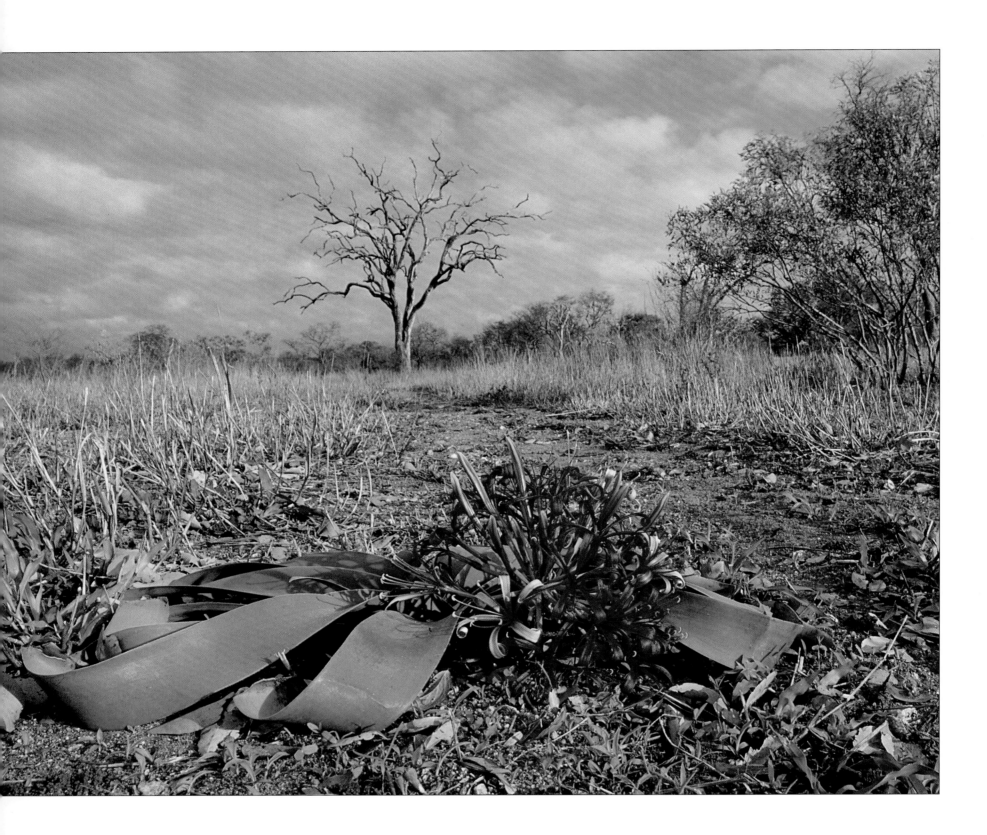

ABOVE *The first rains of the summer bring life to the Kruger National Park with short-lived
flowers like the Gifbol* (Ammocharis coranica), *new green foliage for trees and shrubs and
an abundance of sweet grasses.*

OPPOSITE *Quite commonly found throughout South Africa's arid regions, the curious
Century plant* (Boophone disticha) *throws up a showy cluster of blooms from a fan of
furled grey leaves. Although the leaves are toxic, sheets of the papery bulb at the centre are
moistened and used as a poultice.*

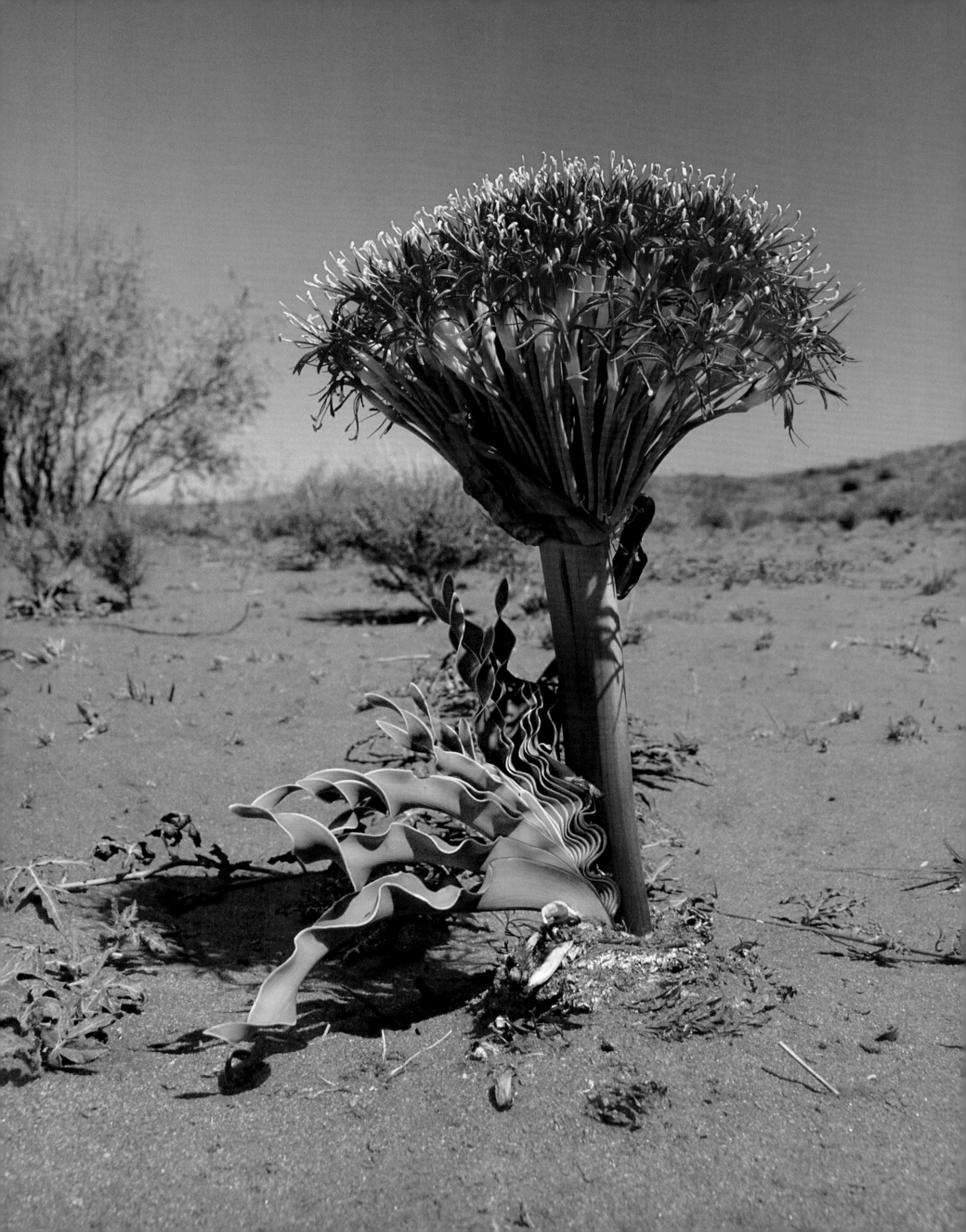

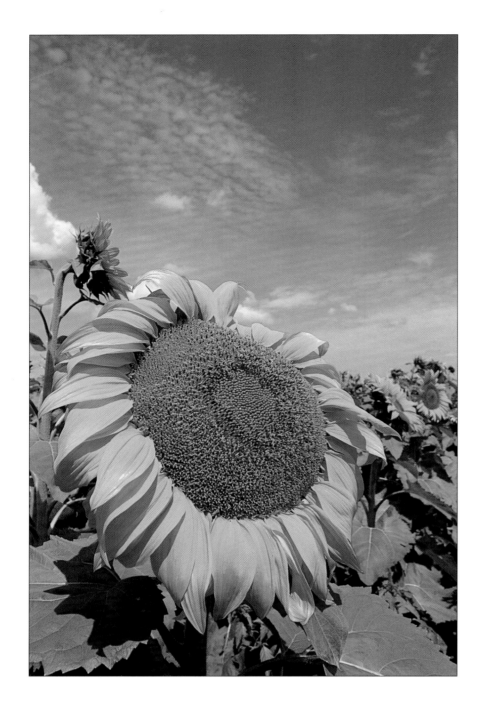

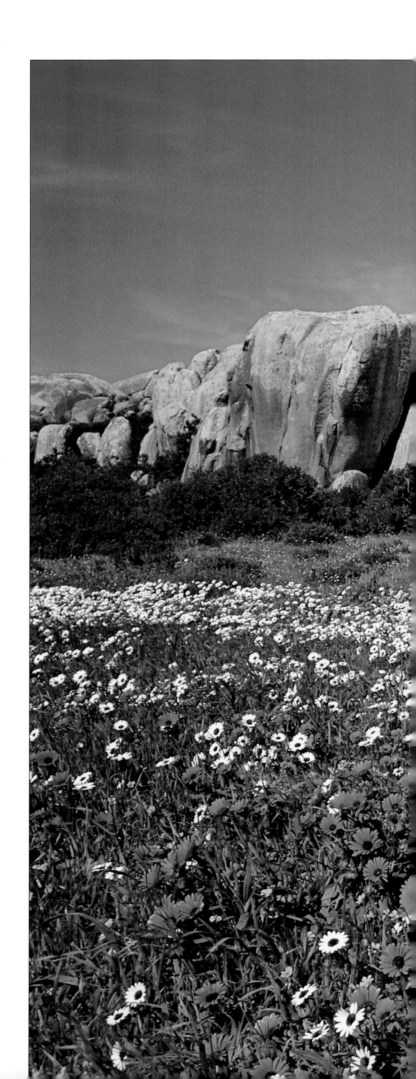

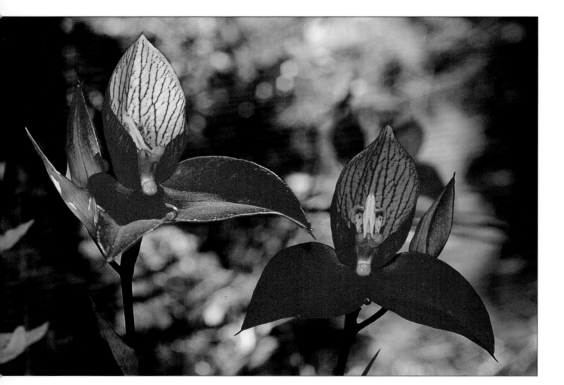

OPPOSITE BELOW *Emblem of the Western Cape, the Red Disa (Disa uniflora)* is found only in the specialised environment provided by damp, cool, shady crevices near water. One of 16 disa species found on the slopes of Table Mountain, the Red Disa has an exclusive pollinator, the Table Mountain Beauty butterfly.

BELOW *Springtime in the Cape is an exuberant celebration, with lavish displays of wildflowers to be seen for hundreds of kilometres up the West Coast. Massed blossoms create a magnificent springtime spectacle in the Póstberg area of the West Coast National Park, open in August and September.*

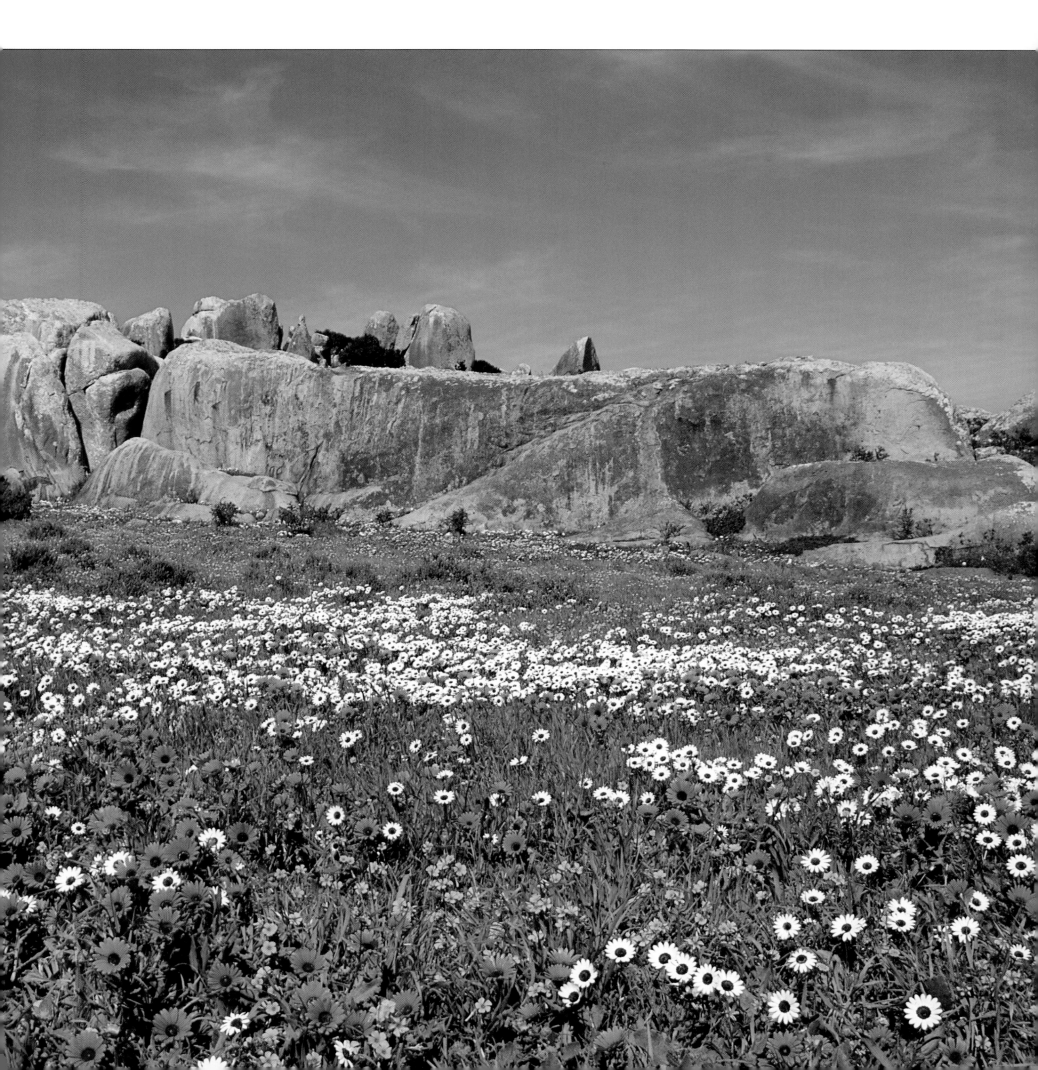

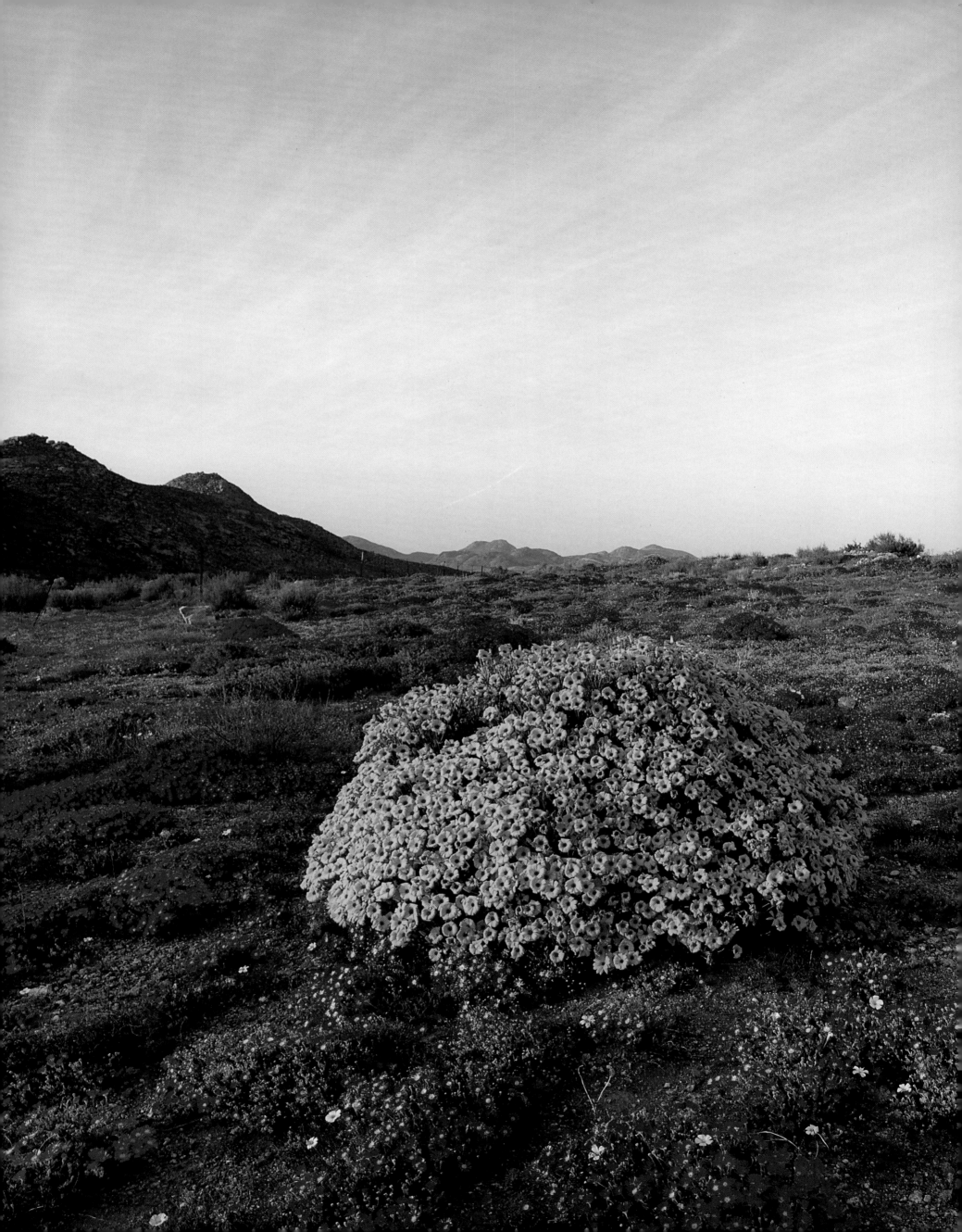

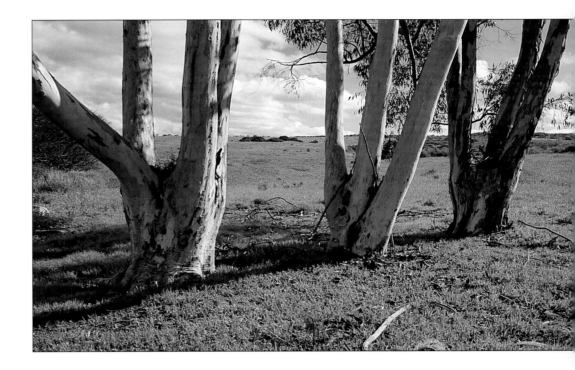

LEFT *Namaqualand's flowering succulents briefly light the desert for a few weeks each year. The region's vegetation includes a large component of short-lived plants, the ephemeral varieties which flower and set seed in a few short, bright weeks.*

TOP AND ABOVE *Although beautiful to behold, large tracts of single-colour plants in Namaqualand indicate soil disturbances, underlining the need for stringent conservation management.*

OVERLEAF *Delicate subtropical azaleas proliferate in Mpumalanga's upland regions where the escarpment creates a verdant environment of dense forest, clear waterfalls and streams 1 000 metres above sea level.*

Resplendent in its various colours, a Lesser Doublecollared Sunbird (Nectarinia chalybea)
perches briefly on a flamboyant crane flower (Strelitzia reginae). *Both are endemic to*
South Africa. The birds probe flowers primarily for nectar but will also eat insects and
spiders. The most brilliant colours occur on the male bird. The sunbird is a common
resident of the coastal scrub, fynbos and forests of the southern Cape.

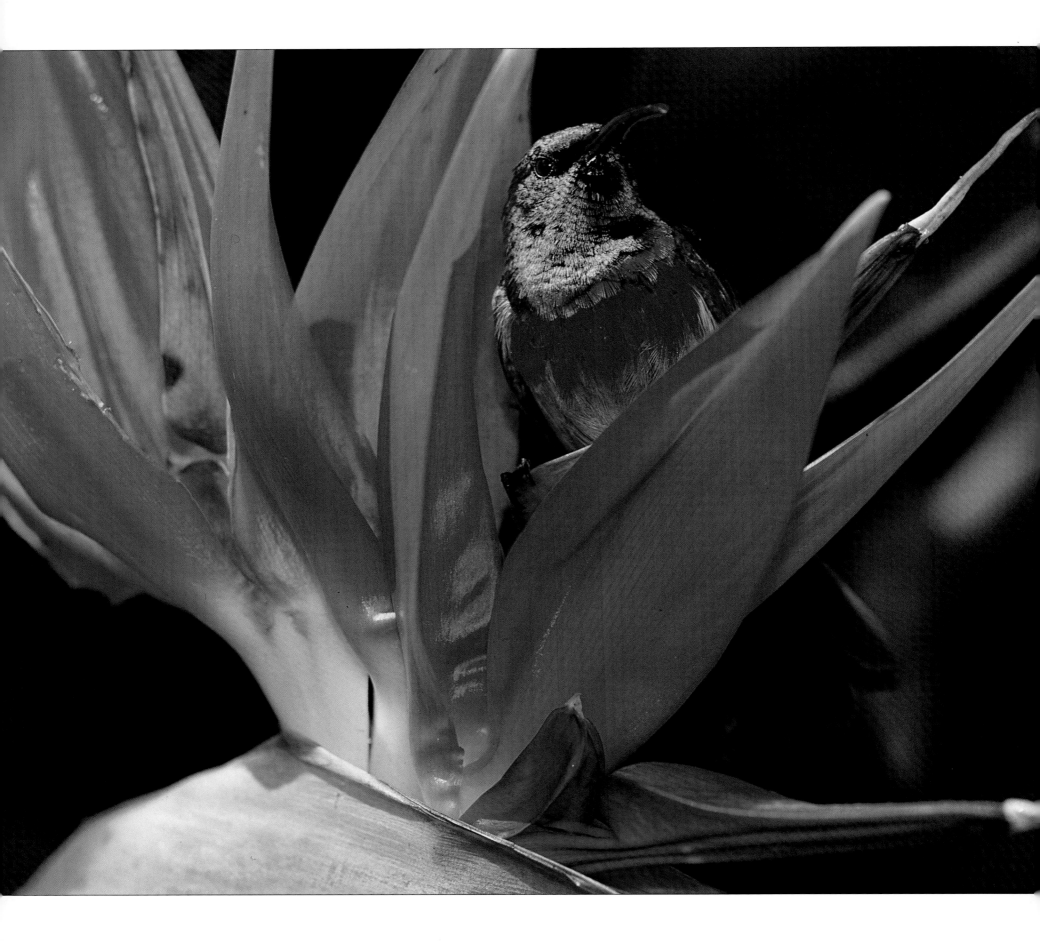

Patriarch of the fynbos family, the King Protea (Protea cynaroides) *rules the Cape floral kingdom. It is also South Africa's national flower. Superb displays of flowering fynbos can be seen in the Kirstenbosch National Botanical Garden in Cape Town, which is the only exclusively indigenous botanical garden in the world. Fynbos is best appreciated in the 'Green Season' from April to October.*

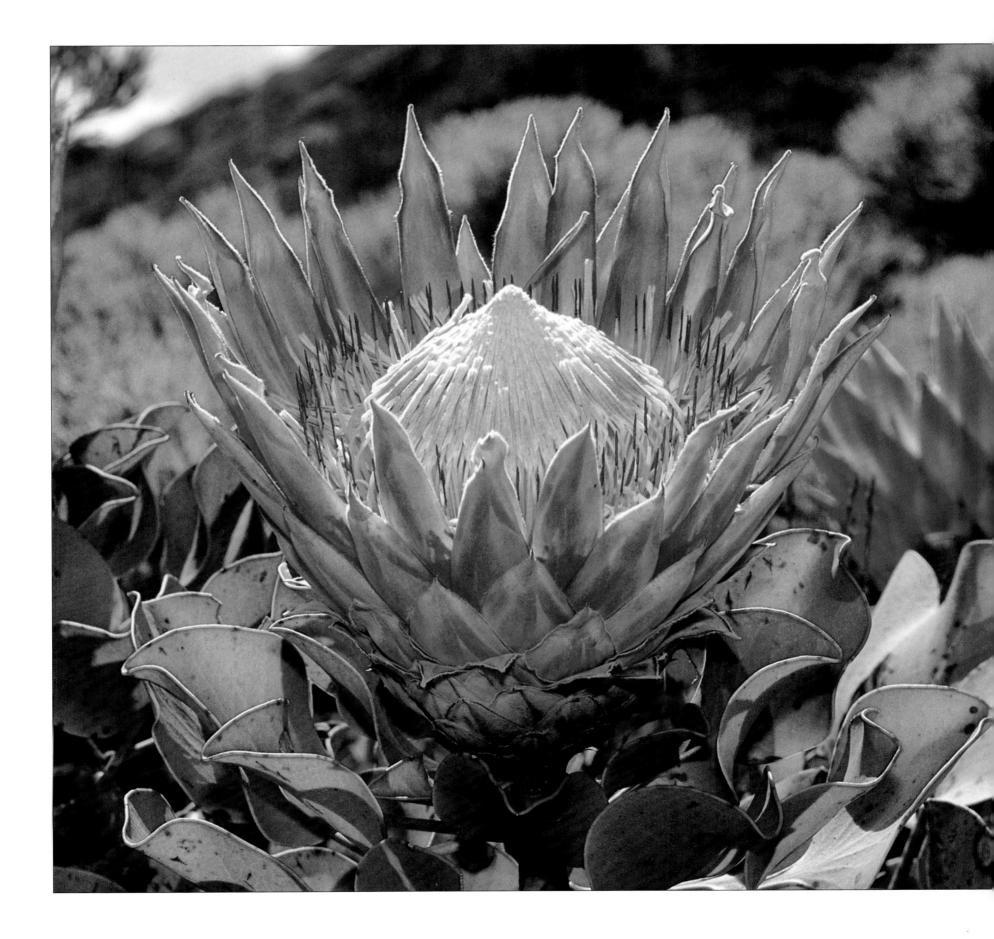

THE LARGESSE
OF THE LAND

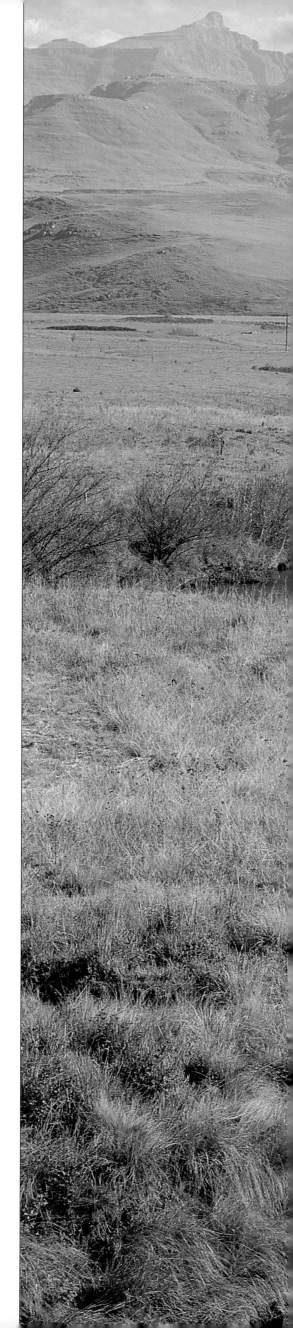

South Africans may be a little blasé about their country's wide open spaces, but for most foreign visitors it is the absence of anything between the high skies and the broad horizons that is most exhilarating. Although served with cities of international standard and in spite of the inroads of industry and an upsurge in investment and tourism, there are still vast areas which are undeveloped. With an area of 1,2 million square kilometres to go round just 40 million people, South Africa's largesse of land can be generously shared with all. Simply travelling the 376 000 kilometre network of road and rail routes that link the country's major urban centres gives a new definition to wide open spaces. There are many kilometres between the small towns and many more between the big ones. For hours at a stretch one may see no more than undulating wheatfields or sunflowers, indigenous forest or a vista of hills and valleys with little Xhosa huts perched atop. There may be a faraway farmhouse standing stoic and solitary in the veld, or a small town, bypassed, blinking in the sun, with a few modest houses clustered round the church. Ecotourism and conservation are high on the agenda of national priorities, assuring the country's status as one of the world's great getaway destinations for generations of new South Africans and their visitors. Millions of hectares have been proclaimed for conservation in 17 National Parks and abundant wilderness areas distributed throughout the country in areas of special ecological concern.

ABOVE *Night falls on the Kruger National Park. The white syringa* (Kirkia acuminata) *is a fairly common woodland specimen in the northeastern regions.*

RIGHT *The southern Drakensberg, beyond which lies Lesotho, is the birthplace of the Mzimkulu River.*

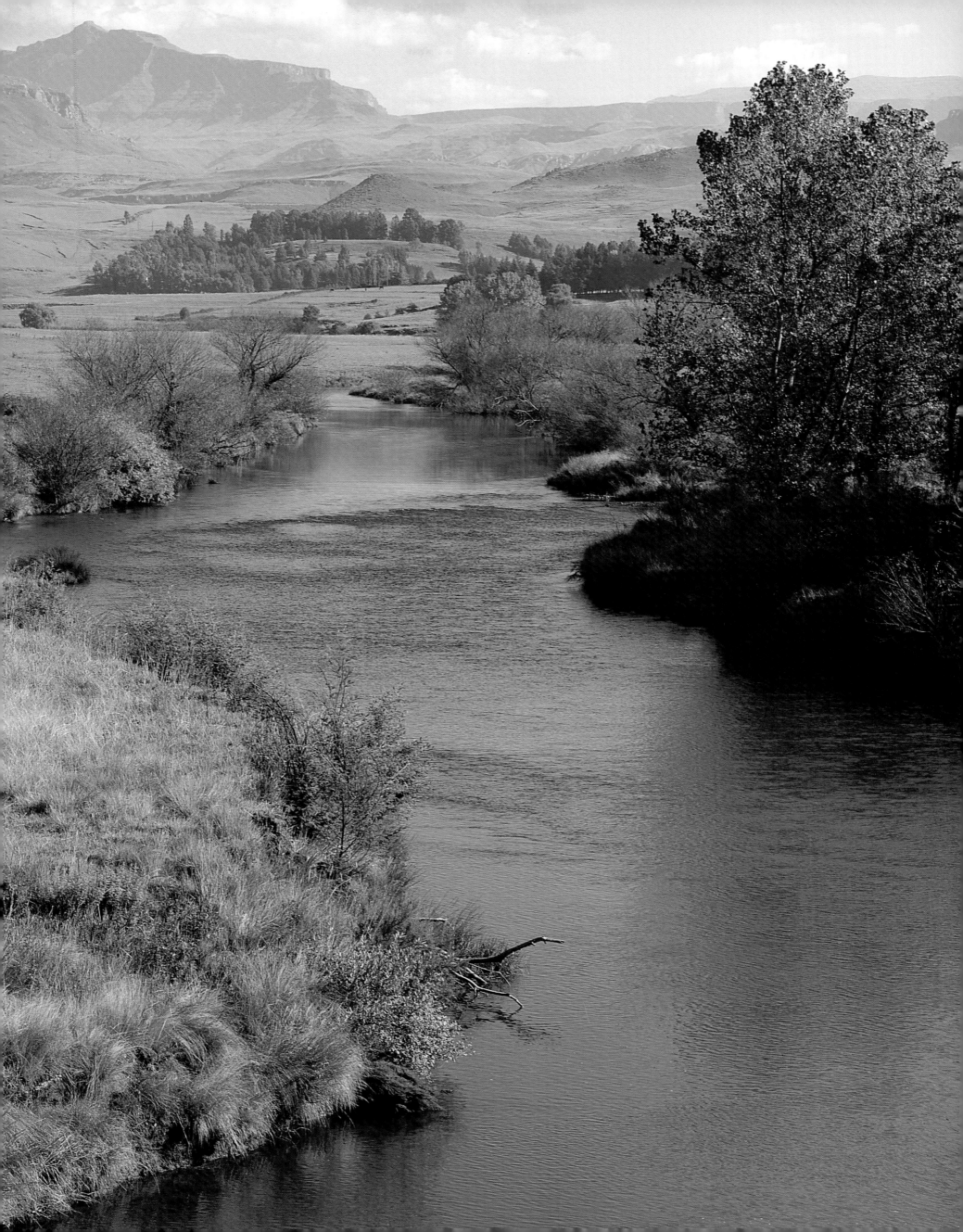

LEFT *A bloody sunrise meets the dying moon over Berg-en-Dal, one of the Kruger's southern camps situated in the hilly woodland terrain northwest of Malelane gate.*

ABOVE *Bateleur Camp's Rooibosrand Dam supports prolific bushveld bird life in the remote northern reaches of the Kruger Park. The camp is named for the Bateleur eagle, the short-tailed, long-winged bird of prey found here.*

OVERLEAF *The Transkei interior is a soft montage of rural huts and small fields, lonely roads and evocative place names punctuated with the characteristic clicks of the Xhosa language.*

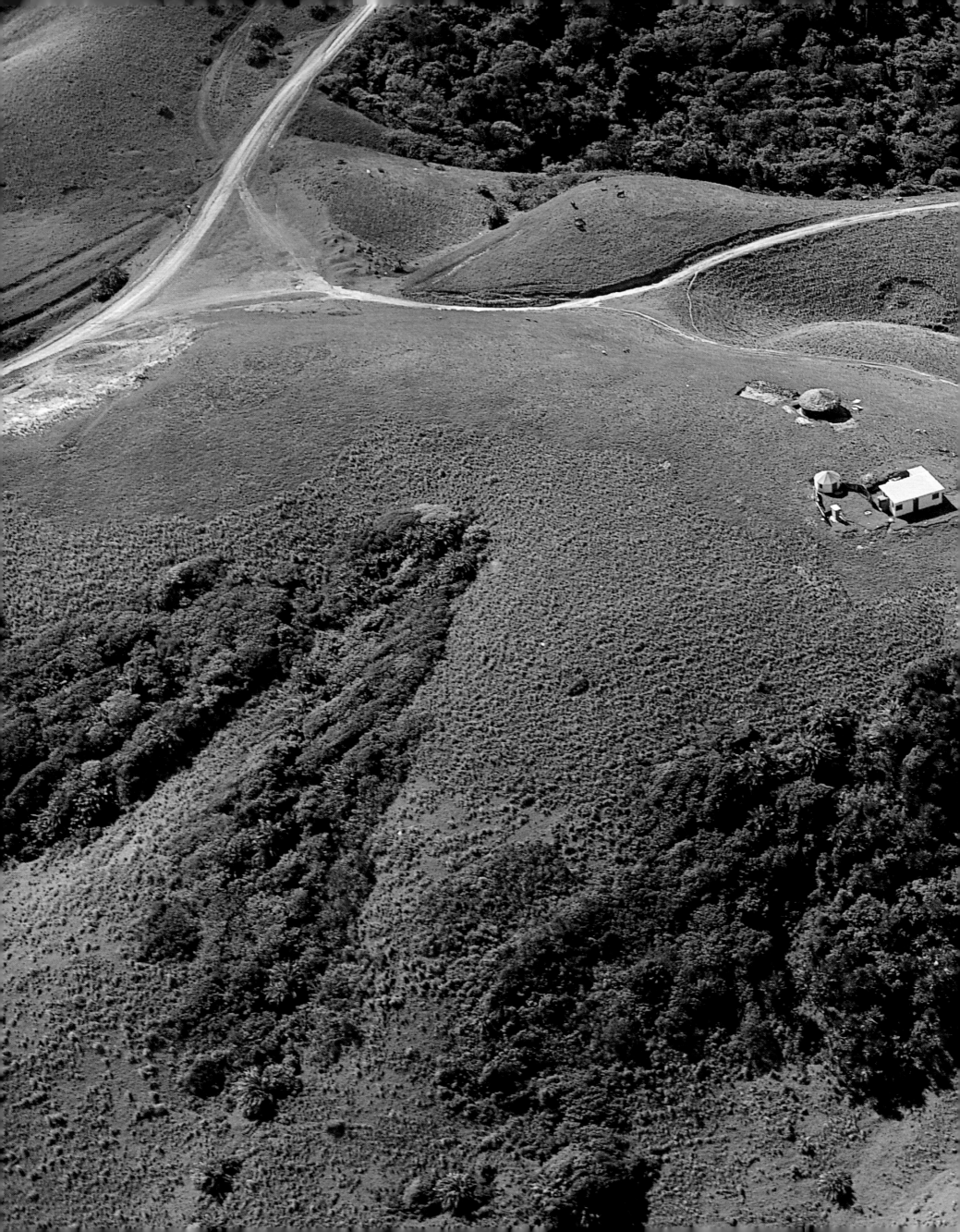

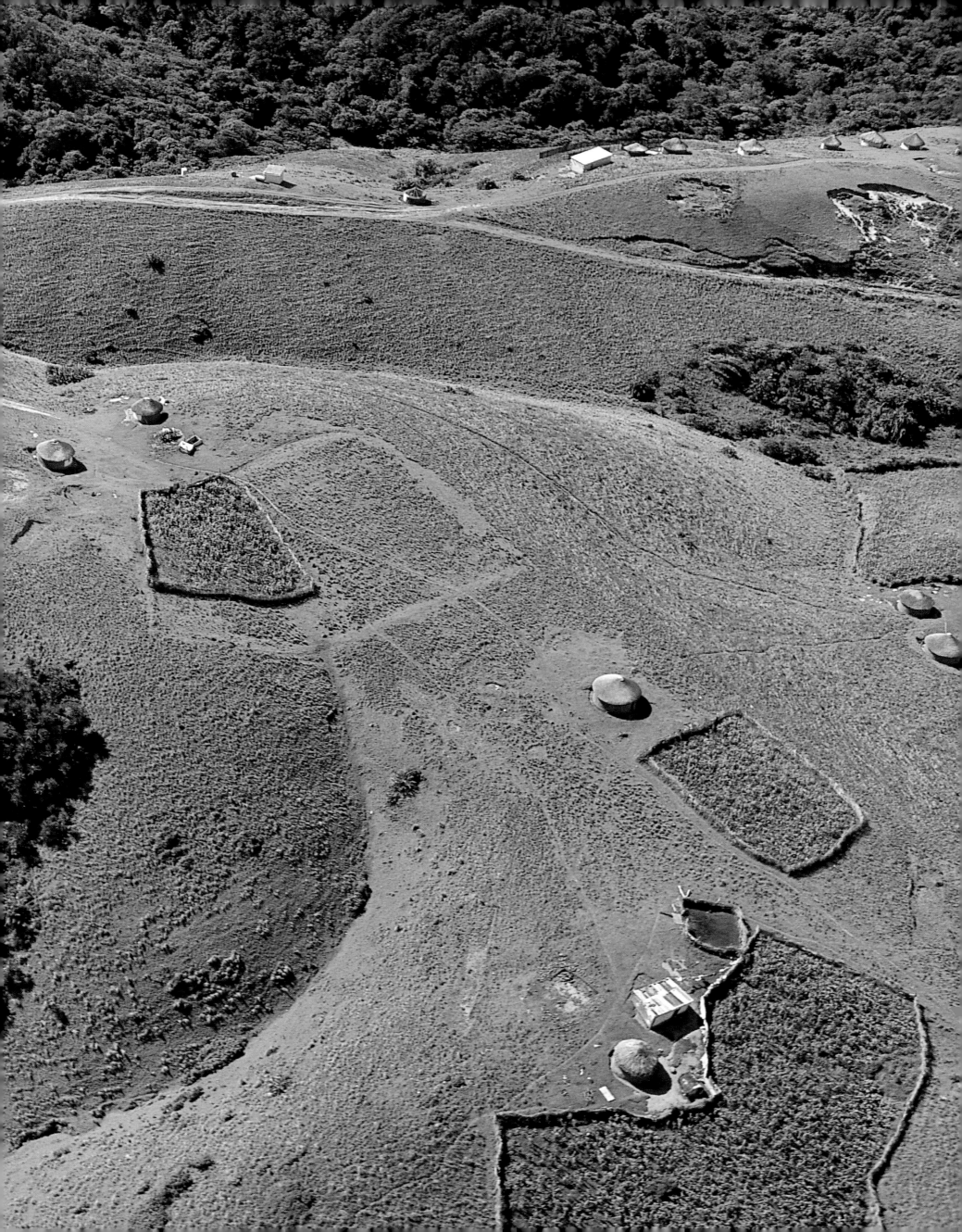

BELOW *A spectacular series of cascades, rapids, channels and a final sheer plunge of 56 metres disrupts the flow of the Orange River at Augrabies, 'the place of great noise'. The river flows level for 1 600 kilometres to this point.*

RIGHT *The Karoo plains fade to infinity from the heights of the Nuweveld Mountains in the Karoo National Park just south of Beaufort West.*

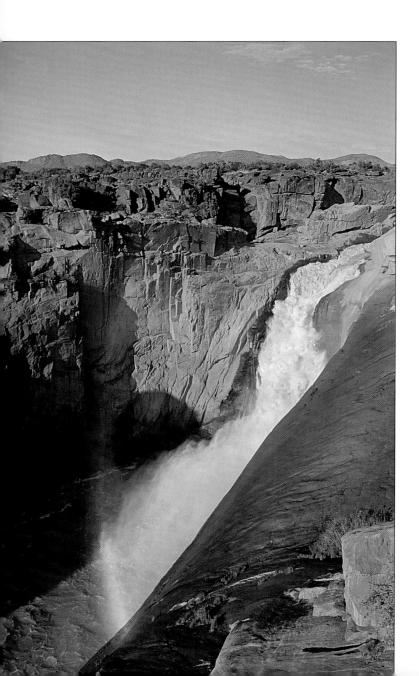

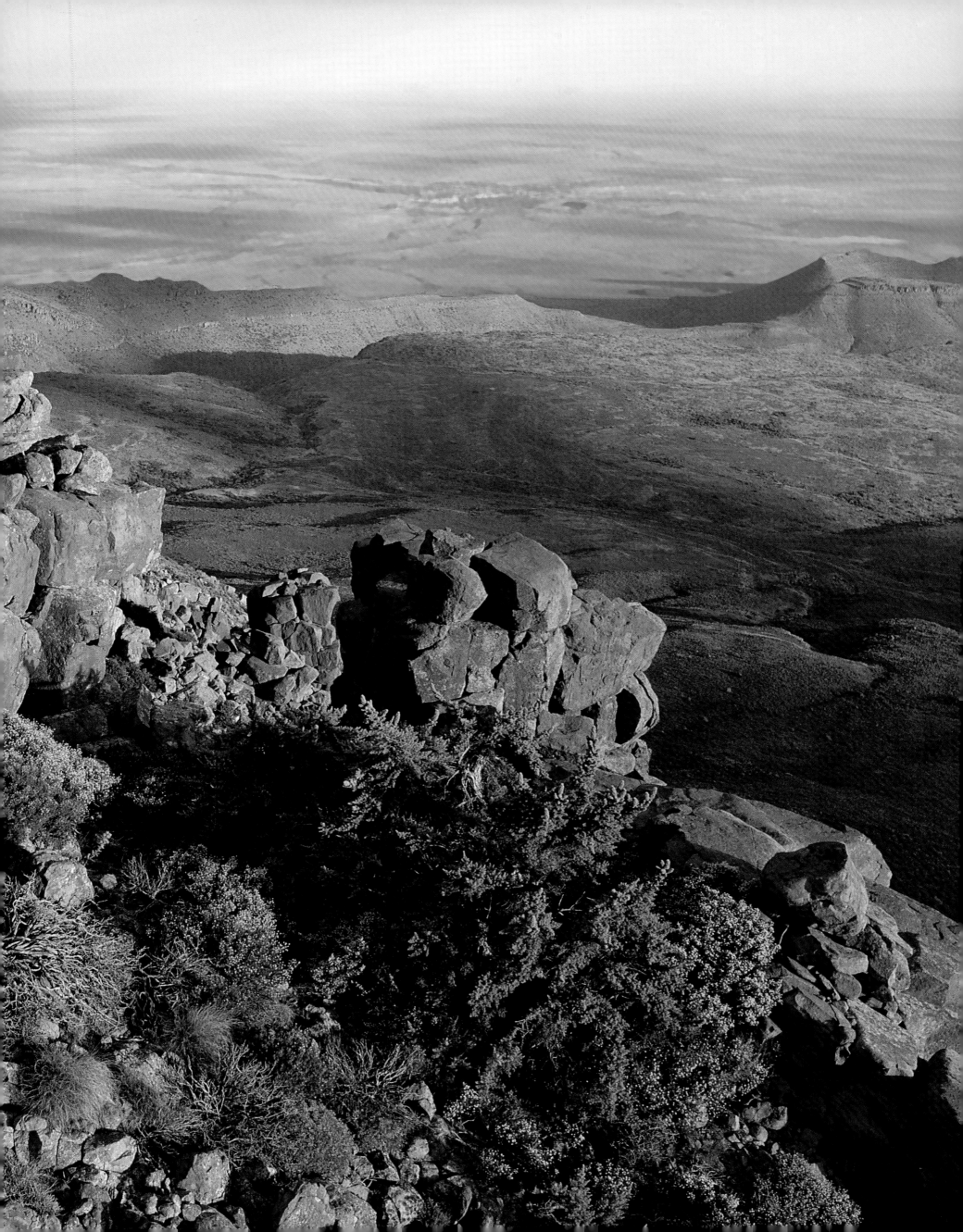

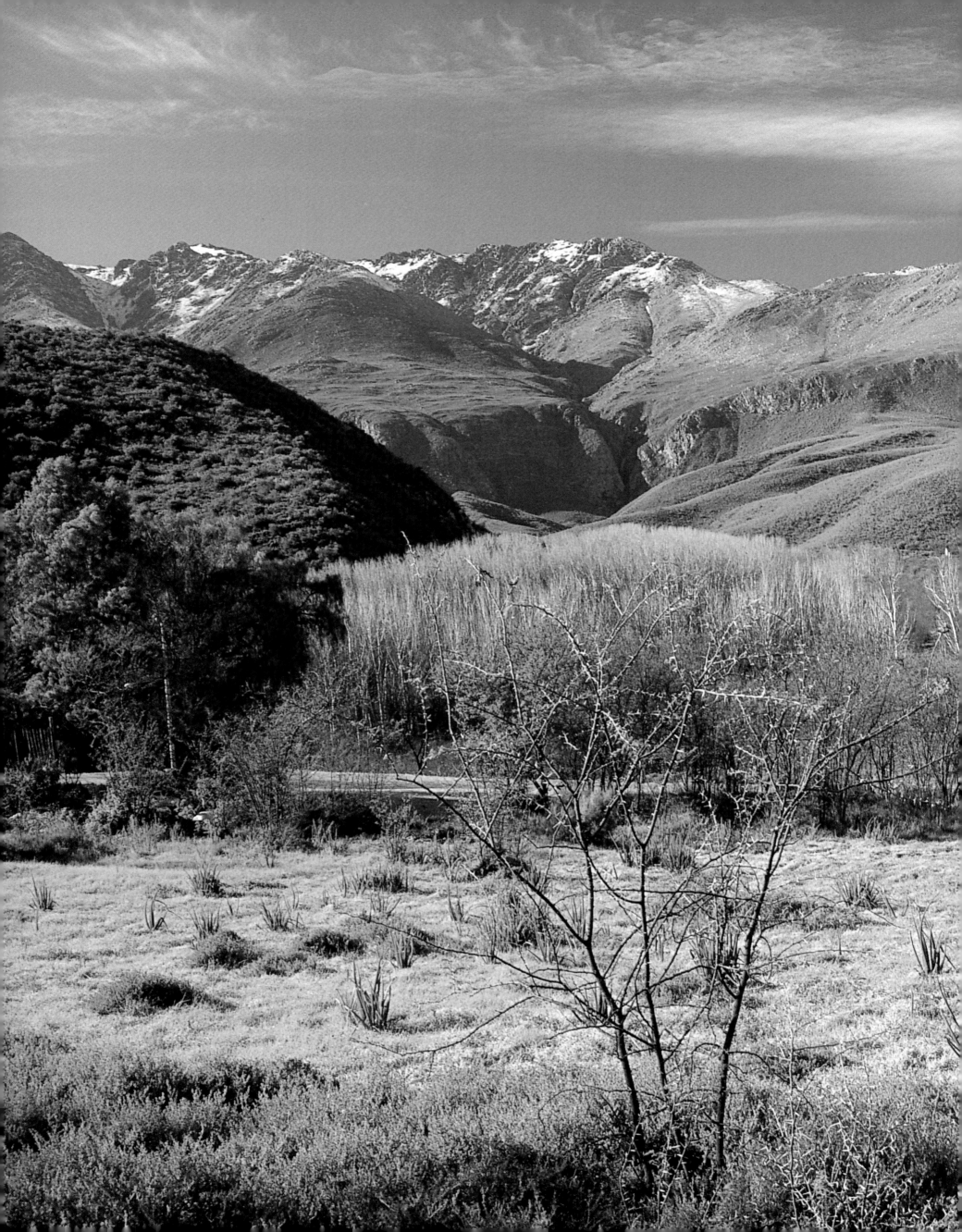

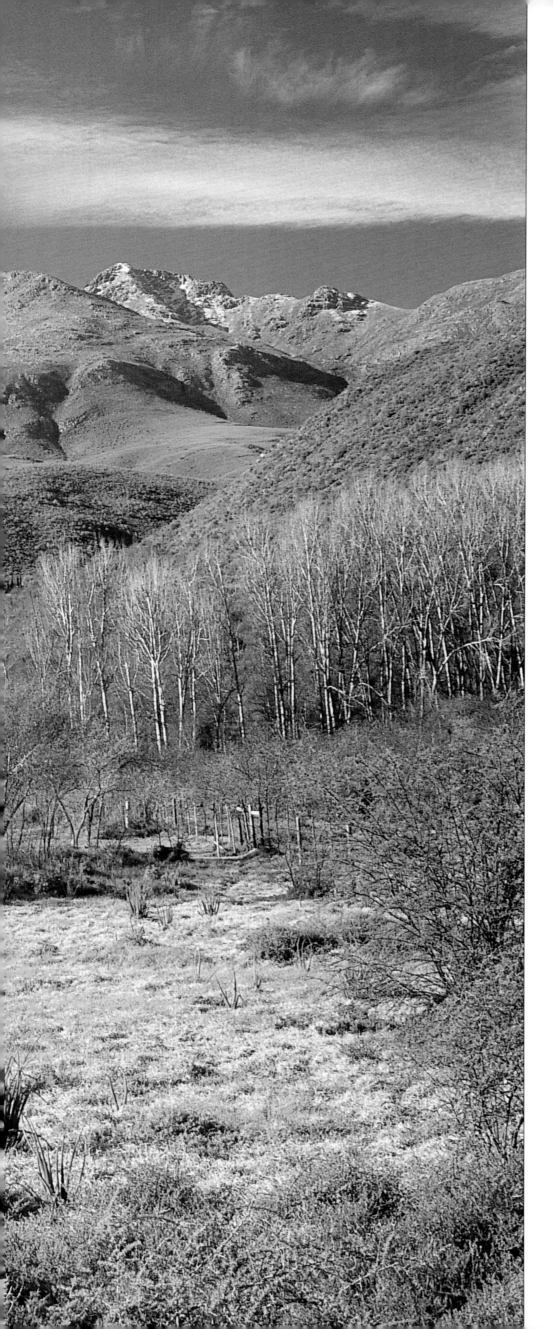

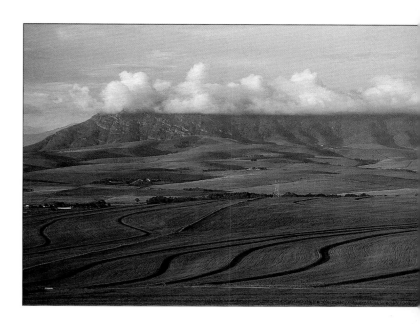

LEFT *Frequently snow-clad in winter, the Swartberg range allows passage to the north through three spectacular mountain passes and gorges: the Swartberg Pass, Meiringspoort and Seweweekspoort.*

TOP *The Swartland is so-called for its early cover of 'renosterbos', a blackish scrub now replaced with rippling wheatfields.*

ABOVE *Composed of a narrow coastal margin and a broad inland plateau, the Overberg produces wheat, fruit, beef and dried wildflowers for export.*

59

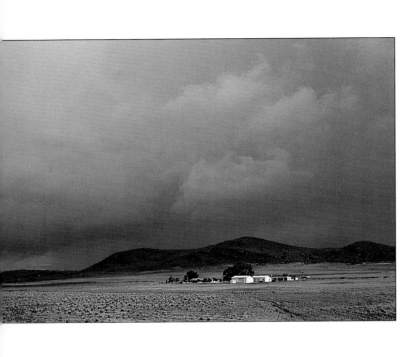

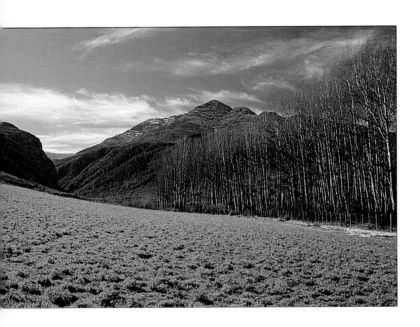

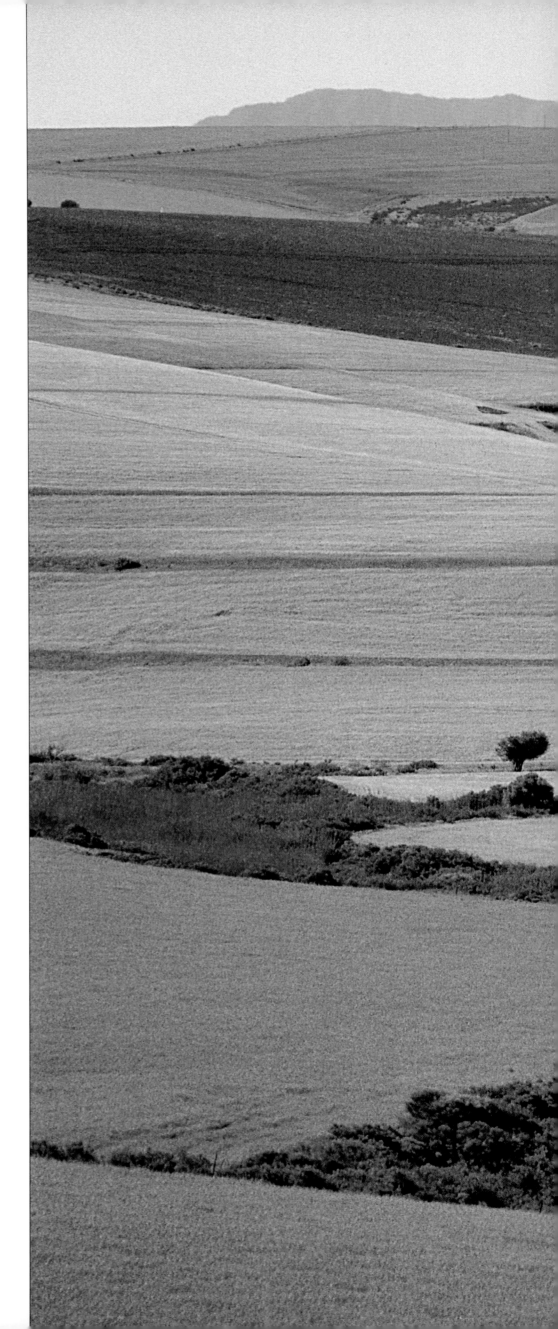

TOP *A solitary farm braces itself against a winter onslaught near Moorreesburg, heart of the Western Cape's wheatgrowing area.*

ABOVE *Lucerne grows against a backdrop of poplar trees stripped bare by winter, and the snow-topped Swartberg Mountains. Lucerne is used as fodder for, among others, the valuable ostriches for which the Karoo is famous.*

RIGHT *Wheatlands near Malmesbury stretch for kilometres and cover the landscape in quilts of green, which later turn gold and brown, with the progression of the seasons.*

60

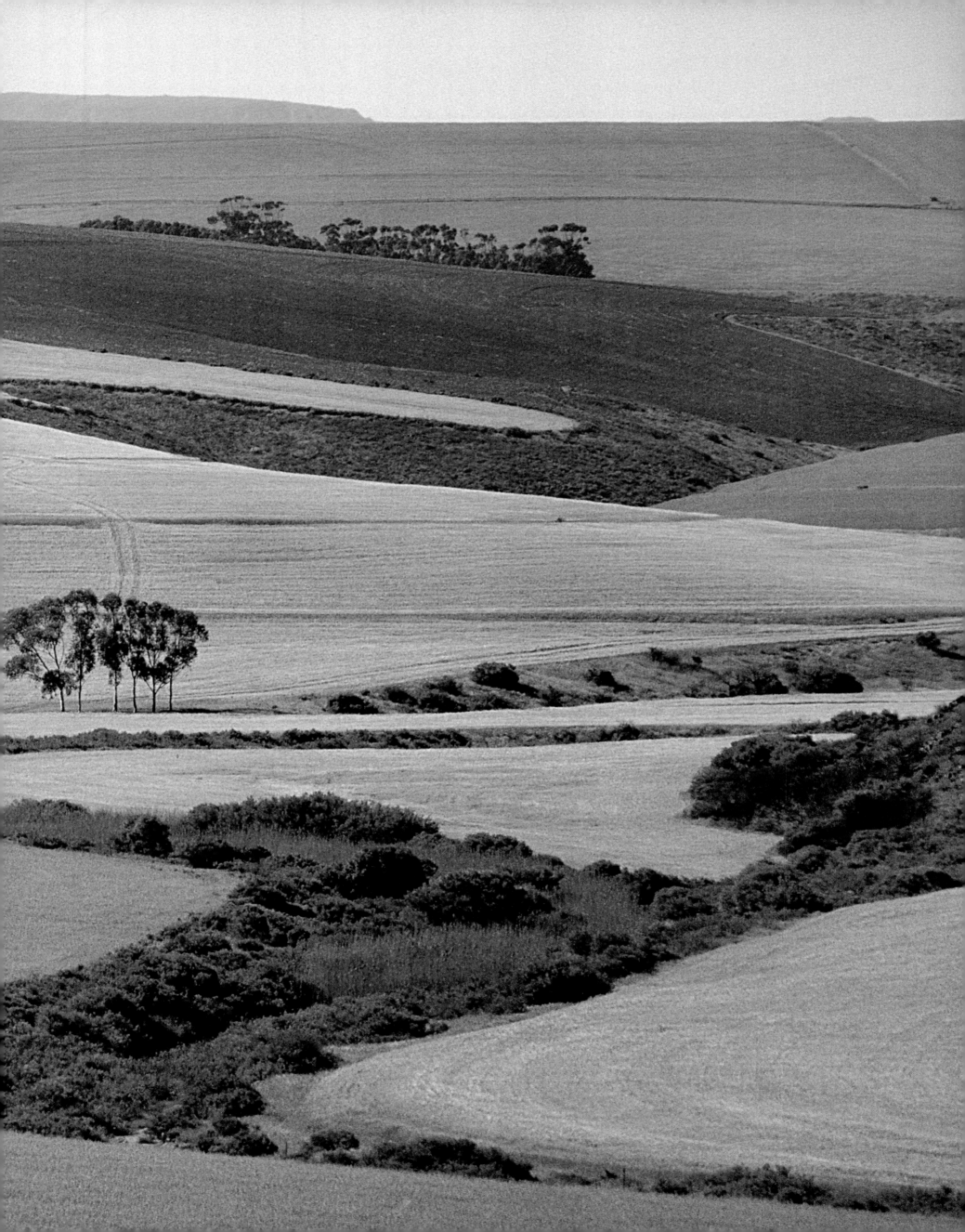

PINNACLES OF PEACE

Whether sculpted by erosion or pushed out of the earth by subterranean upheavals, South Africa's mountains are places of refuge and beauty, shelter for man and beast, and major players in the scenic drama of the country. It is to these quiet places that man comes to pause for breath and restore his equilibrium. The mountain regions form an almost unbroken arc sweeping from the northeast, through the curve of the southern coast and on to the far northwest. Known as the Great Escarpment, this mountain chain is dominated by the Drakensberg (Dragon Mountain) which rises in the Northern Province, skirts Swaziland, traverses KwaZulu-Natal and terminates in a great swish of the tail among the dolerite-topped

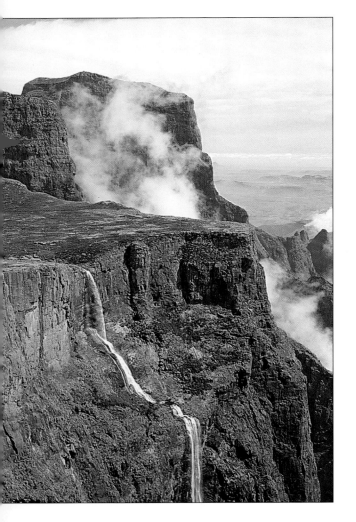

mountains – Kompasberg, Spandaukop and Valley Mountain – of the Eastern Cape. In the south, parallel rows of folded mountains separate the coastal ribbon from the Little and Great Karoo. In the west, the Cedarberg and finally the Bokkeveldberg of Namaqualand in the Northern Cape pick up the chain and meet the Namibian border in the protected mountain desert of the Richtersveld National Park. The escarpment has a dramatic impact on the climate by creating a rain barrier between the coastal plain and the high-lying interior. Perhaps no one mountain is better known than the flat-topped sandstone massif that stands guard over Table Bay and the Mother City – Table Mountain. In the last two hundred years, the mountain has been under increasing pressure from its metropolitan surrounds, and is considered the country's most-threatened natural asset.

ABOVE *South Africa's highest waterfall, Tugela Falls, in KwaZulu- Natal's Drakensberg Amphitheatre.*

RIGHT *The Lisbon Falls near Graskop, Mpumalanga.*

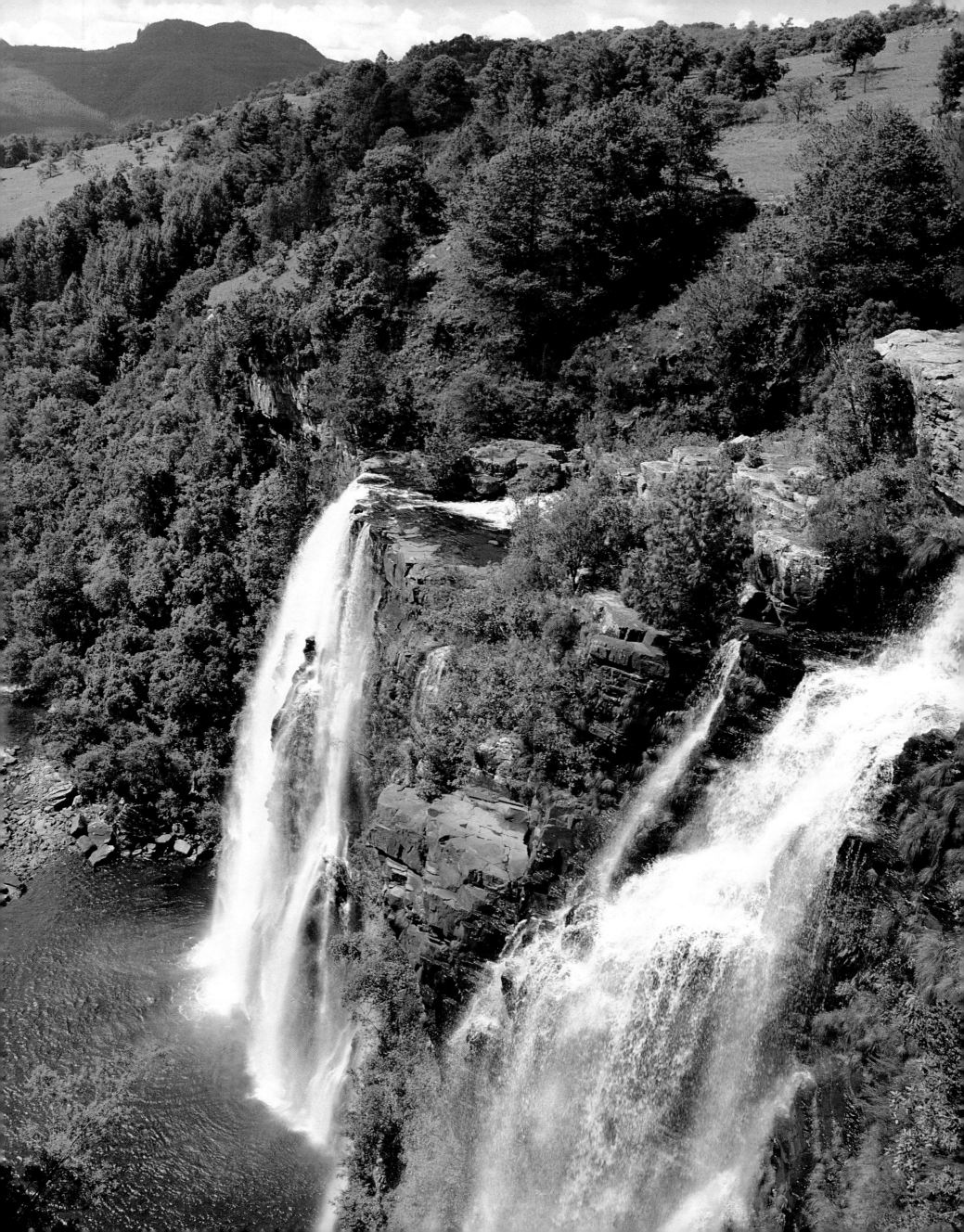

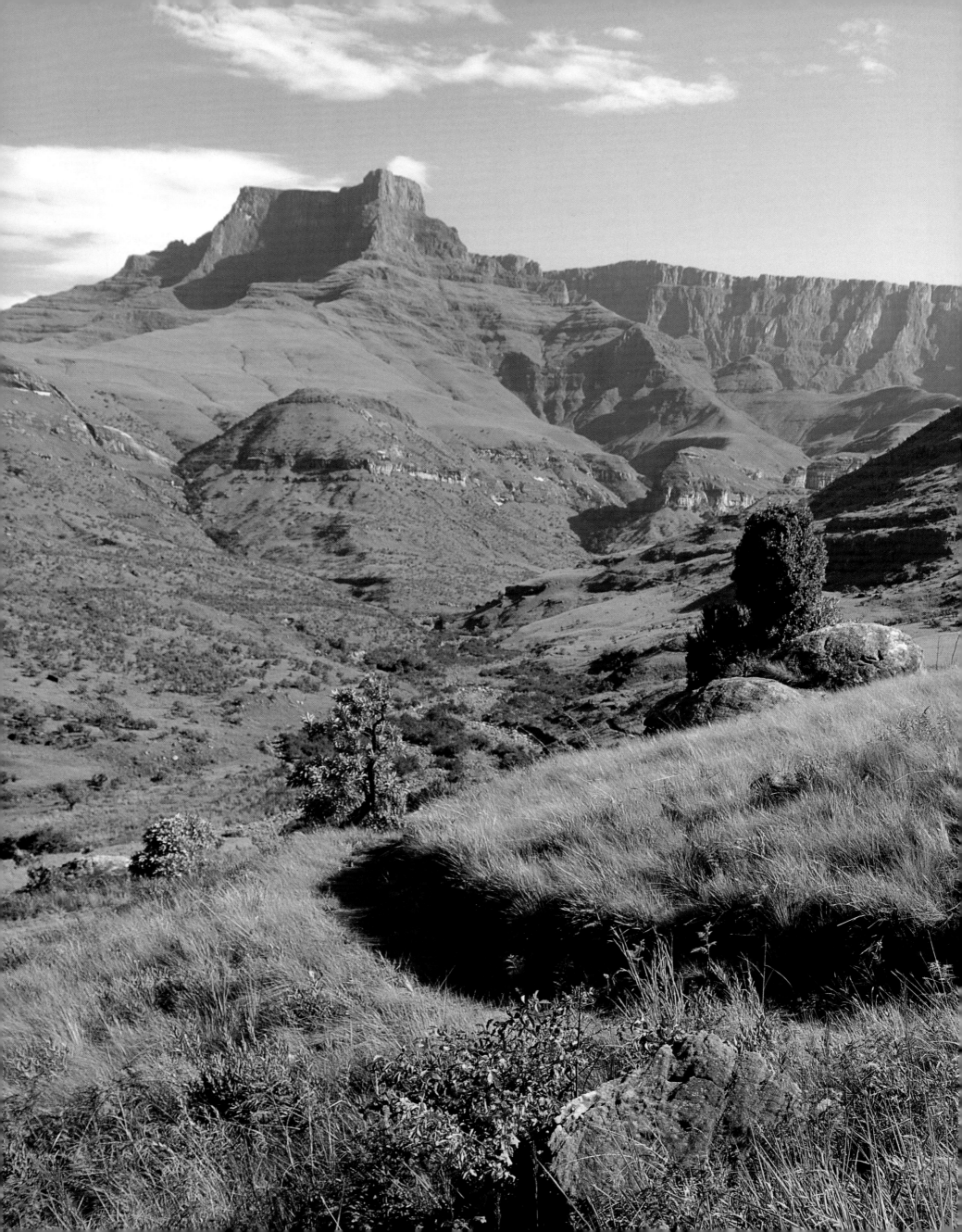

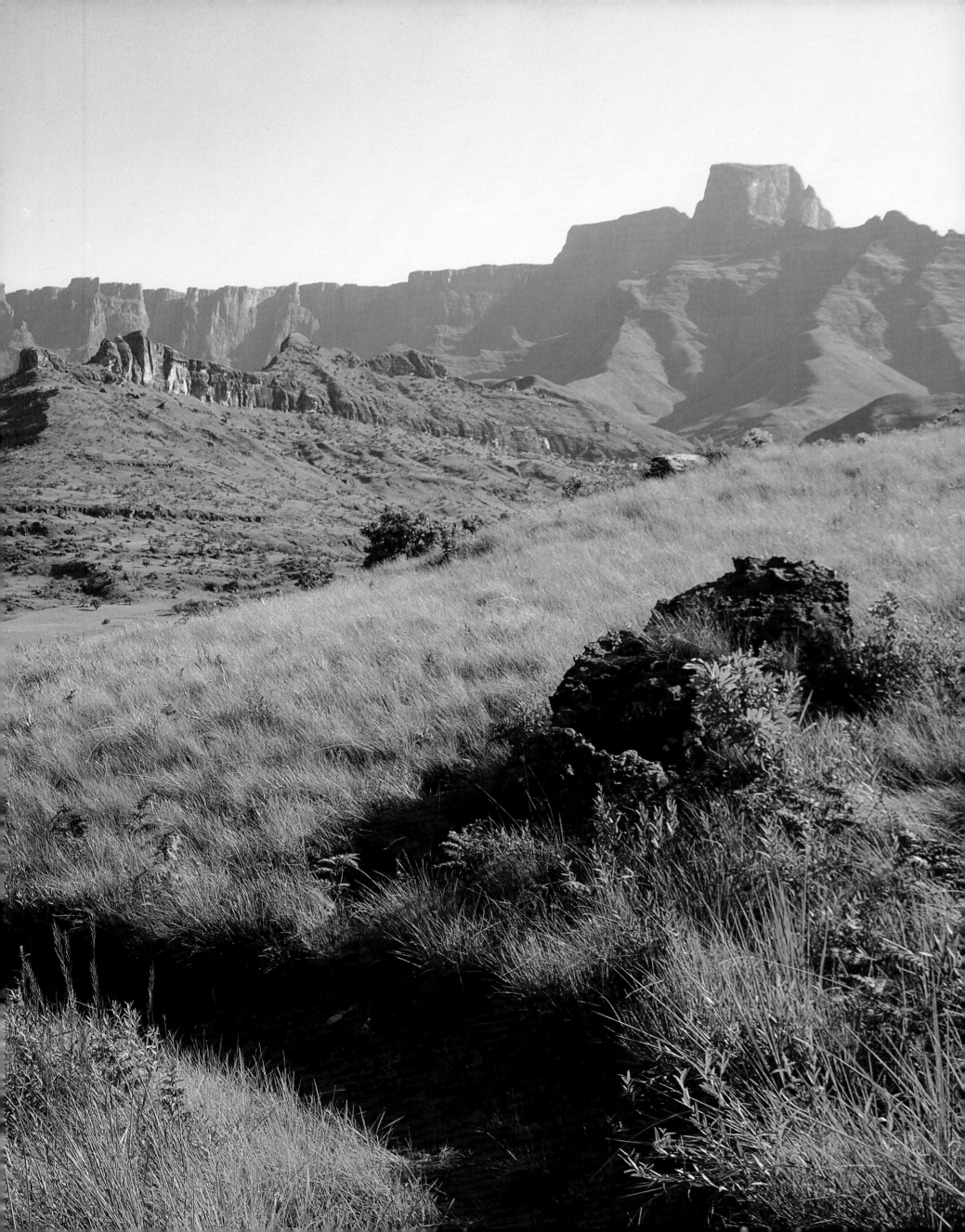

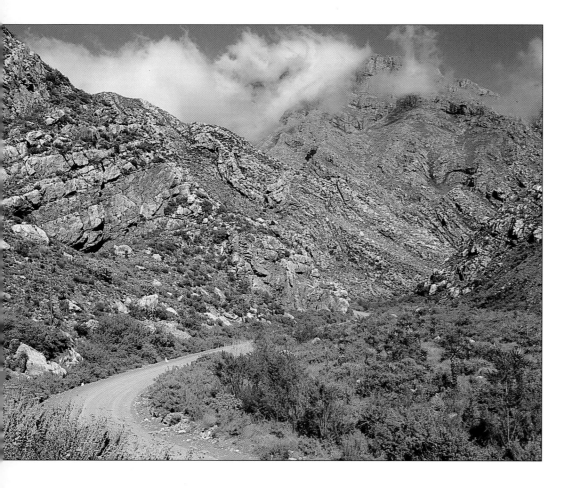

PREVIOUS PAGE *The Amphitheatre is a splendid venue for the never-ending drama of nature which unfolds in the mighty Drakensberg.*

ABOVE *One of three passages through the Karoo's Swartberg range is Seweweekspoort, near Ladysmith, where the near-vertical cliff faces show extreme tilting.*

RIGHT *The Katberg Pass meanders through grassy uplands, forested escarpment and the lush Kat River Valley in the northeastern Cape.*

OVERLEAF *A rare snowfall dusts the Peninsula mountain chain, visible along the summit from the mountain's highest point, 1 113 metres at Maclear's Beacon. From here, it is possible to scan the Peninsula almost all the way to Muizenberg and Hout Bay lying on the eastern and western shores respectively of the mountain 'spine'.*

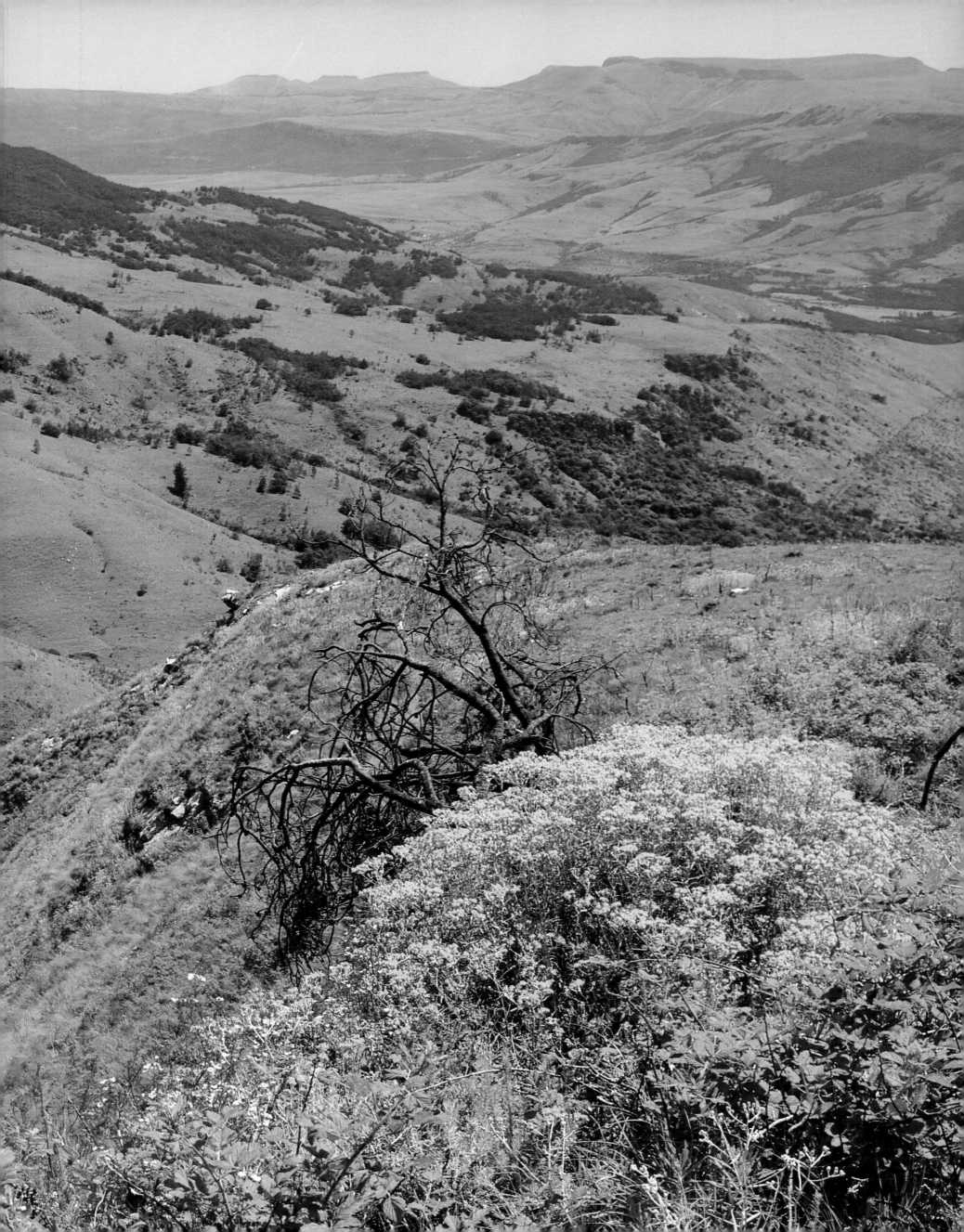

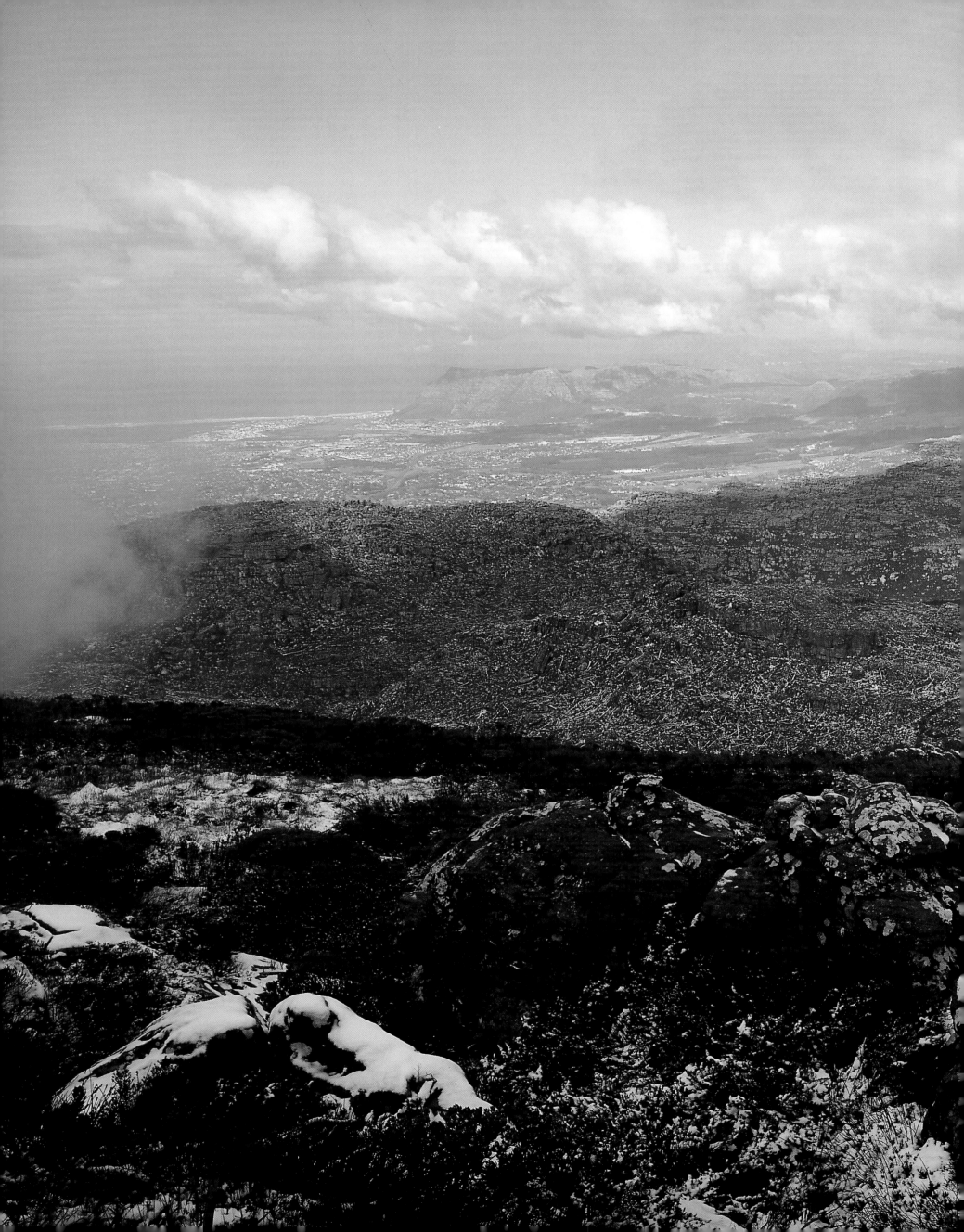

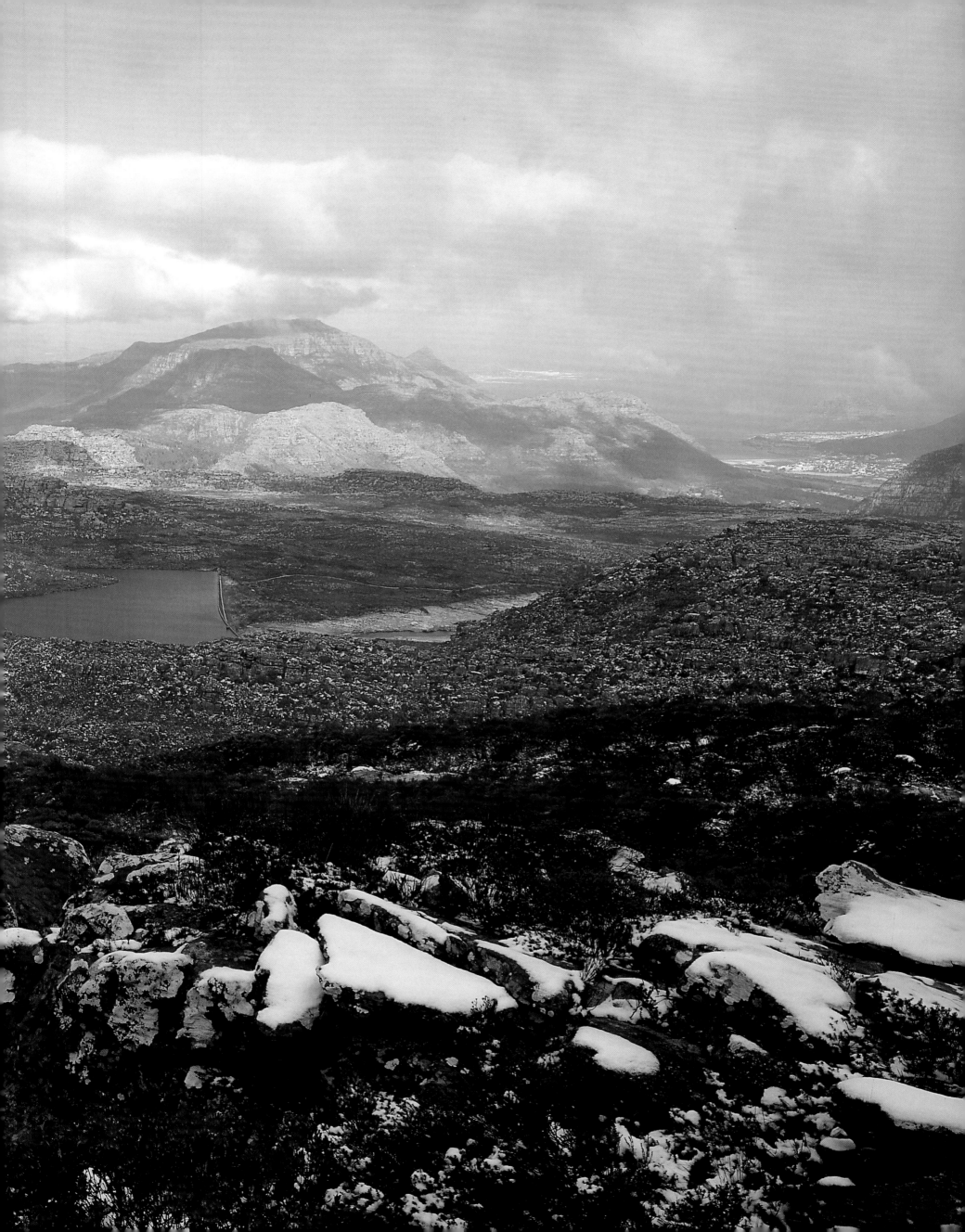

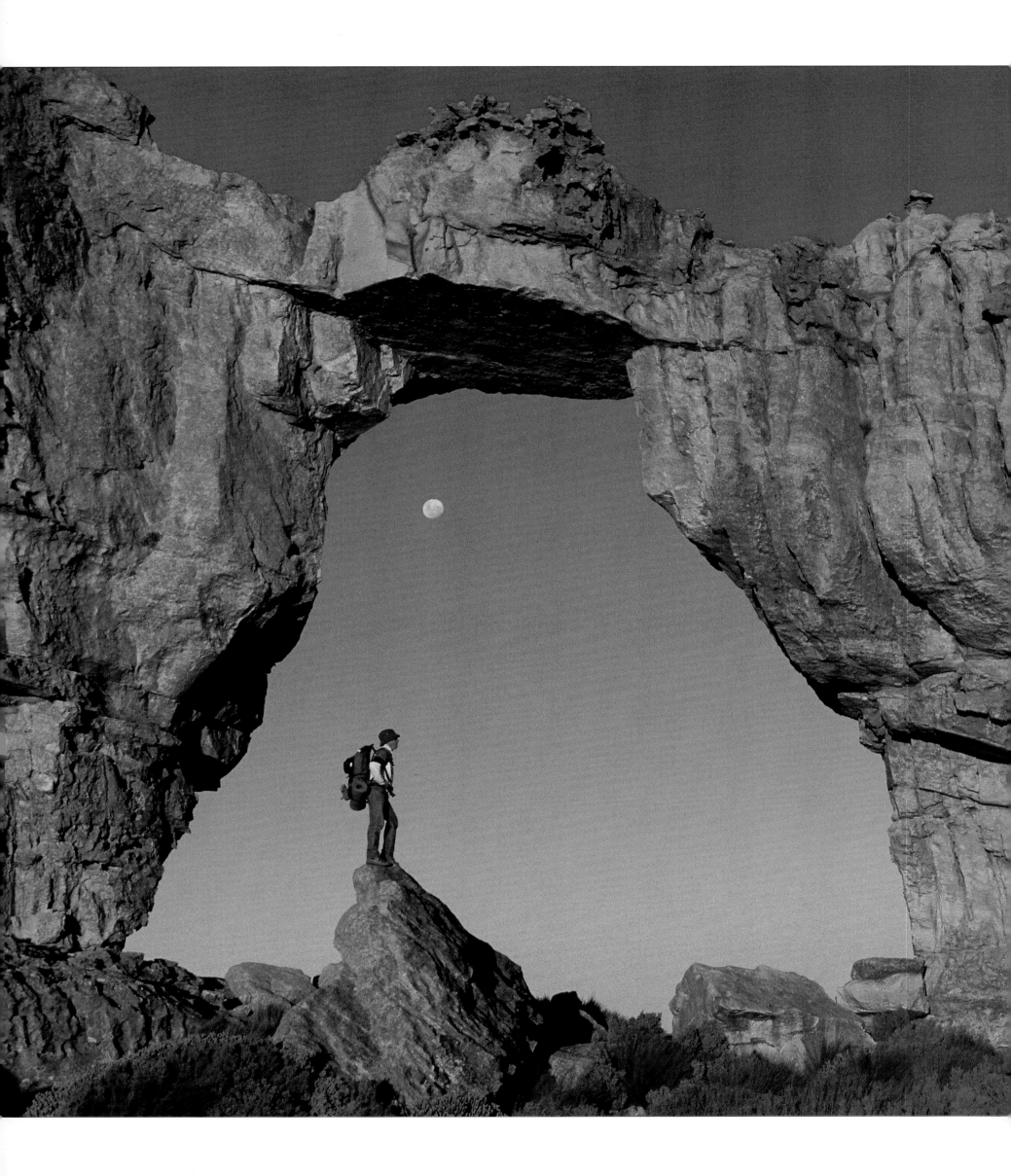

LEFT AND BELOW *Ancient weathered sandstone produces bizarre formations in the Cedarberg, Western Cape. The 71 000-hectare mountain wilderness area is named for its specialised and seriously threatened population of mountain cedars* (Widdringtonia cedarbergensis). *Its streams and pools, isolated peaks and secret caves provided a habitat for the San people, whose rock art is preserved here.*

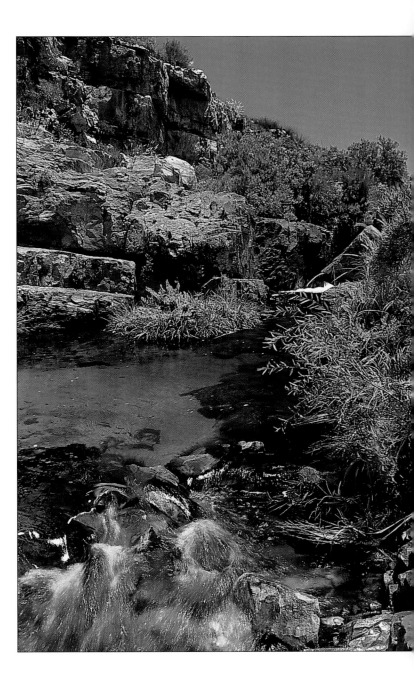

Soaring cylinders of dolomite – the Three Rondavels – cap the sandstone walls of the 1,5 kilometre-wide Blyde River Canyon in Mpumalanga's escarpment region. The evocatively named God's Window is a vantage point for a panorama of unforgettable majesty encompassing lowlands, forests, rock formations and the awe-inspiring canyon itself.

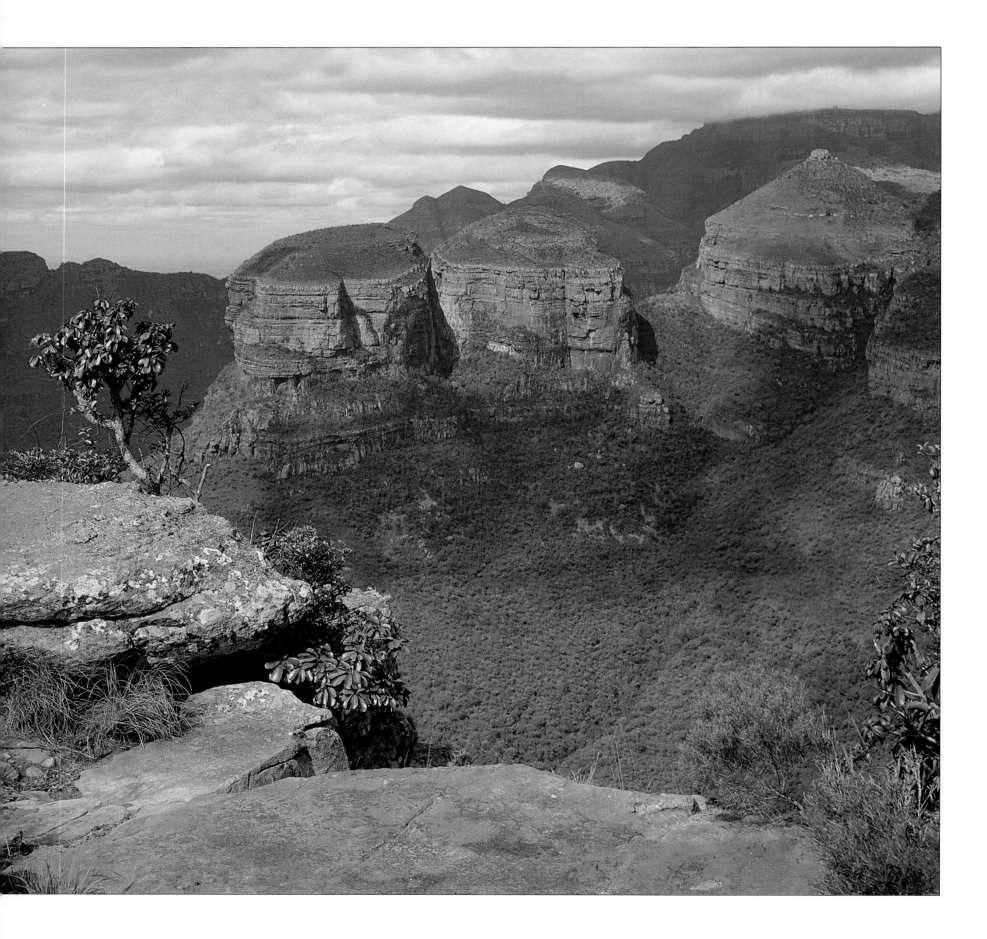

The fertile, fruit-growing Ceres valley is protected by a series of mountain ranges, often dusted with snow in winter. Named for the Roman goddess of agriculture, the district was once the last outpost for gold- and diamond-diggers rushing to the north. Now the area is known for the less frenetic pursuits of trout fishing and occasional skiing in the Matroosberg.

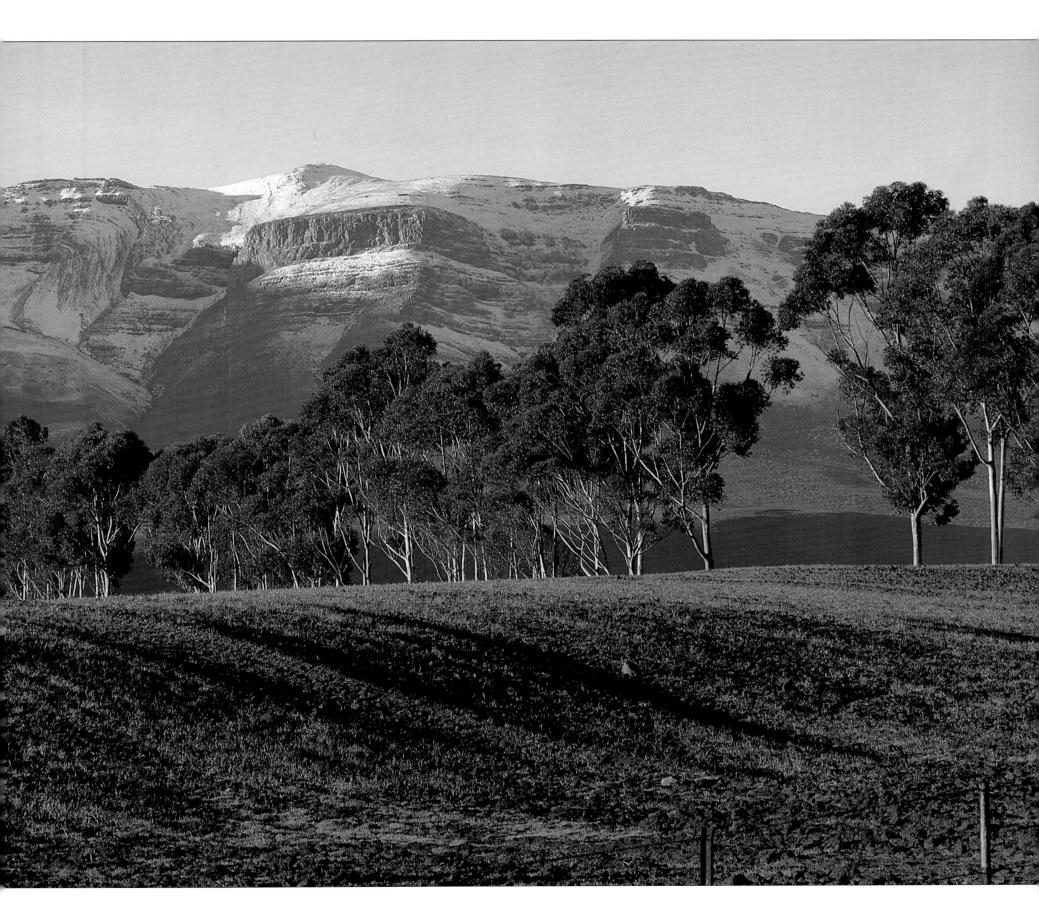

VALLEYS OF THE VINE

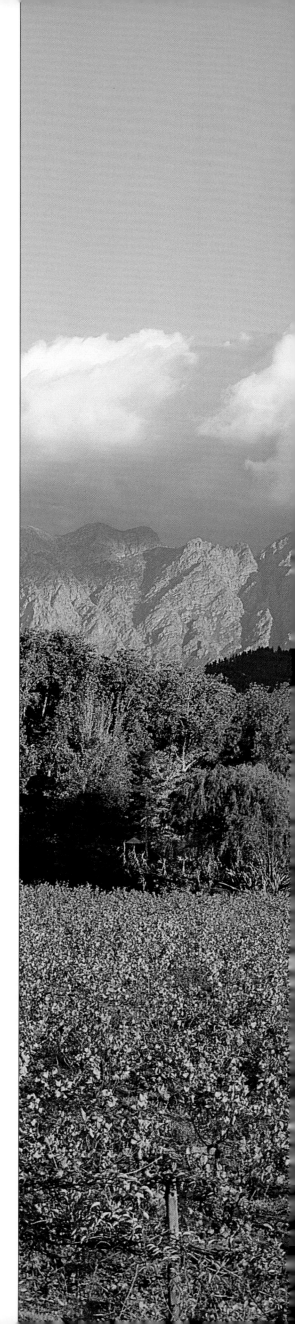

Embodying the very essence of the country's history and hospitality, the world-renowned winelands combine an abundance of food and shelter with ample quantities of the varied and delicious gifts of the grape. They are lovely at any time of the year, with carpets of green, red and gold unfolding in seasonal succession. Here and there will be the elegant form of a gabled homestead, brilliant in fresh whitewash and sighing with history ... some are private homes, many have been converted to country house hotels with excellent restaurants, or small museums which give a glimpse of an earlier way of life in South Africa. Sprawled across the western and northern Cape, the vineyards produce a huge variety of wines, whose distinctive personalities underline their origins in valley or veld, coastal desert or misty mountain slope of 13 wine-growing regions. The South African wine industry owes its greatest debt to Simon van der Stel, governor of the Cape from 1679 to 1699, who established the vineyards and cellars of Groot Constantia. He also founded Stellenbosch, the country's oldest settlement after Cape Town, and planted it with avenues of oaks. The

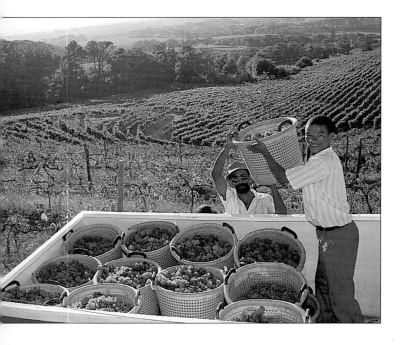

Stellenbosch, Paarl and Constantia vineyards are perhaps the most versatile, producing an extraordinary variety of vintages to please every palate, including many of the country's most exalted wines. Among them, of course, are many delightful vin ordinaires for daily drinking, but it is mainly the noble varieties that travel abroad, or are vied for by investors who pay increasingly competitive sums for rare vintages and sweet wines at the annual Nederburg Auction in March.

ABOVE *Grapes gathered from the cool slopes of the Constantiaberg will produce the next crop of fine wines from the country's oldest cellars at Groot Constantia.*

RIGHT *The Franschhoek Valley is a 'little corner of France', settled by Huguenot refugees three centuries ago.*

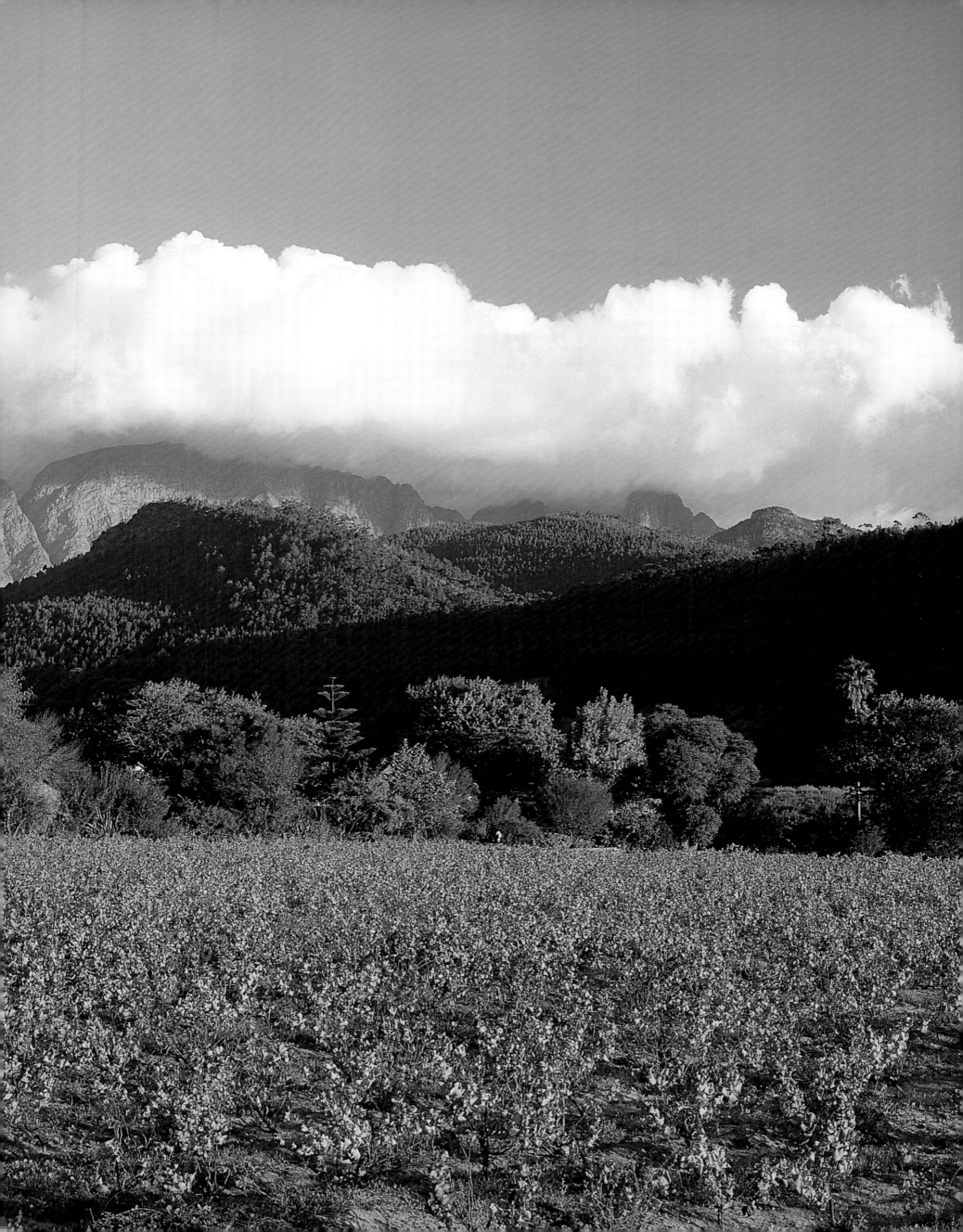

BELOW *The Boland's most distinguished dish combines succulent water plants,* Aponogeton distachyos, *with mutton, potato and sorrel. The 'waterblommetjies' are harvested from shallow ponds in spring.*

BOTTOM *Accommodation for farm workers reflects a rural lifestyle preserved in the Franschhoek valley.*

RIGHT *Summer's energy is stored for a final burst of radiance from autumn foliage on the road to L'Ormarins, producer of noble wines, in the Franschhoek district.*

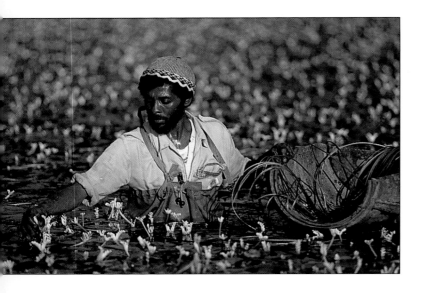

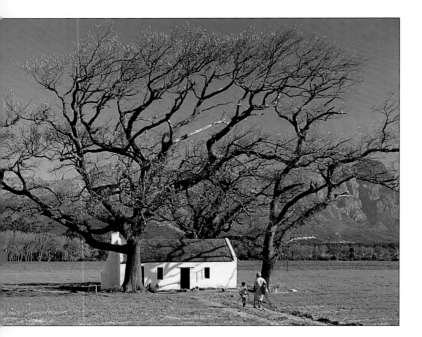

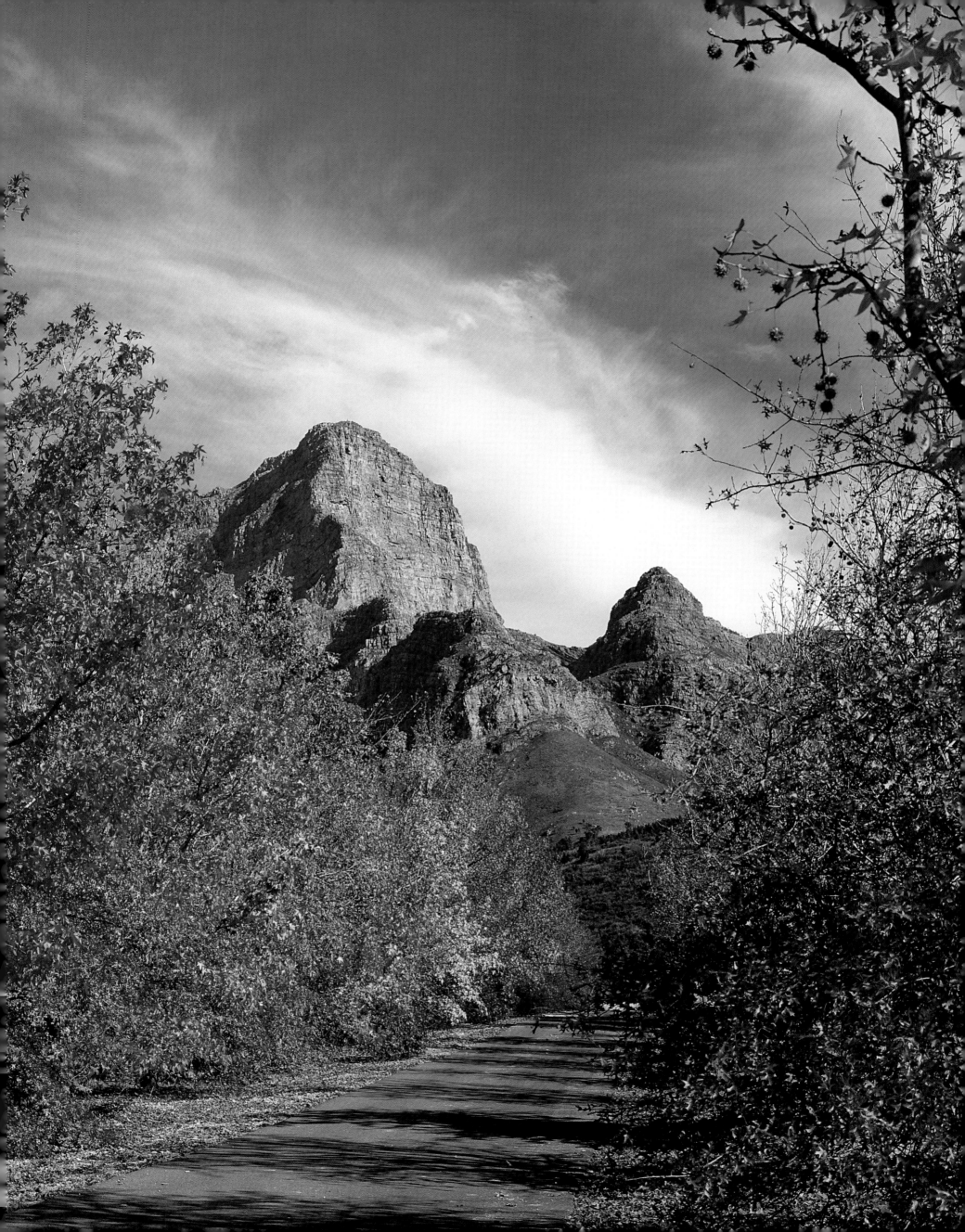

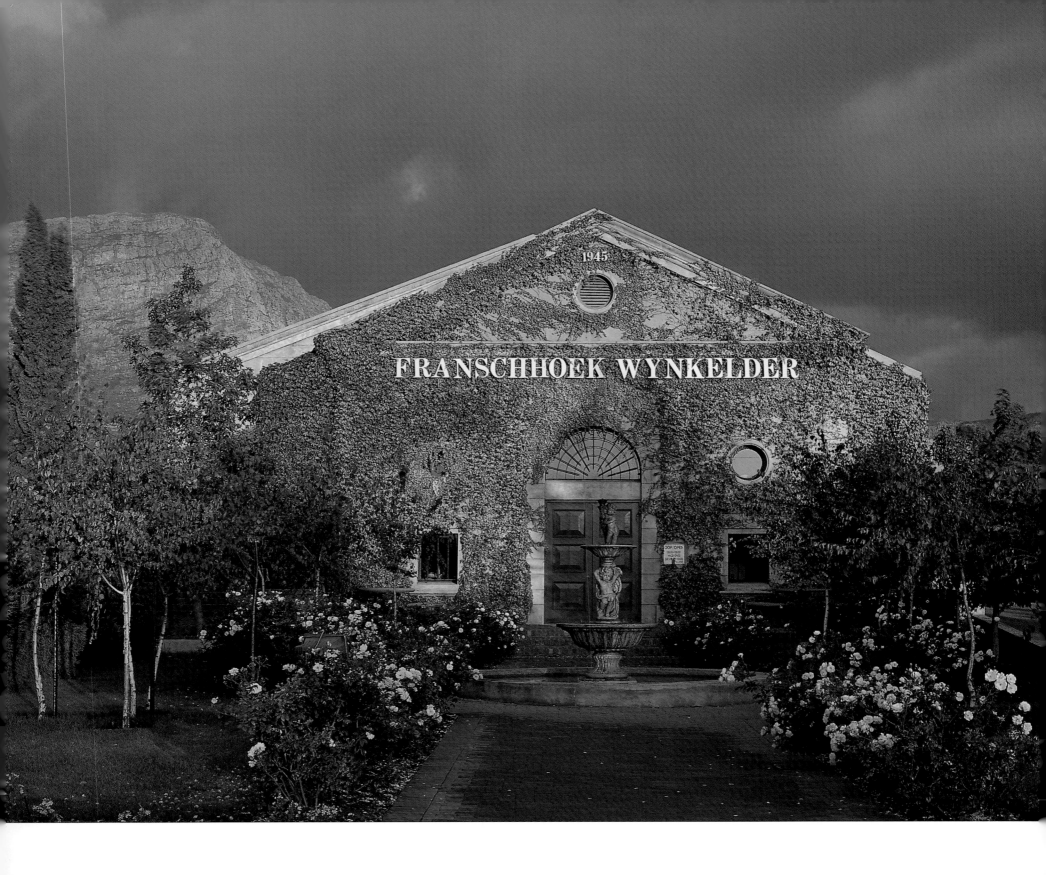

FRANSCHHOEK WYNKELDER

1945

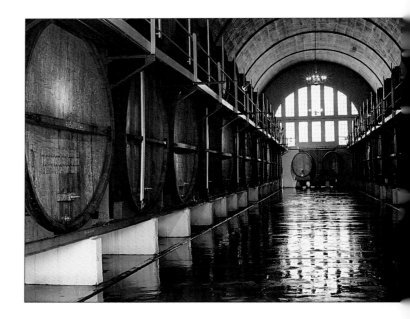

ABOVE *The local cooperative showcases Franschhoek's fine wines, which range from Chardonnay, Sauvignon Blanc and Semillon to rubies and reds such as Shiraz, Merlot, Cabernet Franc and Pinot Noir.*

RIGHT *South Africa's wine industry has its headquarters at KWV, the world's largest cellar complex, in Paarl. The annual Nederburg Auction and Nouveau Wine Festival are highlights on the calendar.*

OPPOSITE *Buitenverwachting – 'beyond expectation' – is part of the original Constantia farm, the home of 17th- century Cape governor Simon van der Stel for the last 13 years of his life.*

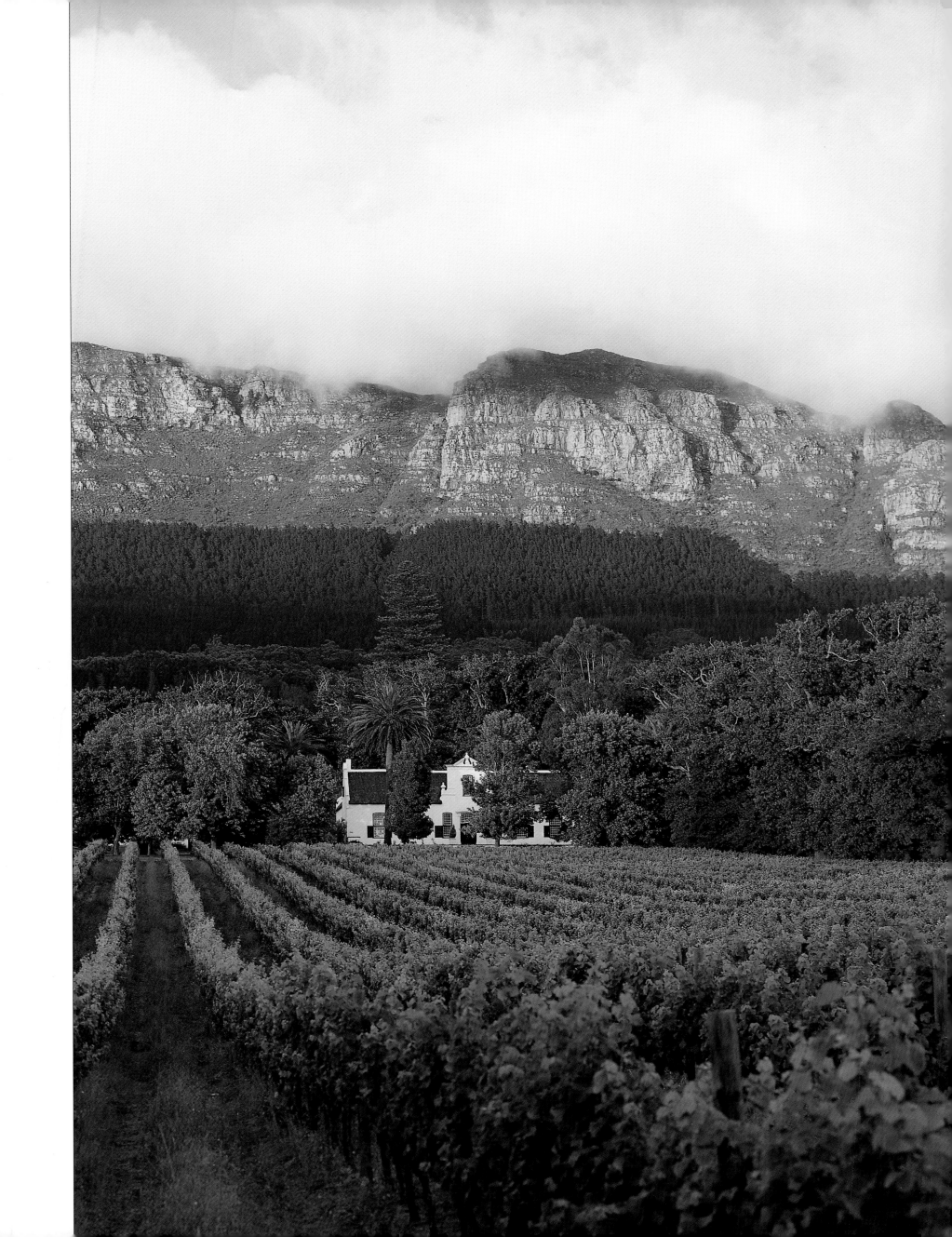

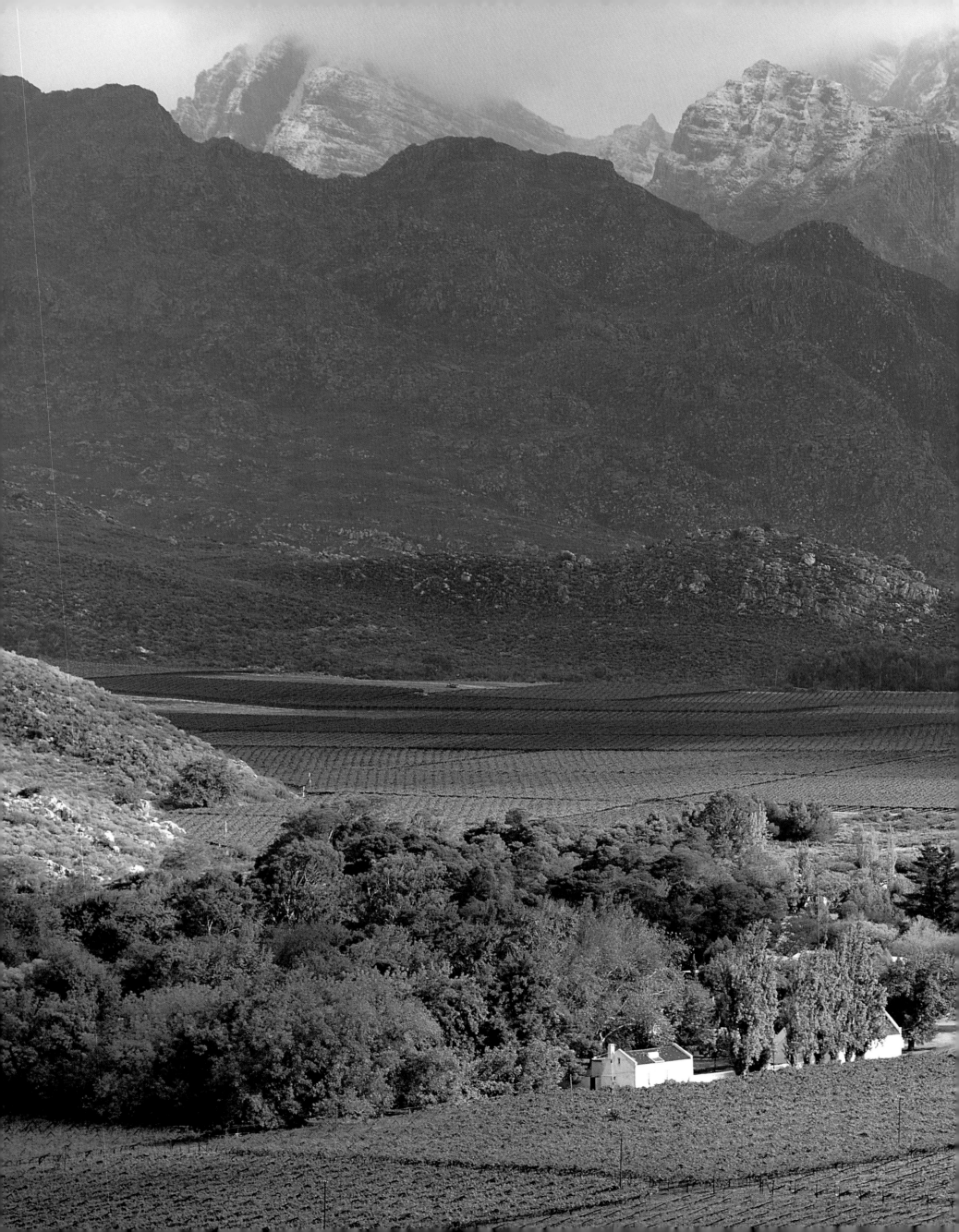

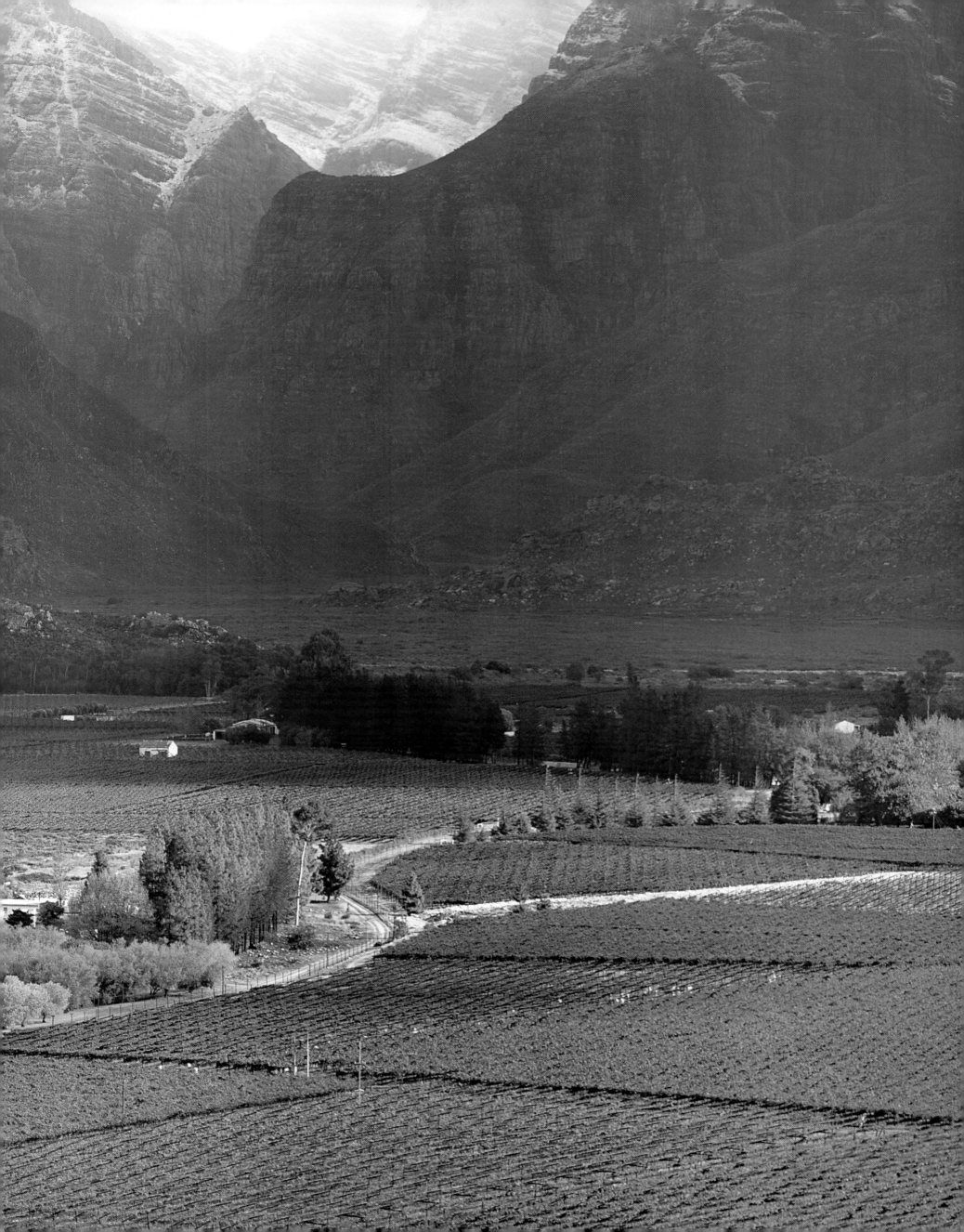

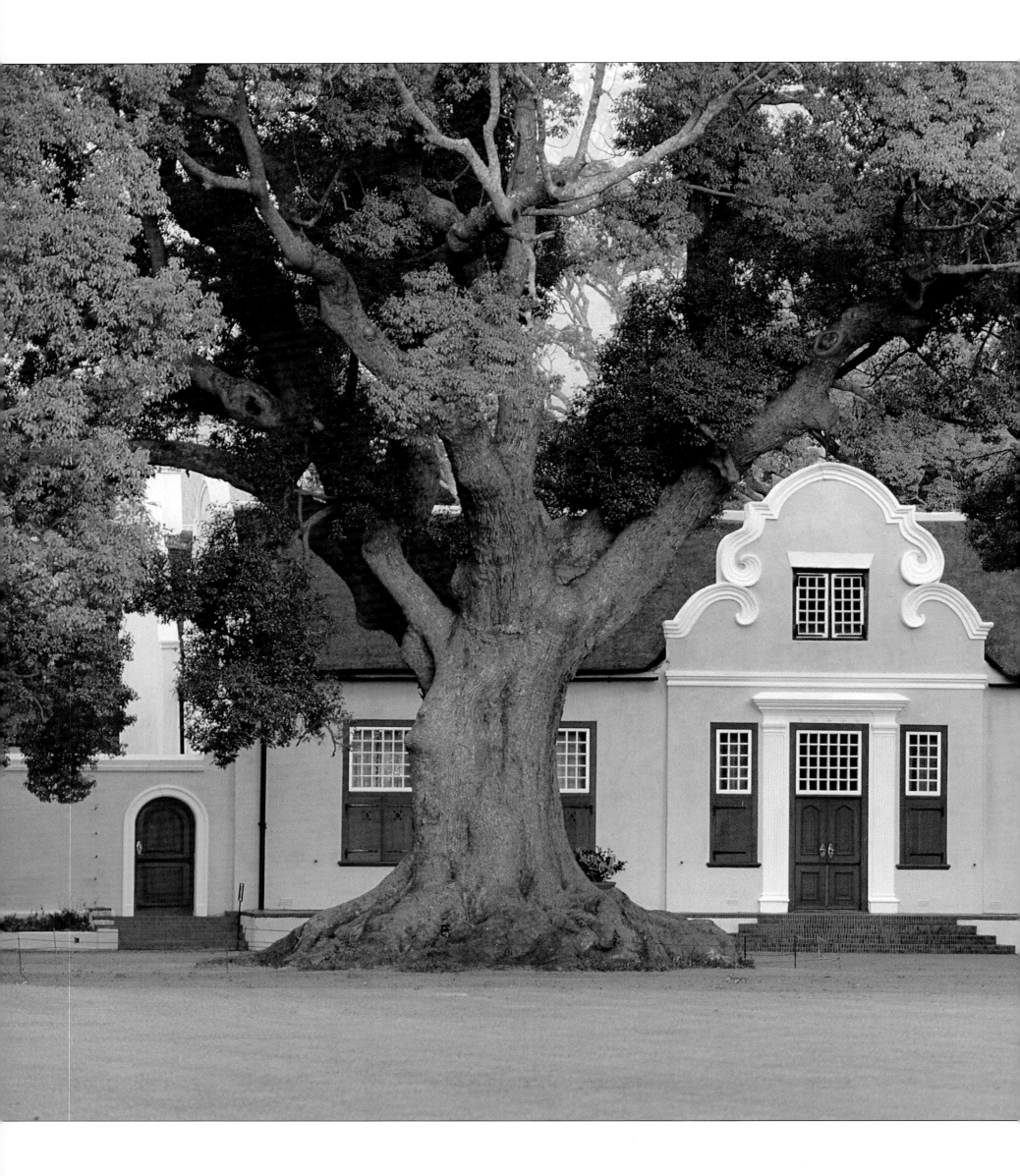

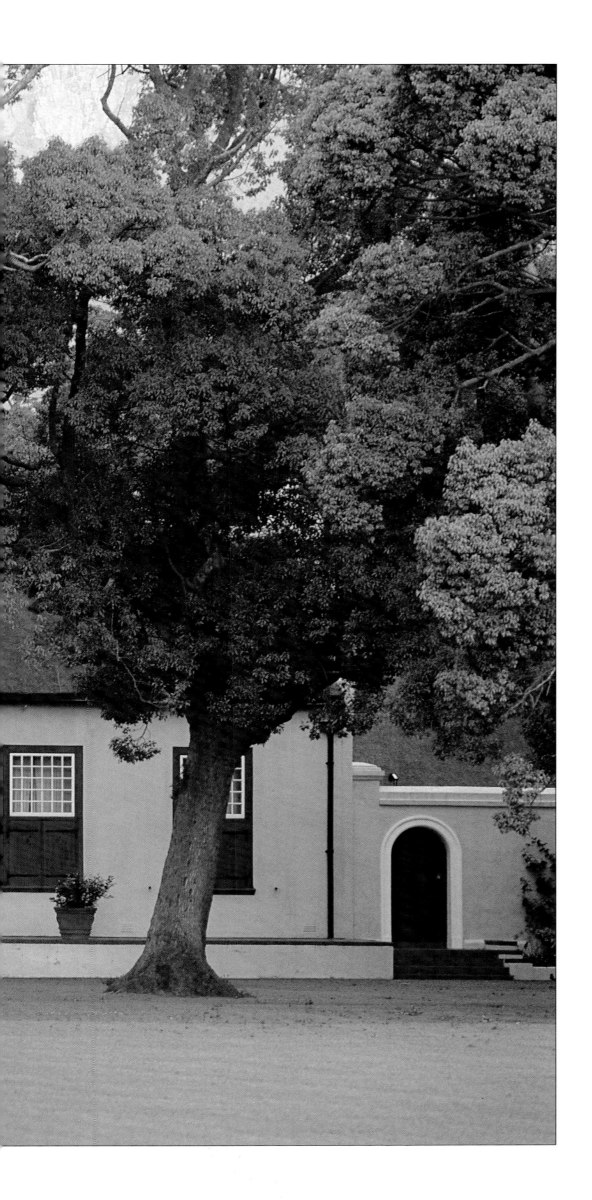

PREVIOUS PAGE *Winter in the Hex River Valley brings snow to cap the mountains and a golden carpet for the floor. Most of South Africa's export table grapes are grown here.*

LEFT *Five 300-year-old Chinese camphor trees stand sentinel at the entrance to historic Vergelegen, now a progressive wine estate and fruit farm. The glorious grounds and gardens attract thousands of visitors a year.*

OVERLEAF *A little farmhouse in the Robertson district, less than two hours from Cape Town, typifies the rural simplicity of the Little Karoo. Robertson is known for its fine wines, racehorse studs and rose gardens.*

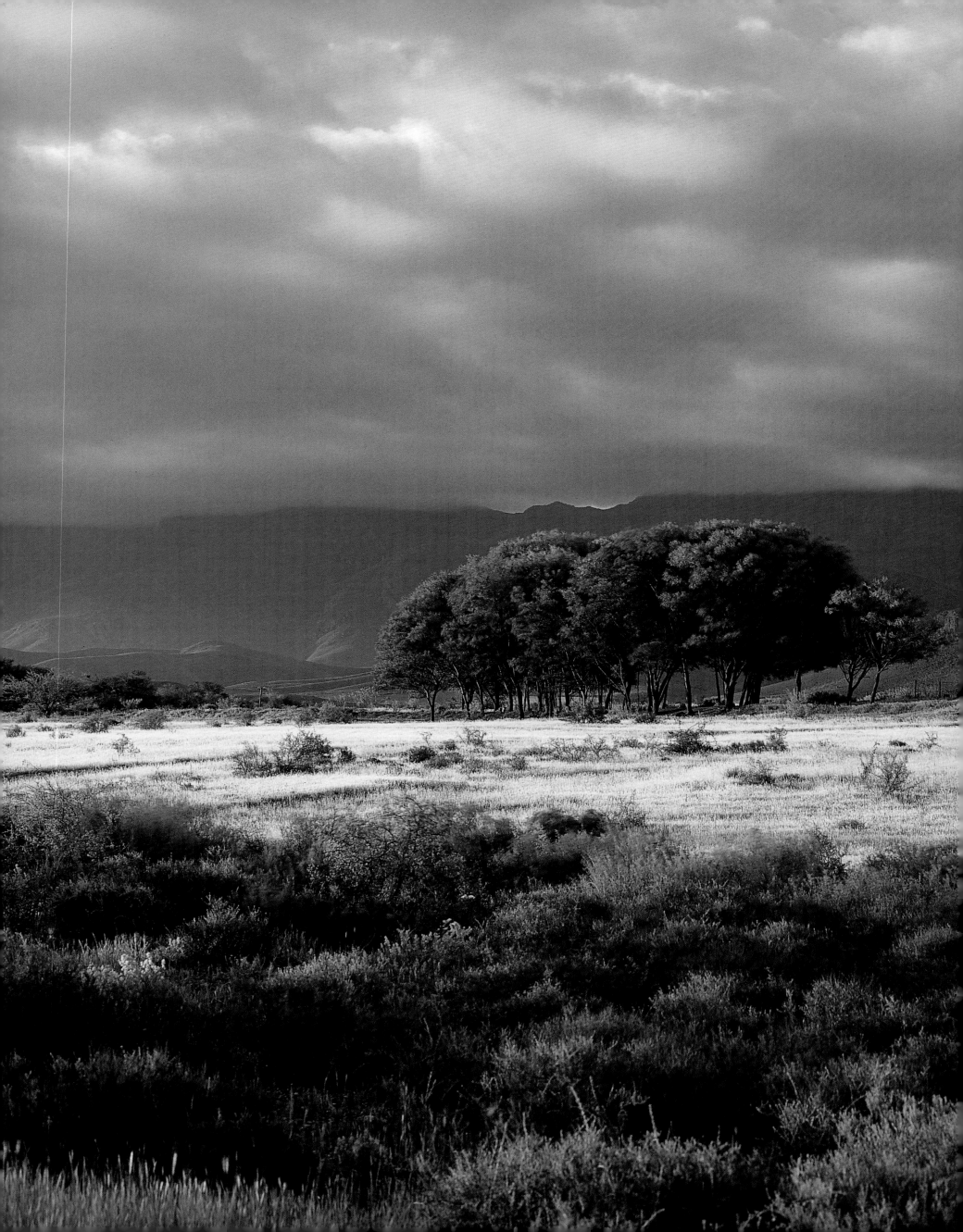

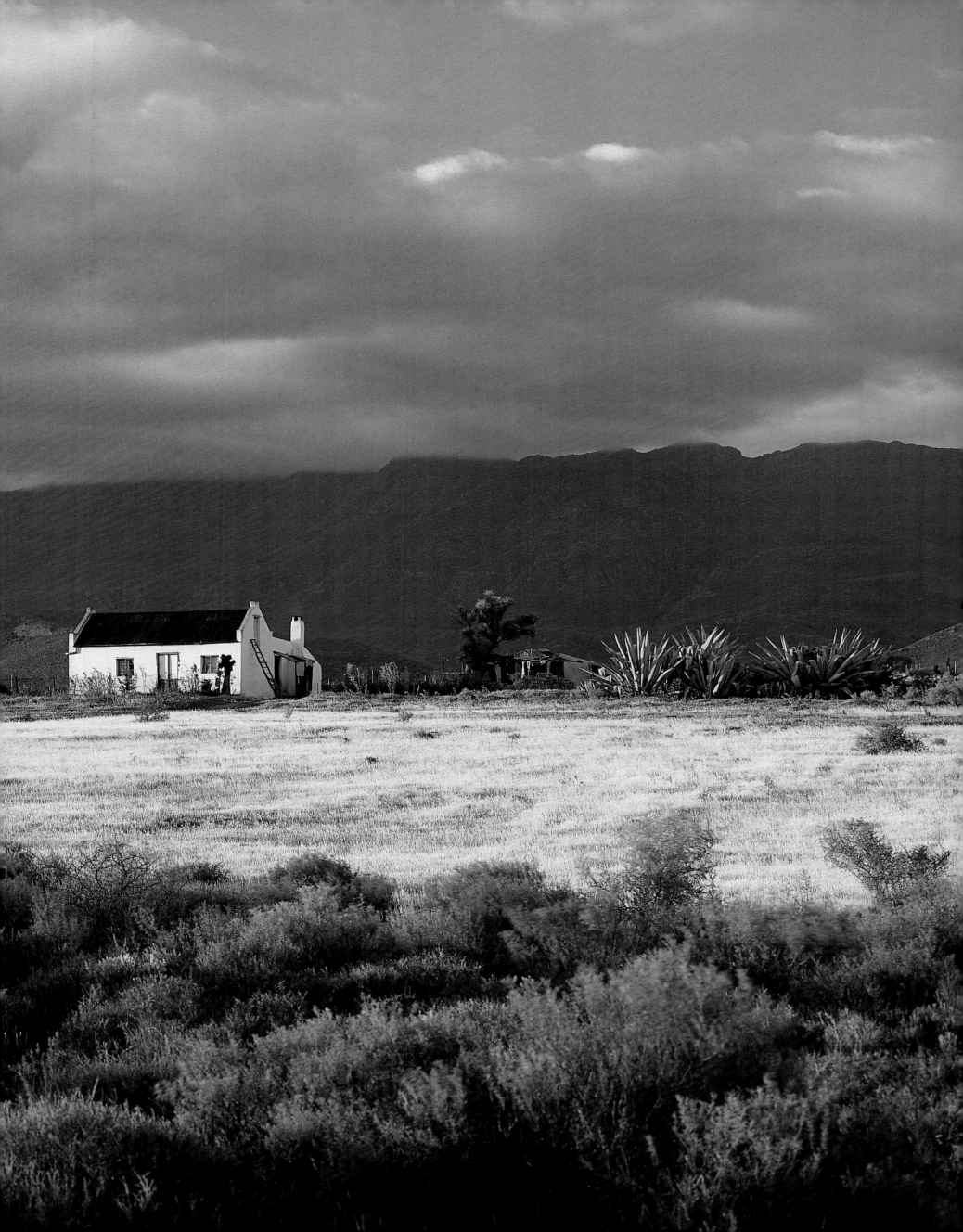

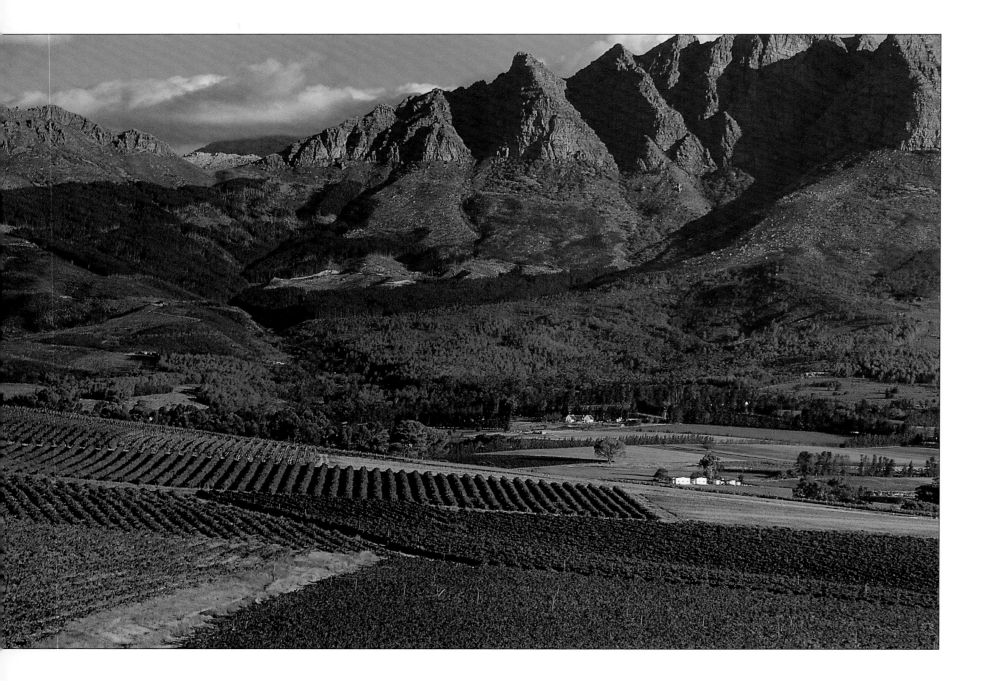

ABOVE *The mountain vineyards of Wellington blanket the lower slopes of the Groot Drakenstein range. Birthplace of Boer leader Piet Retief, Wellington is now an important research and viticulture centre.*

RIGHT *Milk goats are kept for cheesemaking at Fairview Estate, south of Paarl. The famous cheeses and wines can be bought from the estate shop.*

OPPOSITE *In the valleys around Tulbagh, innovative winemakers have introduced night harvesting to preserve the natural aroma and flavour of the grape.*

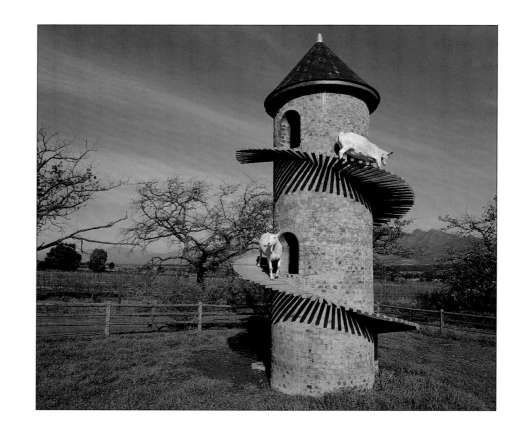

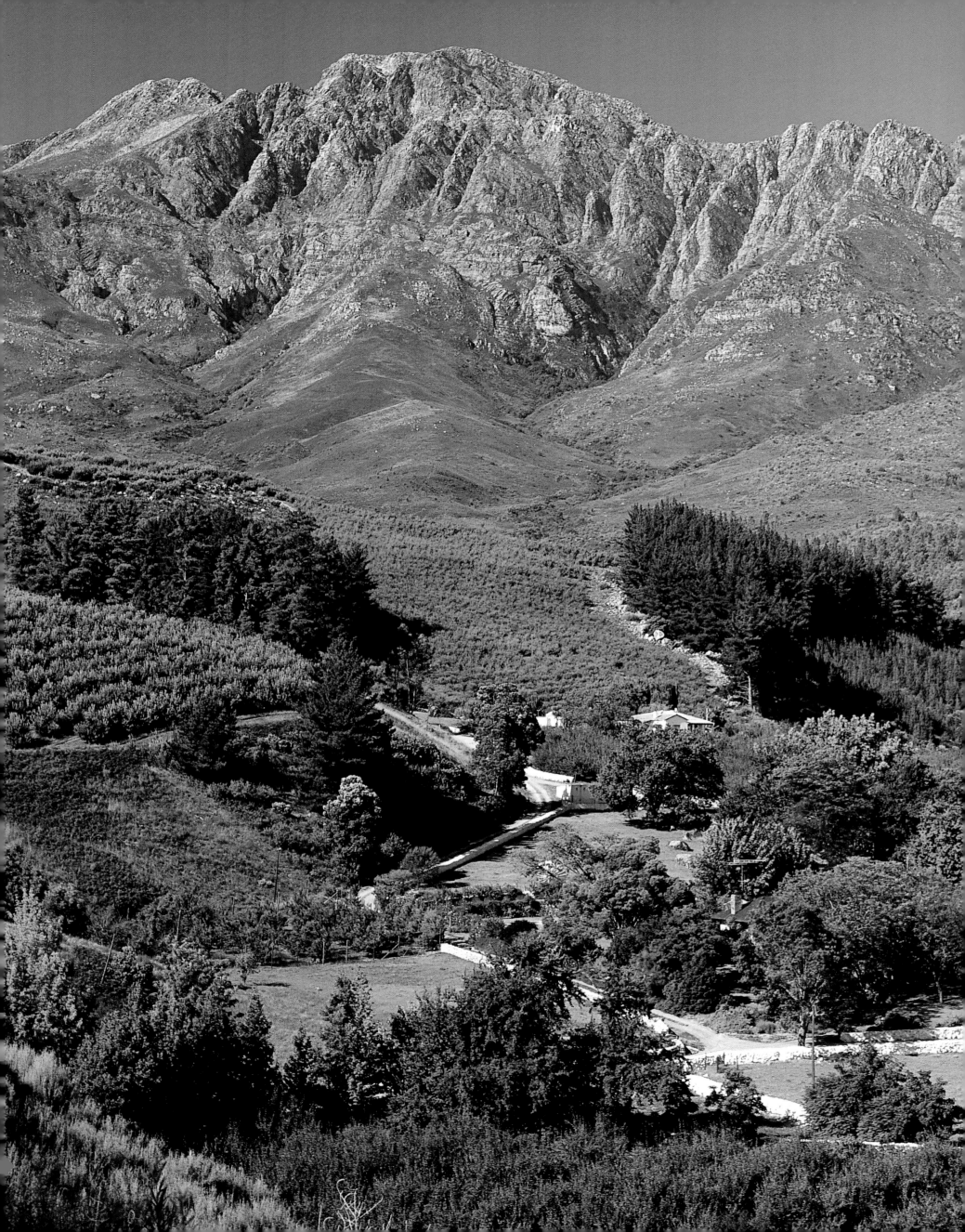

THE FACE
OF THE NATION

A nation is no more than the sum of its people and, for South Africa, what a splendid sum it is: a richly complex pool of ethnic groups which has emerged from the cradle of mankind, through turbulent adolescence to what is fervently hoped will be wise adulthood. For millennia, the gentle Stone Age San and the KhoiKhoi lived peaceably, pursuing their own interests, exchanging linguistic characteristics and integrating through marriage and custom. When Bantu-speaking people moved southwards 2 000 years ago, their lifestyles apparently had little impact on the Khoisan. By the time the Dutch settlers landed in Table Bay there were large, well-established tribes distributed across the South African 'platteland', the east coast and the southeastern interior. These were the Sotho, the Tsonga and the Xhosa clans. Far away in the remote and secluded places of the Drakensberg the Zulu people were amassing

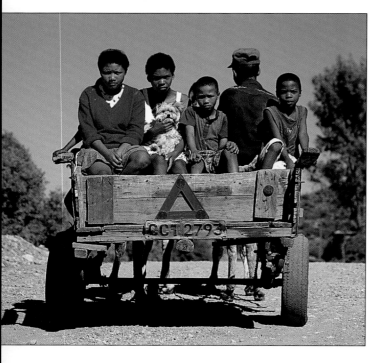

themselves into a powerful nation. Today Zulu is the language spoken by more of South Africa's estimated 40 million people than any other. Over the centuries the subcontinent has seen the arrival of a succession of nations: Portuguese navigators, Dutch settlers, British colonists, French Huguenots, indentured labourers and political exiles from the East. All of these have survived the tumult of centuries, retained their courage, and above all, their identity in the face of suppression and discrimination, and emerged to rejoice in a new era of freedom.

ABOVE *For millions of rural people in South Africa, a donkey cart represents wealth and affords the most convenient transport between villages and farms.*

RIGHT *Primary school children in the playground at a Gauteng school reflect the spirit of the 'Rainbow Nation'.*

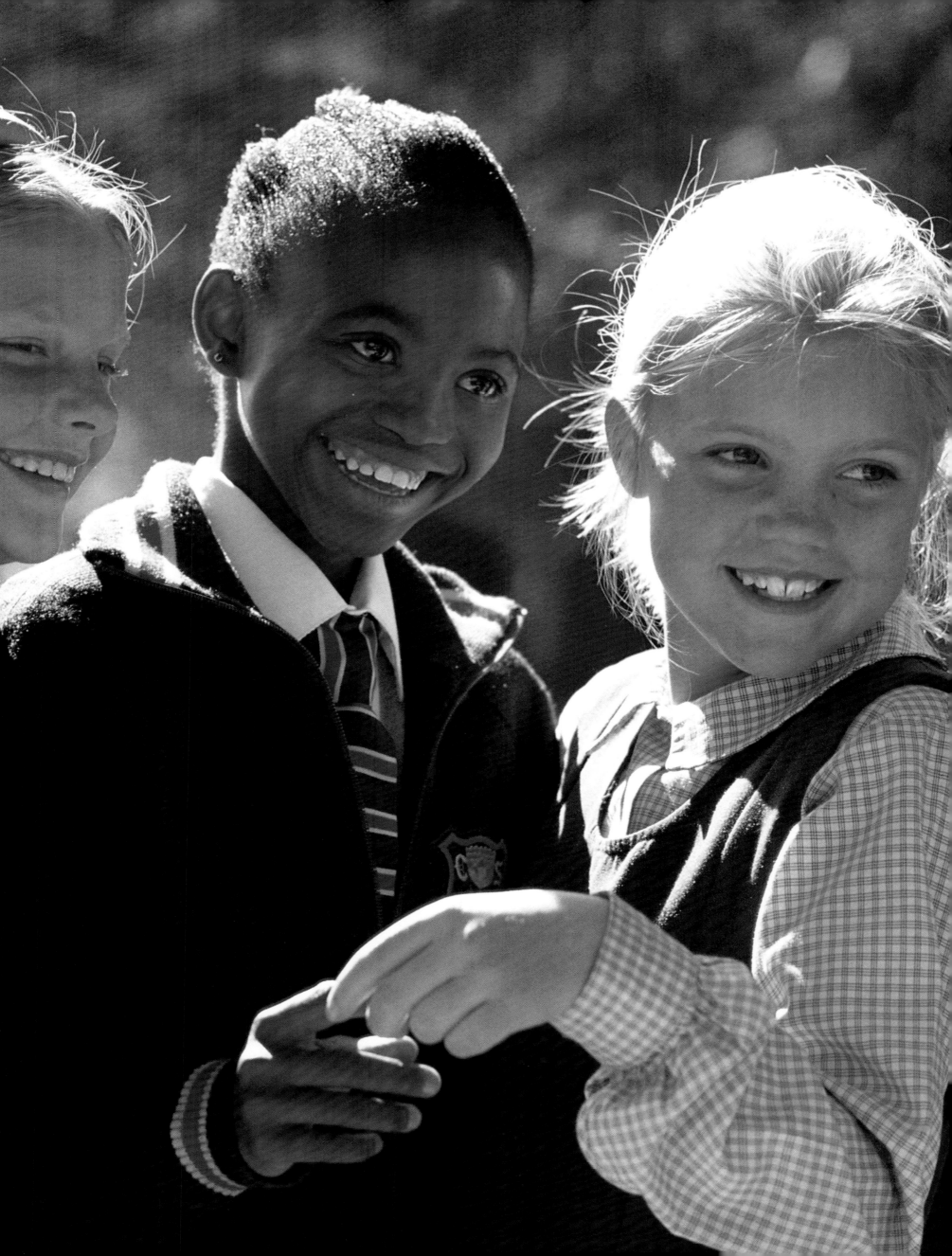

RIGHT *A young Indian woman dressed for the marriage ceremony. South Africa's Indian community numbers around one million people who have contributed diverse skills and a rich culture to the fabric of the nation.*

BELOW *A muezzin, or Indian prayer leader, calls the faithful to prayer five times a day. The vast majority of the country's Indian community is settled in Durban.*

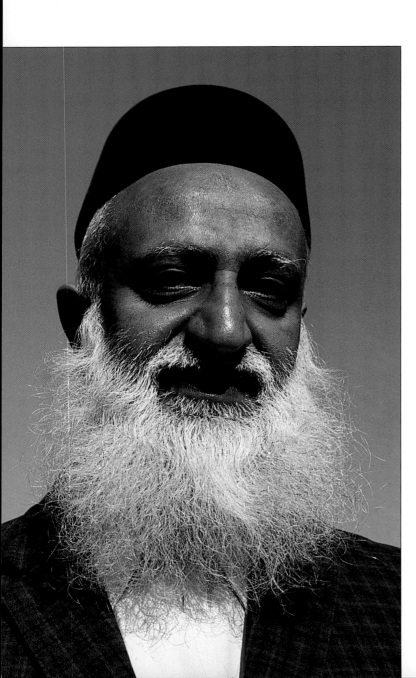

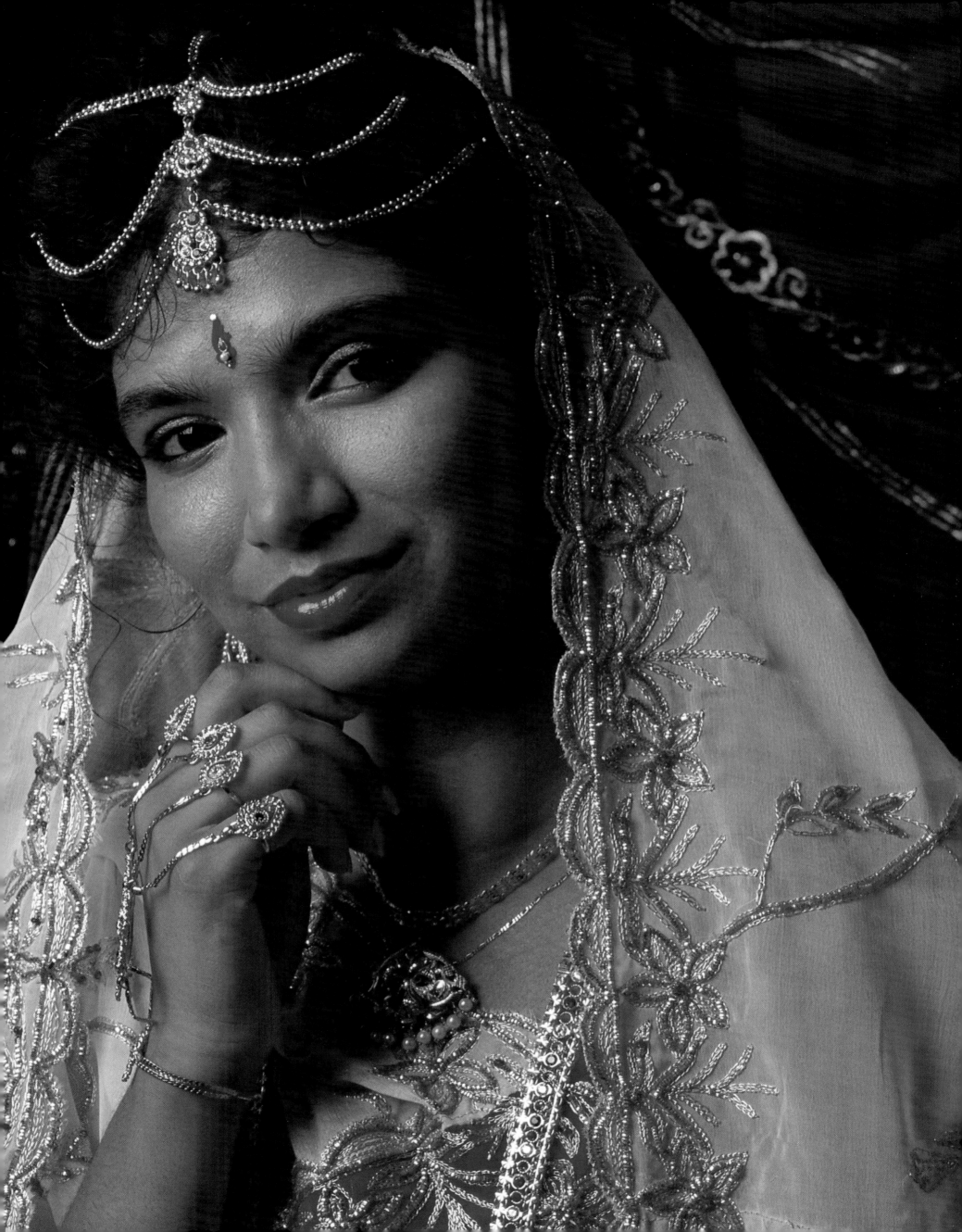

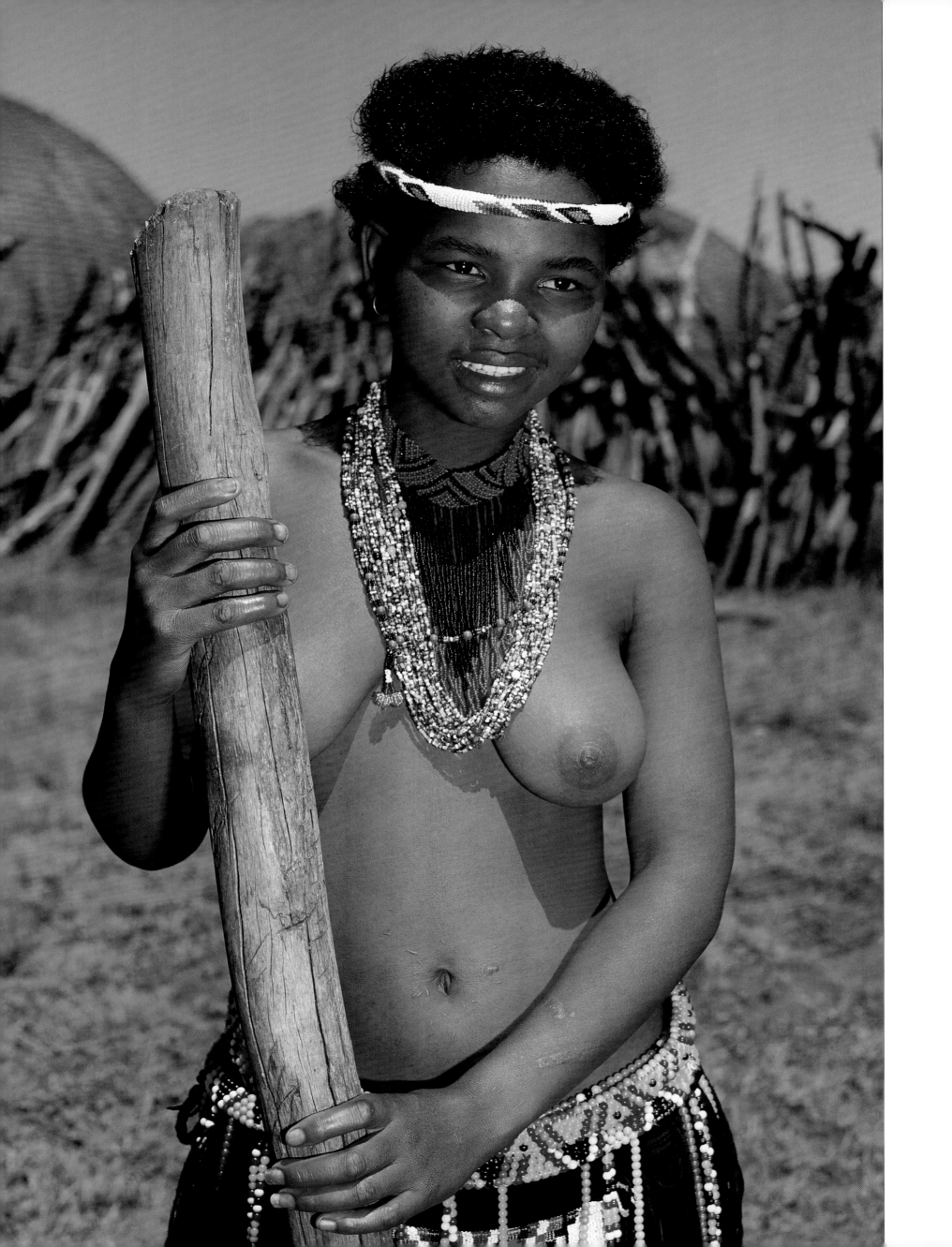

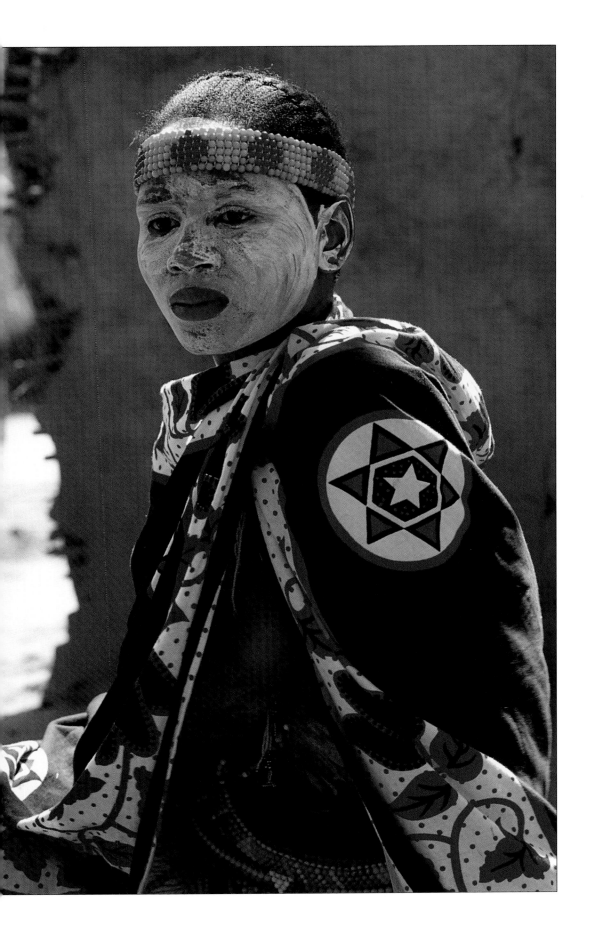

OPPOSITE *Zulu art, expressed most broadly in bead- and basketwork, makes liberal use of triangle shapes, singly or in combination, to convey important statements about, for example, marital status.*

LEFT *Both men and women can be Sangomas (Zulu diviners). They undergo two to three years of rigorous training and will act as an intermediary between their ancestors and their community, and, by interpreting their wishes, help avert disease or disaster among the people.*

OVERLEAF *A handsome young Zulu couple shows off ritual courtship adornments at KwaZulu-Natal cultural centre, Shakaland. The language of the beads is pure poetry, with various colours signifying love, grief, loneliness, jealousy and the entire gamut of human emotion.*

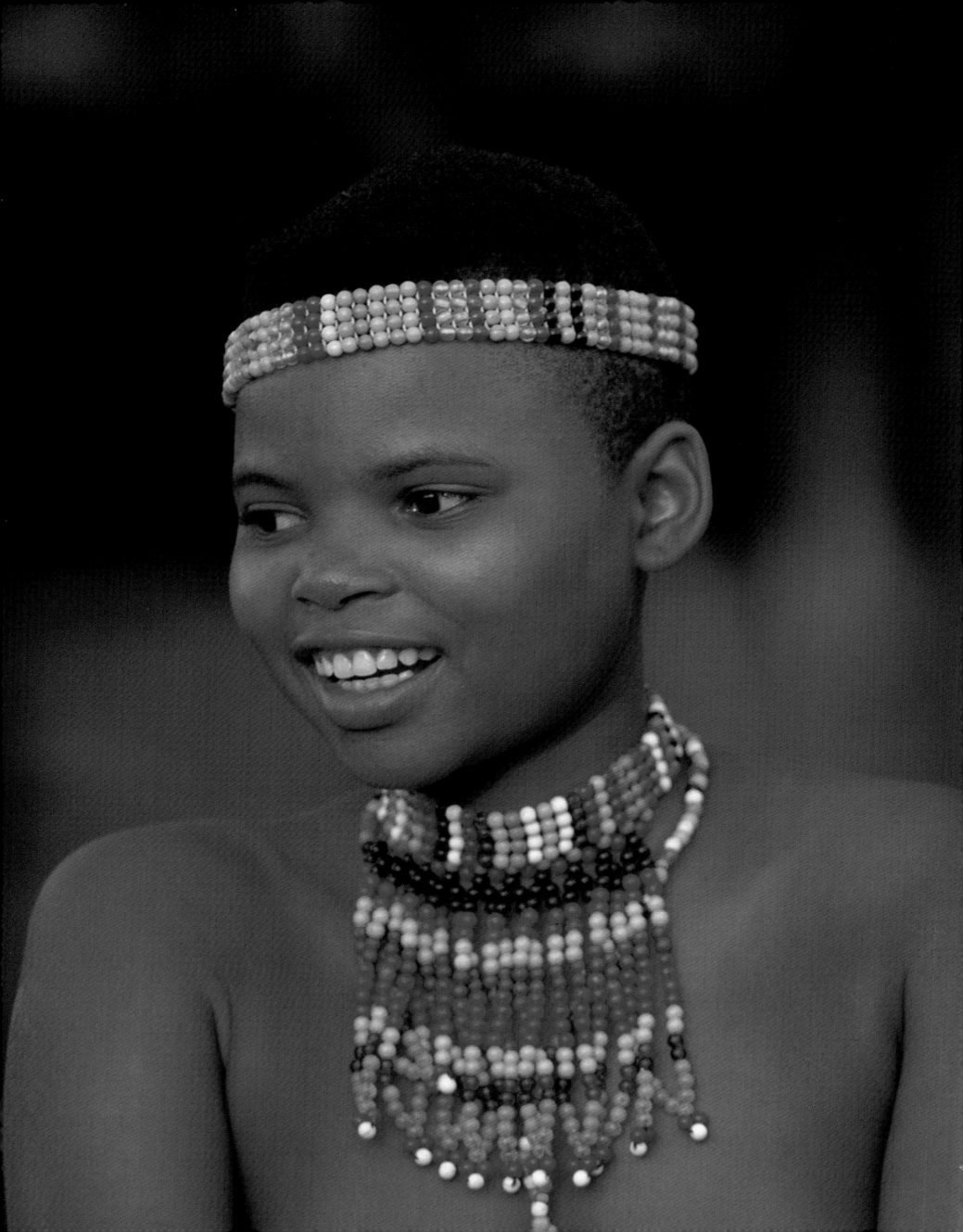

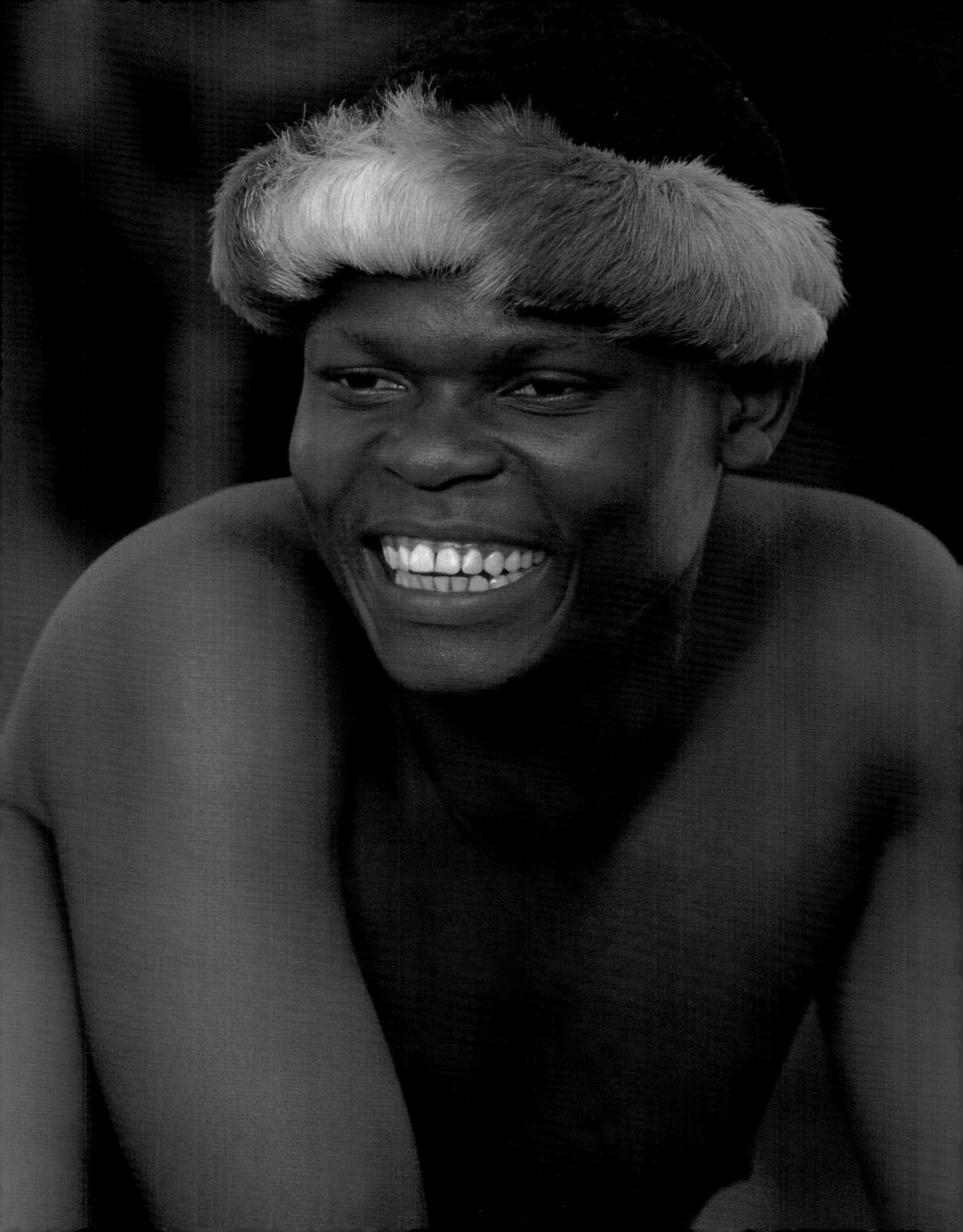

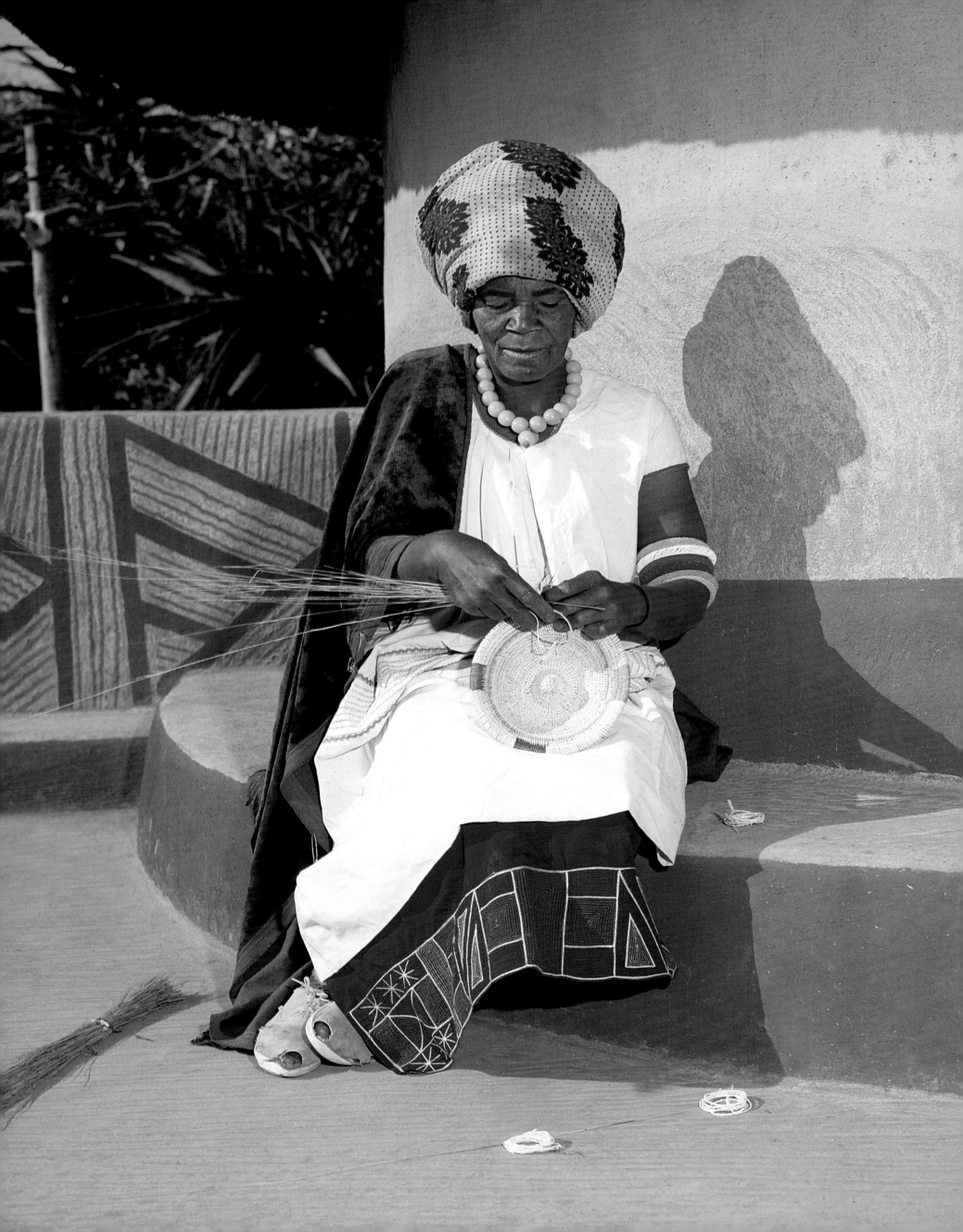

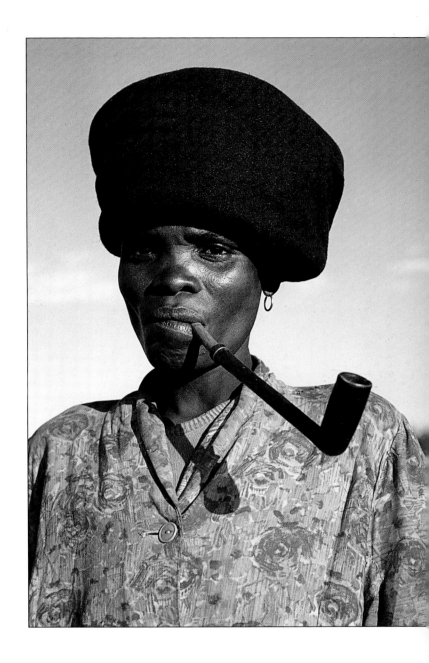

ABOVE *Only once a Xhosa woman has given birth to a specific number of children may she smoke the traditional pipe. The pipe and tobacco are carried in a decorative bag.*

LEFT *Xhosa women who are married wear braided skirts cut on the bias, with long aprons; a cloth, also braided, is rubbed with ochre and worn over the shoulder. White cloths signify a special occasion, as does a more elaborate turban.*

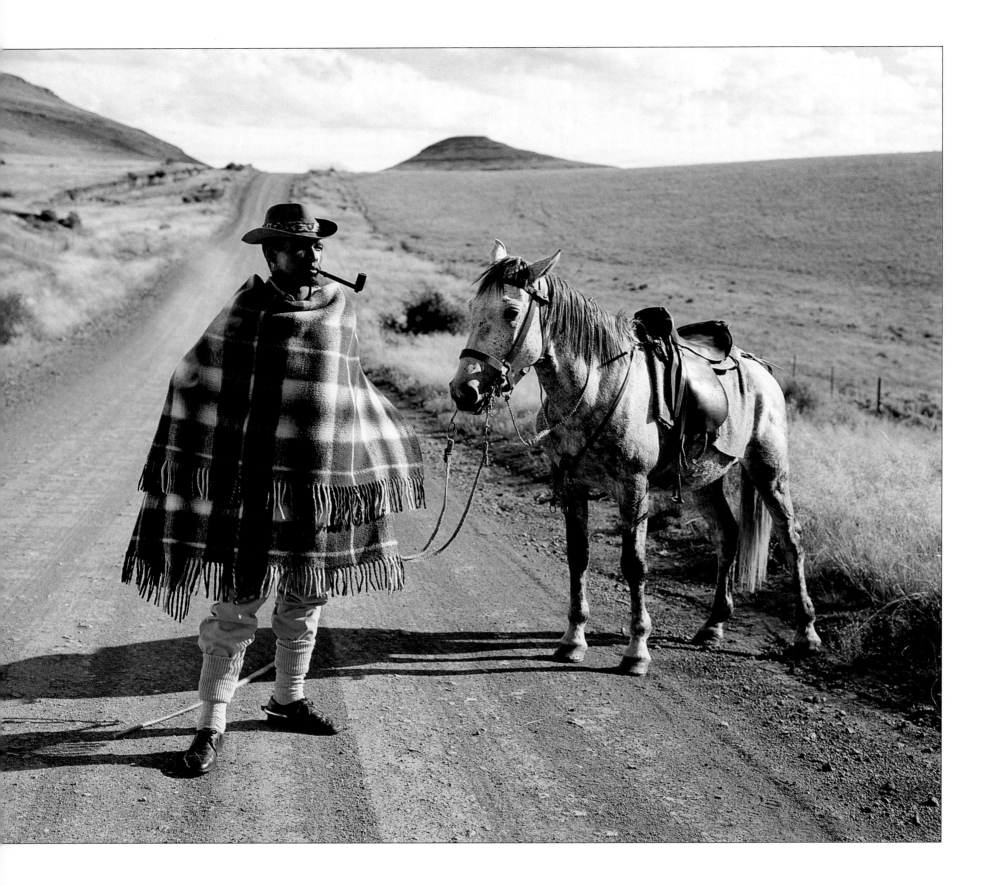

The southern Sotho people (Basutho) are concentrated in Lesotho in the shadow of the Maluti Mountains. These fine horsemen breed the sure-footed ponies that carry travellers on holiday 'treks' through the mountain country.

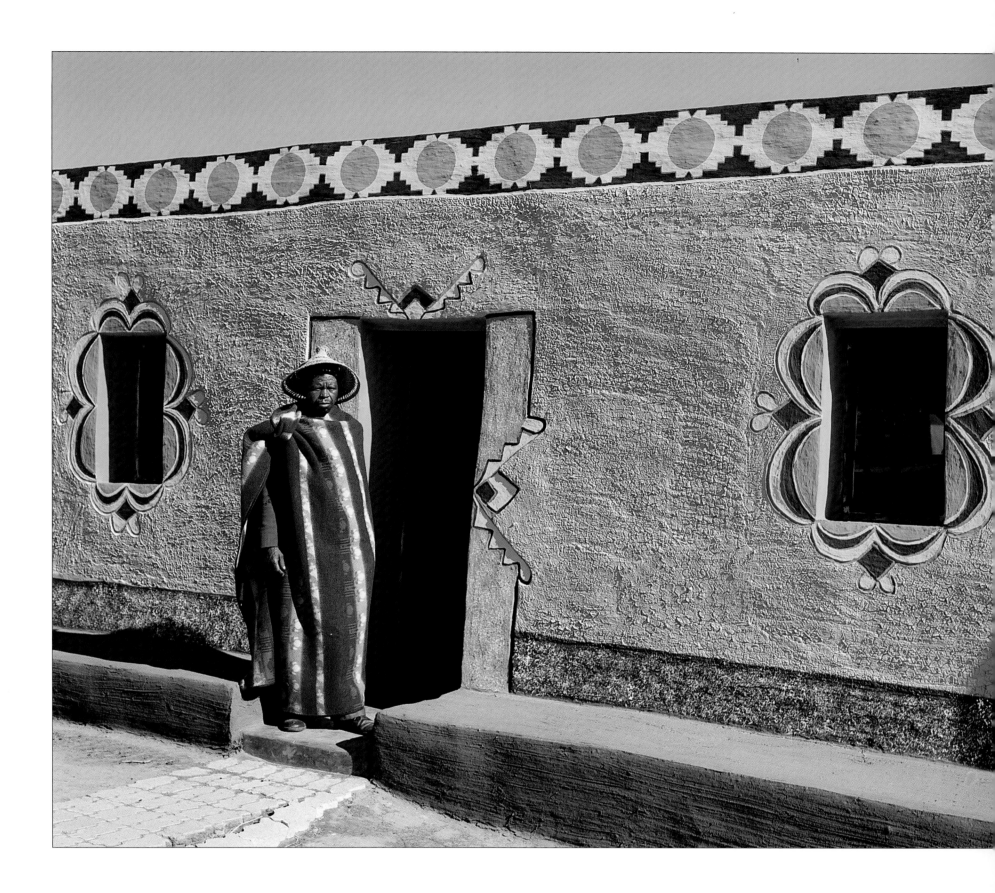

Bright blankets are everyday garb for men and women, replacing the 'karosses'
(animal skins) of days gone by. Men also wear conical straw hats. Customs and
rituals are preserved in a Basutho Cultural Village near the Golden Gate National Park.

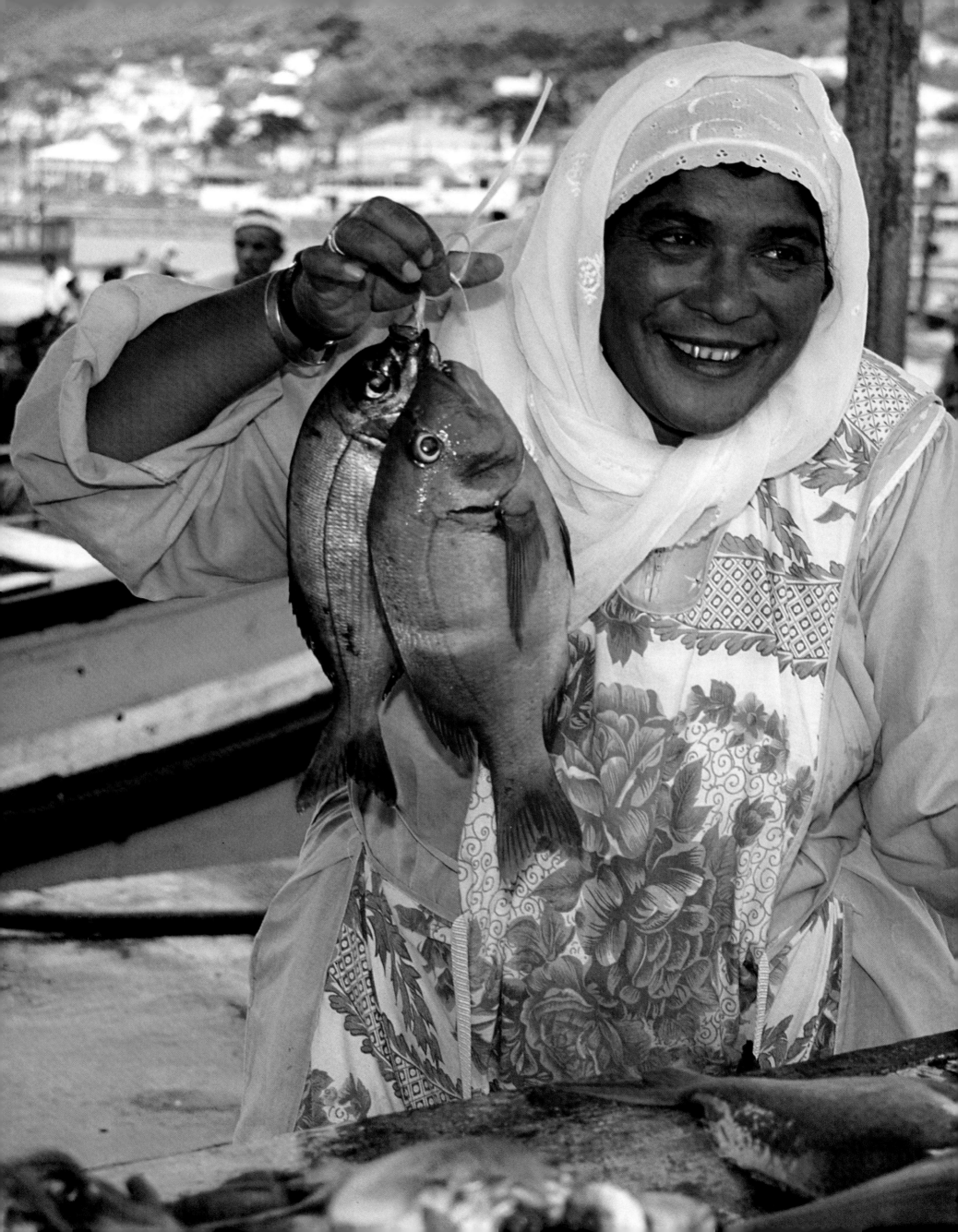

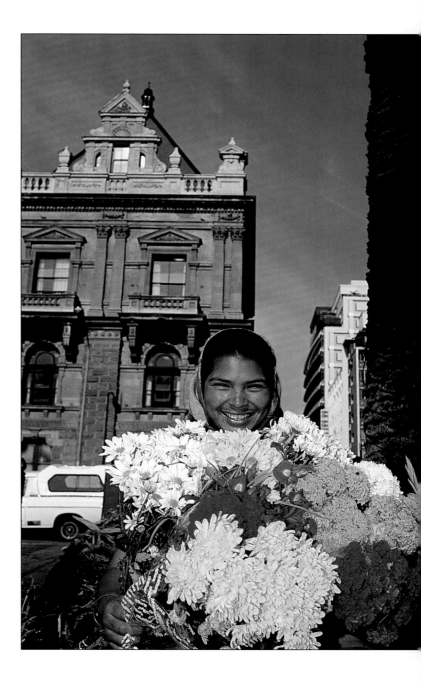

ABOVE *Cape Town's early-morning streets are fragrant with fresh flowers. The markets have burgeoned to every street corner, every suburb. Many shoppers have their favourite 'flower lady' and a little bargaining is allowed.*

LEFT *Malay women will as often sell you fresh fish as give you a recipe or their own special blend of spices to accompany it.*

OVERLEAF *Much noisy rivalry accompanies the annual Coon Carnival in Cape Town, when competing troupes dress up, sing, dance and parade through the city centre. The carnival is synonymous with summer in the city.*

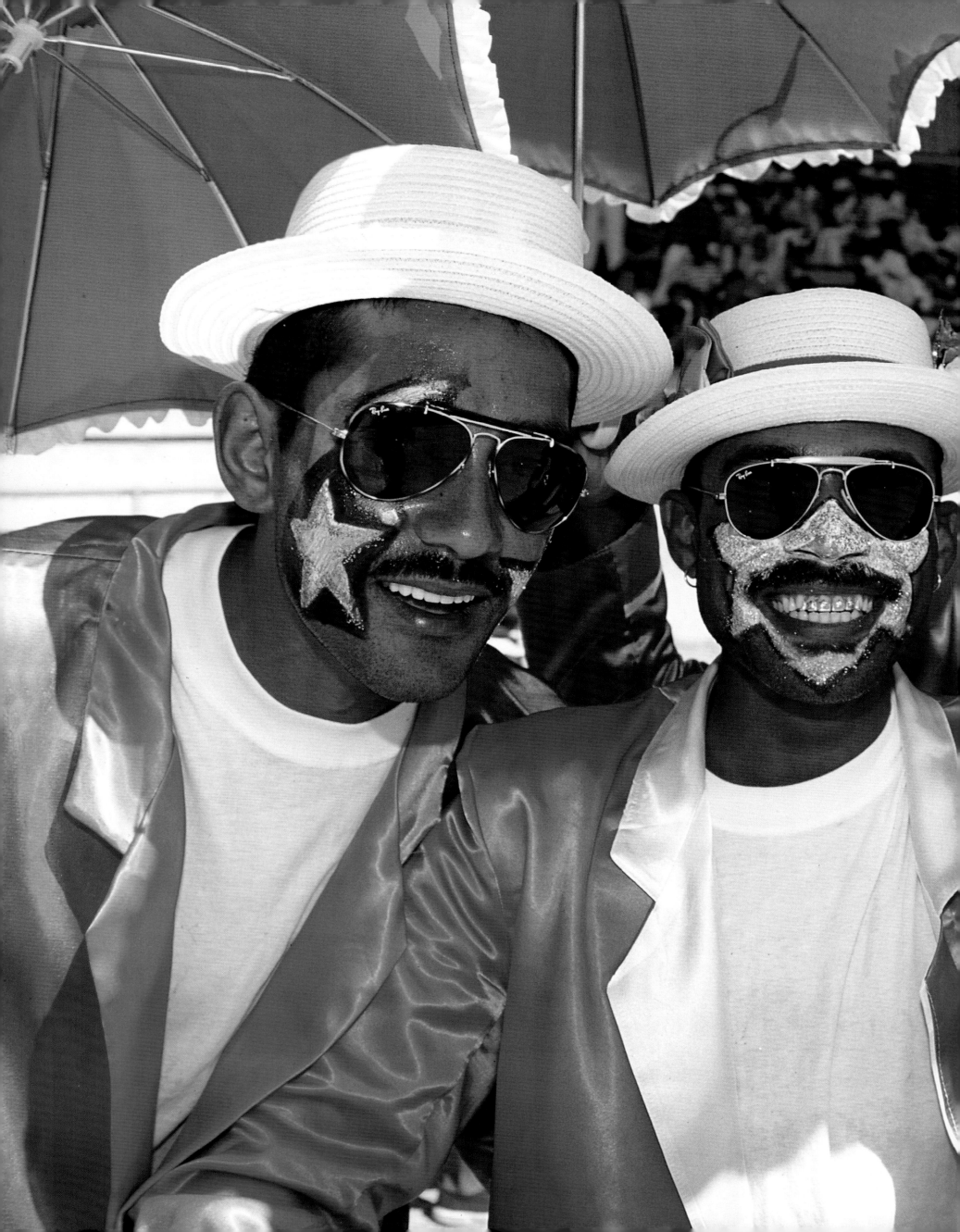

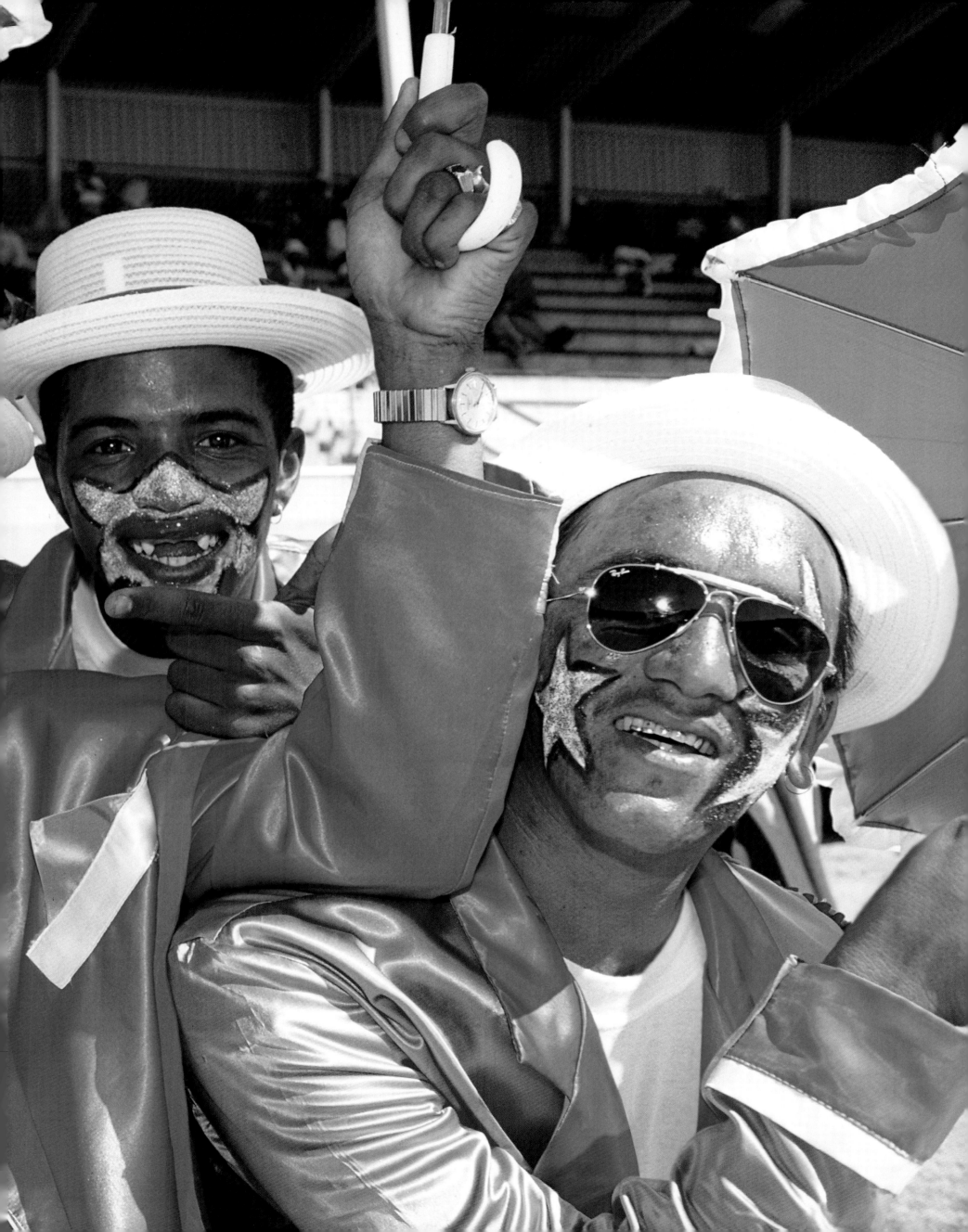

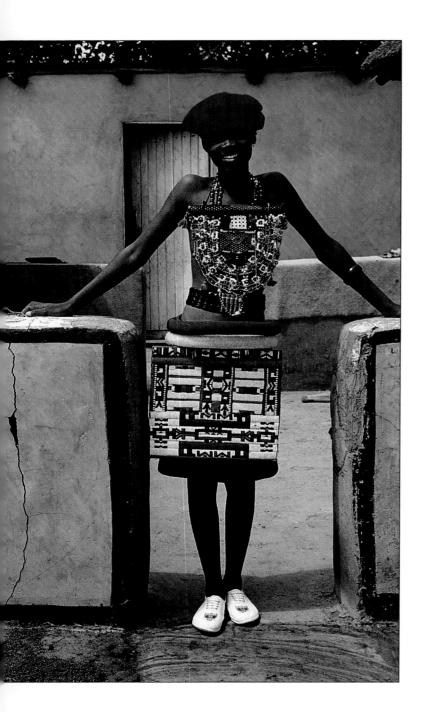

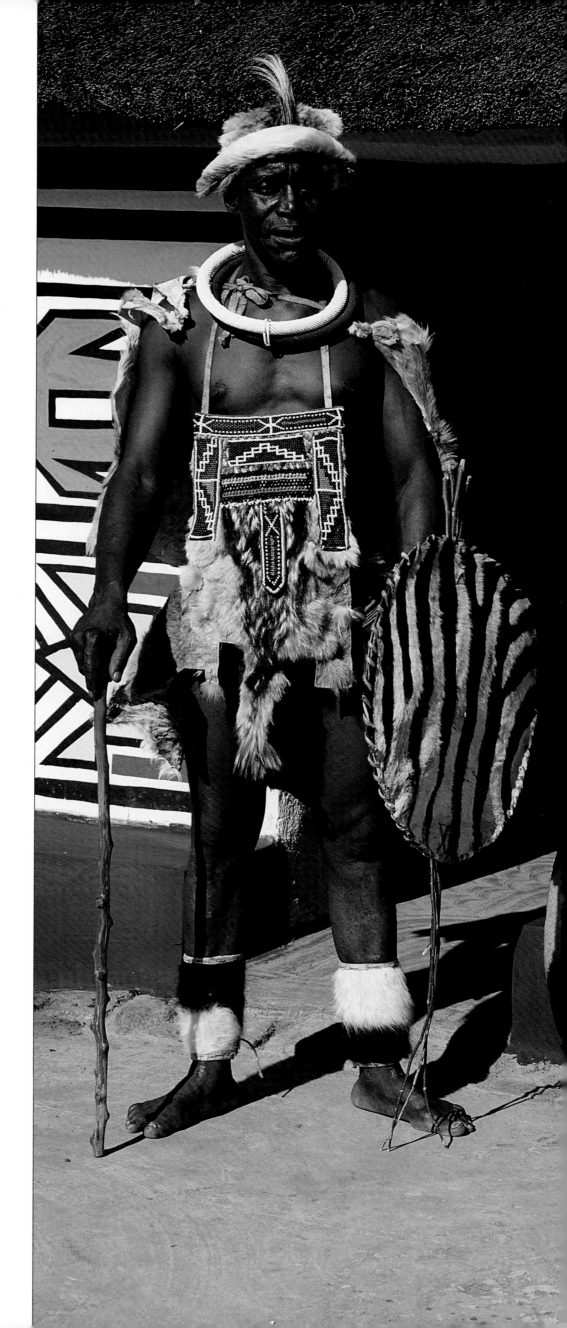

ABOVE *Ndebele girls go into seclusion for three months at puberty, when they are taught the duties of adult women, including the techniques of mural art. After the initiation period they must wear the ornate beaded apron, bib and other ornamentation known as* isiphephetu.

RIGHT *Ndebele murals originally used only natural pigments, but have burst into a rainbow of colour since the advent of shops and commercial paints. Stones and sand, ochre, river mud and charcoal were commonly used for colouring, while plants, feathers and fingers traced the lines.*

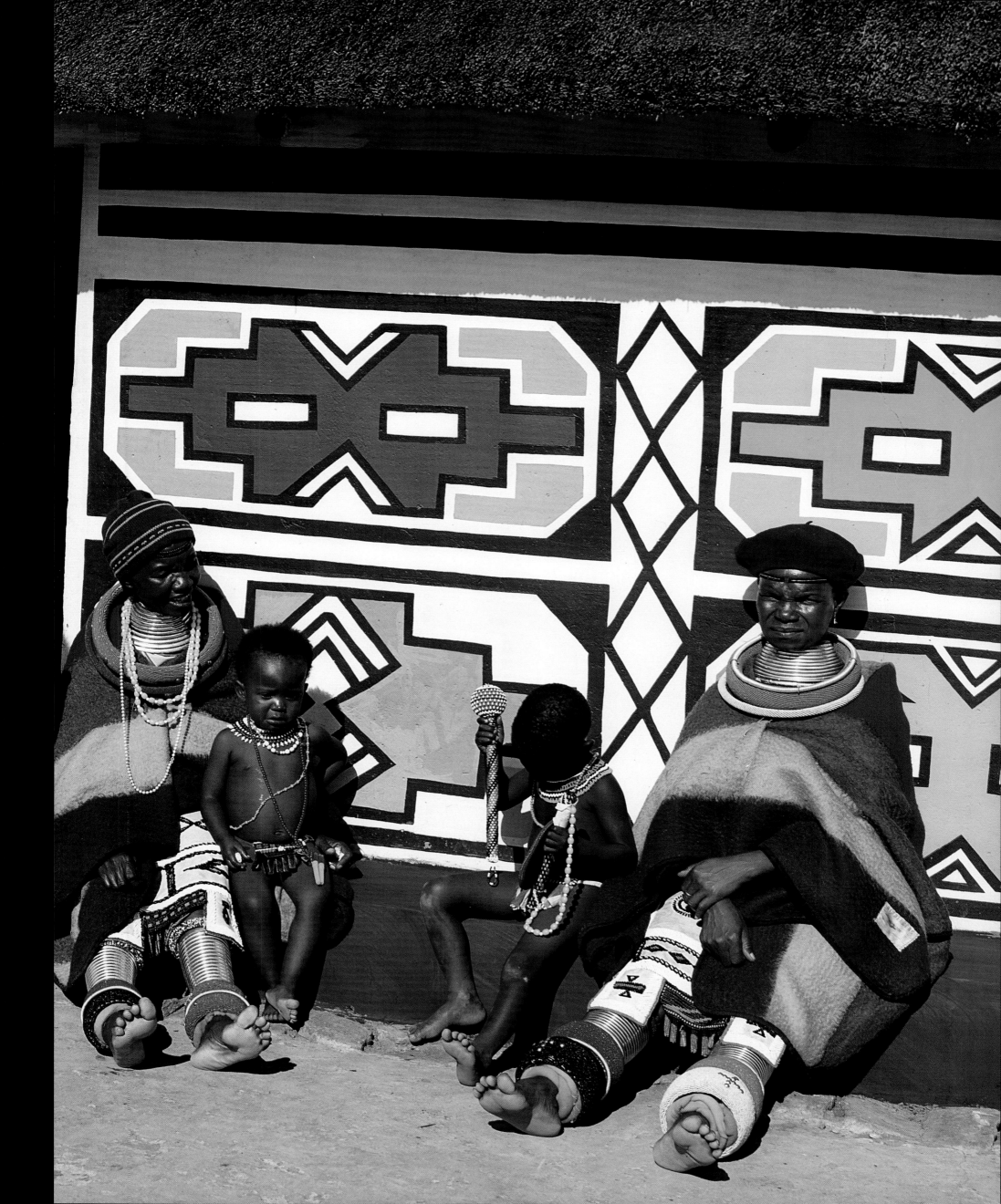

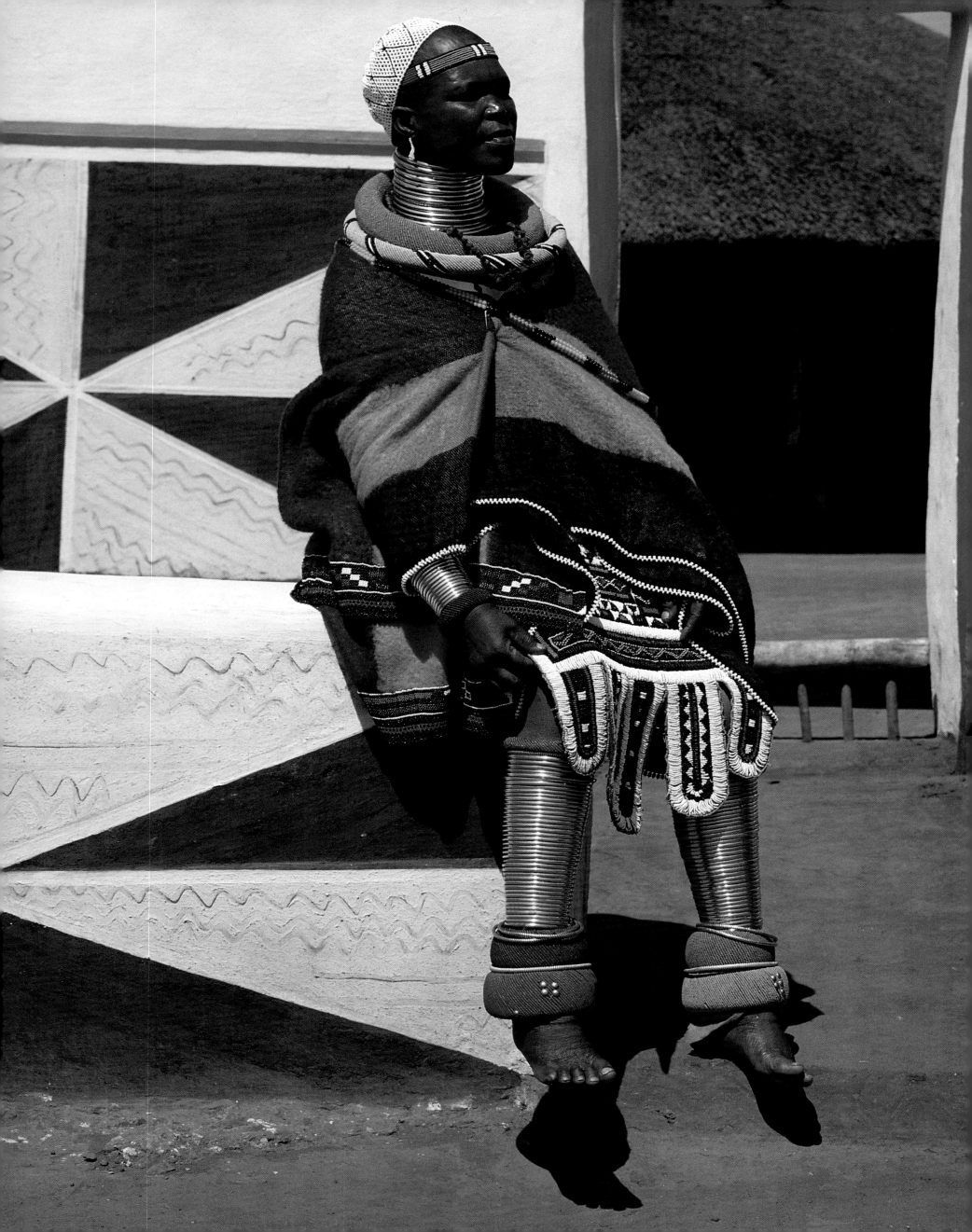

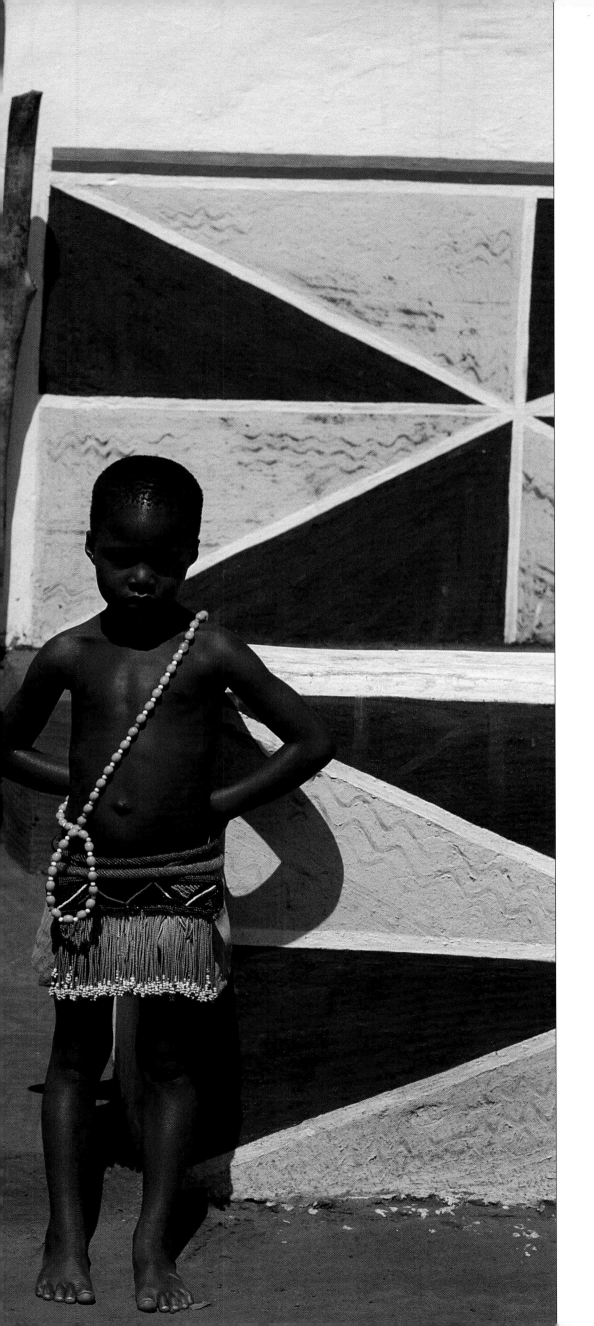

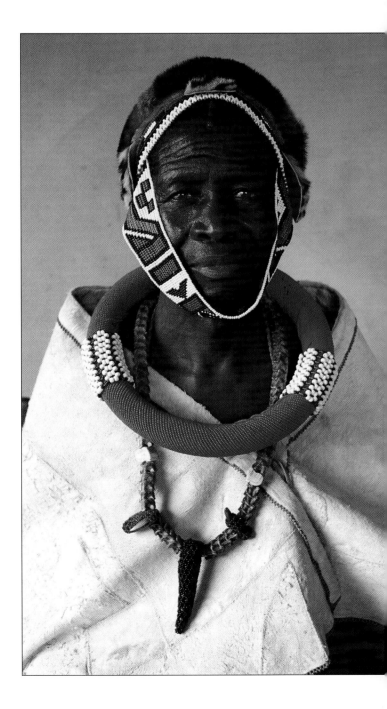

THE NAME
OF THE GAME

The world's richest concentration of wildlife species is found along the eastern boundaries of Mpumalanga and the Northern Province of South Africa, occupying two million hectares of lowland wilderness reserved for the pleasure of man and preservation of beast. Owing to the wealth and variety of its ecosystems, the Kruger National Park is able to provide habitats for a huge diversity of species and it fully deserves its status as one of the great game parks of Africa. Distributed across sweet grasslands or mopane plains, in tropical forest or specialised riverine communities, are 147 kinds of mammal including the legendary Big Five, more than 500 species of birds, a myriad butterflies, fish, reptiles and other creatures great and small. Although the Kruger is one of the ten biggest wildlife reserves in the world, South Africa's wildlife is by no means confined here; the country has an ample distribution of parks and reserves, which give a glimpse into other wildlife worlds. Some have been set aside for birds, penguins or marine life; others preserve single species such as elephant, mountain zebra and bontebok. Several are 'resource' reserves, breeding endangered animals for restocking other wildlife parks. Others still, take a non-invasive approach to conservation: these are 'contractual' parks where wildlife management goes hand-in-hand with the needs of the inhabitants, who in turn benefit from tourism revenue. In total, one-twentieth of the area of the country is proclaimed for conservation.

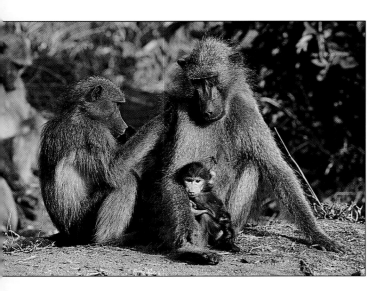

ABOVE *A chacma baboon* (Papio ursinus) *mother with infant is groomed by another member of the troop. Grooming is vital social behaviour among primates.*

RIGHT *The lanky cheetah* (Acinonyx jubatus) *is swifter than the leopard and can keep up short bursts of speed of 110 kilometres an hour.*

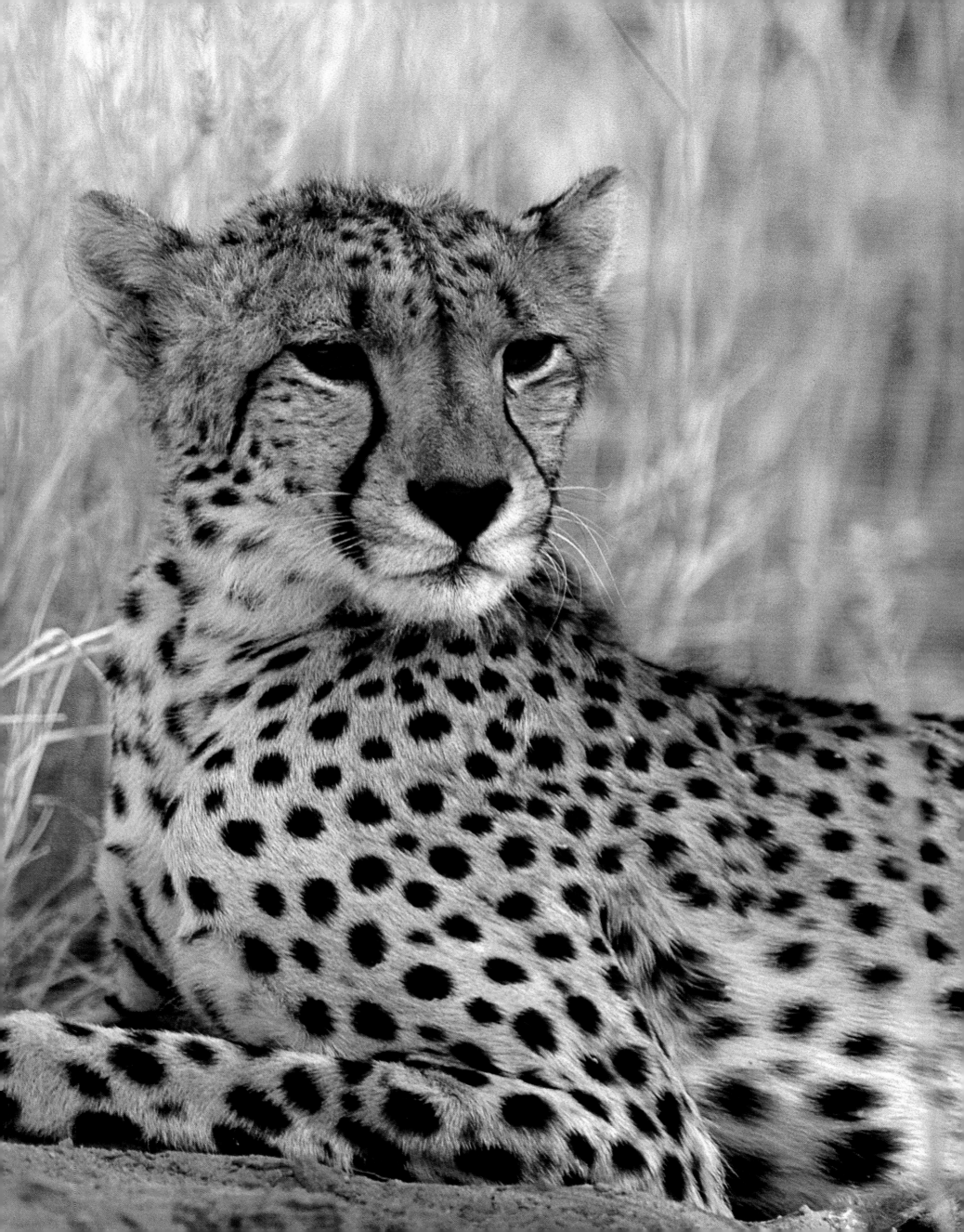

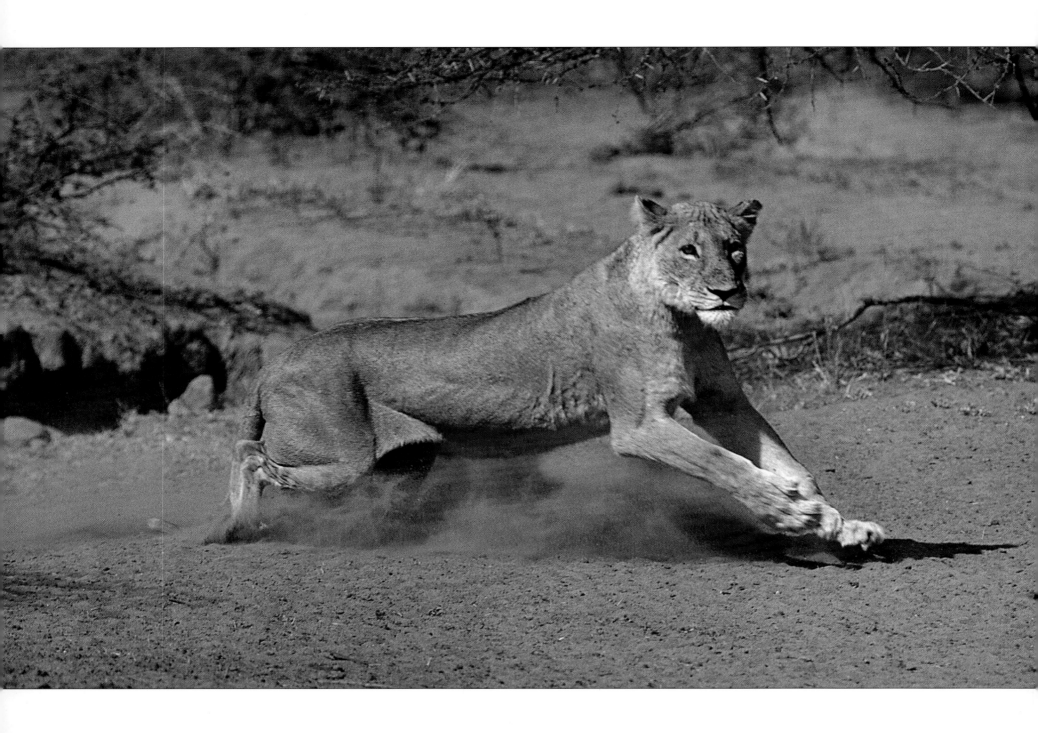

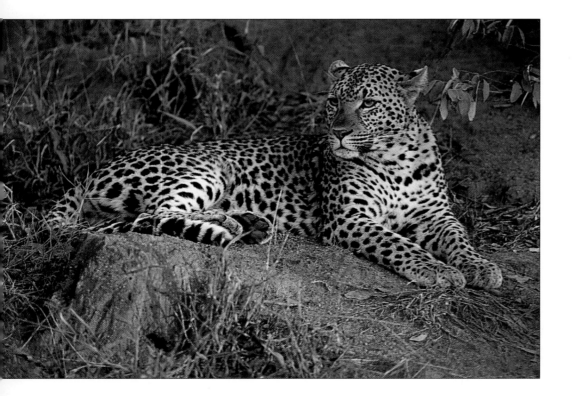

ABOVE *In the lion* (Panthera leo) *family, it is the females that play the prominent role in the kill. There are about 1 500 lion in the Kruger Park.*

LEFT *The leopard* (Panthera pardus) *is a common inhabitant of almost all the country's game parks. A solitary leopard will sometimes roam vast territories in mountain regions quite close to urban environments, occasionally taking domestic animals.*

OPPOSITE *Adult male lions spend most of the day dozing in the shade and are not very efficient hunters, losing four out of every five prey.*

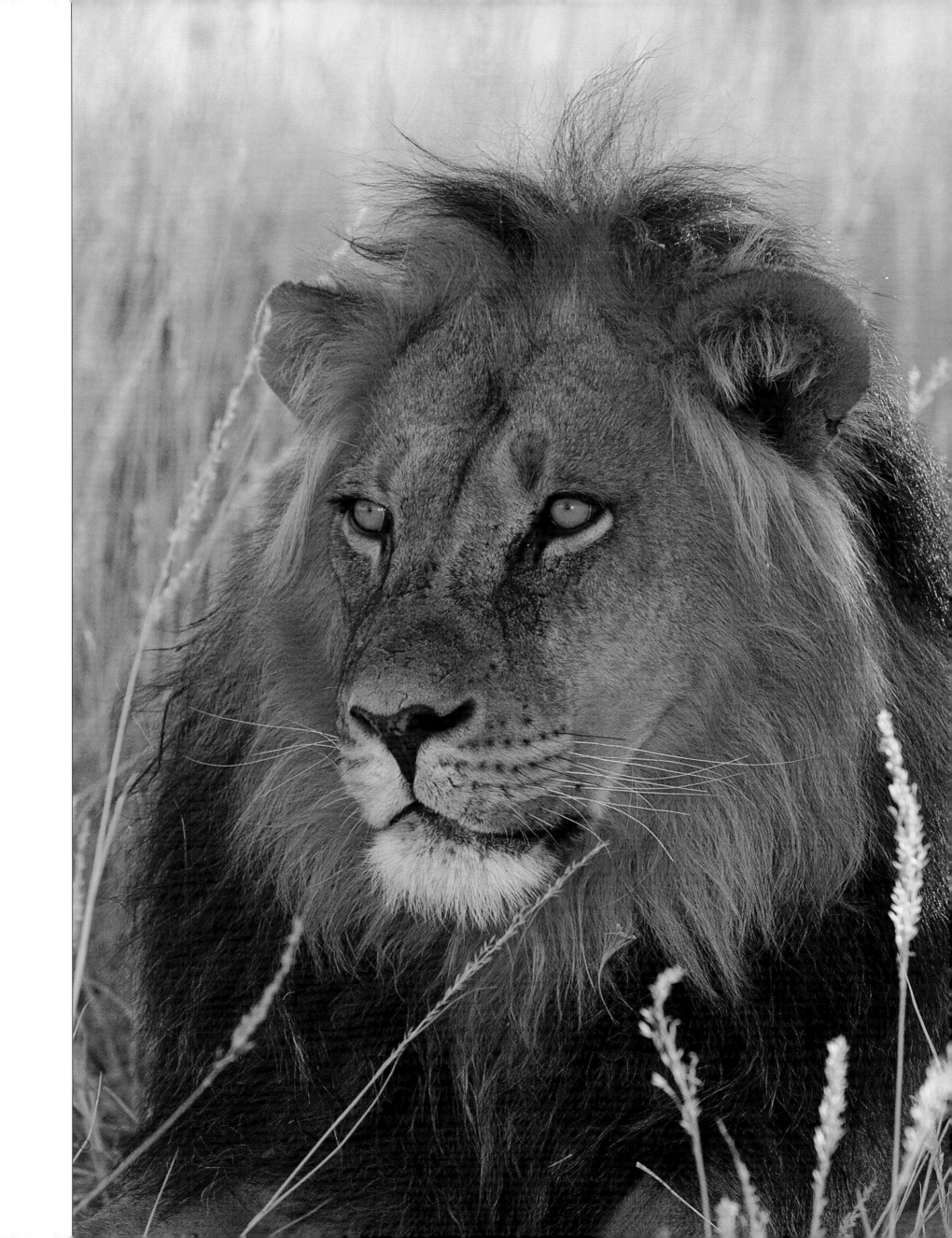

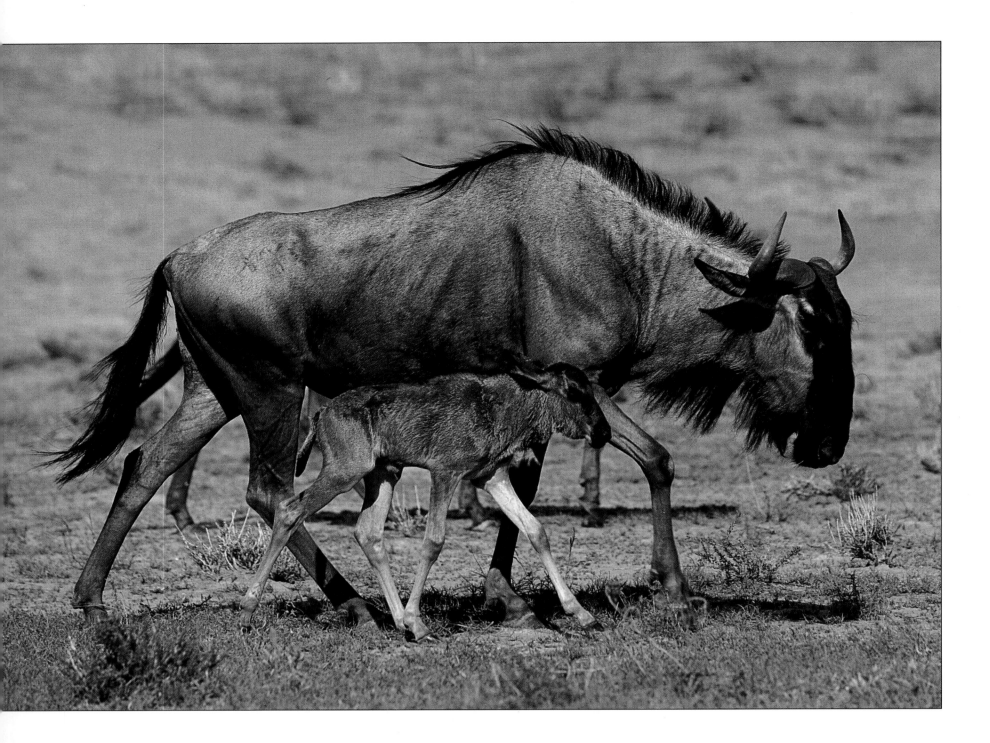

ABOVE *Occasionally derided for its ungainly appearance,*
the blue wildebeest (Chonnochaetes taurinus) *is a superb*
surviver probably due to its mobility. It is found in greatest
numbers in the Kalahari Gemsbok National Park. The calves
are particularly vulnerable to attack by hyaena.

OPPOSITE *Black rhino* (Diceros bicornis) *are among the most*
endangered species in Africa, due to unremitting poaching.
About 400 individuals are in safekeeping at Umfolozi-
Hluhluwe, KwaZulu-Natal, and some have been introduced to
the Augrabies Falls National Park for a closed breeding
programme. The black rhino is smaller but more aggressive
than the white (Ceratotherium simum).

OVERLEAF *Zebra are hardy, prolific and widely distributed*
throughout southern Africa. Burchell's Zebra (Equus burchellii)
is the most common of the region's three species. Zebra are
chiefly grazers, but sometimes browse, never straying far from
a waterhole as they must drink daily.

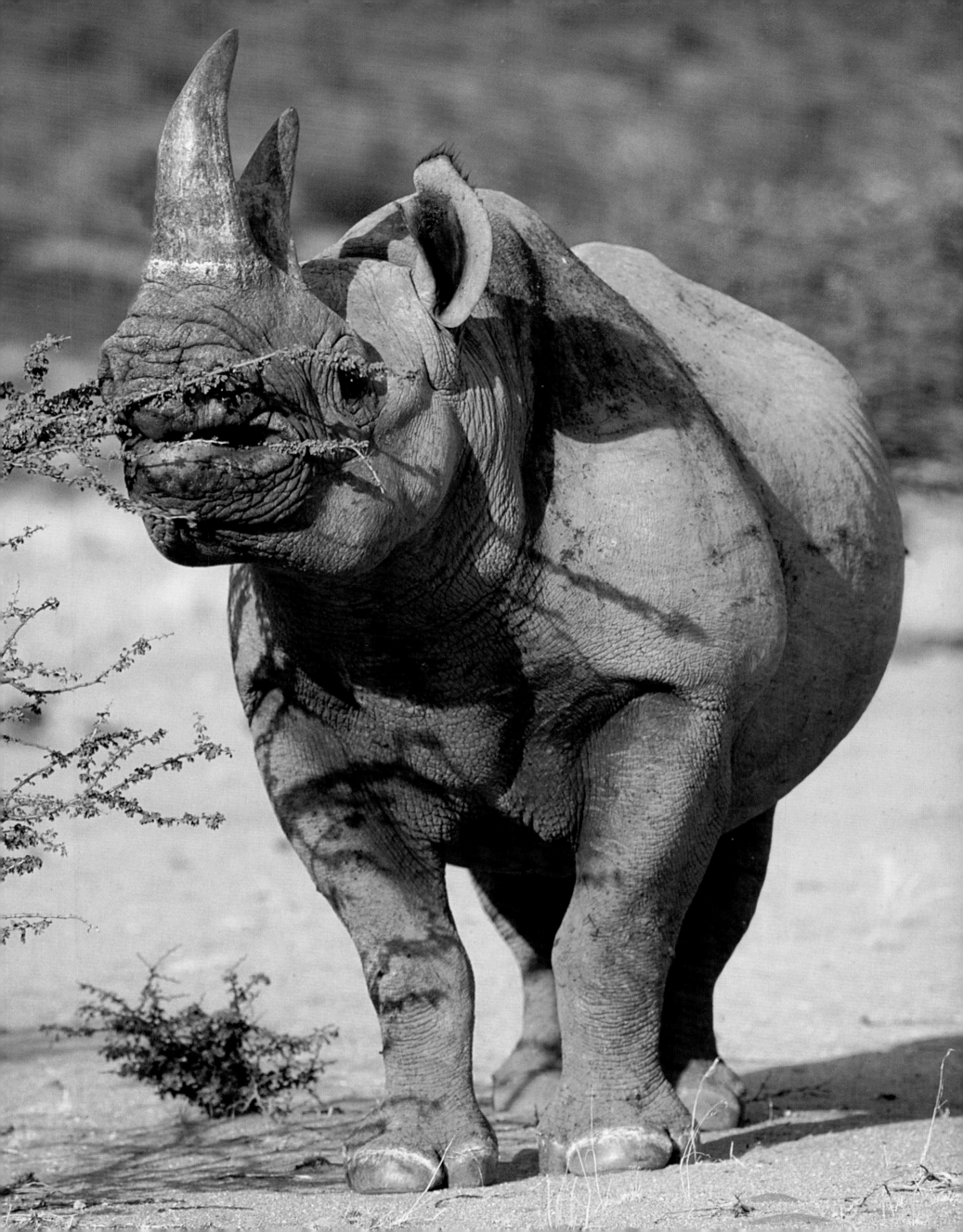

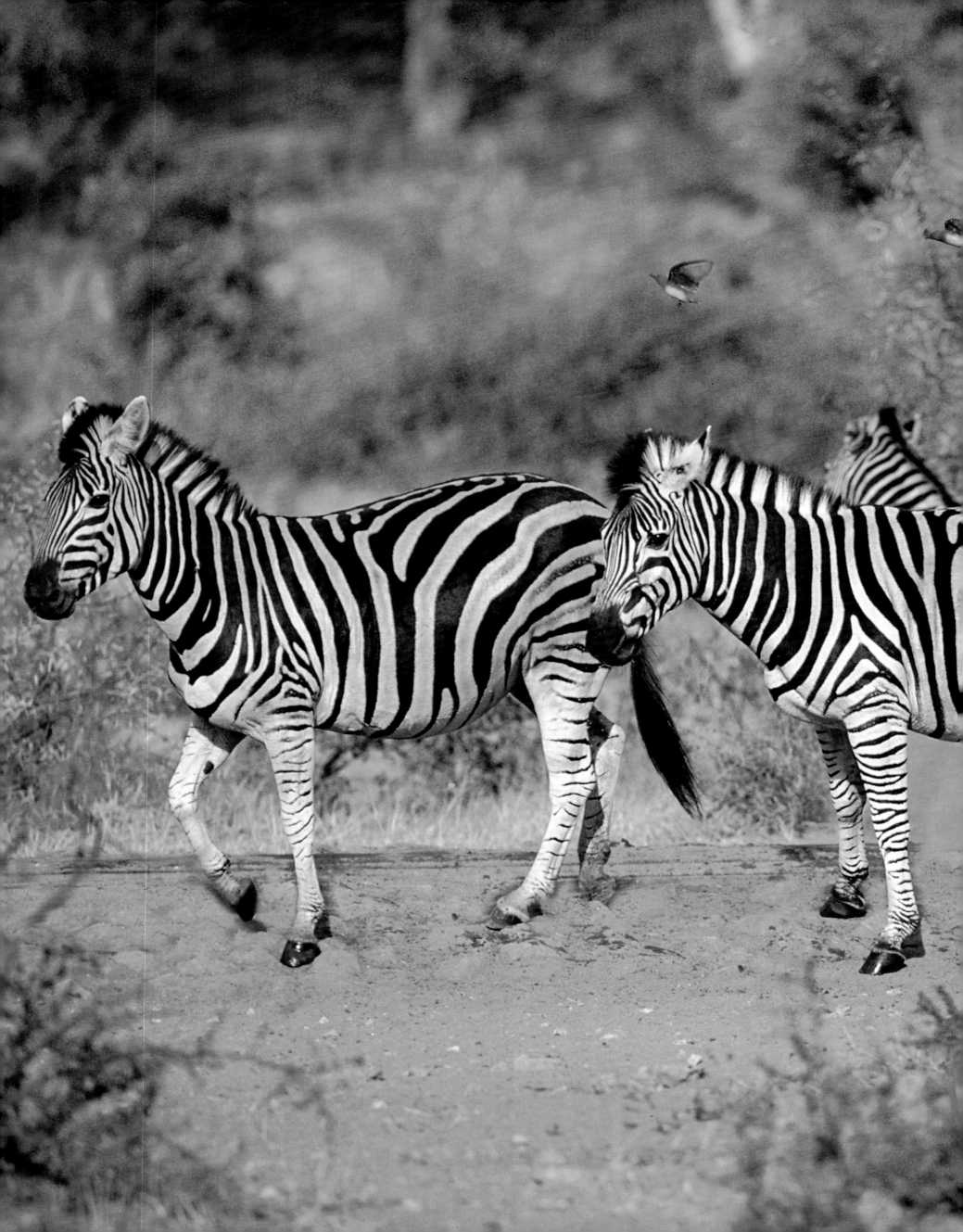

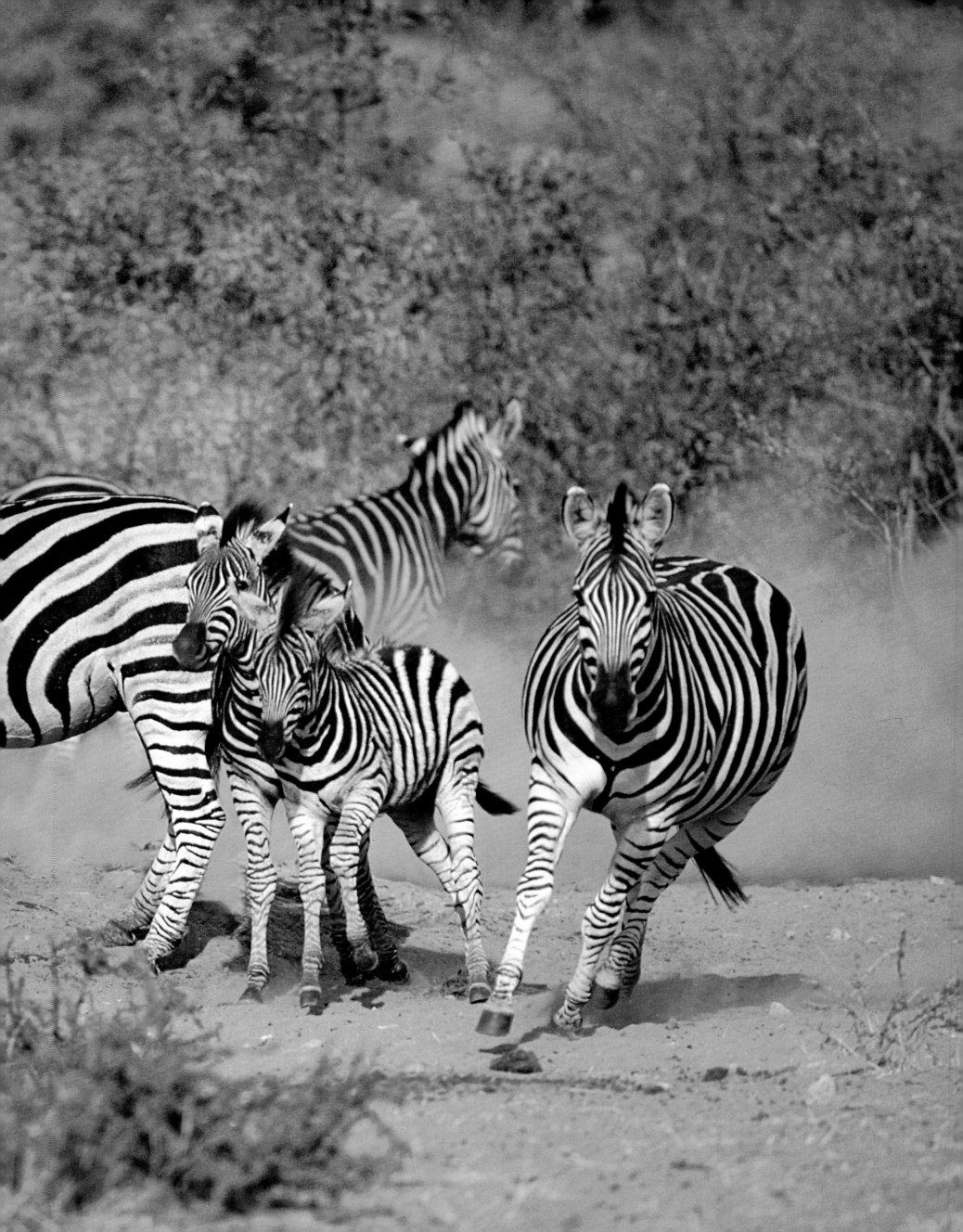

RIGHT *Towering 4,5 to 5,5 metres above the ground, giraffe are natural browsers, feeding mainly on the foliage of acacia trees and usually in the early morning and afternoon. Two species are found in South African game parks – the Masai giraffe* (Giraffa camelopardalis) *and the reticulated giraffe* (Giraffa reticulata). *The difference between the two species is in the markings.*

BELOW *Giraffe are always vulnerable to predators at waterholes, usually drinking in turns to keep a watch.*

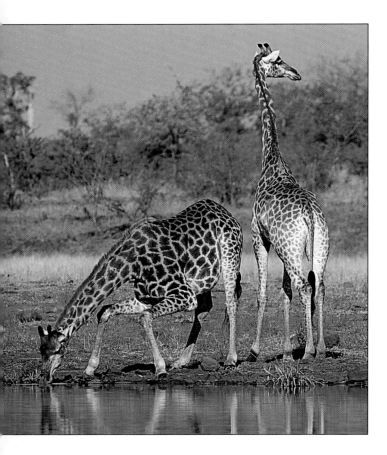

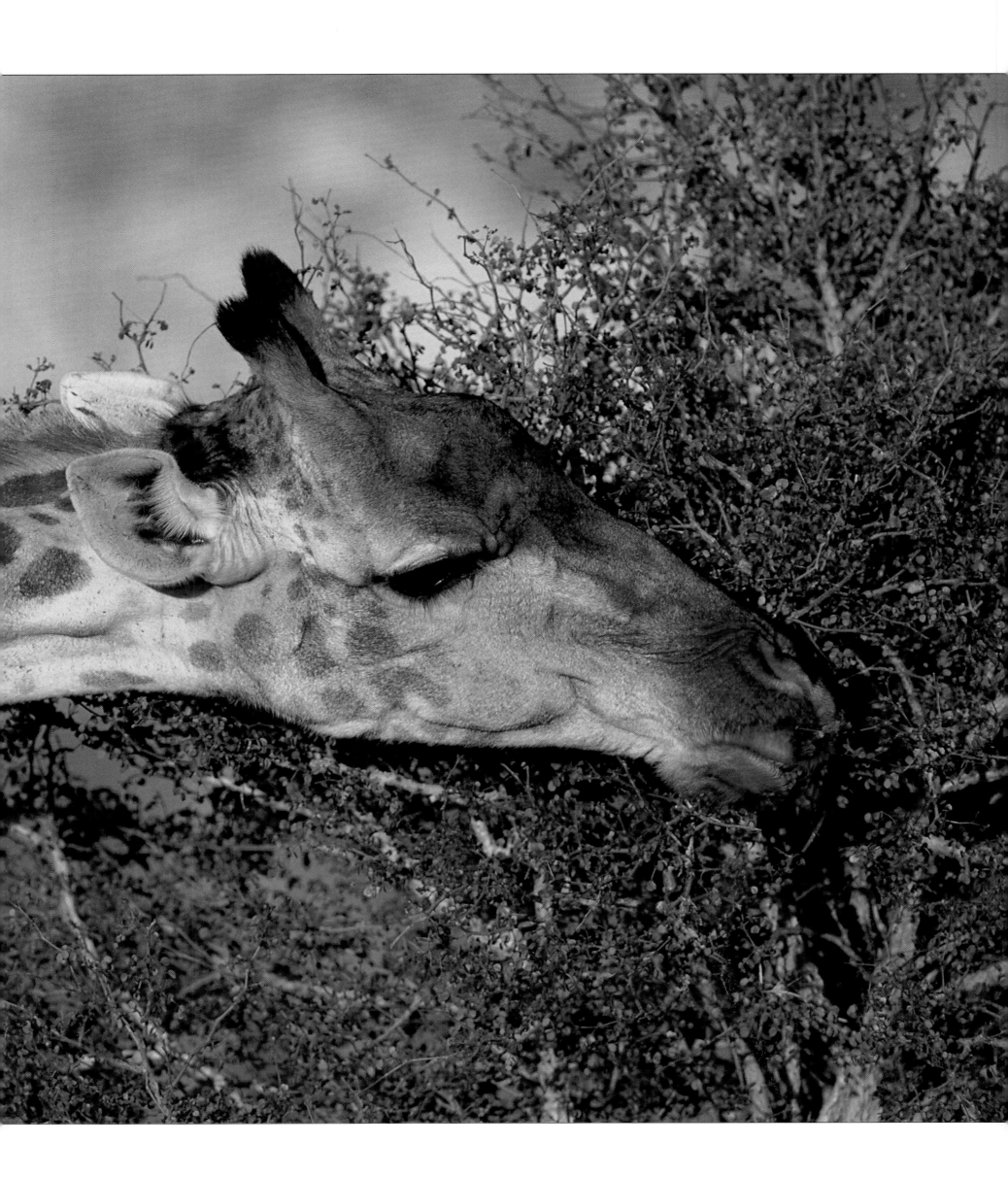

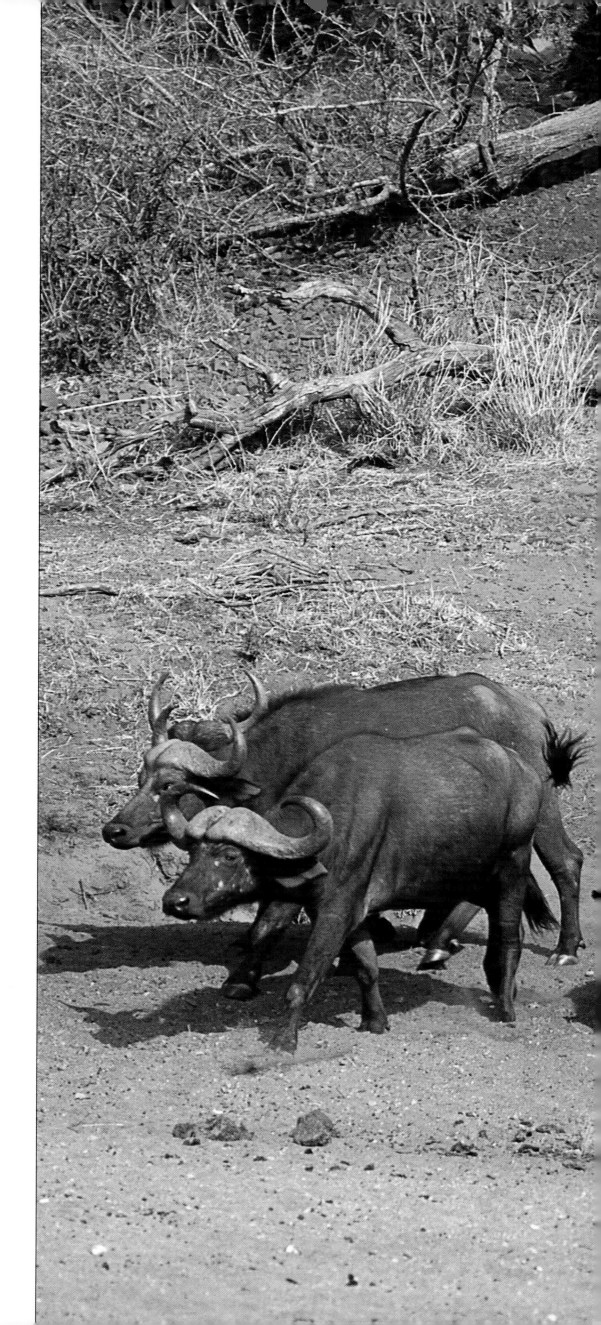

RIGHT *Cape buffalo* (Syncerus caffer) *rarely move more than 50 kilometres from home territory, preferring to remain near the waterholes. Although they do form large herds of up to 100 individuals, the herds separate and disperse when food and water are in good supply. Buffalo can be aggressive and mothers with calves particularly should be given a wide berth.*

OVERLEAF *The sound and smell of Africa: hot dust is raised by the thundering hooves of a large herd of eland* (Taurotragus oryx) *in the Pilanesberg National Park, near Sun City in North-West Province.*

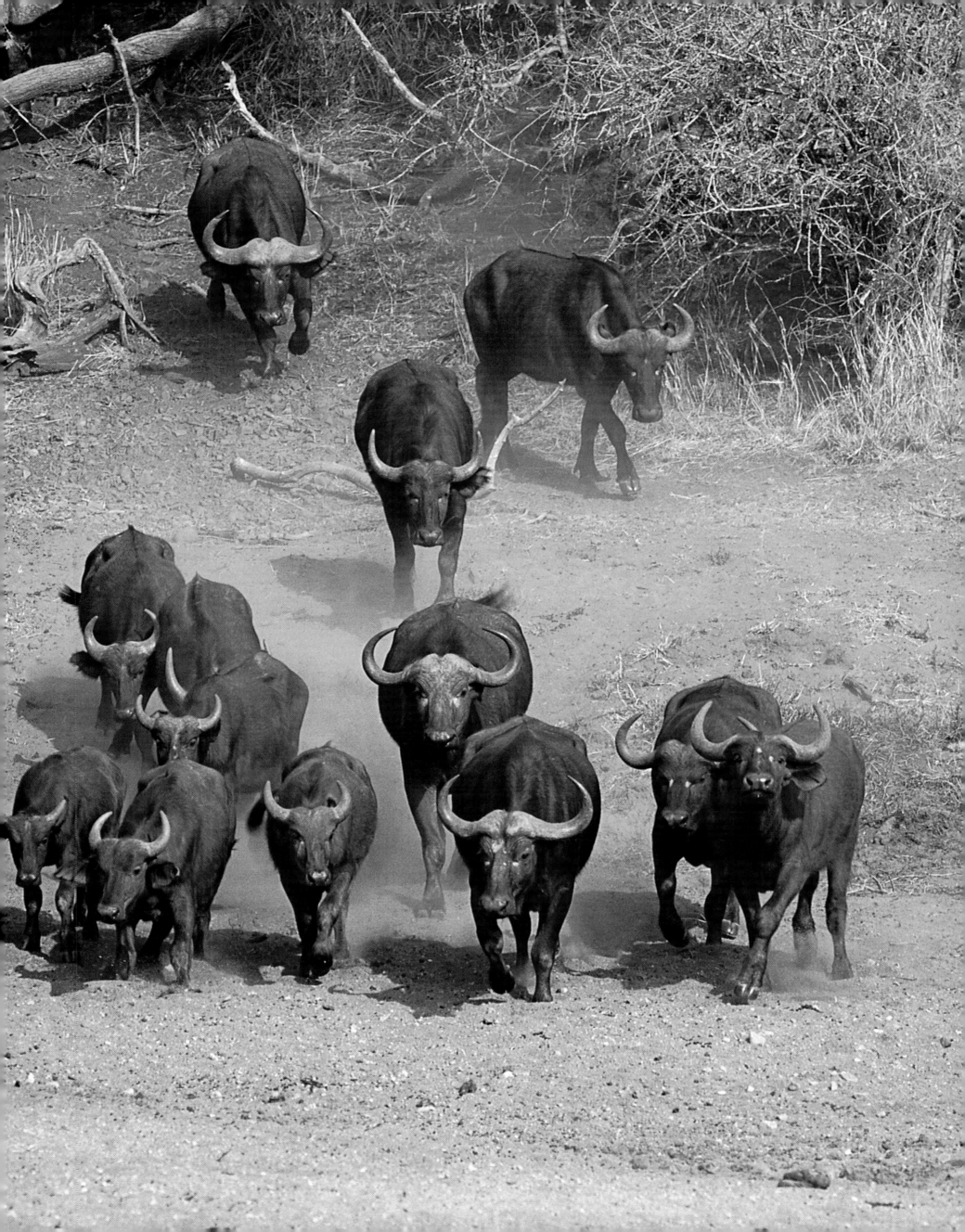

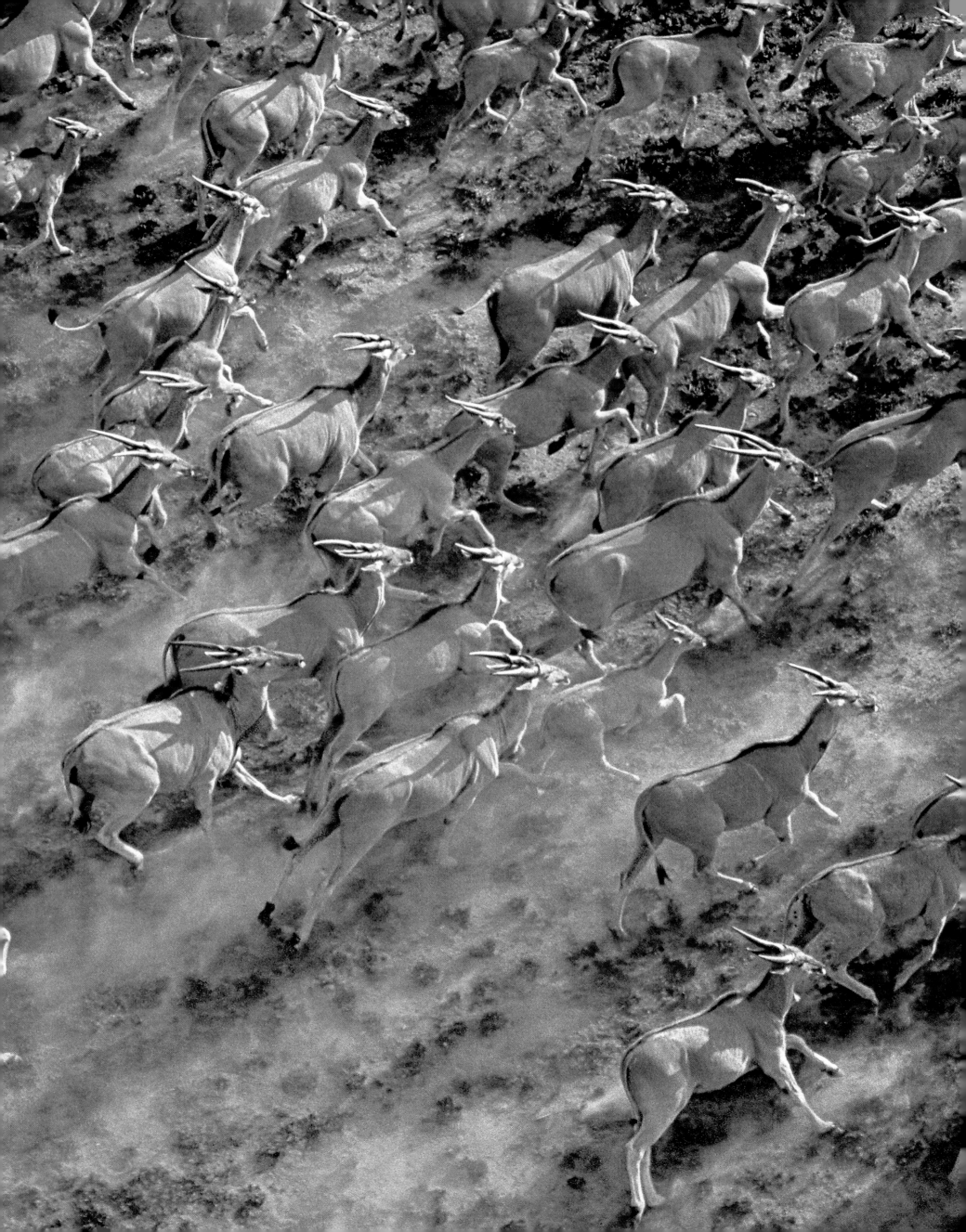

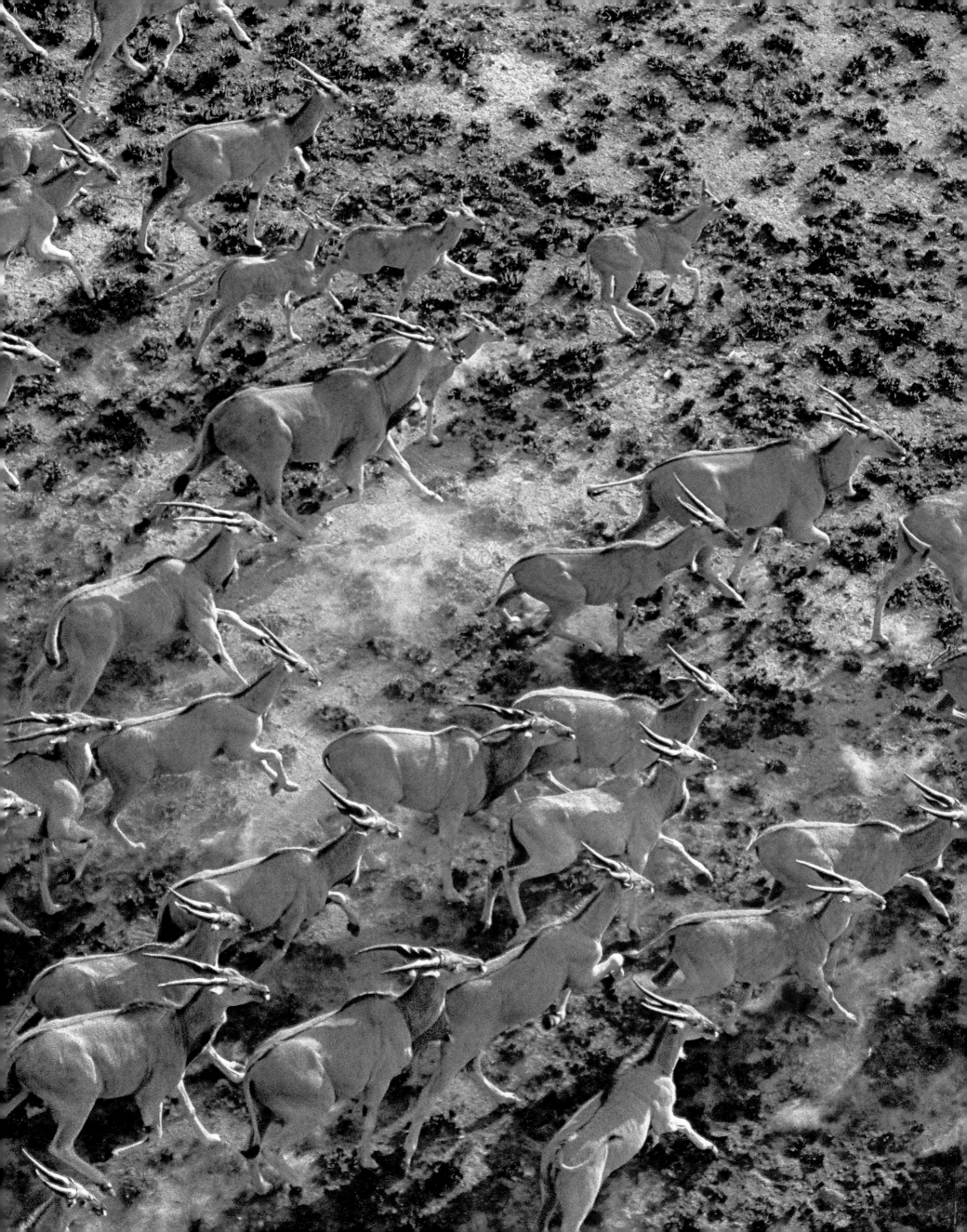

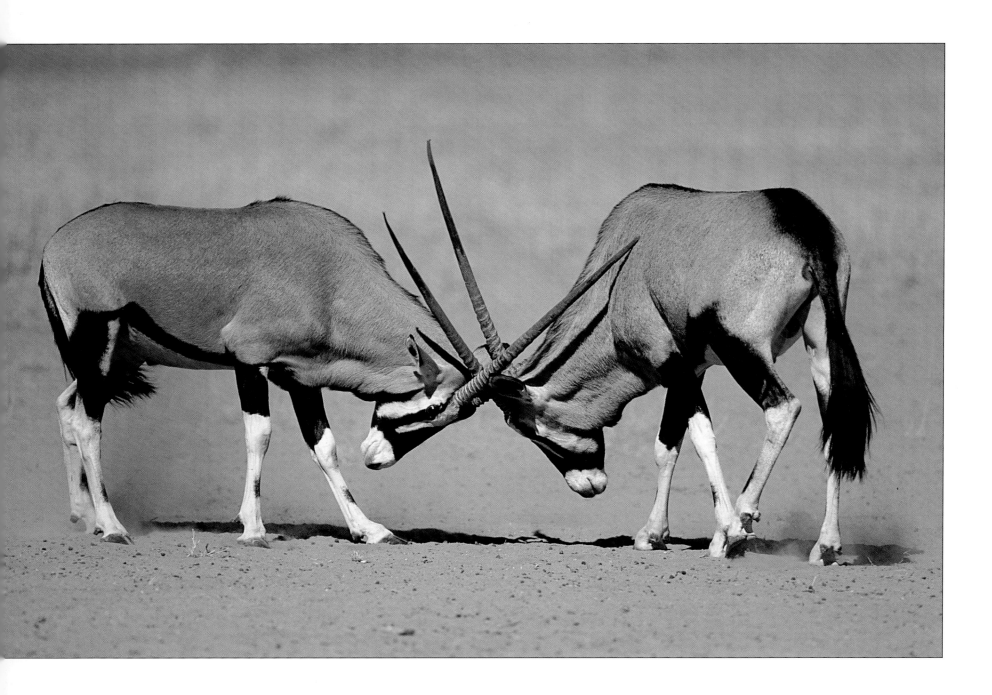

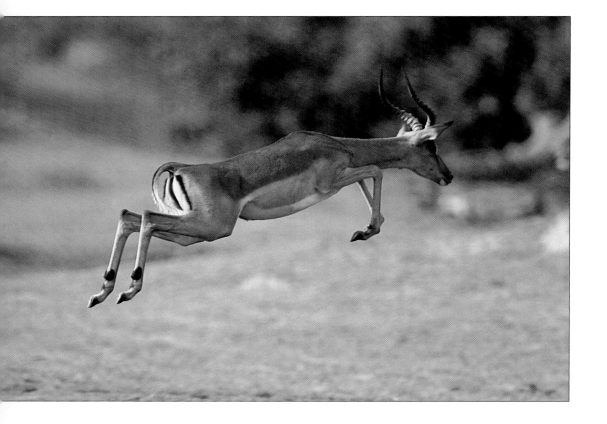

ABOVE *One of Africa's most strikingly beautiful animals is the gemsbok* (Oryx gazella) *which has bold body markings in fawn, black and white. The formidable horns occur on both male and female antelope, being used as powerful weapons on predators and opponents.*

LEFT *Spectacular leaps, up to 10 metres long and three metres high, signal alarm from the impala* (Aepyceros melampus). *The black-faced impala is relatively rare, while its plainer cousin is found in great numbers especially in the Kruger Park.*

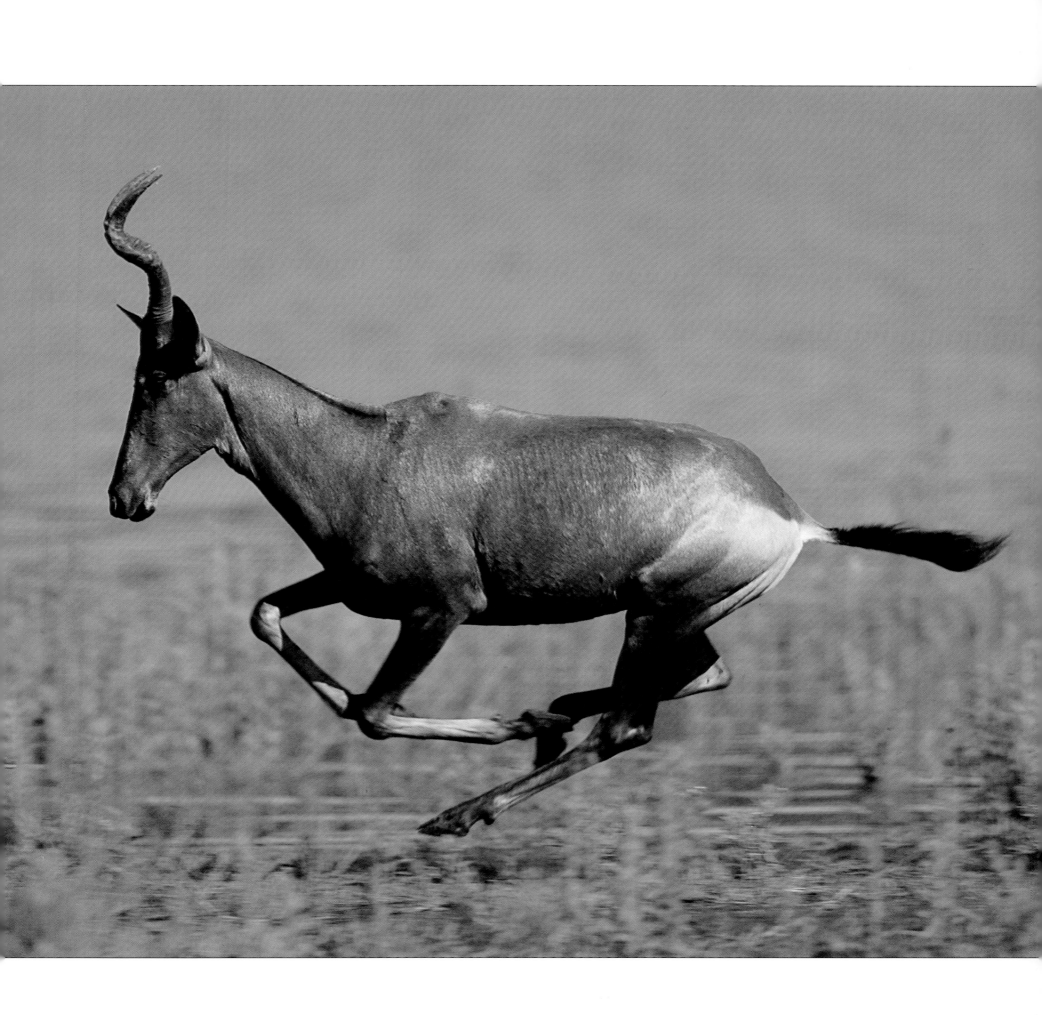

A red hartebeest (Alcelaphus buselaphus) *at full tilt in a KwaZulu-Natal game park. The hartebeest is prey for the big cats, wild dog and hyaena. Heavily ridged horns occur on both male and female, growing from the top of a long, narrow head which gives the animal a slightly quizzical expression.*

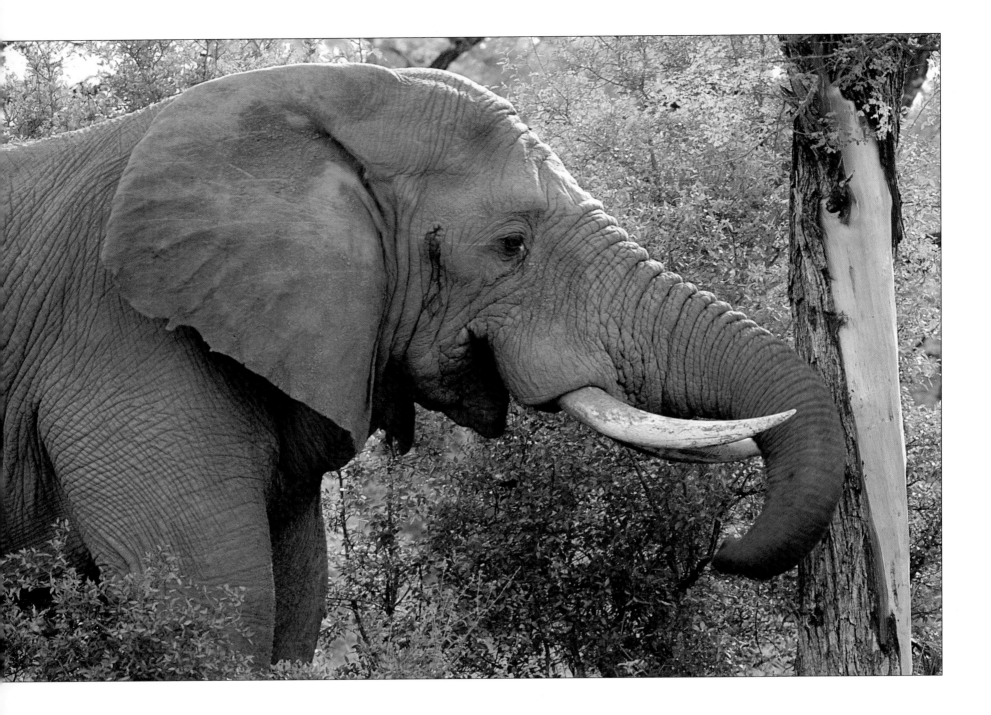

Africa's gentle land mammoth, the elephant (Loxodonta africana), *is damned for its destructive feeding habits, culled to keep numbers down, and mutilated for the ivory from its tusks. Research at the Kruger National Park is focused on elephant birth control which may, in time, remove some of the conflicts in the land versus animal conservation issue. Elephants may live to about 70 years old and have no enemies other than man.*

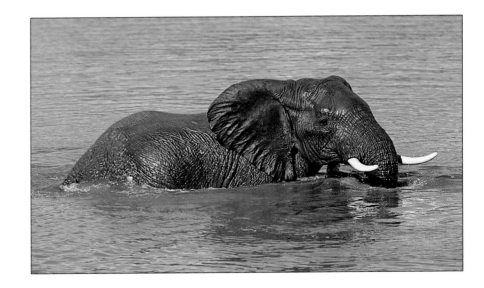

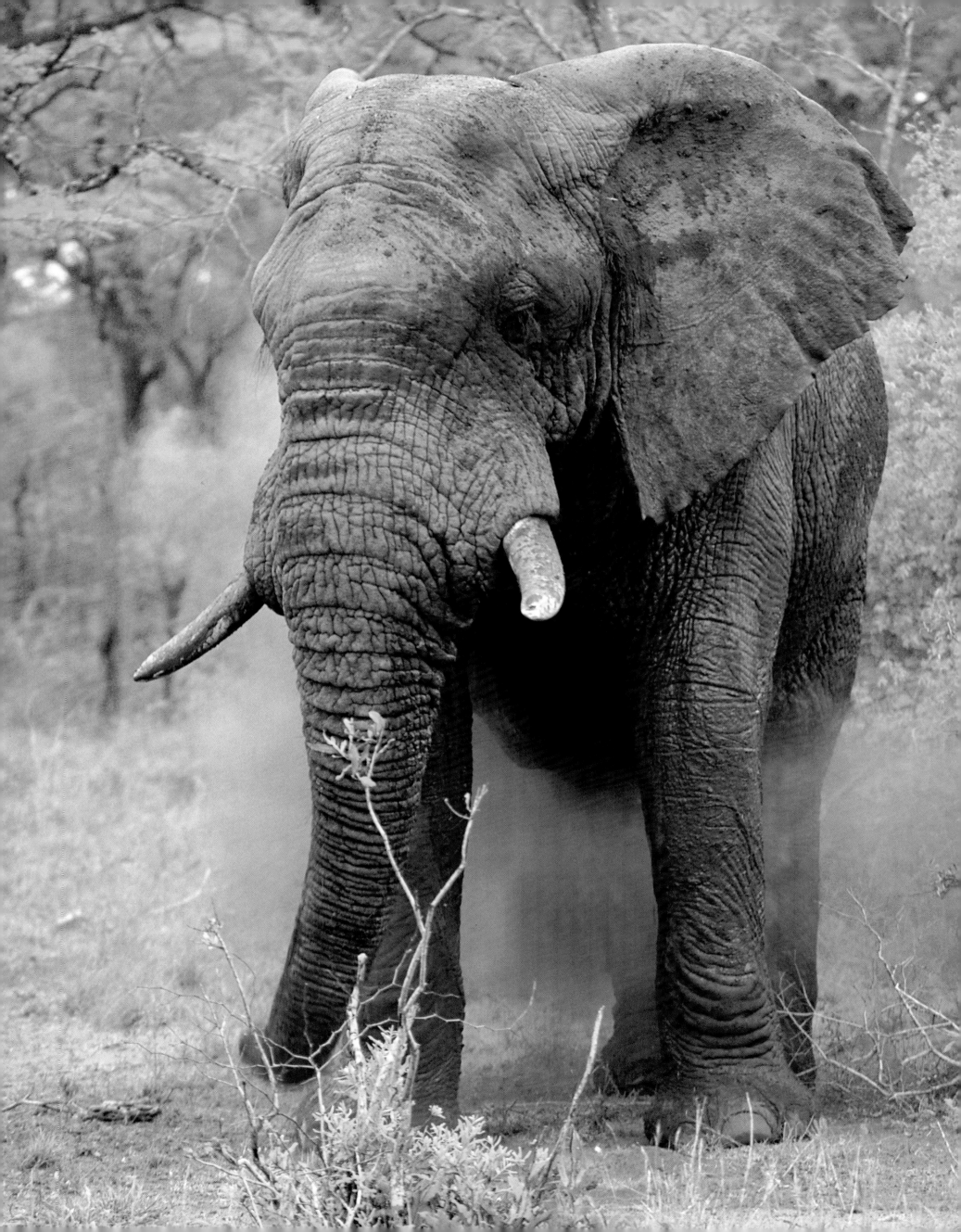

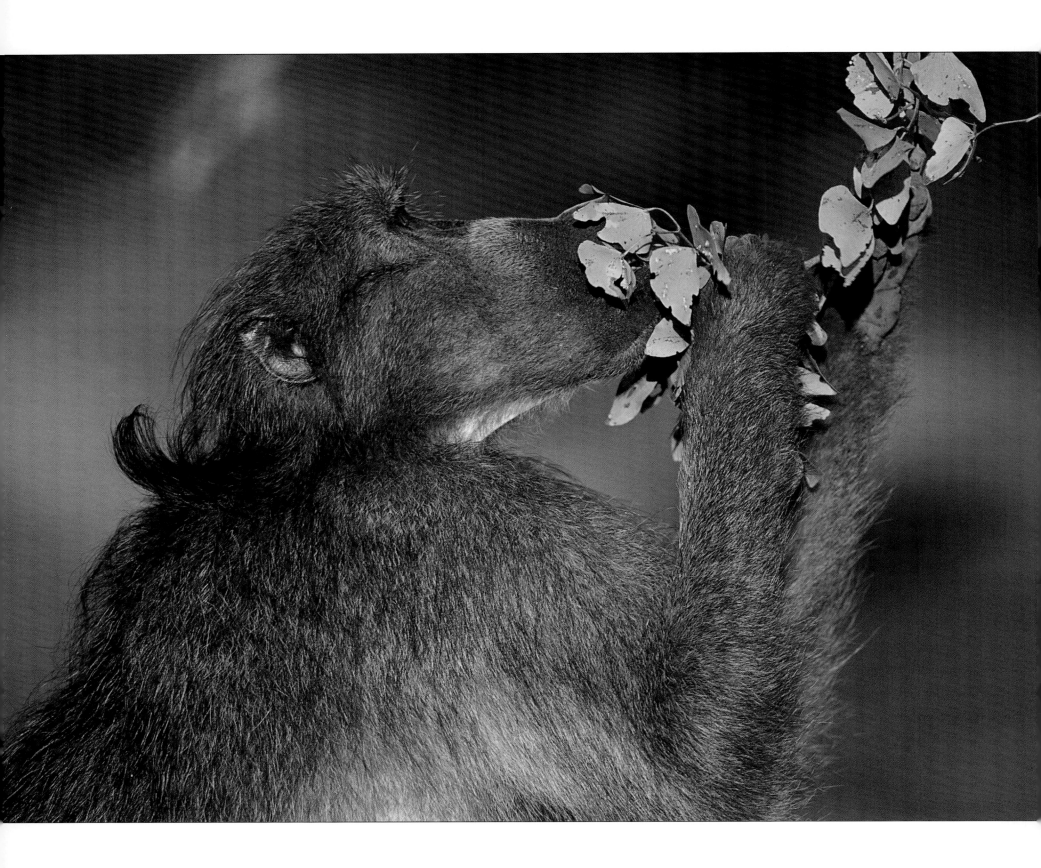

ABOVE *Chacma baboons are omniverous, although the major part of their diet is made up of fruit, roots, leaves and bulbs. They also eat scorpions and other insects and will feed on small vertebrates from time to time. The troops of the Cape of Good Hope Nature Reserve have adapted their feeding patterns to include molluscs and organisms foraged from the intertidal zone on the shores of the reserve.*

OPPOSITE *The yellow mongoose* (Cynictis penicillata) *has an endearing habit of standing upright. This behaviour, however, is simply a means of gaining a better view for purposes of defence or hunting small rodents and snakes, which it attacks in a blur of speed.*

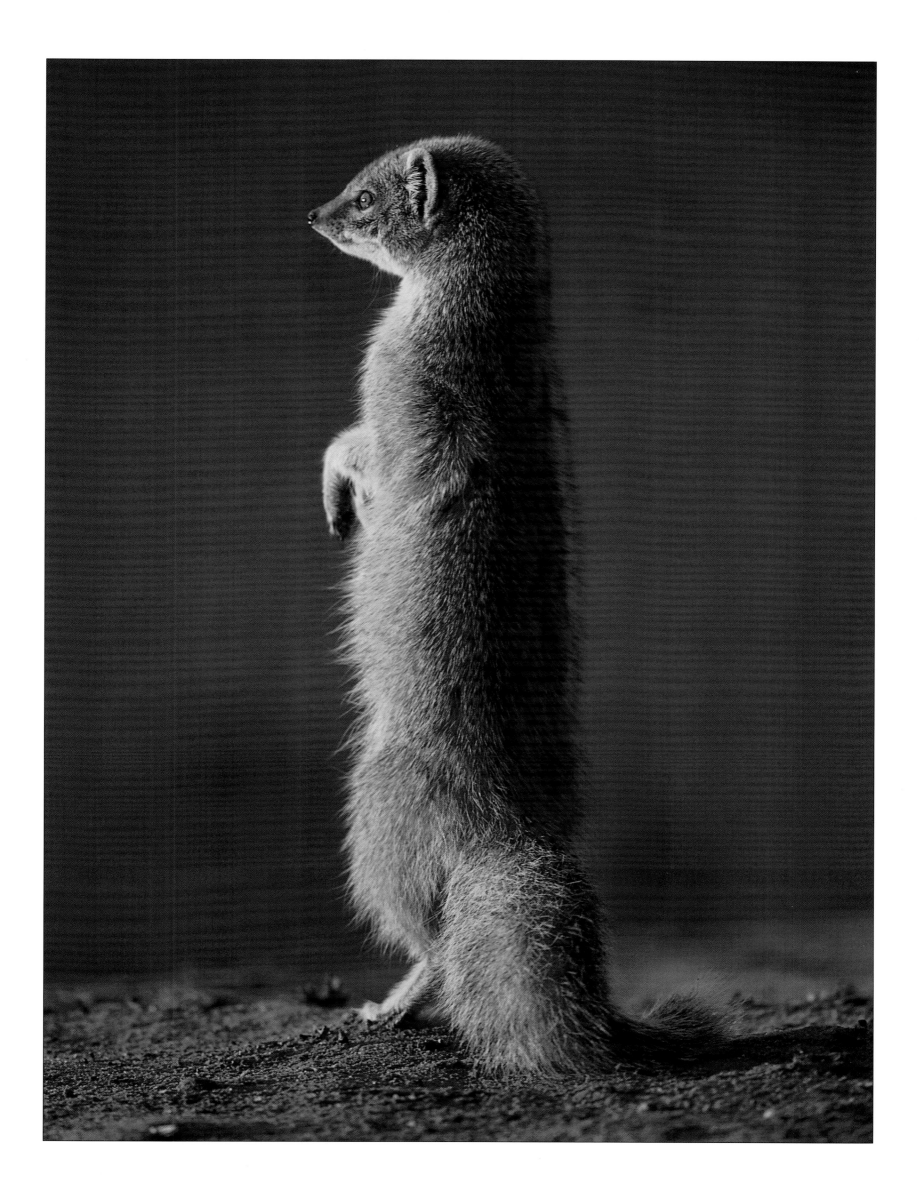

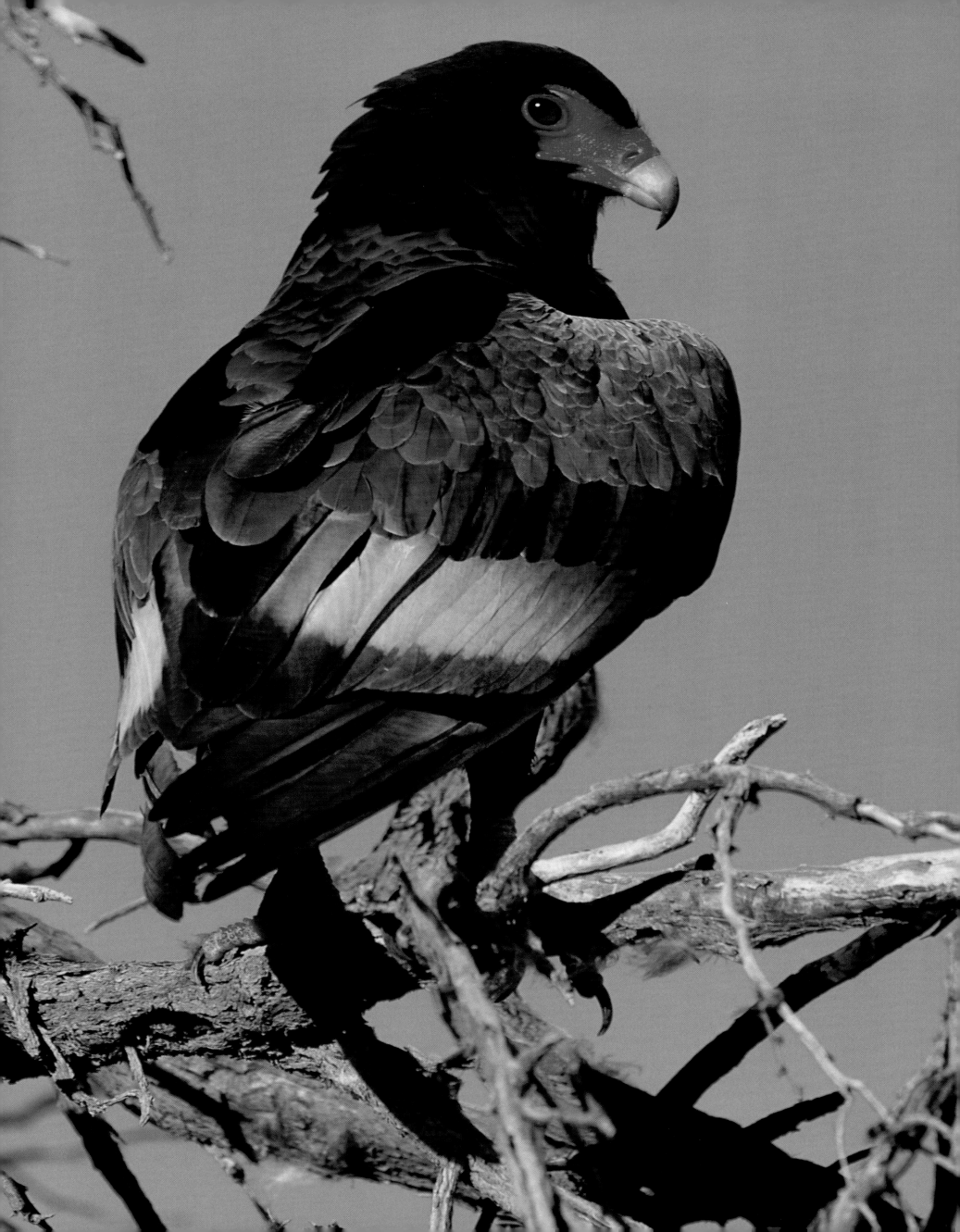

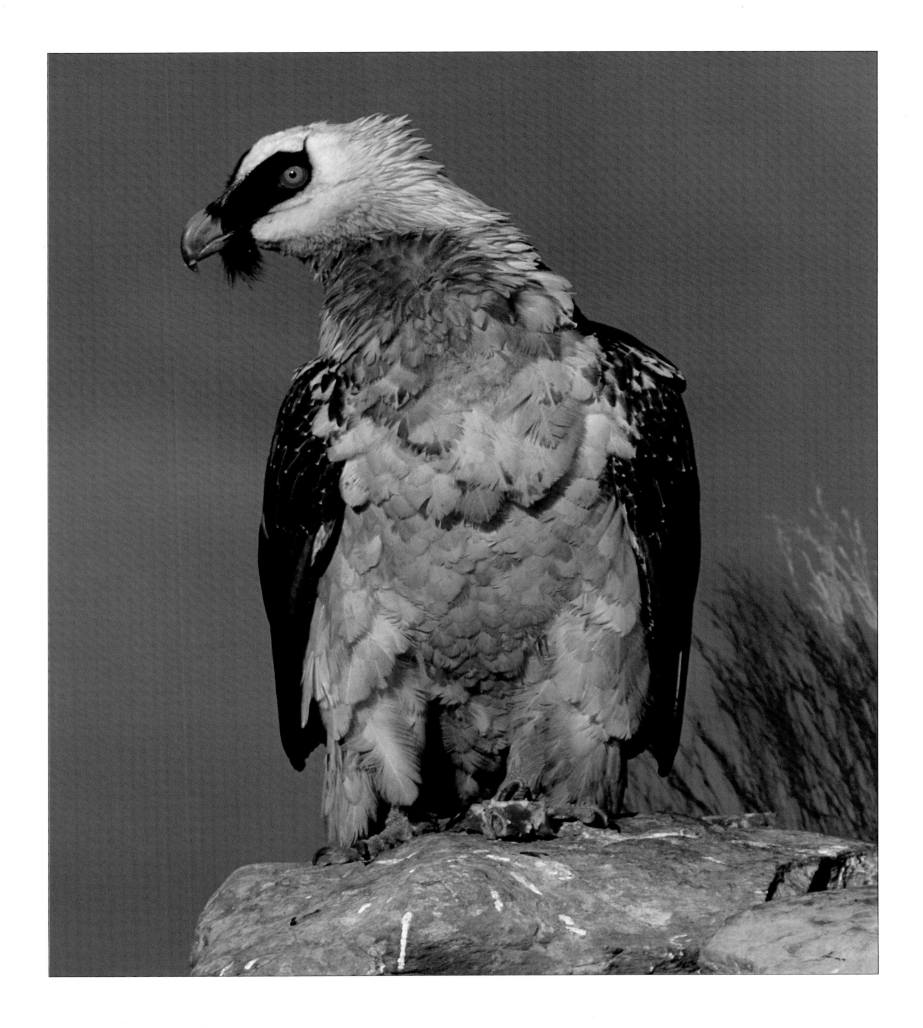

OPPOSITE *The Bateleur eagle* (Terathopius ecaudatus) *was named by the French explorer and naturalist Francois le Vaillant for its in-flight antics which include rocking on angled wings.*

ABOVE *Majestic in repose or on the wing, the rare lammergeyer* (Gypaetus barbatus) *is the largest South African bird of prey. It is confined mainly to the highest ramparts of the Drakensberg.*

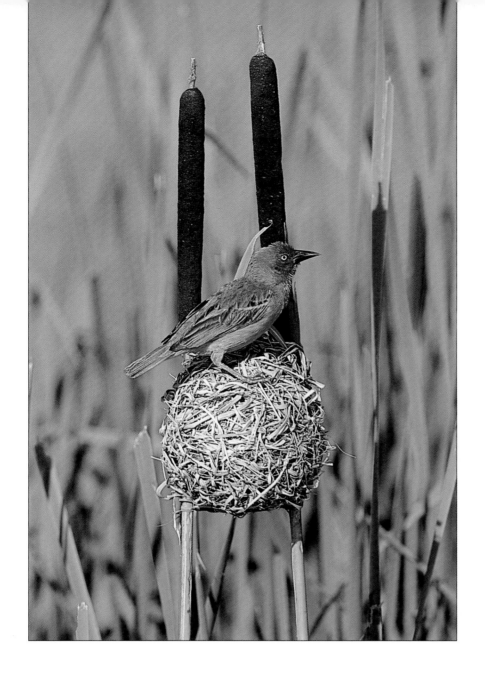

LEFT *Intricate nests are woven by the Cape weaver* (Ploceus capensis) *and suspended in reedbeds or from branches of trees, often dangling over water. The Cape weaver (male shown at nest in KwaZulu-Natal) is endemic and a common resident in grassland and fynbos. It is larger than other weavers and has a longer, pointed bill.*

BELOW *Male redheaded finches* (Amadina erythrocephala) *gather after rain in the Kalahari; the species is near-endemic and broadly distributed throughout South Africa and Namibia, in open grassland and scrub. The birds feed on seeds, gathering on the ground in small flocks and whirring up when disturbed.*

OPPOSITE *A visitor from tropical Africa, the saddlebilled stork* (Ephippiorhynchus senegalensis) *has a pronounced yellow 'saddle' at the base of the bill. All species, whether migrant or indigenous, are protected in South Africa.*

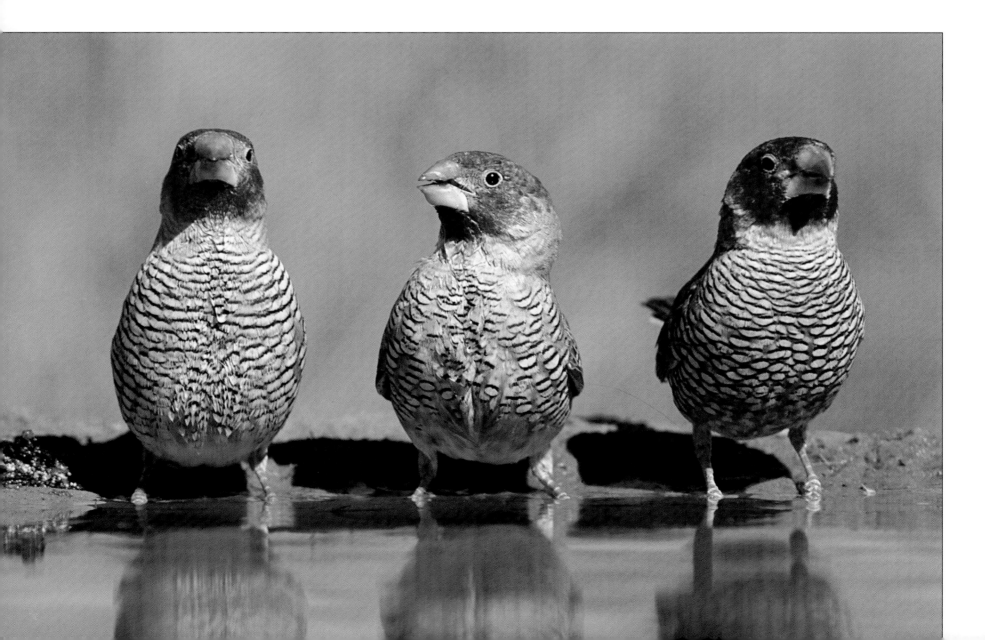

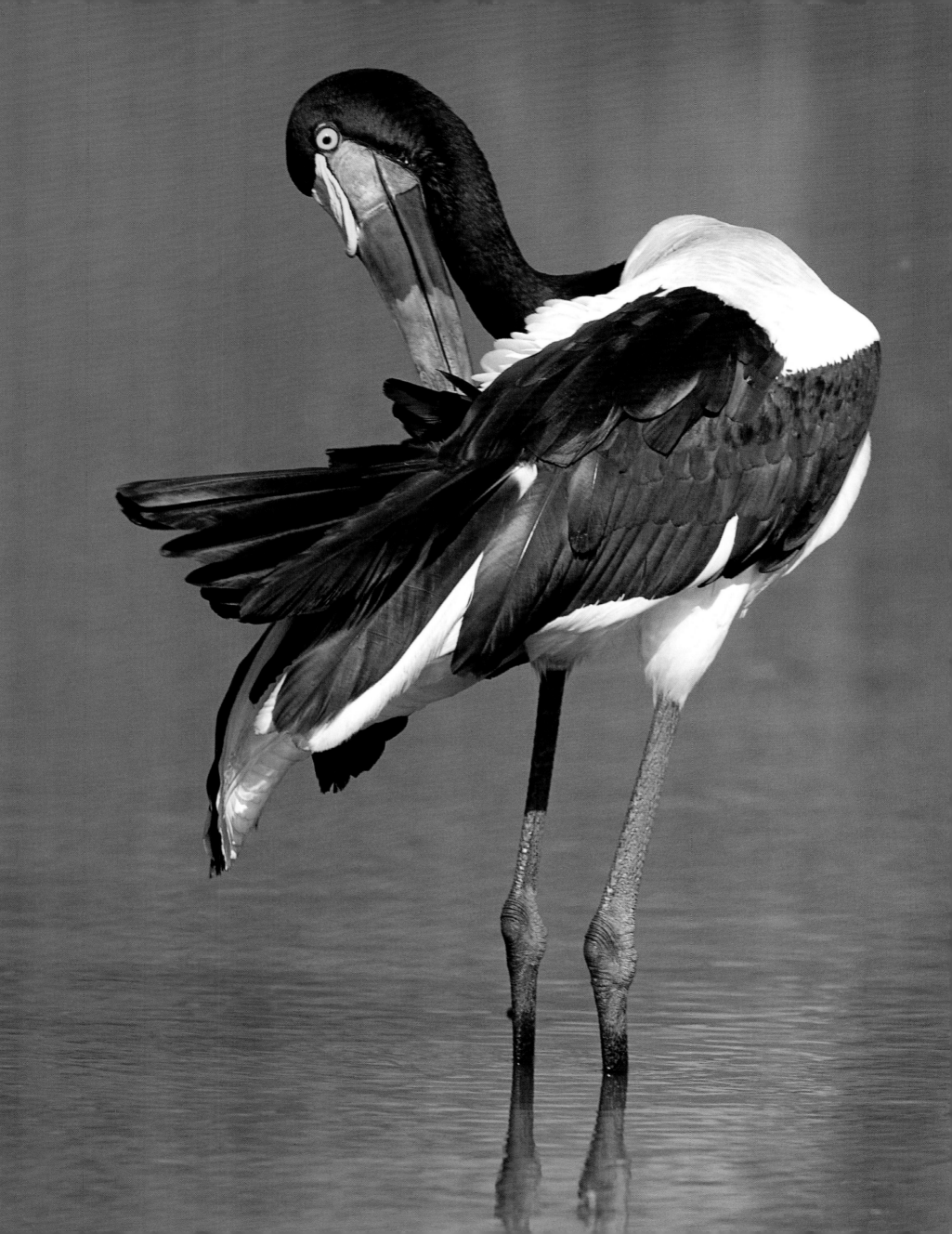

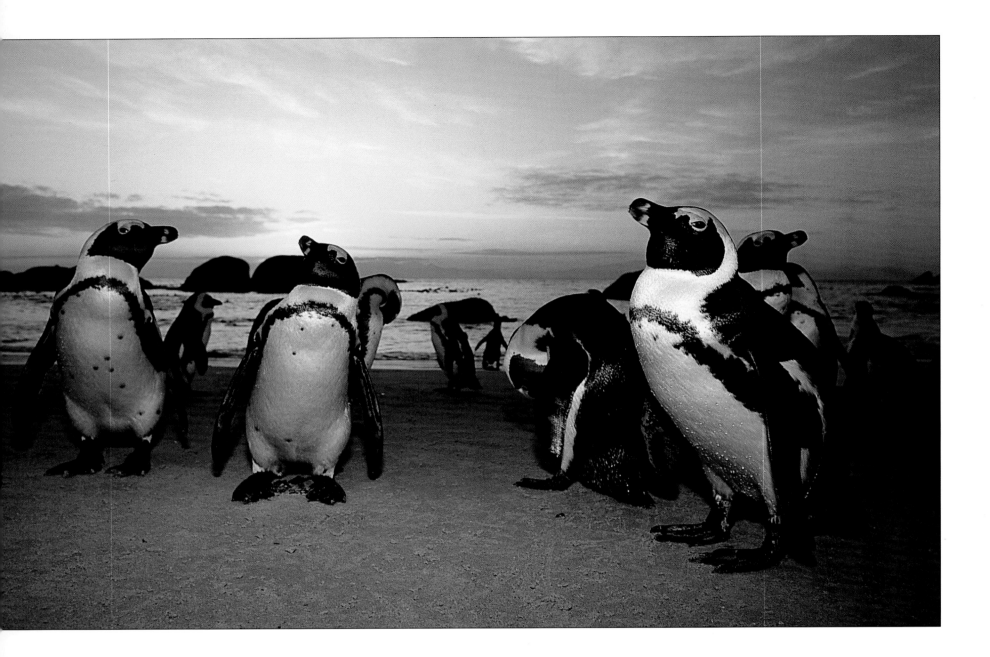

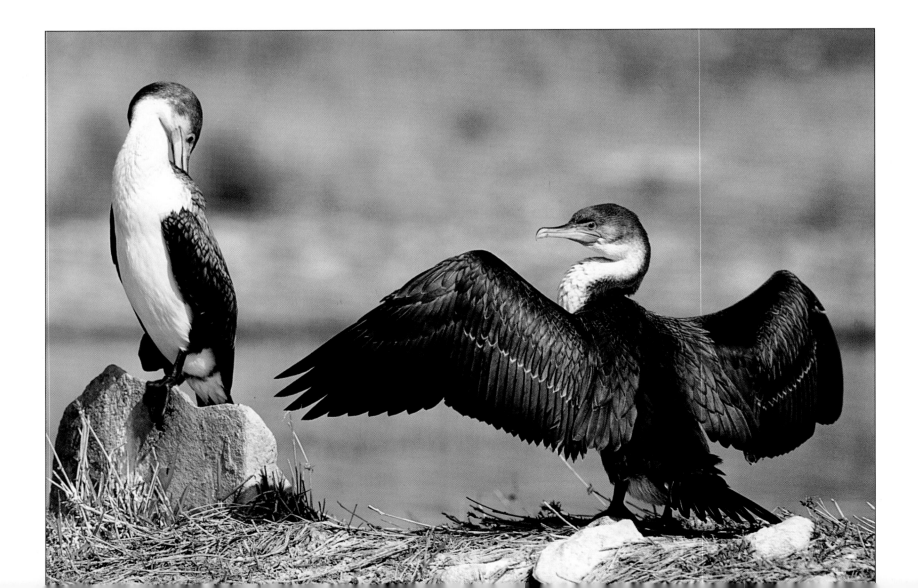

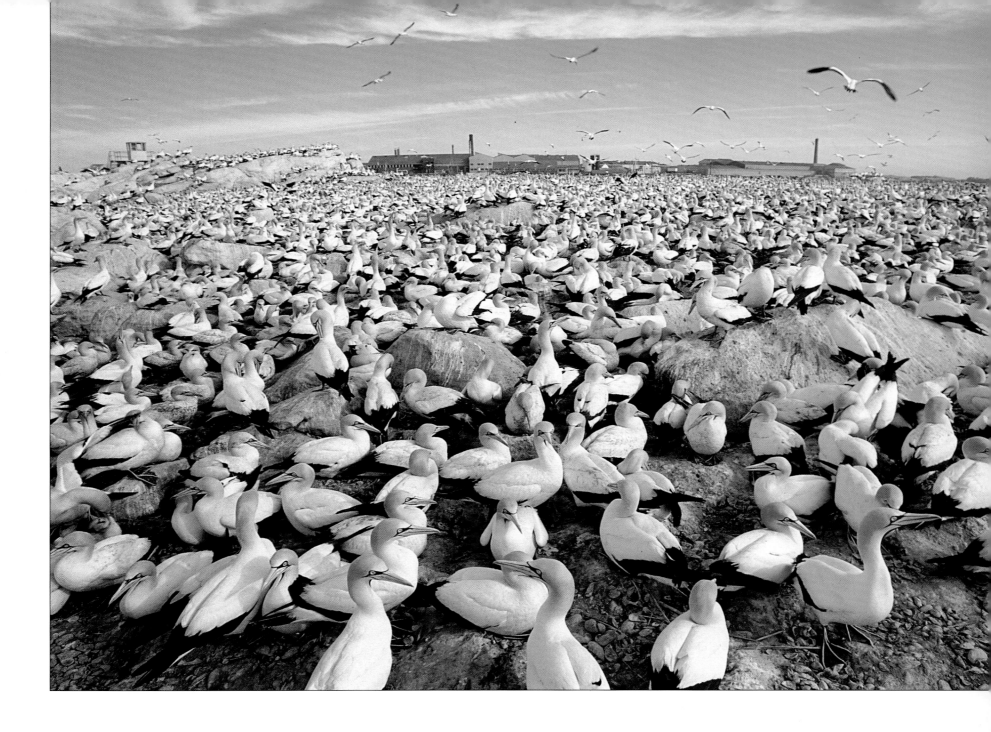

ABOVE OPPOSITE *Jackass penguins* (Spheniscus demersus) *are South Africa's only endemic and highly protected species of flightless marine bird.*

BELOW OPPOSITE *Unlike other waterbirds, the cormorant* (Phalacrocorax sp.) *does not have water-repellent feathers, and the birds spread their wings to dry.*

ABOVE *A large colony of Cape gannets* (Morus capensis) *at Lambert's Bay, West Coast, can be seen close up from a viewing platform.*

RIGHT *The more common of South Africa's two pelican species is the eastern white pelican* (Pelecanus onocrotalus).

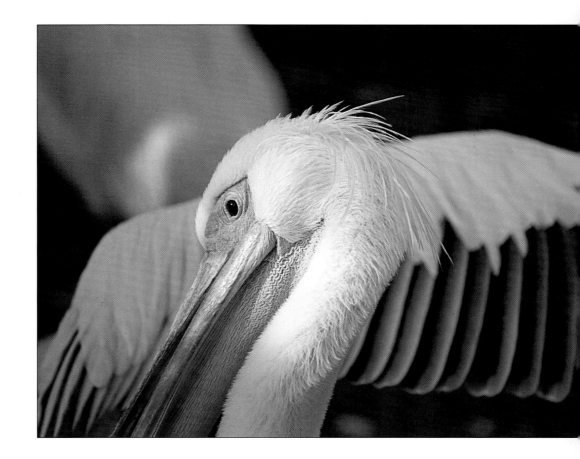

URBAN EDIFICES

South Africa's built environment is as diverse as its natural environment ... a conglomerate of influences from near and far. Some of it is indigenous, remaining in small country towns or in the settlements of rural tribal people. Much has been borrowed and adapted to meet the demands of climate, a paucity of building materials and the needs of a youthful country. The first South Africans, the nomadic Khoisan, lived in rock dwellings in winter and in summer, grass huts. They adopted the dome-shape almost universally used for shelter by other early people across the face of the earth. Xhosa people made environmentally friendly mud huts painted half-brown, half-white to absorb or deflect heat. Trekboers (itinerant farmers) built round, corbelled dwellings from stacks of flat stones, while the Zulus made their homes in huts woven of grass. They used simple methods and locally available materials – mud, grass, saplings, stone, cow dung and clay. By way of ornamentation the Ndebele in particular have made an art form of wall paintings in natural pigments. When the early Dutch settlers

started building, they too used simple sun-baked clay blocks, thatch, dung floors embedded with peach pips, great tree trunks for beams, and reeds and clay for ceilings. They employed skilled Malay craftsmen, especially for fine plastering. Perhaps the most striking feature of early South African architecture is the Cape Dutch gable, which embellishes some of the country's most gracious buildings. Soaring from the centre of the facade, it signalled the status of the owner.

ABOVE *Elaborate Victorian buildings housing antique and rare book shops line Cape Town's Long Street.*

RIGHT *The Houses of Parliament in Cape Town occupy a portion of what was once Jan van Riebeeck's garden at the foot of Table Mountain in the oldest part of the city.*

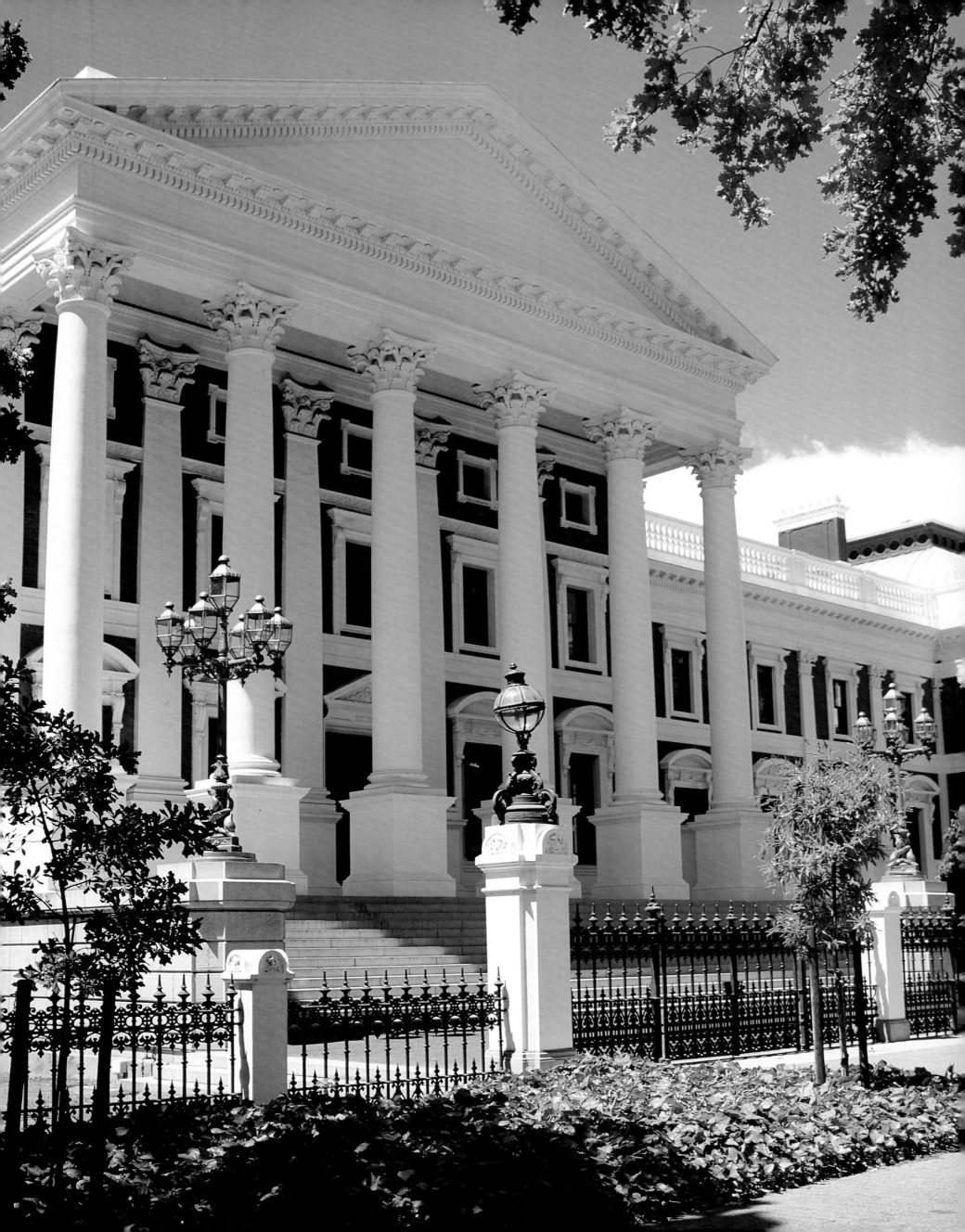

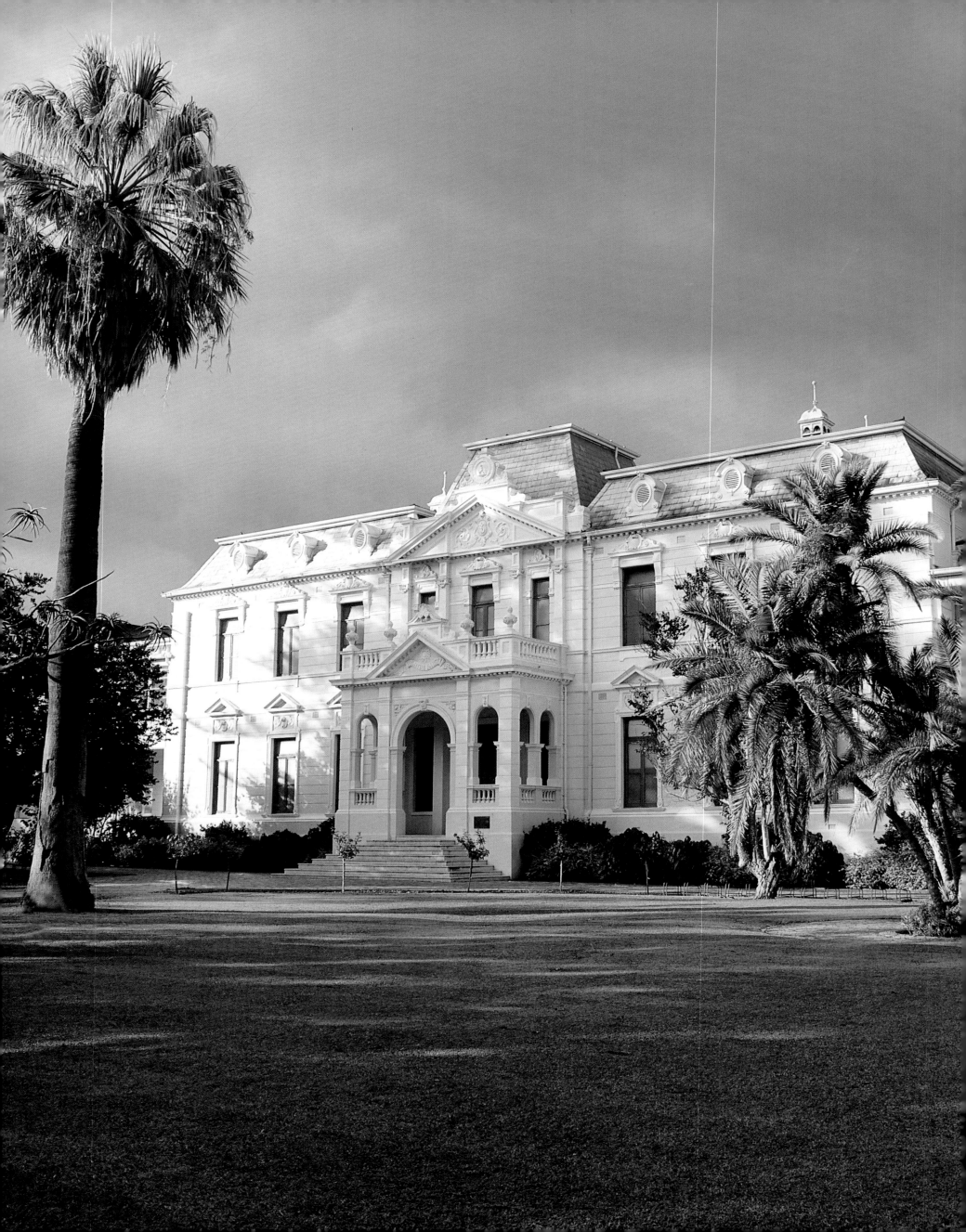

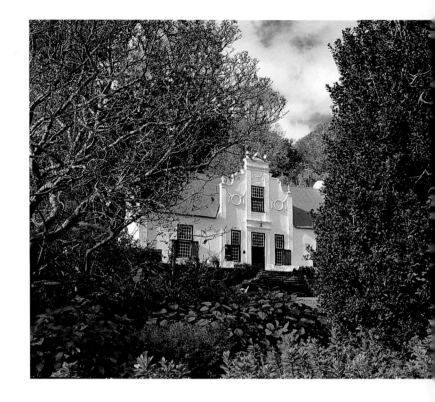

ABOVE *One of the Cape's most gracious gabled homes, Old Nectar in the Jonkershoek Valley near Stellenbosch, is famed for its beautiful gardens.*

LEFT *Stellenbosch, South Africa's second-oldest settlement, has a university rivalled only by that of Cape Town. The sprawling campus incorporates some of the town's oldest buildings as residences or halls of learning, such as the Theology Department featured here.*

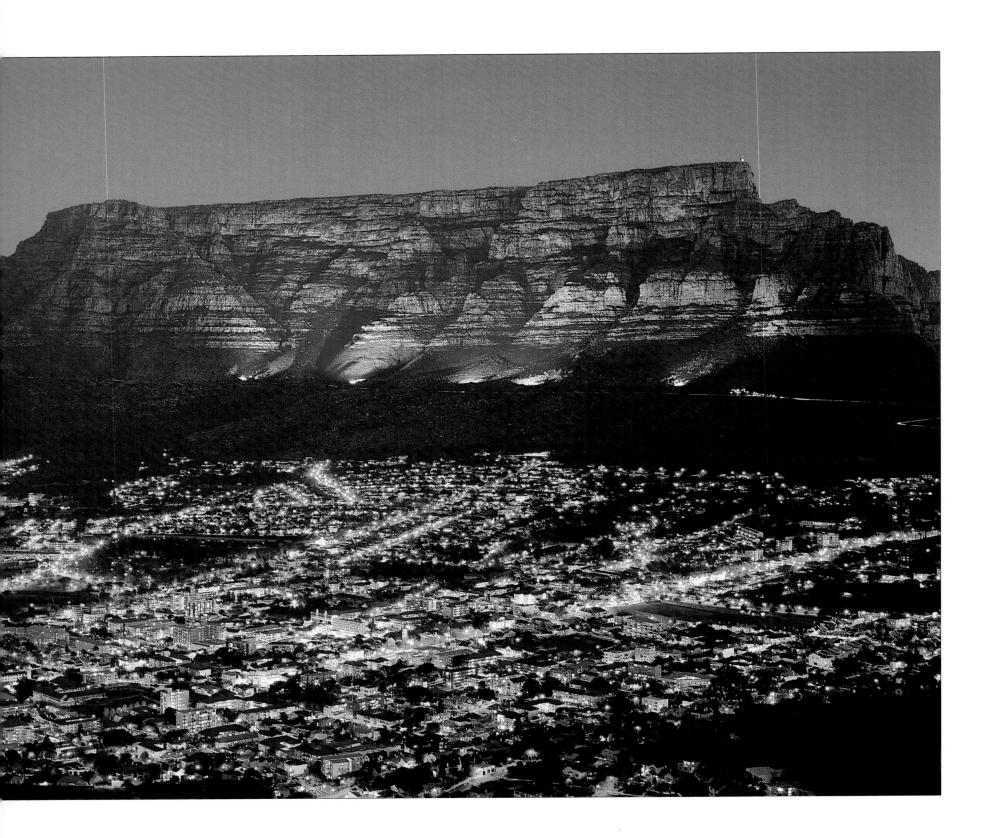

The Mother City generates a night-time brilliance to rival the day, with boulevards and shopping malls glowing in invitation. Civic landmarks, corporate headquarters, public gardens and even the country's most famous natural feature, Table Mountain, are illuminated. In downtown Cape Town, the offices of the vast oil, shipping, airline and banking corporations have briefly emptied while restaurants, cinemas and theatres winking their wares in neon ready themselves for the night's trade.

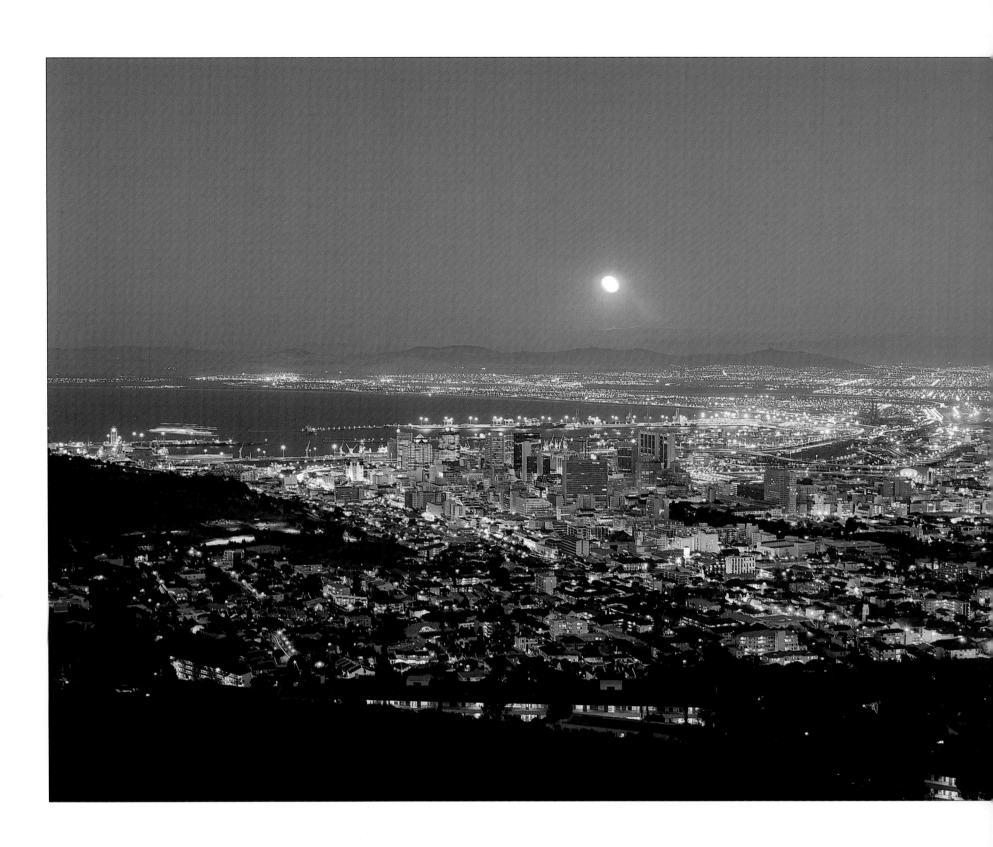

Cape Town stirs to meet a new day. The broad sweep of Table Bay is edged with all the workings of a busy harbour. Industry takes over on the northern shore, and commerce is concentrated on the southern edge. The densely-developed central business district (foreground) is laid out in a narrow space between the waters of the bay and the foothills of Table Mountain. Much of this space has been recovered from the sea, in massive land reclamation which has expanded the city precinct with more than 300 hectares of valuable real estate.

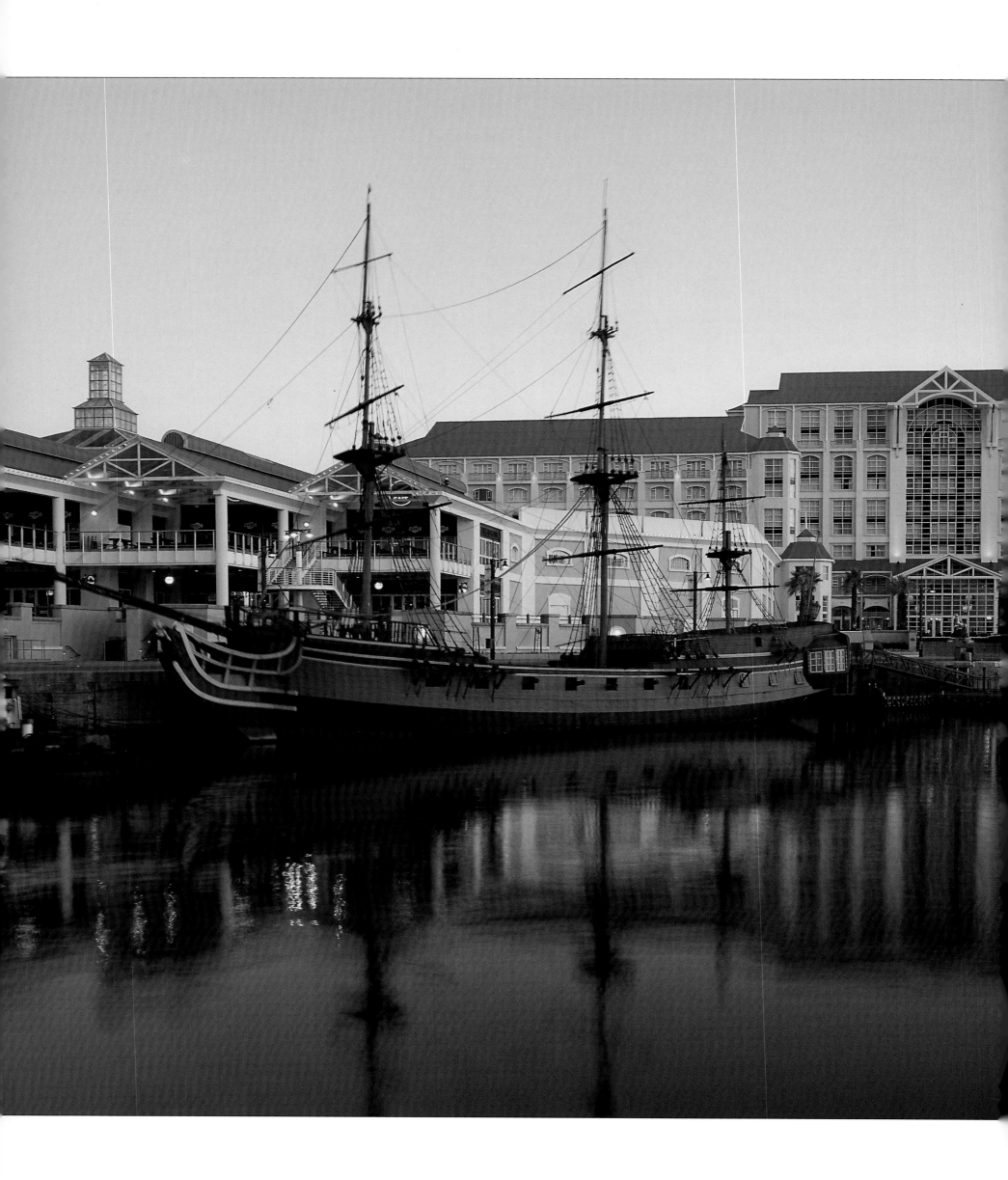

LEFT *The museum ship* Victoria, *a replica of an old-fashioned sailing vessel, occupies a prime mooring in the V&A Waterfront's Victoria Basin. Behind the ship is the Victoria Wharf shopping complex, and in the background, The Table Bay Hotel. With its eclectic mix of architecture, and the finest in shopping, dining and accommodation, the V&A Waterfront development has breathed new life into Cape Town's old dockland area.*

BELOW *Although greatly modified over the years, the venerable Lutheran Church on Strand Street in central Cape Town has been a house of worship since the 1700s. Modern office buildings in the backround reflect the fast-changing face of Cape Town's urban landscape.*

OVERLEAF *At dusk, with the majestic backdrop of Table Mountain and Devil's Peak, the Waterfront becomes a place of magic and light.*

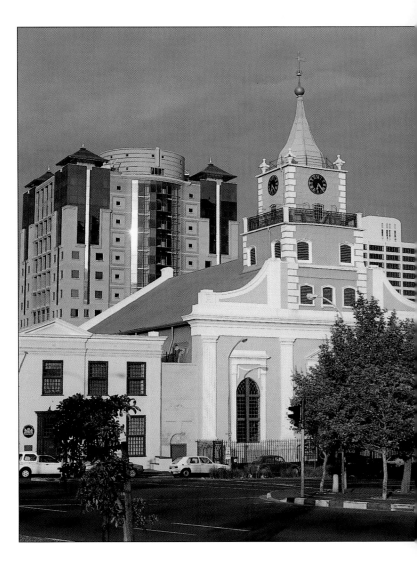

141

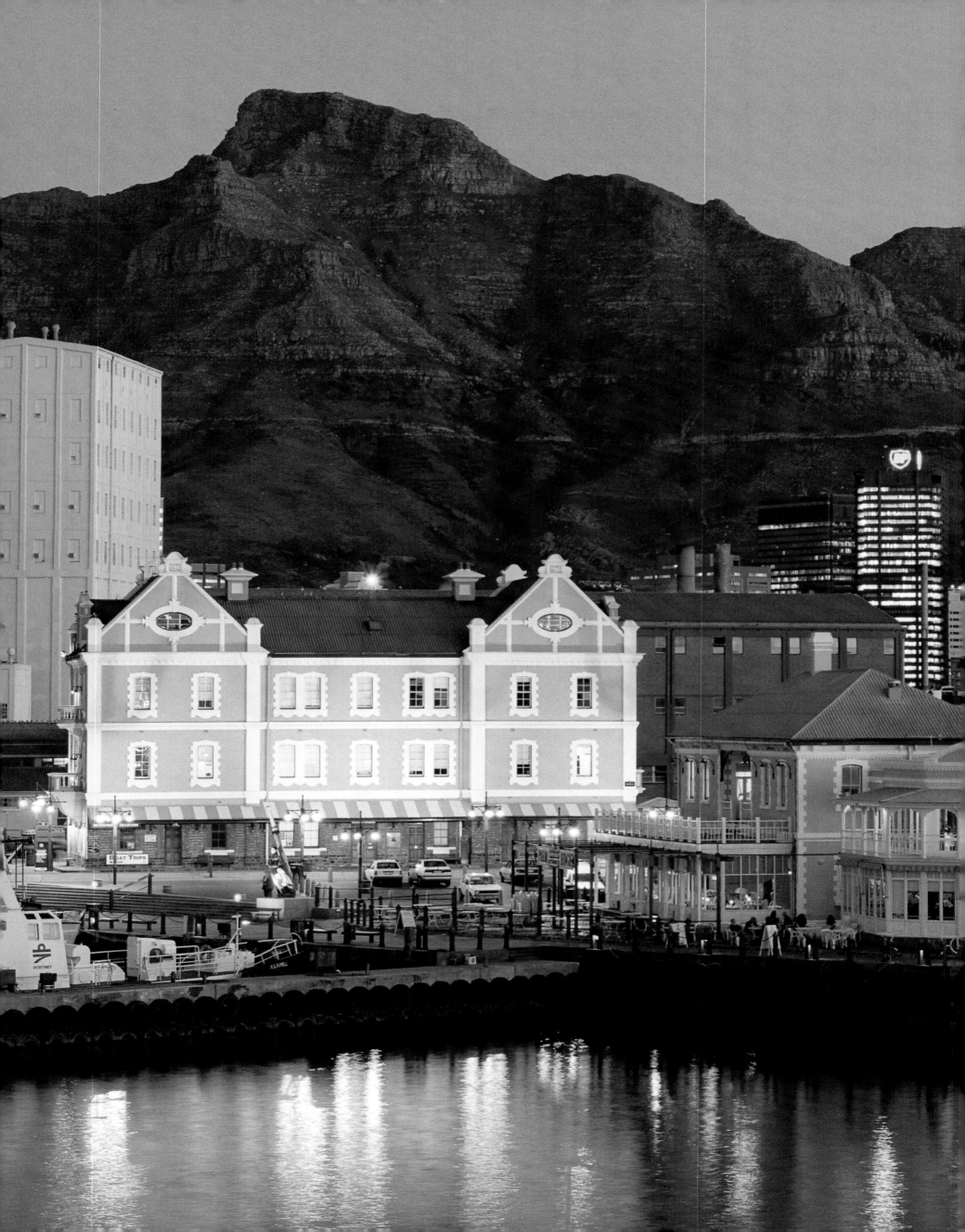

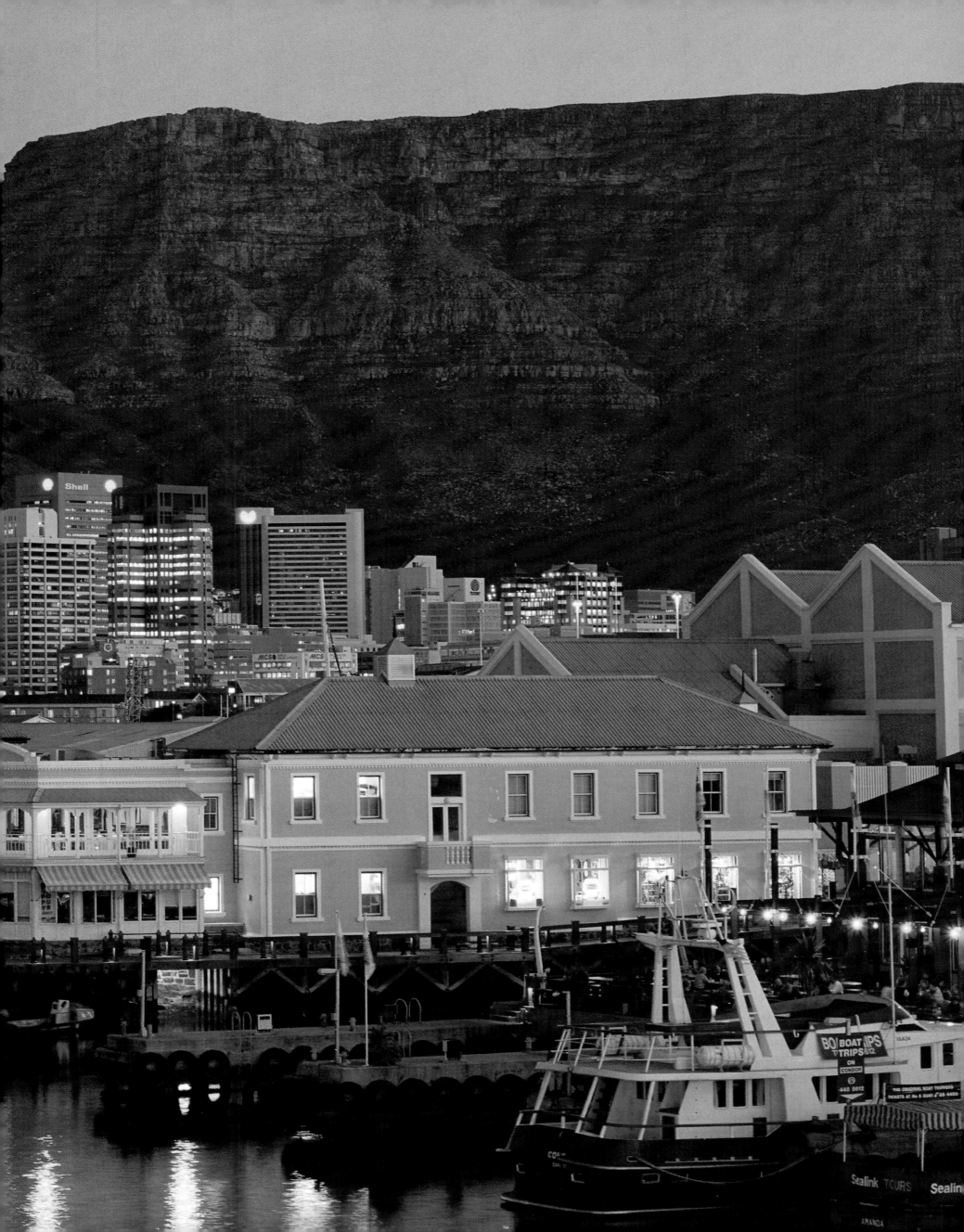

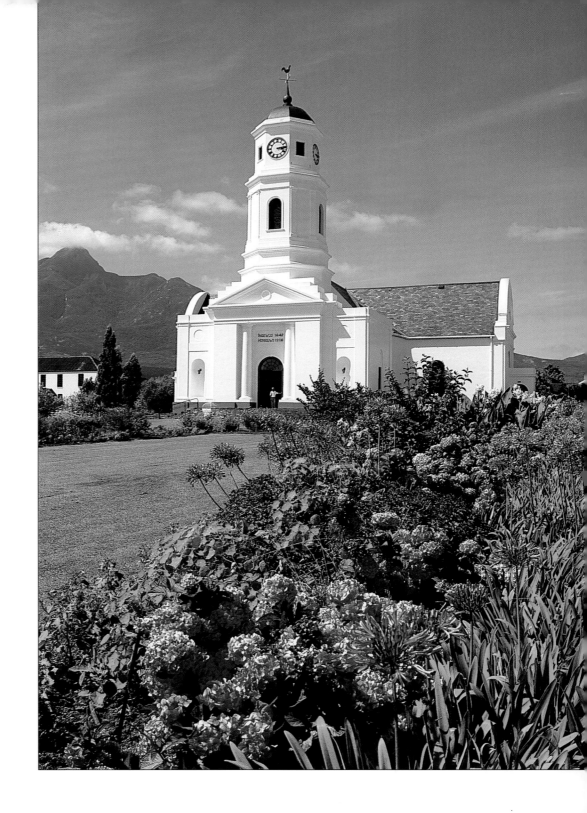

ABOVE *The southern Cape town of George arose, like many others, at the foot of the Dutch Reformed Church. The town was laid out in 1811 in what French naturalist Francois le Vaillant described as 'the most beautiful land in the universe'.*

LEFT *The Muslim burial site* (kramat) *on Signal Hill, Cape Town, is one of six which form a 'holy circle of Islam' surrounding Cape Town. These are the burial grounds of Muslim holy men and high-ranking individuals,* tuans, *and are believed to protect all who live inside the sacred circle.*

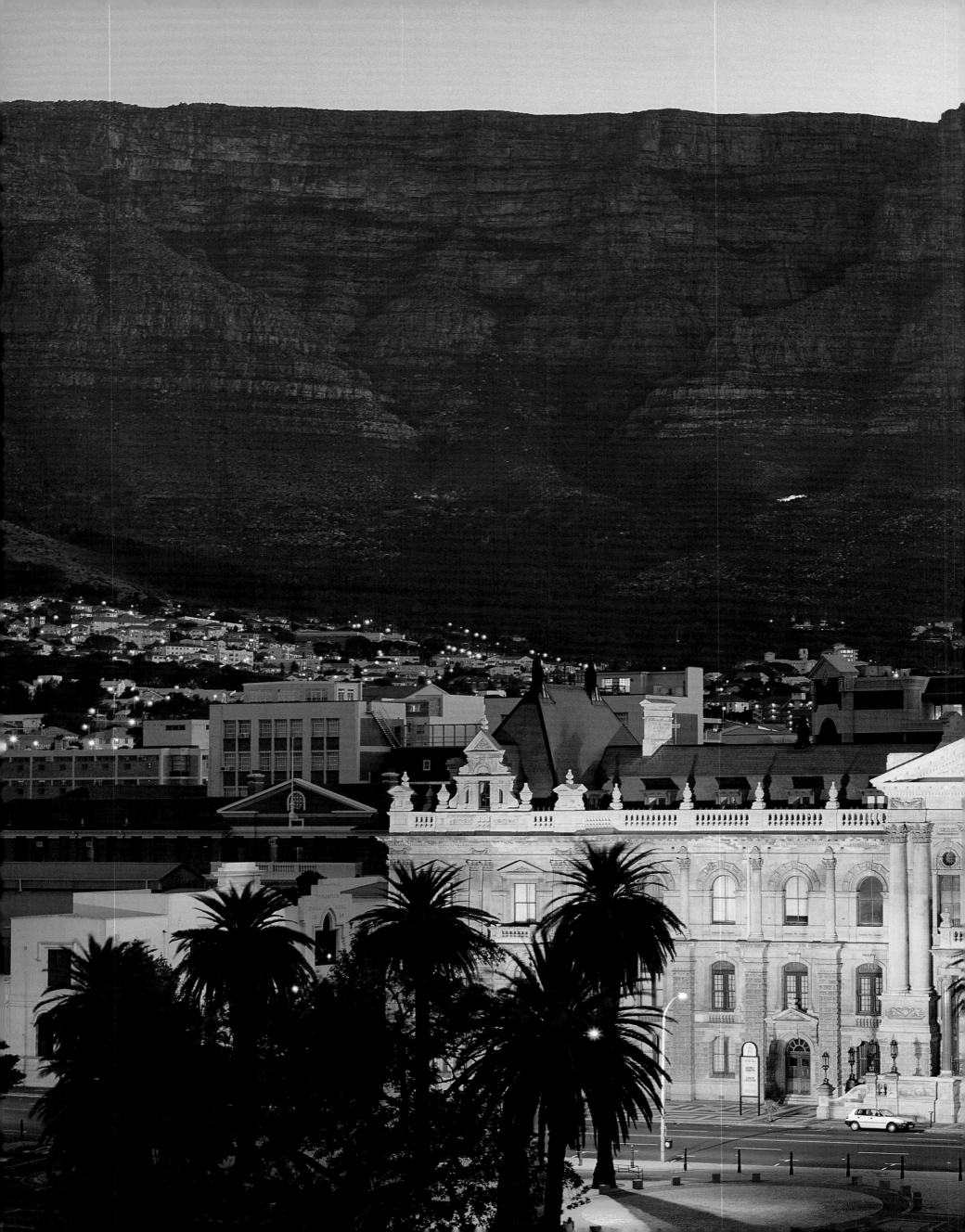

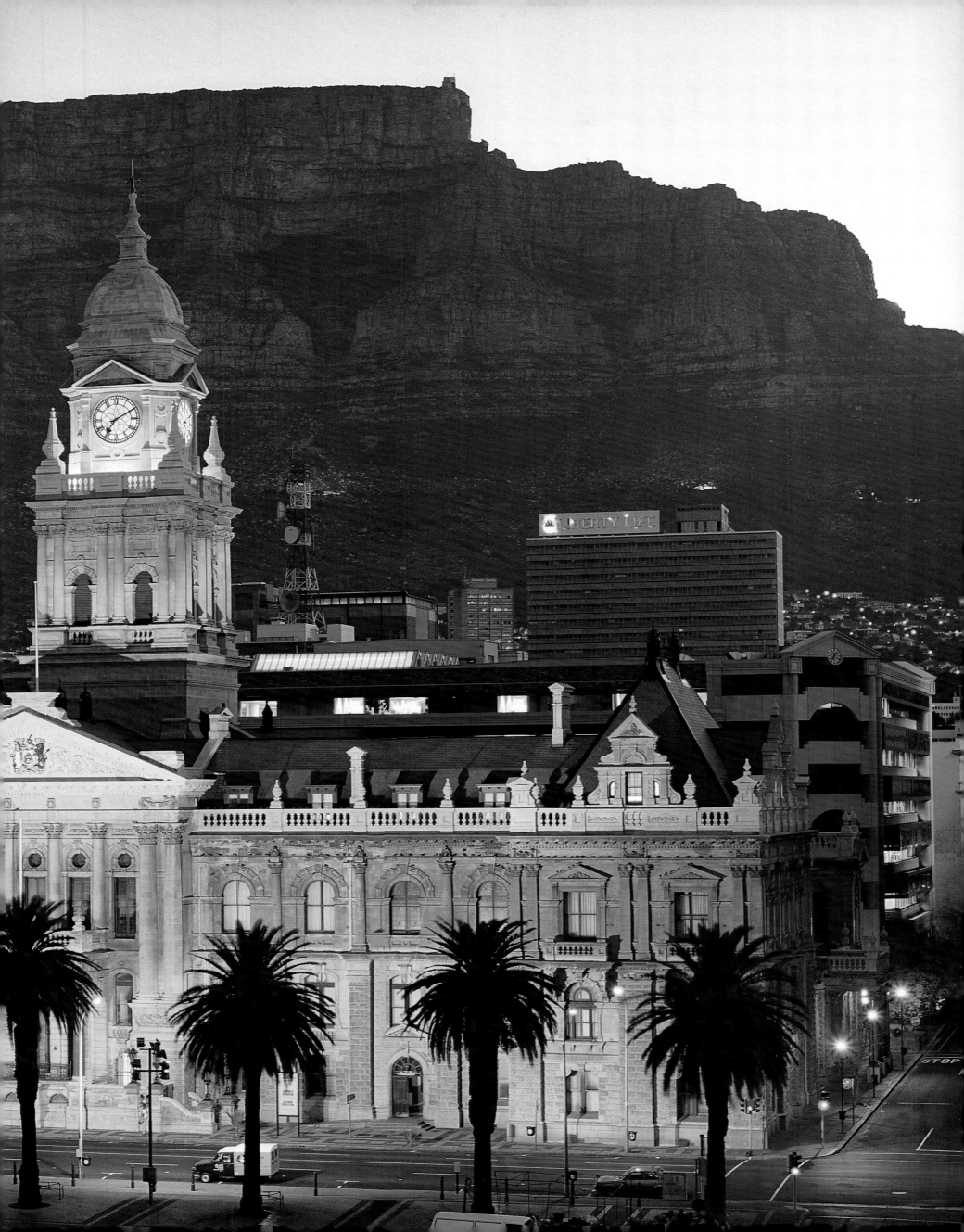

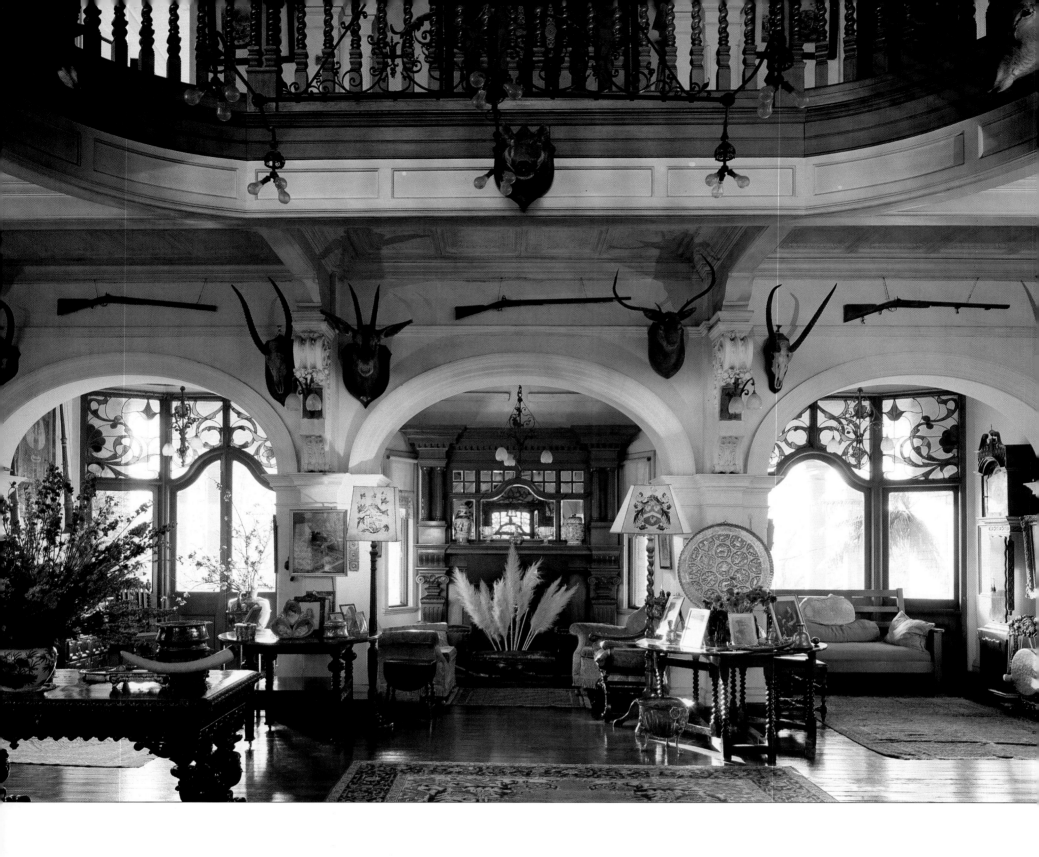

PREVIOUS PAGE *The handsome Cape Town City Hall, built in 1905, has a half-size Big Ben which chimes the Westminster quarters. The clock tower houses the largest carillon in the country, which commemorates South Africa's First World War dead. The chimes first rang out on April 30, 1925, for the Prince of Wales' visit.*

ABOVE *The colonial mansion Dolobran, a celebration of the opulence of turn-of-the-century Johannesburg, rises from a koppie in Parktown. The original owner, Sir Llewellyn Andersson, shunned Sir Herbert Baker's shingles and casements for 'sun, air and light' provided by British architect Cope Christie.*

RIGHT *Man-made jewel of the North-West Province, the Palace of the Lost City has recreated a forgotten legend, and become one in its own lifetime. A pleasure palace of astonishing opulence, it is one of the world's fabled resorts.*

OVERLEAF *Corporate kingdoms have their palaces in Johannesburg's CBD, rising with walls of glass or granite, or in marbled monoliths from the jumble of tumbledown shops – the old Johannesburg – at their feet.*

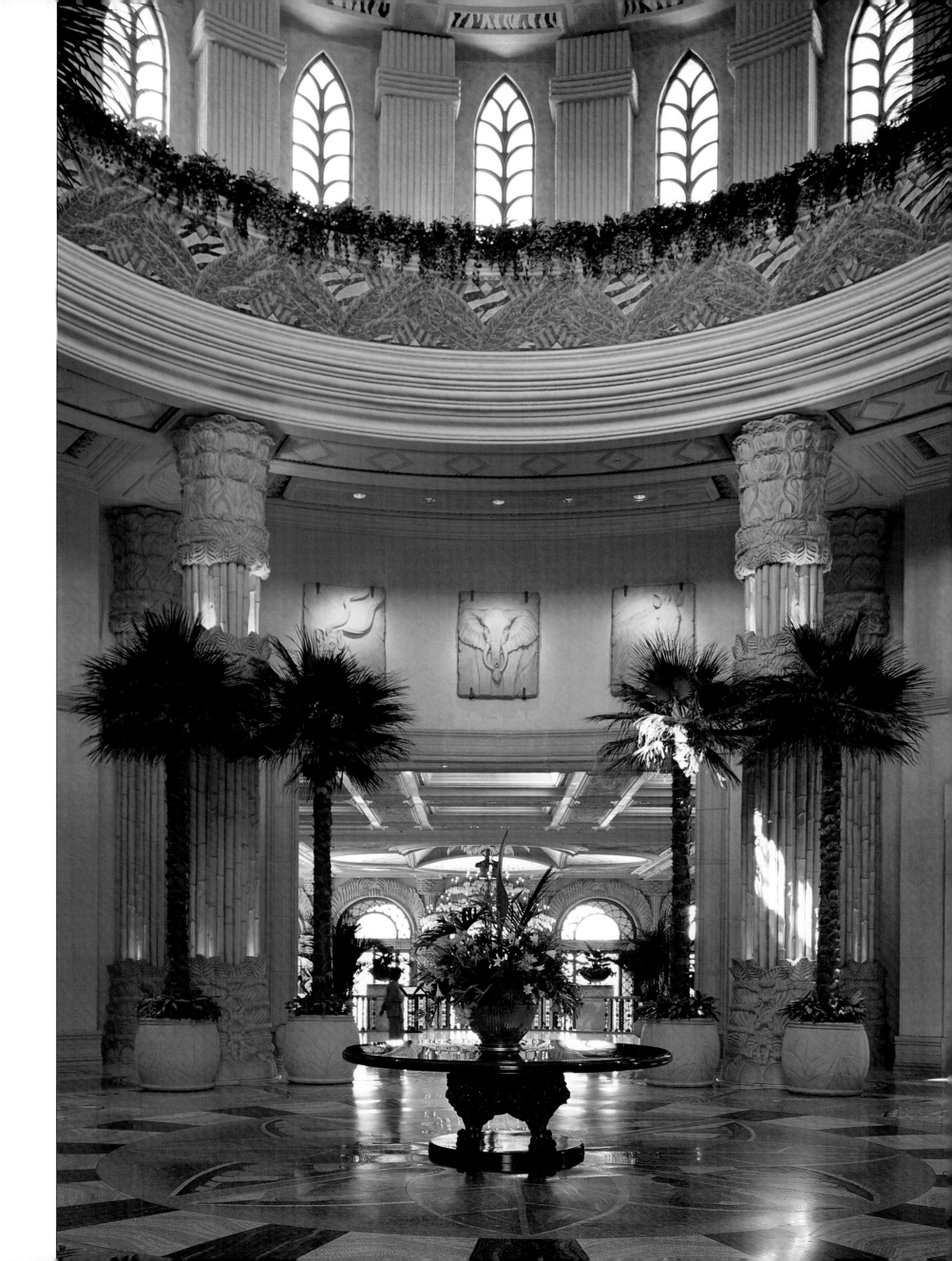

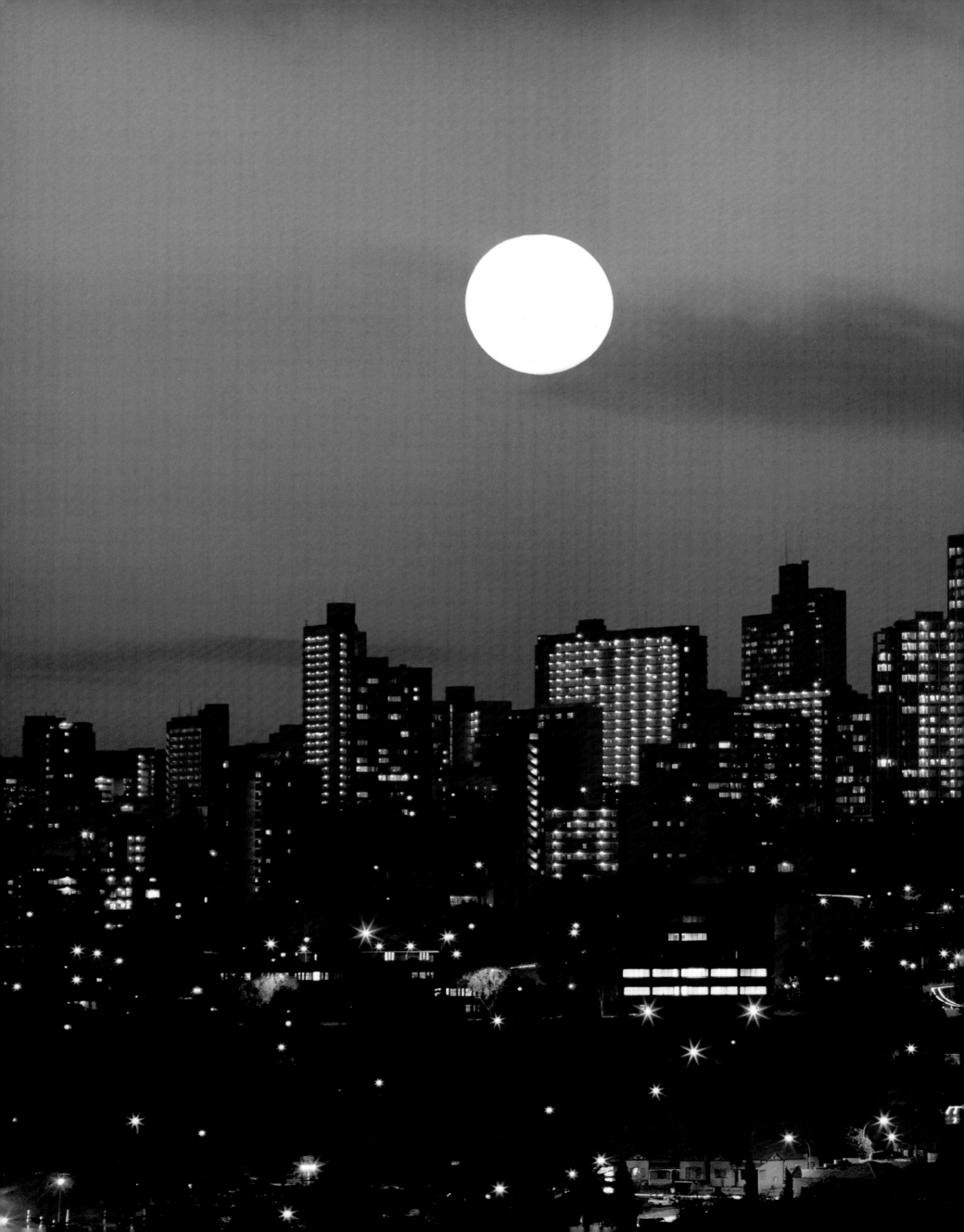

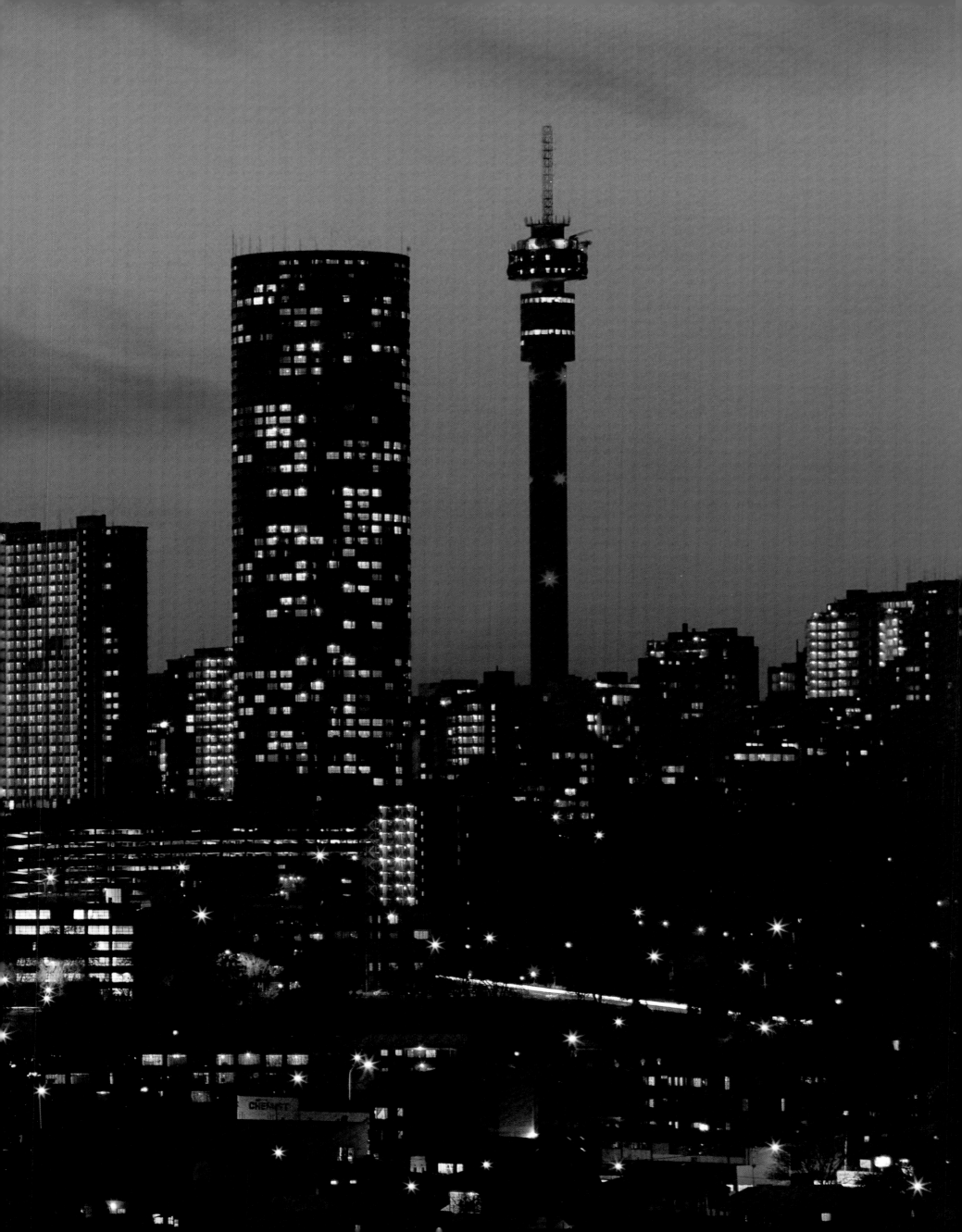

PREVIOUS PAGE *The moon rises over Hillbrow, the Johannesburg suburb that never sleeps.*

ABOVE *Banking headquarters make a formidable statement of wealth and power in Johannesburg's CBD.*

RIGHT *The exuberance of victory takes expression in fiery balls in the night sky over Ellis Park in Johannesburg. Never have the games been more spirited than in the last few years of South Africa's re-entry into international sports.*

OVERLEAF *Gold Reef City is an entertaining reproduction gold mining village with old-time banks, breweries, pubs, a Victorian fun fair and authentic tribal dancing every day.*

154

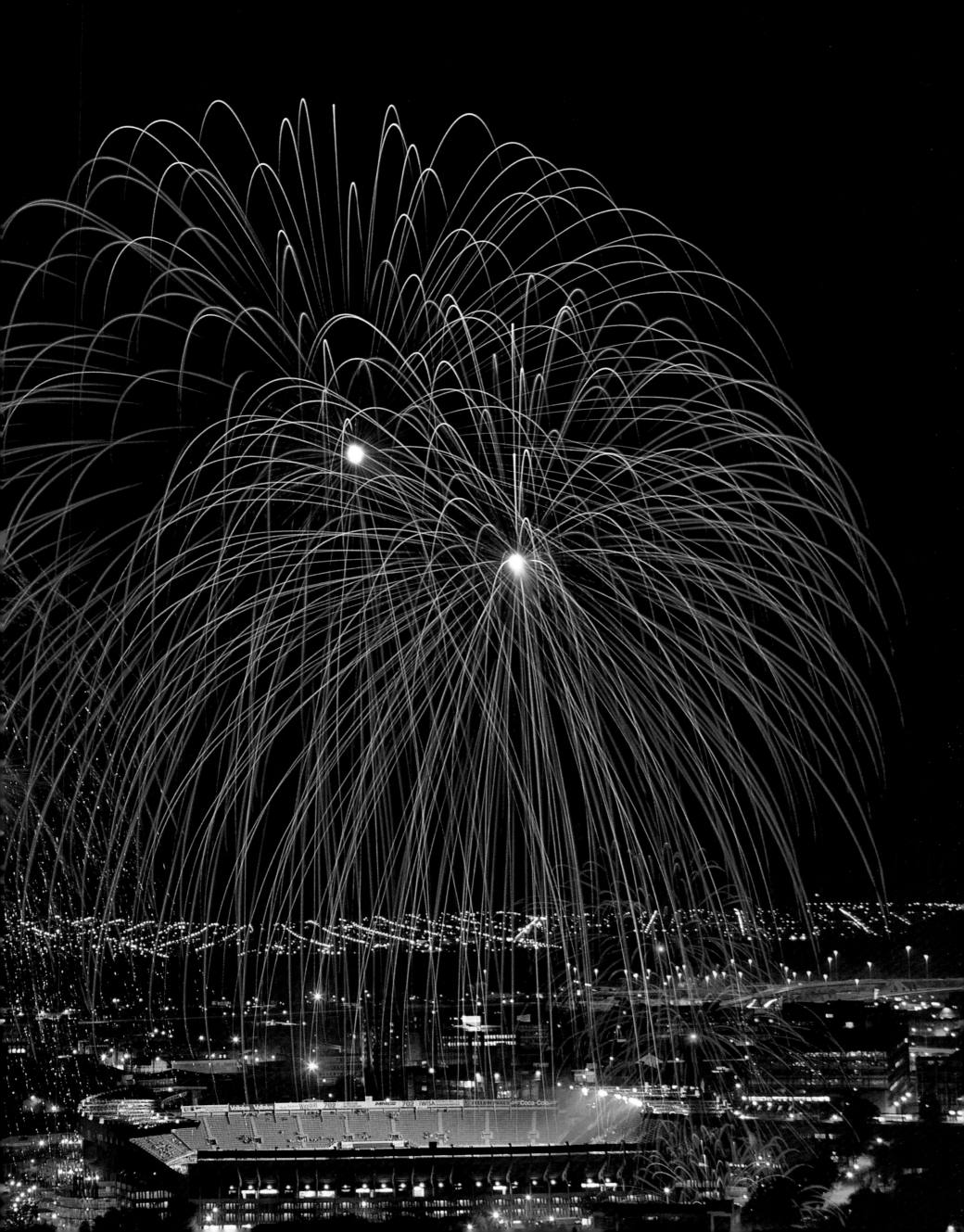

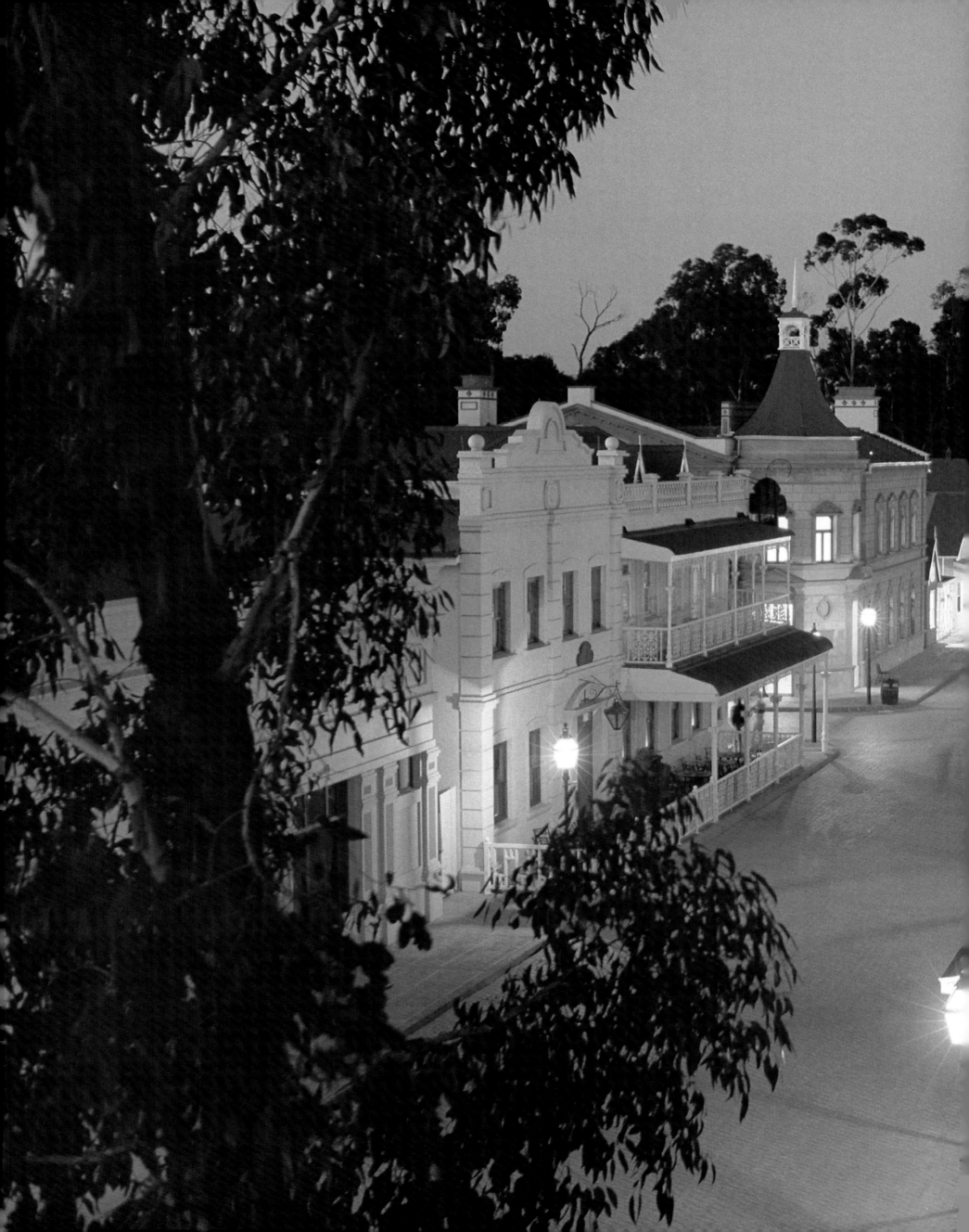

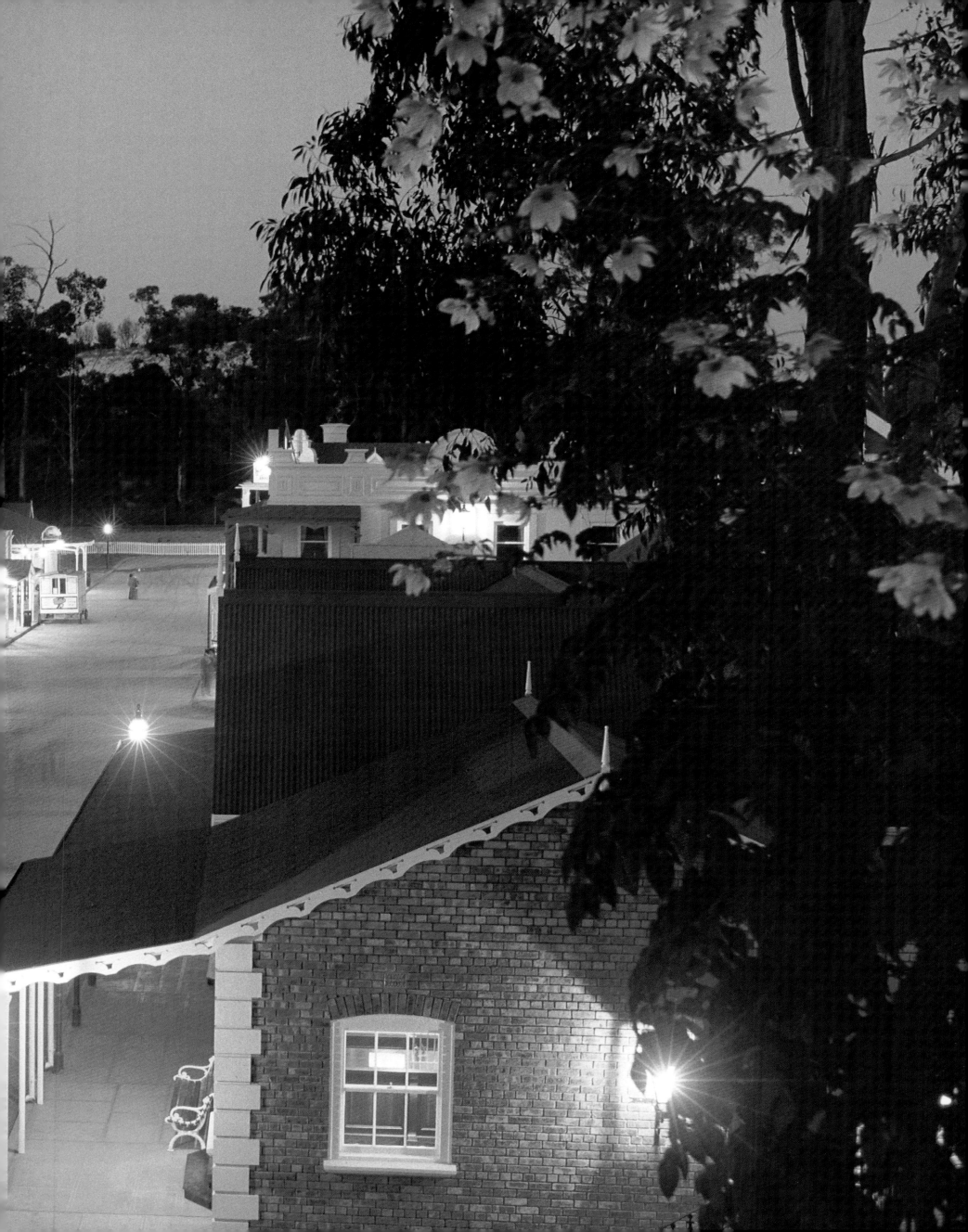

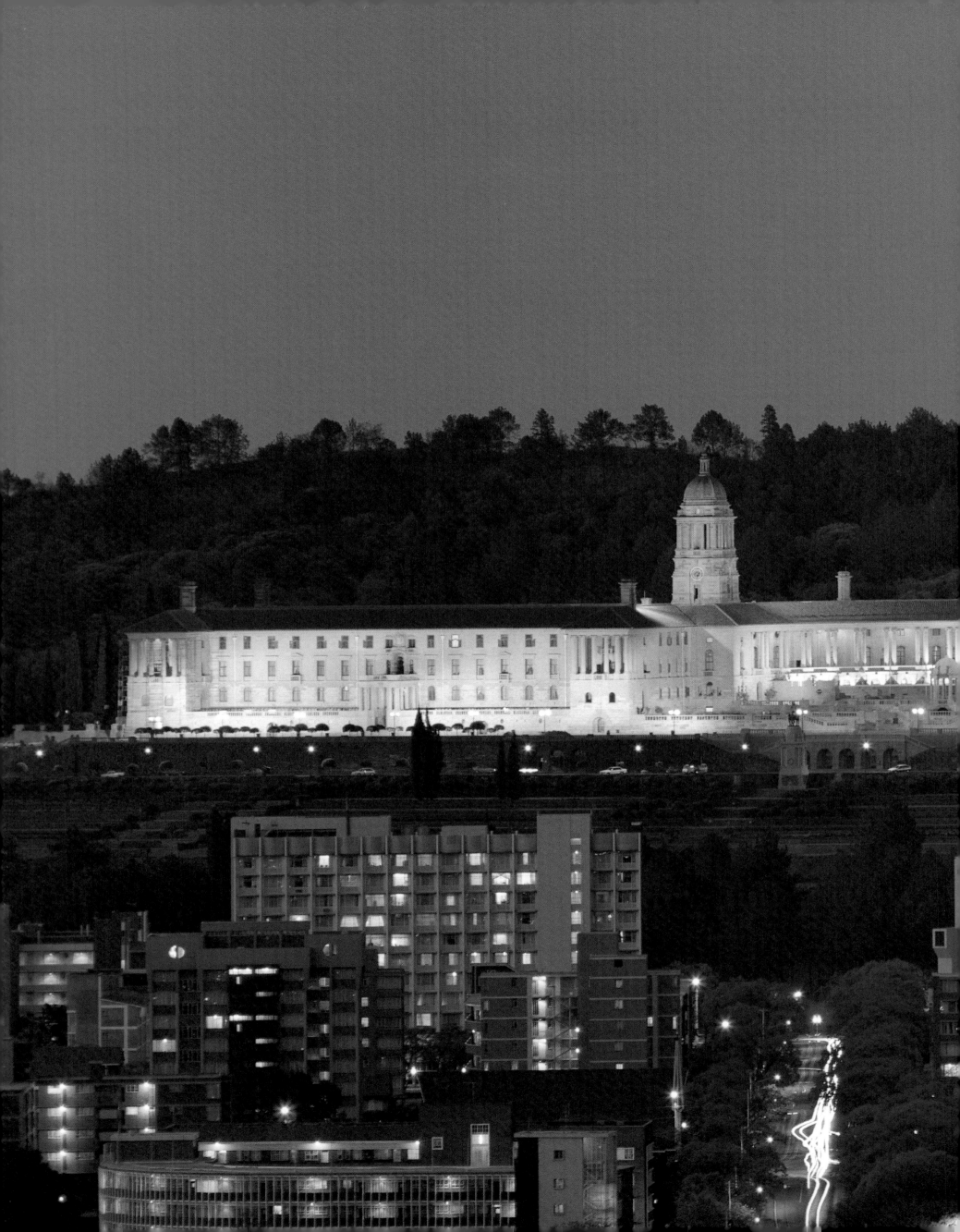

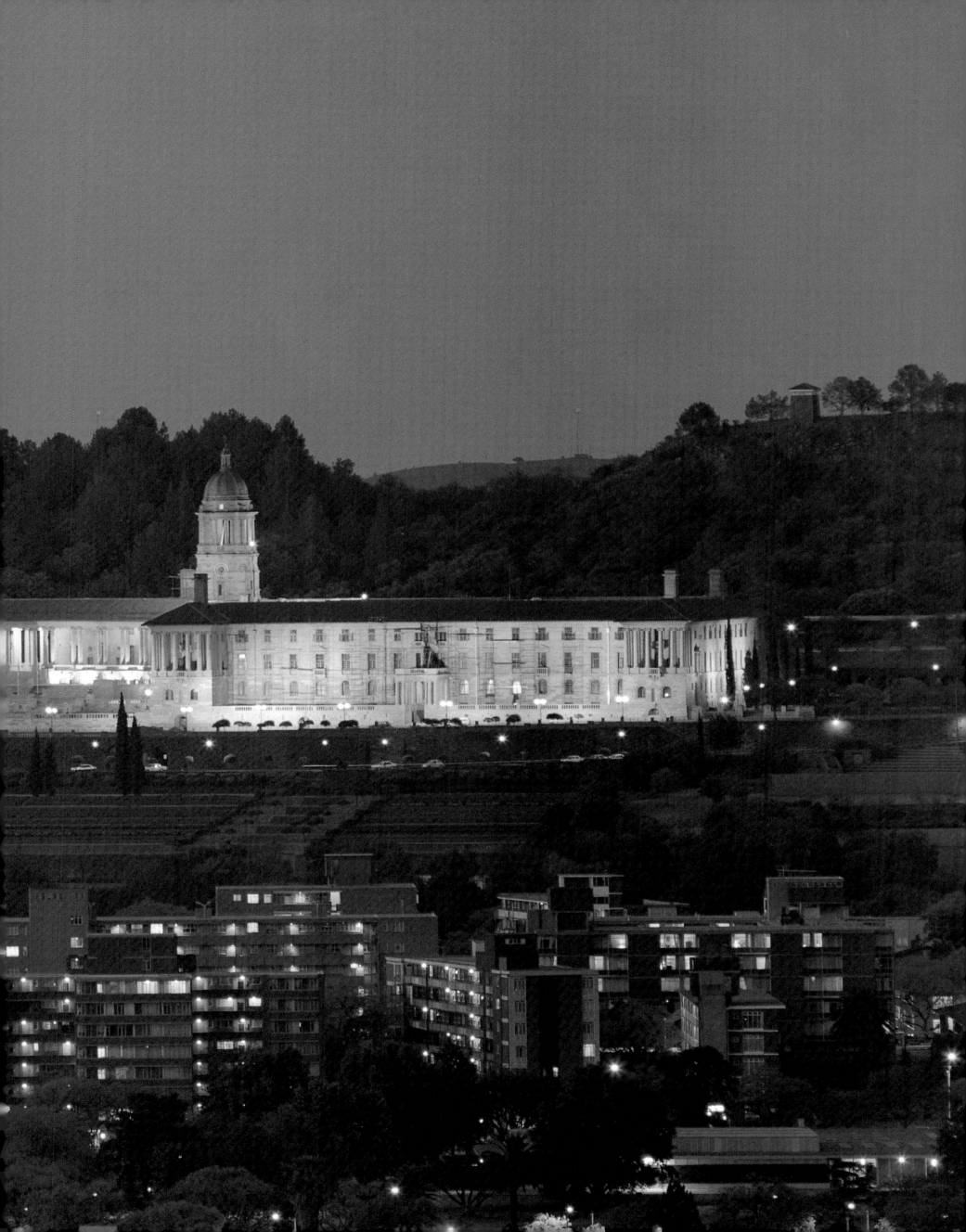

PREVIOUS PAGE *Sir Herbert Baker, one of the British Empire's most celebrated architects, designed the Union Buildings in Pretoria. Headquarters of the country's civil administration, they cost 1,1 million pounds when completed in 1913.*

BELOW *Pretoria, half an hour's drive from Johannesburg, is elegantly laid out against the eastern foothills of the Magaliesberg. In spring the city is thrown into a lilac shade cast by the blossoms of a myriad jacaranda trees.*

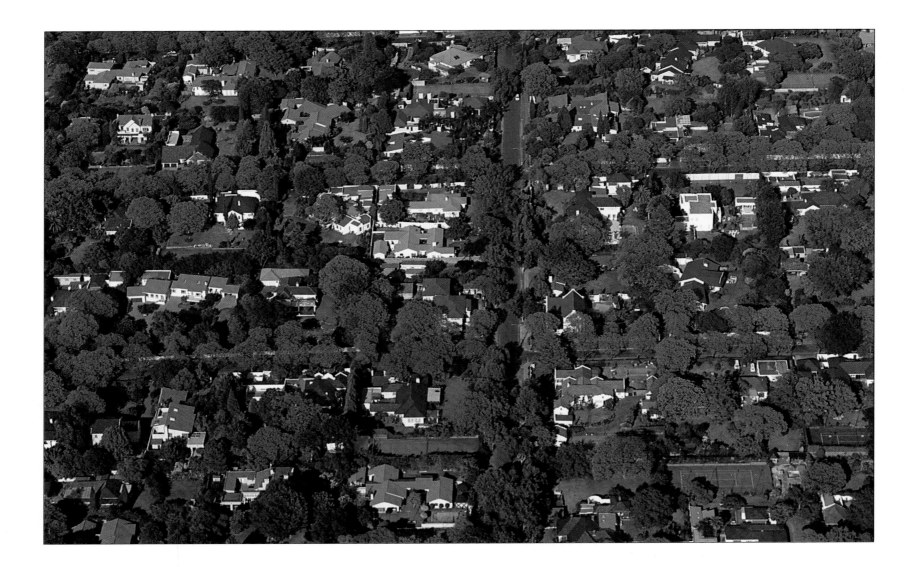

PHOTOGRAPHIC ACKNOWLEDGEMENTS

SIL = (Struik Image Library)

Shaen Adey: p133(top,SIL); Adrian Bailey: p122(bottom); Gerald Cubitt: pp18(bottom), 19(bottom), 57, 73, 90, 97; Roger de la Harpe: pp36(left,SIL), 42(top left,SIL), 62(SIL), 91, 93, 94-95(SIL); Nigel Dennis: Half Title(SIL), Title, pp7(SIL), 13, 40, 41(SIL), 50, 52(SIL), 53(SIL), 56, 108(SIL), 109(SIL), 110(top), 111-112(SIL), 113, 114-115(SIL), 116(SIL), 117-119, 122(top), 123, 124(bottom,SIL), 126(SIL), 127, 128-131(SIL), 132(bottom); Gerhard Dreyer: pp 9, 16, 17, 18(top), 19(top), 45(top,SIL), 45(bottom), 59, 60, 71, 86(top), 87, 133(bottom,SIL); Walter Knirr: pp14-15, 22(SIL), 24-25(SIL), 39(SIL), 46-47(SIL), 63, 64-65(SIL), 72, 80-81(SIL), 92(SIL), 96(SIL), 98(SIL), 99(SIL), 105-6, 135, 145(SIL), 152-53(SIL), 155(SIL), 158-59(SIL); Mark Lewis: pp12(SIL), 104(SIL), 107(SIL); Herman Potgieter: pp6, 34-35, 37, 54-55, 61, 89, 120-121, 150-51, 154, 156-57, 160, Alain Proust: pp32-33, 79, 148-49; Mark Skinner: pp10-11, 20-21(SIL), 23(SIL), 28(top,SIL), 28(bottom,SIL), 29-31, 42(bottom left), 43(SIL), 44, 48(SIL), 49(SIL), 68-69(SIL), 74(SIL), 75, 77, 78(top), 84-85, 86(bottom,SIL),100-101, 132(top), 134, 136-38, 139(SIL), 140-43, 147-8(SIL), endpaper; Lionel Soule: p110(bottom); Erhardt Thiel: p76(top,SIL); Hein van Horsten: pp58, 66, 67(SIL), 70(SIL), 76(bottom,SIL), 78(bottom), 88(SIL); Lanz van Horsten: pp26-27(SIL), 82(SIL), 102-103(SIL), 124(top,SIL), 125(SIL).

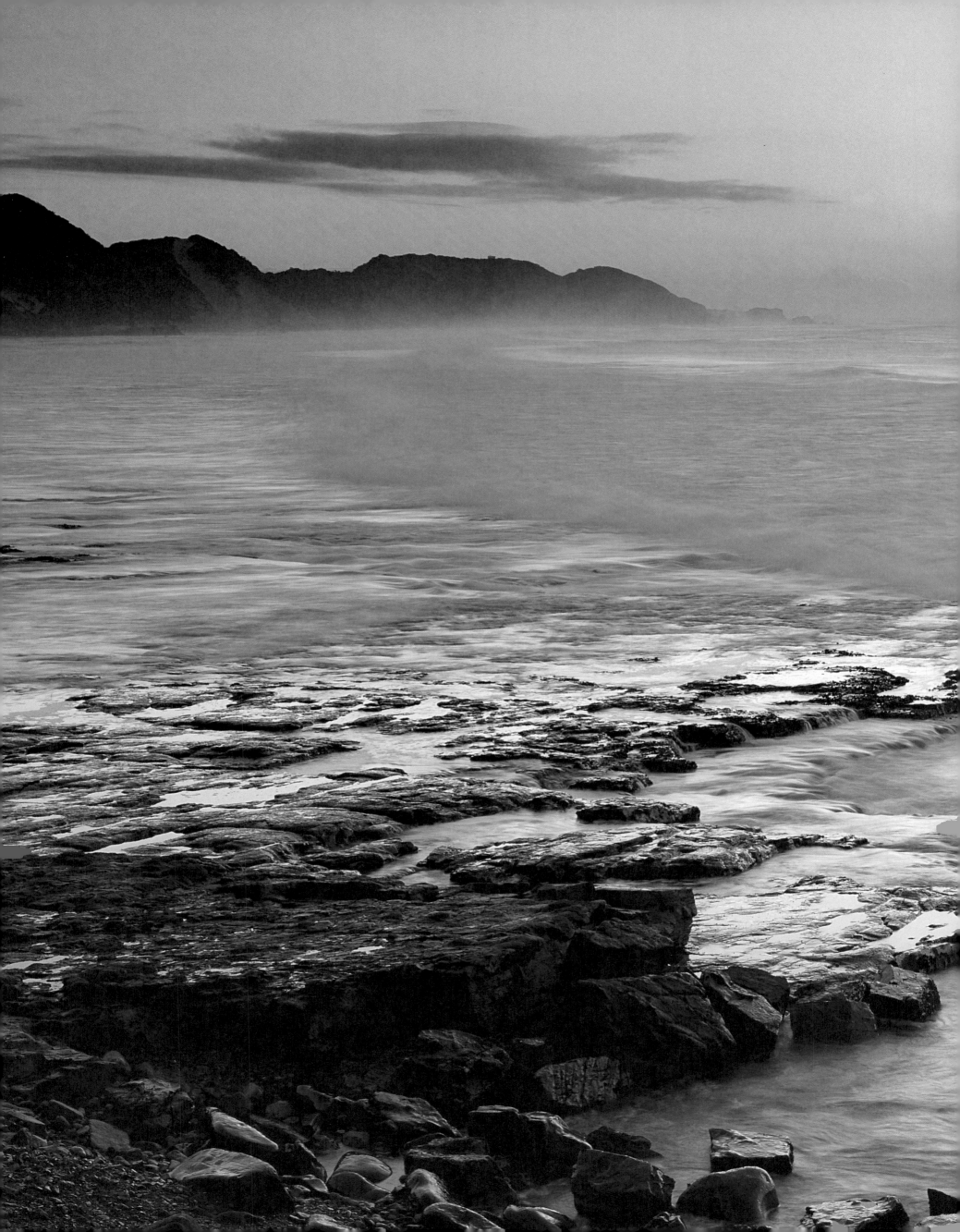